Jack London,
PHOTOGRAPHER

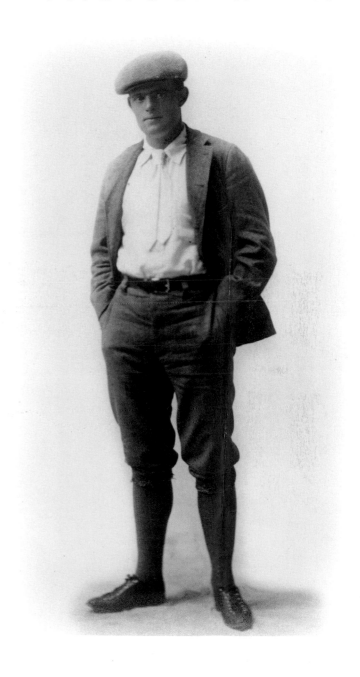

Jack London,

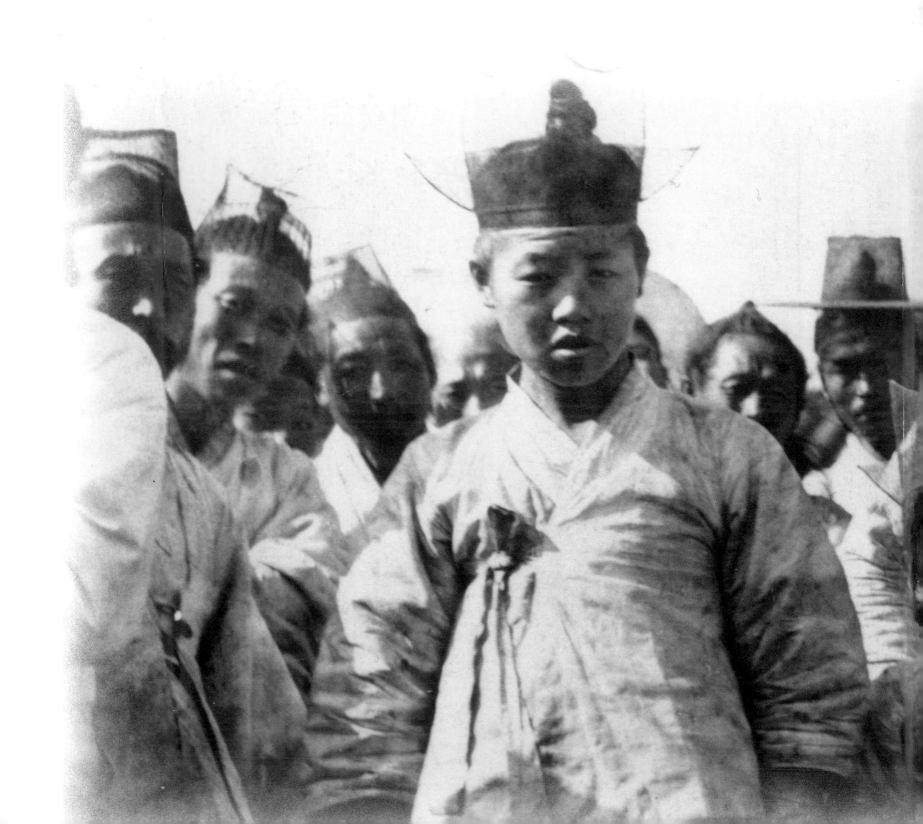

Photographer

JEANNE CAMPBELL REESMAN, SARA S. HODSON & PHILIP ADAM

THE UNIVERSITY OF GEORGIA PRESS *Athens and London*

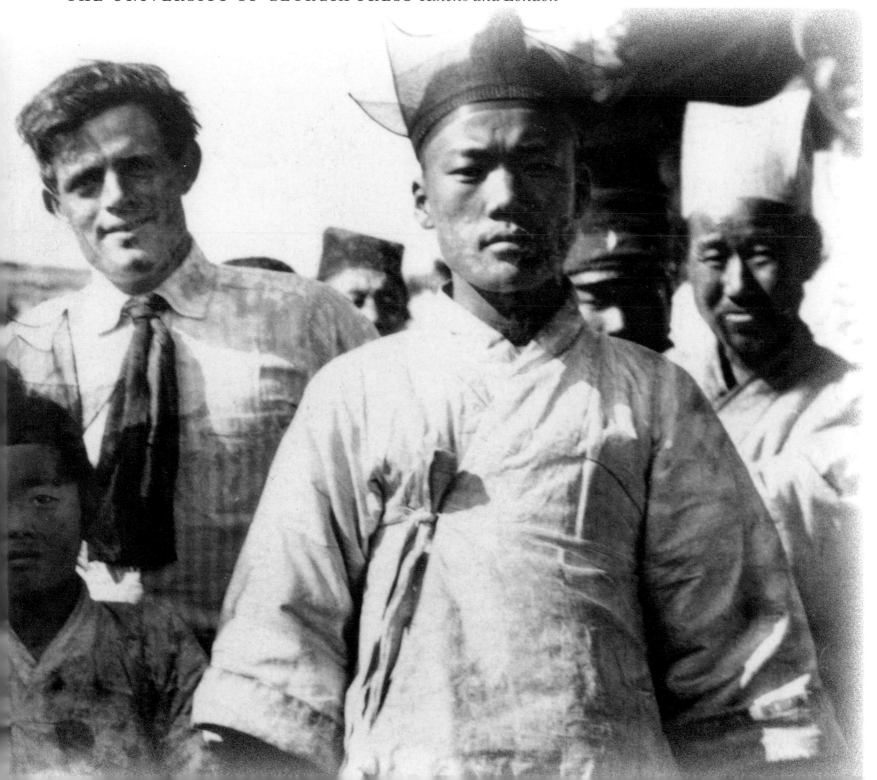

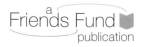
a Friends Fund publication

Unless otherwise noted, all images are from the following two sources: the Jack London Historic Negative Collection (these images appear courtesy of California State Parks, Jack London State Historical Park 2010) and the Jack London Collection, Huntington Library, San Marino, California.

Portions of chapter 4, *"The Cruise of the Snark,"* were first published, in a slightly different form, in *Jack London's Racial Lives: A Critical Biography*, by Jeanne Campbell Reesman (University of Georgia Press, 2009).

Designed by Richard Hendel
Set in Miller and Fresco types by
April Leidig-Higgins, Copperline Book Services

The paper in this book meets the guidelines for permanence and durability of the Committee on Production Guidelines for Book Longevity of the Council on Library Resources.

Printed in China

14 13 12 11 10 C 5 4 3 2 1

Library of Congress
Cataloging-in-Publication Data
Reesman, Jeanne Campbell.
Jack London, photographer /
Jeanne Campbell Reesman, Sara S. Hodson,
and Philip Adam.
 p. cm.
Includes bibliographical references and index.
ISBN-13: 978-0-8203-2967-3
(hardcover : alk. paper)
ISBN-10: 0-8203-2967-3
(hardcover : alk. paper)
1. London, Jack, 1876–1916 — Archives.
2. Photographers — United States — Biography.
3. Authors, American — 20th century —
Biography. 4. Henry E. Huntington Library
and Art Gallery — Photograph collections.
I. Hodson, Sara S. II. Adam, Philip. III. Title.
TR140.L664R44 2010
770.92 — dc22
[B] 2010005973

British Library Cataloging-in-Publication Data
available

This publication was made possible
in part by a generous grant from
Craig and Diana Barrow in honor
of their many friends who work with
and for the University of Georgia.

To

Milo Shepard

and Earle Labor,

for their vision.

JCR

SSH

PA

Contents

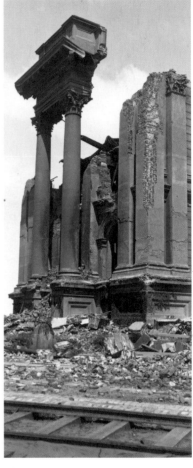

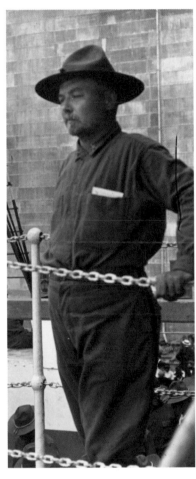

J*ack London, Photographer* proved to be a labor of love for its editors, publisher, and many others—a long and complex labor of love spanning nearly ten years. Editors Jeanne Campbell Reesman, Sara S. Hodson, and Philip Adam are grateful at last to be able to present this book, making the fascinating photographs of Jack London (1876–1916) available to the world.

A little background: In the summer of 2001, Hodson, the curator of literary manuscripts at the Huntington Library, and Reesman, a Huntington Fellow, were sitting side by side in the curatorial conference room at the library, selecting photographs for an exhibit in France on London's life and career. First, they entertained the idea of compiling a book of the Russo-Japanese War photographs, but then they realized that London's photographic oeuvre deserved a full, book-length sampling. Over several summers, they reviewed all twelve thousand prints in Jack London's photographic albums at the Huntington. At the Sonoma Barracks, where the California State Parks system stores London's negatives, they were able to locate original negatives for most images. Over the years, they came to a new understanding of Jack London as a photographer and found that the images shed much light on his works, life, and milieu. They also marveled that almost no one knew of London's treasure trove of photographs—beyond the few dozen frequently reproduced—and that no one had ever written about him as a noteworthy American photographer. Reesman and Hodson met Philip Adam in 2006 when the California Historical Society mounted his exhibit of London's San Francisco earthquake photographs to commemorate the centennial of the disaster. Recognizing the extraordinarily high quality of Adam's prints, Reesman and Hodson asked him to join the book project.

Confronted with so many images, Reesman and Hodson puzzled over how to choose the fraction that would best represent London as a photographer. They reviewed every photograph, and about four hundred of them several times. By examining many years of microfilm, they were able to understand how London's photographs appeared in the press, especially newspapers, and in what contexts. They developed techniques for differentiating London's photographs from those taken by his wife Charmian and his friend Martin Johnson, both of whom frequently accompanied London on his travels. With Adam's help, final choices were based on each photograph's artistic merit, ability to amplify themes in London's literary work, and capacity to reveal how some relatively unexplored places and unknown peoples appeared one hundred years ago.

The majority of London's photographs were printed from the original negatives in the California State Parks collection and from copy negatives made from the origi-

nal photographs in the albums at the Huntington Library. Prints made by Adam were scanned at the Huntington Library under the direction of photographer John Sullivan. London's negatives and prints are here reproduced as duotones from the silver gelatin prints made by Adam. Thus they appear in a historically accurate and appropriate medium. Yet until the publication of this book, no one, including London, had ever seen them printed so painstakingly, with full shadows and highlight details.

Since our first engagement with the project, the three of us have felt that this was a unique and important endeavor worthy of our best combined efforts in our areas of expertise: the intricate craft of photography, literary biography and history, the history of photography, archival research, and fundraising. We were fortunate to secure funds from the National Endowment for the Humanities, the Huntington Library Fellowship Program, the University of Texas at San Antonio Faculty Development Leave Program, the California Historical Society, Rudy Ciuca, James Jameson, Joseph N. Johnson, Jacqueline Koenig, Earle Labor, Lou Leal, Mr. and Mrs. Martin Lee, Robert Peduzzi, Ali M. Pfenninger, David Pfenninger, Relf Price, Jack Richmond, and several other private donors who wish to remain anonymous. We are immensely grateful to Craig and Diana Barrow for their generous gift to the University of Georgia Press to support the book's publication.

Jack London, Photographer also represents the combined professional efforts of many others besides ourselves. We have relied upon the cooperation and support of interested photographers, historians, museum experts, and, especially, librarians.

We are most grateful for the outstanding assistance we received from the staffs of the Huntington Library and California State Parks. At the Huntington, we especially recognize the efforts of library director David S. Zeidberg; director of research Robert Ritchie; chief photographer John Sullivan and his colleague, photographer Manuel Flores; digital specialist Devonne Tice; library associate Barbara Quinn; and chief curator of manuscripts Mary Robertson and her colleagues Lita Garcia, Natalie Russell, Bert Rinderle, and Diana Pam. Sara Hodson extends special thanks to her favorite adviser, best friend, and dear husband, Peter Blodgett. Expert advice, preparation, and permission to reproduce the photographs were generously furnished by Carol A. Dodge, a museum Curator for the California State Parks system. We are tremendously grateful to Dodge for her faith in the project and her trust in our stewardship of London's original negatives.

We also thank David Crosson and Mary Morganti of the California Histori-

cal Society and Nathan Lipfert of the Maine Maritime Museum for photographic assistance.

For their careful review of earlier versions of this book we warmly acknowledge the invaluable insights of Donna Campbell and Ken Light.

We wish to thank the University of Georgia Press for its beautiful reproduction of London's photographs. At the Press, we are especially grateful to Nancy Grayson, executive editor, for her endless enthusiasm and perseverance. We also thank Jon Davies, David Des Jardines, Walton Harris, Regan Huff, John McLeod, Nicole Mitchell, Kathi Morgan, Beth Snead, Lane Stewart, and Margaret Swanson. For designing the book, we enthusiastically thank Rich Hendel. We also recognize the contributions of Malcolm E. Barker, Loraine Barr, Edward Beardsley, Stan Bellamy, Lalo Borja, Bill and Janet Broder, Peter Browning, Sharon Dreyer, Lise Dumont, Peter Fairfield, Carol Sarnoff Frizzell, Greg Hayes, Pirkle Jones, Giorgios Katsagelos, Tom Levy, Ken Light, Stewart Martin, Noël Mauberret, Alison Moore, James Nagel, Tom Neff, Keith Newlin, Robert Olivier, Mark Oscherwitz, Tony Page, Christian Pagnard, Herbert Quick, Joyce Slater, Karen Smith, Jenny Speckels, Al Weber, Wendy Welker, Bradley Wiedmaier, and Sally Wood.

Milo Shepard, Jack London's great-nephew, was extraordinarily generous with his time, advice, and support for this book, as was Earle Labor of Centenary College of Louisiana, London's leading biographer.

By far our greatest debt is to London's second wife, Charmian Kittredge London, who sent many of his albums and files to the Huntington Library and in so doing saved his manuscripts, photographs, letters, and notes. She inserted his photographs into the dozens of albums now stored at the Huntington. Milo Shepard donated these and many other remaining items to the Huntington and the negatives of London's photographs to the California State Parks system. Without Charmian's diligence and Milo's careful stewardship, scholars would have far fewer London resources. We also acknowledge London's stepsister, Eliza London Shepard, who compiled London's first photograph album—for *The People of the Abyss*.

For permission to print the photographs in this book, we primarily thank the Huntington Library for allowing us to use photographs from the Jack London Papers and the California State Parks system for use of the negatives. For other images, we acknowledge the California Historical Society and the Maine Maritime Museum.

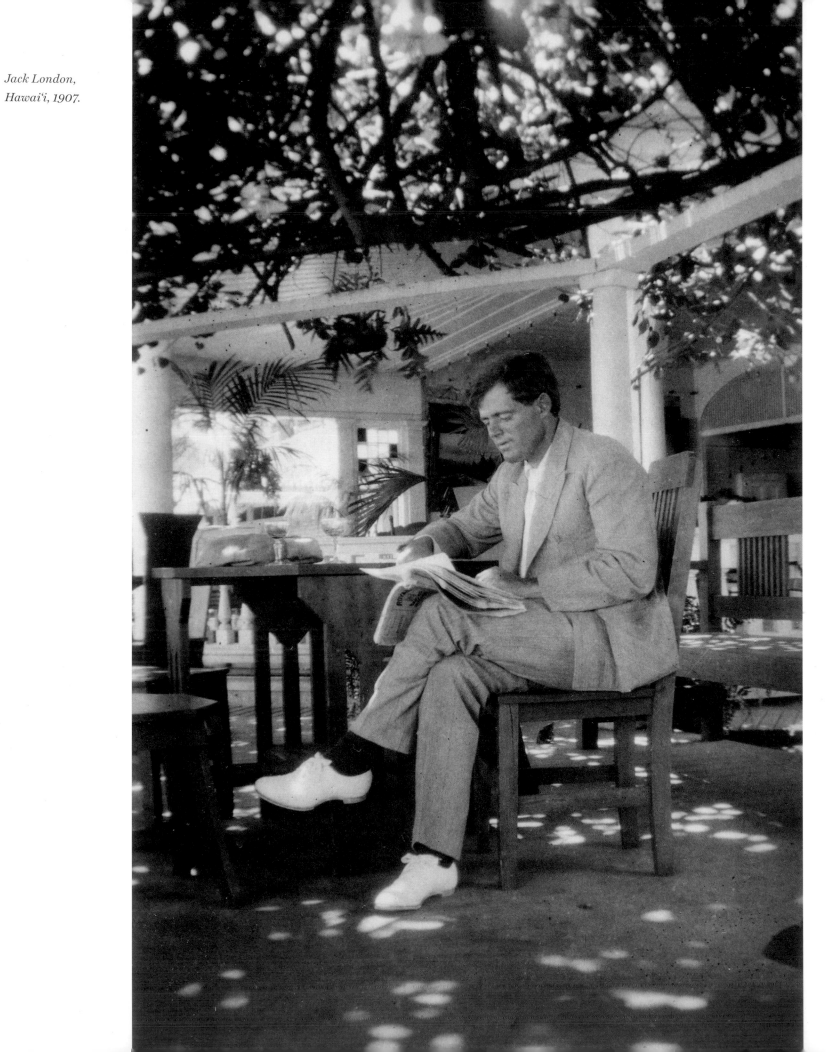

Jack London,
Hawai'i, 1907.

n the winter of 2005, I was asked to produce the first fine prints ever made of Jack London's photographs of the 1906 San Francisco earthquake and fire. They were to be shown at the California Historical Society in San Francisco to commemorate the centennial of the disaster.

The experience of looking at the negatives and making the prints was stunning. I felt as if I had discovered a lost treasure! Few Jack London scholars knew how many photographs he had made.

Thanks to California State Parks museum curator Carol Dodge, I became immersed in the world London explored with his camera. At the dawn of the twentieth century, this self-assured proto-photojournalist, equipped with a humanistic approach, possessed a discerning eye.

As I began printing London's earthquake negatives, it became clear that even though he had been a novice in 1900, he was a fast learner, quickly mastering the techniques needed to make quality images.

For example, most of his photographs of ruined buildings show little distortion. Instead of tilting the camera up to avoid cropping off the top of a partially fallen structure, London kept the camera level. He solved the problem of including too much foreground by carefully positioning his camera to fill the foreground with relevant subject matter. This improved the overall composition and gave the viewer more than the expected. Professional photographers working with a fixed-back roll-film camera often use this technique. I was impressed that London had figured it out.

The remarkable collection of photographs I was printing made me curious about London's process and abilities behind the camera. I learned from my colleagues Jeanne Reesman and Sue Hodson that anytime London embraced a new challenge —whether surfing, organic farming, or navigating open waters with a sextant—he was a quick study.

London used the Kodak 3A, a postcard-format folding camera. A vintage instruction booklet provided a thorough explanation of proper photographic technique. I was amused to find two pages of text and illustrations insisting that the camera be kept level for optimum results. London had not simply read the booklet; he had mastered Eastman Kodak's advice.

But mastering the fundamentals does not make you a photographer. To make meaningful photographs, you must do more than look: as Ruskin suggested, you must *see*. London's photographs showed me he had acquired this skill. It clearly set him apart from the casual "snap shooters" of his day.

For London, a curious man devoted to critical observation, the camera was the

A Photographer's Reflections on Jack London

PHILIP ADAM

The greatest thing a human soul ever does in this world is to see something, and tell what it saw in a plain way. . . . To see clearly is poetry, prophecy, and religion,—all in one.—John Ruskin, Modern Painters *(1856)*

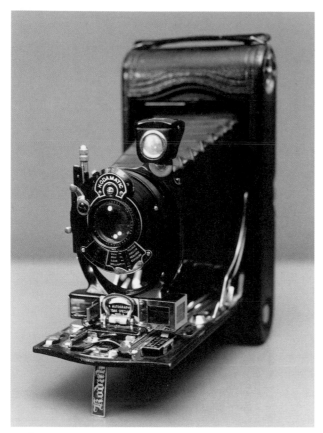

Kodak 3A camera, London's most frequent choice.

perfect tool. From 1900 to 1916, he made more than 12,000 photographs, both on professional assignments and during personal adventures. His desire to experience life is legendary. With the courage and determination of an explorer, London negotiated a wide range of challenging environments and conditions, taking photographs all along the way. His desire to build a visual narrative propelled him to discover and seize opportunities to use his camera.

In *The People of the Abyss* (1903) London's passion and intent to bear witness in words and photographs is clear: "I was open to be convinced by the evidence of my own eyes, rather than by the teachings of those who had not seen, or by the words of those who had seen and gone before."

Photographs do more than teach the viewer about the subject they have captured; they also reveal a great deal about the photographer. London's instinctive response to the world around him opened his heart as well as his camera's shutter. The photographs that most powerfully demonstrate this to me are those he made to illustrate *The People of the Abyss*, the dignified portraits of village leaders he made in Korea while covering the Russo-Japanese War, and his portraits of native peoples in the Marquesas, the Solomon Islands, Bora Bora, Mexico, and the Hawaiian Islands.

It is fascinating to me to contemplate London's photography in relation to his literary works and reportage. Over and over again in the photographs he made, London not only showed his powers of perception, but also revealed his compassion, respect, and love for humanity.

Jack London,
PHOTOGRAPHER

Photographic portrait of Jack London by Arnold Genthe, ca. 1903. (Used by permission of California Historical Society)

On February 1, 1904, Jack London (1876–1916), newly a war correspondent and recently arrived in Japan, planned to travel to Korea to cover the Russo-Japanese War for the Hearst newspapers, but was arrested in Moji by Japanese military police. On February 3, he wrote to Charmian Kittredge, his new love and soon-to-be second wife:

Still trying to sail to Chemulpo. Made an all-day ride back from Nagasaki to Moji to catch a steamer, Feb. 1 (Monday). Bought ticket, stepped outside and snapped three street scenes. Now Moji is a fortified place. Japanese police "Very sorry," but they arrested me. Spent the day examining me. Of course, I missed steamer. "Very sorry." Carted me down country Monday night to town of Kokura. Examined me again. Committed. Tried Tuesday. Found guilty. Fined 5 yen and camera confiscated. Have telegraphed American Minister at Tokio, who is now trying to recover camera.

Received last night a deputation from all the Japanese Newspaper correspondents in this vicinity. Present their good offices, and "Very Sorry." They are my brothers in craft. They are to-day to petition the judges (three judges sat on me with black caps) to get up mock auction of camera, when they will bid it in and present it to me with their compliments. "Very uncertain," however, they say.[1]

The Japanese authorities suspected London of being a Russian spy. But as he relates in one of his earliest newspaper dispatches, "How Jack London Got in and out of Jail in Japan," his Japanese "brothers in craft" succeeded in securing the return of his camera. London recalls his meeting with a reporter for the *Osaka Asahi Shimbun*: "I could have thrown my arms around him then and there—not for the camera, but for brotherhood, as he himself expressed it the next moment, because we were brothers in craft. Then we had tea together and talked over the prospects of war. . . . We parted as brothers part, and without wishing him any ill-luck, I should like to help him out of a hole someday in the United States."[2]

London went on to cover the war in Korea as one of the first and only correspondents to reach the front lines, though he was repeatedly arrested and returned to Seoul. (The land battles of the war were fought mainly in Korea and Manchuria.) He sent regular dispatches on battles largely unseen by anyone but the participants, and he made dramatic photographs, mostly behind the lines. These images and accounts, along with his few actual battle photographs, ran across the top pages of the *San Francisco Examiner* and in syndicated papers worldwide. London's hundreds

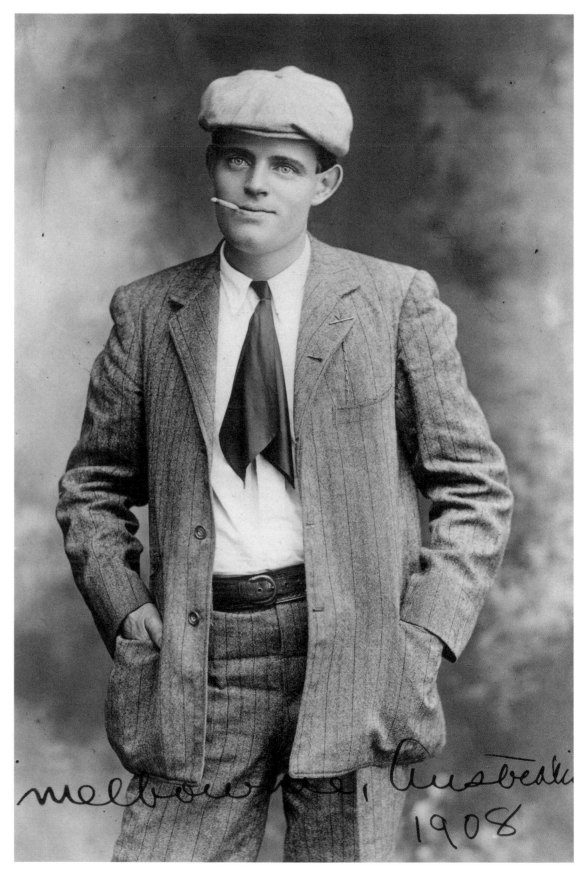

"Melbourne, Australia, [December] 1908."
Jack London photographed while covering
the Jack Johnson–Tommy Burns world
heavyweight fight in Australia for the
New York Herald.

of photographs capturing military scenes and the daily lives of Korean refugees and Japanese foot soldiers form an extraordinary record of what he called the "human documents" of the war. This period of his development as a photographer coincided with his first worldwide acclaim as a writer, especially for his novels *The Call of the Wild* (1903) and *The Sea-Wolf* (1904).

At the turn of the twentieth century, London's new perspectives on America and its presence in the world filled magazine and newspaper pages and inspired his best-selling books, naturalist and socialist antidotes to the prevailing romantic and imperialistic ideologies of the day. From the time that he achieved lasting fame with *The Call of the Wild*, his brief but remarkably productive career took him to many faraway places and exposed him to diverse cultures, some on the brink of disappearance and others undergoing dramatic change. Besides reporting on the Russo-Japanese War, he sailed aboard a Pacific sealing vessel; joined an army of homeless men in a march on Washington; traversed the Klondike; documented the poor of the East End of London; reported on the U.S. invasion of Veracruz in 1914; toured top universities on socialist speaking engagements; covered the aftermath of the San Francisco earthquake; described Jack Johnson's world heavyweight fights for an international readership; and sailed the Pacific on his forty-three-foot sailboat, the *Snark*, from 1907 to 1908, a voyage during which he observed the lepers of Moloka'i and the passing of Melville's Typee into disease and extinction. He also undertook scientific ranching in northern California.

Once snubbed by the literary critical establishment (especially during the Cold War) for being too popular, too unorthodox, and too socialistic, London's writings have been brought out in numerous new editions, attracted fresh scholarship, and been reconsidered for their literary artistry and the light they cast on cultural and historical concerns of his era. But whatever the shifts in his critical standing, his worldwide popularity among ordinary readers has never fluctuated.

Until *Jack London, Photographer*, the absence of London's photographs from the bookshelves has presented a glaring irony: once seen around the world on the front pages of newspapers and magazines, a century later his photographs have been available to only the few with access to the archives where London's materials are held. Most of his prints were placed directly into the Londons' personal albums from 1903 to 1916, the year of his death. Only two of his books (*The People of the Abyss* and *The Cruise of the Snark* [1911]) contain his own photographs, and most publishers today reproduce the original photographs poorly and selectively, if at all.

The Huntington Library, in San Marino, California, holds the largest archive of

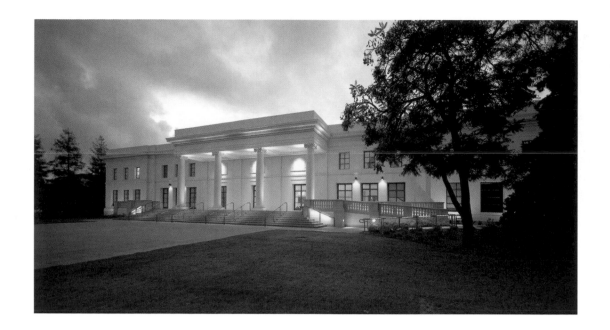

The Munger Center at the Huntington Library, San Marino, California, where most of Jack London's manuscripts and photographs are stored.

London's papers and materials. The Jack London Papers continue to be the most heavily used literary collection in the library, appealing to scholars, documentary filmmakers, dramatists, artists, and fans. Yet the thousands of original photographs taken by London have not been studied; they demand further attention from photographers as well as literary and cultural historians.

As a visual icon himself—so much so that the cruise of the *Snark* was the most heavily publicized American adventure until the Lindbergh flight twenty years later —London knew the power of the image. His own seemed to appear everywhere, perhaps above a story reporting that he was lost in the Solomon Islands or was riding with Pancho Villa in the Mexican Revolution. In fact, London was one of the most photographed celebrities of his day, the first modern multimedia celebrity after Mark Twain. At the Huntington, dozens of huge ledgers full of clippings provide a staggering record of how often his name and image appeared in print, whether above a factual story or a fictional one. He was pictured showing off his livestock. He posed for numerous formal portraits, and his image appeared in advertisements for his books as well as for cigarettes, grape juice, and typewriters. Occasionally, illustrators and photographers depicted him mistakenly or whimsically. For example, a newspaper illustration for a war-correspondent piece absurdly showed him with a pith helmet atop his head! In his Russo-Japanese War reportage published in the *San Francisco Examiner*, a line drawing shows him negotiating with Japanese officers in addition to photographing the battle behind a photographer's dark-cloth. In his coverage of Jack Johnson's world heavyweight matches in 1908 and 1910, line art and photo-

(facing page)
Jack London photographing the hull of the Snark. *Shipyard of H. P. Anderson, Hunters Point, San Francisco Bay, February 1906.*

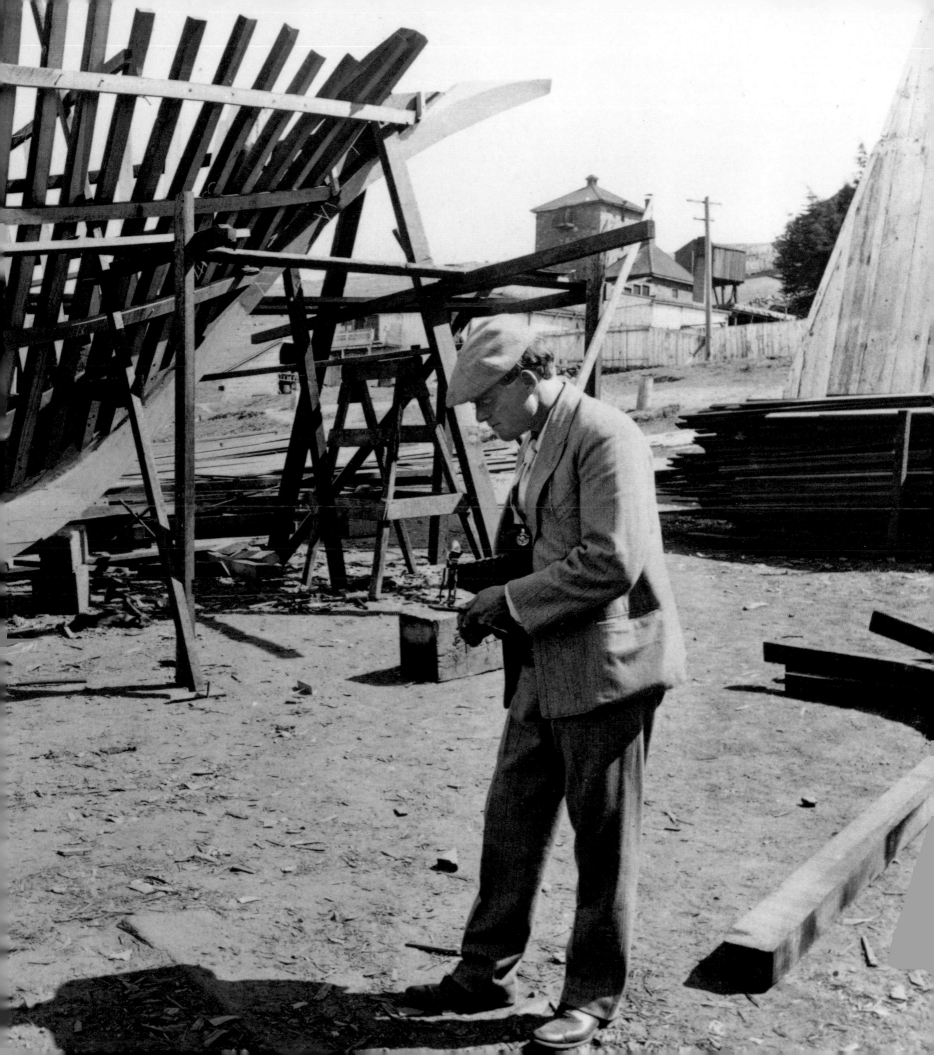

"County Days at the Exposition, Sonoma County."

graphs pose London—and not Tommy Burns or Jim Jeffries—as Johnson's opponent.

The artistic and historical value of London's photographs makes them an accomplished body of work. Of course, London was not primarily a photographer who had adventures but rather an adventurer and writer who made photographs. Yet he thought of himself as a professional: he expected to sell his photographic output just as he did his writing. His photographic work includes virtually no touristic photographs and few made on his California ranch. Most of London's images are of considerable biographical and literary interest, and readers will find in them unique insights into the author and his works. London has long been described as one of the most visual of writers; in fact, he photographed many people upon whom he modeled characters. He often used pictorial imagery in his fiction. *Before Adam* (1907), for example, begins: "Pictures! Pictures! Pictures! Often, before I learned, did I wonder whence came the multitudes of pictures that thronged my dreams; for they were pictures the like of which I had never seen in real wake-a-day life."[3] The subject matter of his photographs—the English poor, Korean refugees, Japanese soldiers, tent cities in the aftermath of the San Francisco earthquake, prisoners of war in Veracruz, a sailing crew rounding the Horn, fieldworkers in Hawai'i, and the disappearing societies of the Marquesas and other South Seas islands he visited—also makes his photographs of value to military historians, cultural geographers, anthropologists, and other interested parties.

As a writer who was also a practicing photographer, London was not unique, though few so excelled in both roles. Artists contemporary with London who were interested in both photography and literature included the writers Henry James, William Dean Howells, and Stephen Crane as well as the photographers Edward Steichen, Walker Evans, and Alfred Stieglitz.[4] As a young man, Stieglitz "devoured" each of London's books as it appeared.[5] Another connection between the two areas of artistic endeavor: the term *photographie*, coined by Hércules Florence, a French explorer in the Amazon of the 1830s, means "writing in light."

The sense of realism—"writing in light"—that pervades London's fiction also informs his photography. His writings have been described as both realistic and

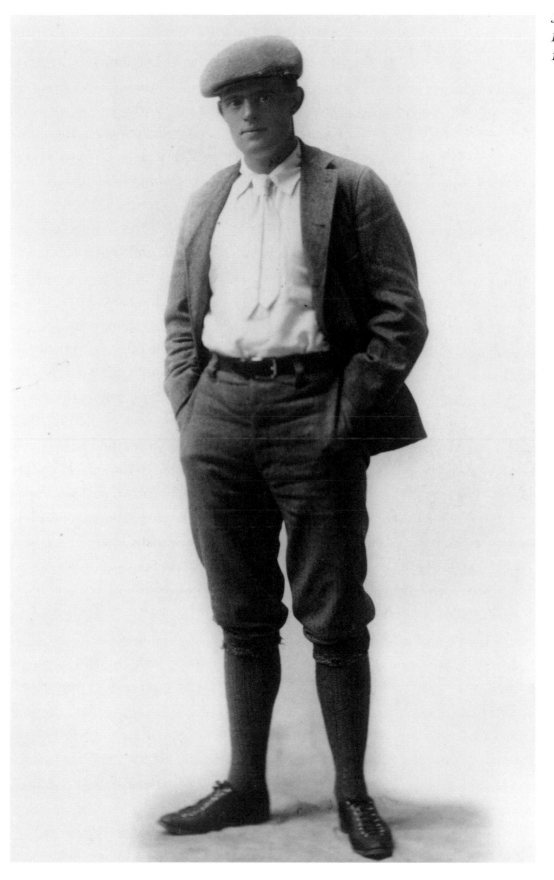

Jack London,
London, England,
1902.

romantic, but most often they are termed *naturalistic*. Influenced by the ideas of Karl Marx, Sigmund Freud, and Charles Darwin, and using the techniques of the French novelist Émile Zola, American naturalistic writers such as London, Stephen Crane, Frank Norris, and Theodore Dreiser depicted the lives of the poor as struggles against the pitiless and illimitable forces of biology and society. Though many of their protagonists are heroic, they are not usually able to overcome the forces arrayed against them. These writers employed a documentary, photographic use of detail that contrasted strongly with the leisurely accumulation of details in realist novels.

In his photography, as in his writing, London sought unusual settings and subjects, far from the everyday locales and general experience of his readers. For example, nearly all of his photographic subjects are members of nonwhite cultures in Asia and the South Pacific. There is a major difference, however, between his fiction and his photography. His stories and novels delve into the past, present, and future of their heroes and heroines; often, the tales are either narratives of decline, or they portray a hero who survives by holding onto certain values of community. But in the photographs, London seems uninterested in the past, especially the defining "primitive" past or "timelessness" of "natives." As to the future, London could not know it, though in the case of the tropical islanders, he felt certain that it would involve decline and death. This was a tragic truth that became shockingly obvious to him at the *Snark*'s first South Seas port of call, the island of Nuku Hiva in the Marquesas, where white men's diseases had wiped out nearly all the indigenous people. Especially in *The Cruise of the Snark*, London mourns such destruction. Yet, though full of feeling, the photographs do not resort to romantic idealism or sentimentality. Nor are they gratuitously shocking. For example, London chose not to photograph the worst ravages of European diseases on Pacific islanders; even his photographs of lepers on Moloka'i present the subjects with dignity and as distinct individuals.

London's photographs of outcasts and the downtrodden found a ready audience in the United States. Led by the Hearst Syndicate, U.S. newspapers and magazines depicted the appalling lives of the poor, in the manner of Jacob Riis's *How the Other Half Lives*, a study of New York tenements that was first published in Howells's *Atlantic Monthly* in 1890. (In the same issue appeared Norris's "Comida: An Experience in Famine," about civilian war victims in Cuba, and London's short story "An Odyssey of the North," a tale of the impact of white newcomers on the Indians of the Yukon.) Tales of life in the slums appeared in the works of Riis and the muckraker

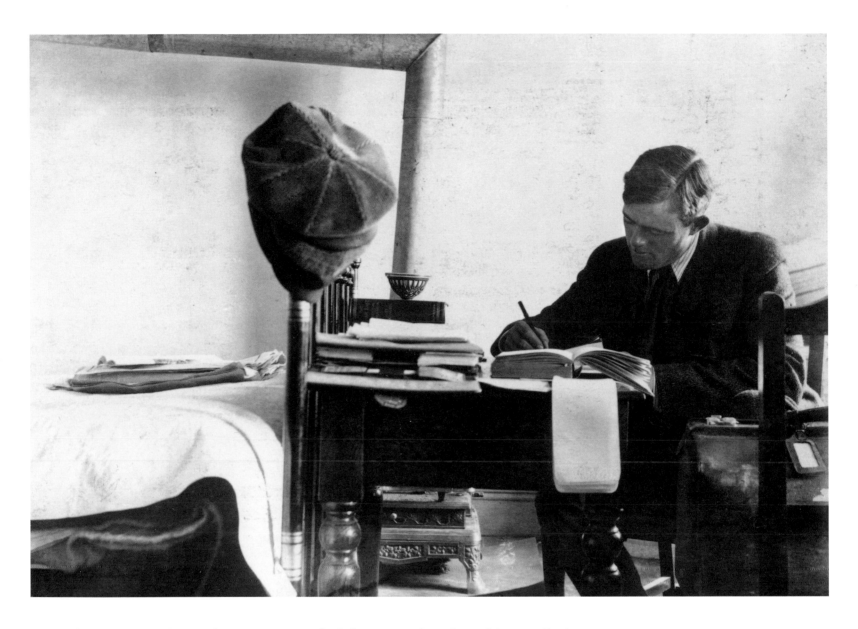

journalists, in Crane's novel *Maggie: A Girl of the Streets* (1893), and in London's *The People of the Abyss*, *The Iron Heel*, and stories such as "The Apostate."

Jack London at work in his bedroom, ca. 1900.

 In his photographs as in his fiction, London most often sought to capture the common emotional life of his subjects—not a culture, but the individuals who made it up. Even in his photographs of the many buildings destroyed by the San Francisco earthquake, his compositions evoke the human toll of the cataclysm, sometimes by contrasting the size of human subjects with the massive ruins around them. London sought to depict the potential for human drama. He was drawn to any subject—even a ruined city hall that would later be rebuilt—that indicated something of the struggle to survive.

THE "HUMAN DOCUMENT"

London called the photographs he made "human documents," a phrase first used by the French novelists Alphonse Daudet and Edmond Goncourt and picked up by London through his participation in a project overseen by Sarah Orne Jewett. The famous New England literary realist was editing an ongoing series in *McClure's Magazine* with that title. It proposed to compare photographs from different stages of a great man's life in order, as she put it, to "tell his affairs openly."[6] Jewett regarded the series as an attempt "to read the sign-language of faces, and to take the messages they bring":

> All time has been getting our lives ready to be lived, to be shaped as far as may be by our own wills, and furthered by that conscious freedom that gives us to be ourselves. You may read all these in any Human Document—the look of race, the look of family, the look that is set like a seal by a man's occupation, the look of the spirit's free or hindered life, and success or failure in the pursuit of goodness—they are all plain to see. If we could read one human face aright, the history not only of man, but of humanity itself, is written there.[7]

London working on The Sea-Wolf, *Glen Ellen, 1903.*

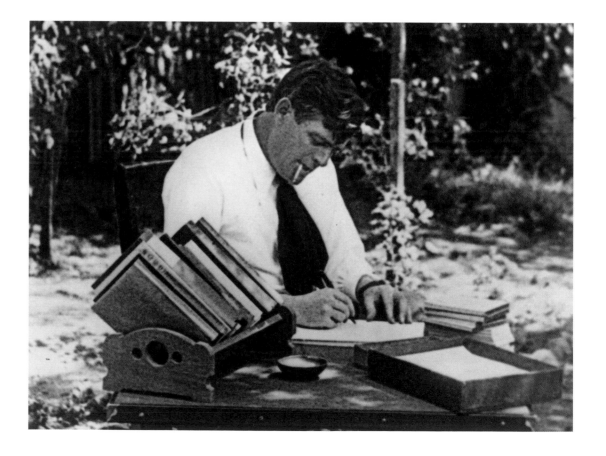

Such thinking seemed to inspire London's photography, which engages the viewer with portraits of people of all ages the world over. Like London's best short stories, his photographs tend to dwell closely on their subjects, presenting brief, intimate portraits of diverse characters.

In the early years of photography, portrait subjects tended to be the eminent and famous, except for "exotics" presented as case studies or anthropological curiosities. London was one of only a few photographers of his day to portray nonwhite people as individualized members of humanity rather than specimens. These were "human documents" in London's sense of the term—subjects photographed for no other purpose than the photograph itself. Whether or not a picture was published and paid for, London photographed whom he wanted, how he wanted.

London's first significant photographs were made during his stay in the East End of London, England, in 1902, and appeared in *The People of the Abyss*. In these photographs, London's sense of the "human document" in the people he photographs is tied to the arguments he makes for socialism. He shows in image after image the failure of the British Empire to govern its own citizens humanely. When asked in 1907 to write a letter of advice for young authors, London responded, "The biggest

Jack London with camera, Manu'a, Samoan Islands, 1908.

hint I have to offer to the beginner is that he be not a slave to convention; that he build not as his fathers built; that he think for himself, and that he accept truth wherever he finds it, and not because it is garbed in fine linen and goes prancing around in an automobile or a church pulpit, a university-chair, or an editor's sanctum."[8] In other words, the goal should be to look for "human documents" outside the mainstream and among common people. Such an approach to writing—and photography—fit well with London's general worldview, which highly valued the individual.

LONDON'S PHOTOGRAPHIC TIMES

As a young man, London learned photography from a former schoolmate at Oakland High School, Fred Jacobs, and Jacobs's fiancée, Bessie May Maddern, who tutored at Anderson's University Academy in Alameda and helped London cram for his college entrance exams. Maddern became London's first wife after Jacobs was killed in 1898 in an accident aboard the military transport ship *Scandia*. She had a small darkroom, and there she and London developed and printed pictures they made on outings together. In describing a bicycle trip with Maddern to Mill Valley, London refers to her as "an amateur photographer" whose "camera usually accompanies us on our trips." He continues: "We have been waiting for a rainy day for developing and printing the shots we have taken—she's got some kind of a film or plate, or whatever it is, which does not require the sun for printing."[9]

London's interest in photography extended to others' depictions of places he loved. On November 5, 1900, London wrote to Cornelius Gepfert, a Klondike friend at the Stewart River who had returned to the Klondike to prospect for gold. Noting that he divided his time between his typewriter and the darkroom, he then asked Gepfert:

> When on a jaunt down to Dawson, if you should run across any good fotographs [*sic*] of the country, dogs, dog-teams, water, ice, snow, hill, cabin, raft, steamboat, ice-run, jam, etc., etc., scenes, why buy them and send them out to me, and then I will send in the cost of transportation and purchase price. Of course, if it is possible to send them out by the mails. I haven't any fotos of the country, and if I were lucky enough to get hold of any I should prize them most dearly. I haven't ceased kicking myself yet for not having taken a camera with me in '97.[10]

This is one of the ironies of London's photographic career, for there are no known photographs either of or by Jack London in the locale for which he is most famous.[11]

London took up photography at a time when the field was expanding in numerous directions: besides standard portraiture, the era was rich with documentary photography (although that label did not come into use until around twenty years after London's death), the beginnings of photojournalism (including war photography), the development of mass media, technical innovations in the craft, and the uses of photography in science. London's photographic record contains evidence of all these developments except scientific photography.

London knew well, and was photographed by, one of the nation's most respected photographers, Arnold Genthe (1869–1942), who besides his portraits (including many of London) also made photographs of urban poverty. Genthe had a studio in San Francisco from 1898 to 1911. Along with London, Mary Austin, and George Sterling, he was one of the first to settle in the artist's colony in Carmel-by-the-Sea, where he built a house in 1905.

Genthe was known for two bodies of work: his photographs of the San Francisco earthquake and fire, and his book *Pictures of Old Chinatown* (1908). A portrait of an immigrant community within a great American city, this book retains a distinctively Euro-American point of view of a culture deemed exotic and alien by most whites. Genthe used a very small camera and concealed it under his coat to catch his subjects unawares. Despite the obvious emotional gap that such a practice entails, Genthe gives a close view of his subjects; if somewhat detached, it is not without considerable empathy. In a letter to William B. Parker (February 21, 1912) at the Century Company, London remarked of Genthe: "I consider him the biggest photographer of the world today."[12]

In his memoir *As I Remember* (1936), Genthe recalls a note about London sent him by John O'Hara Cosgrave, editor of the San Francisco magazine the *Wave*: "Please make a picture of bearer. He has written a rattling good story for *The Wave* and I feel sure he will be heard from in the future."[13] Genthe made many formal portraits of London during the following years, noting that "as a token of his appreciation he gave me copies of every one of his books, inscribing some lines on the flyleaf of each. Sometimes just a word, like 'Friendship's Grip.'"[14] He also recalls attending the annual Hi-Jinks at the Bohemian Grove with London, George Sterling, and Ambrose Bierce, among others:

Jack London had a poignantly sensitive face. His eyes were those of a dreamer, and there was almost a feminine wistfulness about him. Yet at the same time he gave a feeling of a terrific and unconquerable physical force. When he built

Photographic portrait of Jack London by Arnold Genthe, ca. 1903.

his boat, *The Snark*, which he had designed himself for his trip to the South Seas, some of the naval officers at the Bohemian Club insisted that it was not seaworthy. "He won't get as far as Hawaii," said a commander. "If he strikes the tail end of a typhoon, that boat will go down to the bottom like a flash." "The boat may go down," said I, "but Jack London never will." That was the impression he gave me.[15]

The Beginnings of Photojournalism

Among the multiple photographic contexts of London's day, the most important for London's work behind the camera was the combination of the documentary style and what would later come to be called photojournalism. Early photographic documentation included the series of photographs taken in the 1850s and 1860s of uprisings in India and China, the Crimean War (1854–56), and the U.S. Civil War, which was recorded by Matthew Brady, Alexander Gardner, and George N. Barnard, among others. Later, London's friend James Henry "Jimmie" Hare (1856–1946) gained a reputation for war photography during the Spanish-American War, in 1898. He went on to photograph the Russo-Japanese War, the San Francisco earthquake, the First Balkan War (1912–13), the Mexican Revolution, and World War I. Yet even in the intensely competitive arena of war reporting and photography, London's photographic work for newspapers was comparable to anyone's. At the same time, he was less interested in the news conveyed by the photograph than in the human subjects, their faces, their personal stories, what later came to be called "human interest." Whereas much of Hare's Russo-Japanese War photography shows sunken ships, bombed buildings, and mangled artillery, London's work is almost exclusively of human subjects.

London lived during the first true mass-media era, when the use of photographic images in newspapers and magazines ushered in a new way of covering the news. In almost every country, magazines were illustrated with wood engravings cut from sketches, drawings, paintings, and at times photographs. The first magazine to reproduce photographs exclusively was the *Illustrated American* in 1890. Because of technological limitations, the majority of daily newspapers, however, lagged behind

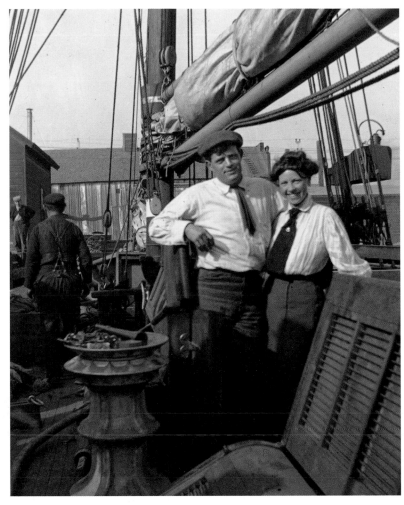

Jack and Charmian London prepare for the voyage of the Snark, *San Francisco, 1907.*

illustrated magazines in their use of photographs. The practice of integrating words and photographs in newspapers began in 1890 with the *Berliner Illustrierte Zeitung* (*Berlin Illustrated Newspaper*).

Technological developments furthered photography in London's day, especially in the printing of photographic images as halftones and the development of flash powder, faster-speed films, and handheld cameras. The halftone process enabled photographs to be reproduced economically; widely distributed newspapers and picture magazines were available to nearly everyone. For London, the most important technological innovation was the portable folding camera, introduced around 1900. The smaller cameras, faster films, and faster lenses gave photographers greater freedom of movement and allowed them to capture previously elusive types of subjects. In place of glass plates, the folding camera contained flexible roll film, enabling the photographer to make a series of photographs on the same roll. With the introduction in 1900 of the Eastman Kodak 3A, often referred to as a "postcard format" camera, a national craze for photographic postcards ensued, especially for those from foreign and exotic places. Thus London was a photographer nearly at the inception of modern popular and news photography.

Photography and Science

From the 1850s through London's era, scientific photography focused on specimens, from the horticultural to the anthropological. It was thought to be an excellent means of categorizing such groups as the criminally insane as well as a critical tool for demonstrating the inferiority of racial and ethnic "others" in order to justify Western colonization. Photography was used "to describe, compare, and rank 'racial' types," observes photography historian Mary Warner Marien; "with the rapid colonization of the non-Western world, human diversity was increasingly discussed and classified."[16] The Royal Ethnographic Society in London developed systems for measuring cranial capacity, skull thickness, angle of jaw projection, and the ratio of arm length to body height—all compared against European standards. According to the society, full-face, full-length, and profile shots were considered the most scientifically useful. Louis Agassiz, a professor of zoology and geology at Harvard, and his followers posed nonwhite people in the rigid forms dictated by the society in order to provide evidence for the theory of polygeny, the belief that the races were created separately and with unequal attributes.

"Scientific" and even popular photographers of Jack London's day continued to photograph in ways that supported racialist theories. As photography was used at

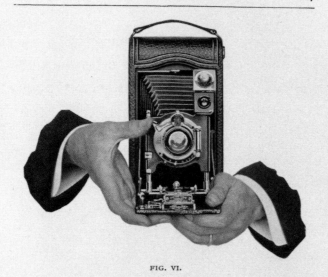

FIG. VI.

Fig. VI. shows how to hold the camera when making an exposure without the use of the bulb. Grasp the bed of Kodak firmly with the left hand, steady it with the right, and with the thumb of the right hand lightly touch the exposure lever.

4.—HOLD IT LEVEL.

The Kodak must be held level.

If the operator attempts to photograph a tall building while standing near it, by pointing the camera upward (thinking thereby to center it) the result will be similar to Fig. VII.

This was pointed too high. This building should have been taken from the middle story window of the building opposite.

FIG. VII.

The operator should hold the camera *level*, after withdrawing to a proper distance, as indicated by the image shown in the finder on the top of the camera.

NOTE—The rising front may be used in helping to center high objects on the plate. See page 29.

If the object be down low, like a small child or a dog, the Kodak should be held down level with the center of the object.

5.—COMPRESS THE BULB.

HOLD THE CAMERA STEADY,
HOLD IT LEVEL AND
COMPRESS THE BULB.

This makes the Exposure.

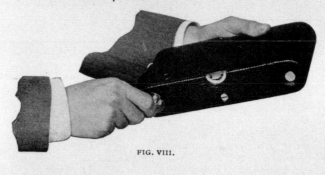

FIG. VIII.

home and abroad to survey "inferior" groups such as the poor, the criminal, the ill, or the insane, "those engaged in collecting all this new knowledge considered the fruits of their labours to be 'pure' fact, objective and empirical observations," Martin Parr and Gerry Badger note. Thus, photography was regarded as a "transparent vehicle" for the "transcription of fact, a means by which the world virtually represented itself."[17]

War photographers who followed Western armies intent on colonization portrayed for audiences back home the strangeness of foreign places and their ripeness for Western domination. The earliest photographs of wartime were sometimes designed to emphasize differing racial characteristics. For example, in the second half

Pages from George Eastman's instructions for the 3A camera.

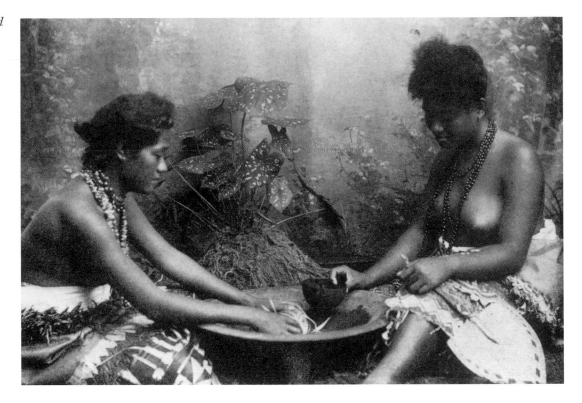

Postcard: "Making the 'ava.'" As this postcard and others pasted in a photo album by Charmian indicate, in contrast to London's natural photographs of islanders, "native" women of the South Seas were usually portrayed topless and engaged in some service activity such as food preparation. Until the advent of the Kodak 3A and 4A portable cameras, which London used, such scenes were photographed indoors with fake backdrops.

of the nineteenth century, photographers followed colonizers and their troops in India, China, North Africa, Abyssinia (now Ethiopia), and the Middle East. In addition to images of battles and their aftermaths, they made photographs that stressed the exotic qualities of the landscapes, architecture, and people in foreign lands. Sometimes they set up studios abroad and made photographs for colonial settlers. These photographs promoted the idea that the photographer was an adventurer, bravely exploring the edges of the world. Some important photographers of colonial sites were Samuel Bourne (1843–1912) in India, Félice Beato (1832–1909) and others in China, and Francis Frith (1822–98) in the Middle East. Soon, explorers realized the importance of the camera as a means of information gathering. Travel photography led to the idea of the photographic series, or "essay," in which images were arranged in particular sequences to give the viewer a broad sense of the locale. As photographic technology advanced, the stereograph, postcard, and illustrated travel book became popular. Ironically, as Marien notes, "behind the eagerness for stereographs was the ideal of democratic access to information," but there was at the same time the urge to include photographs of "the growing number of colonial sites around the world."[18] Some popular titles along these lines were Murat Halstead's *Pictorial History of America's New Possessions* and William Boyce's *United States Colonies and Dependencies*.

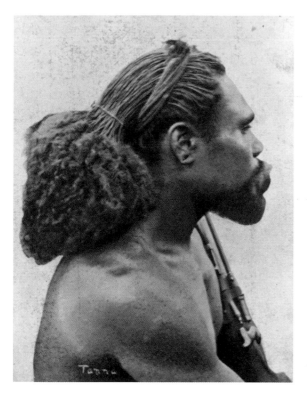 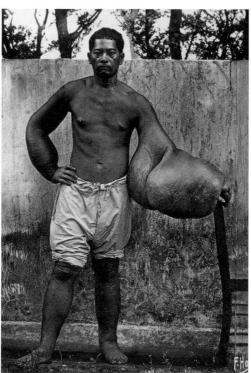

Close to 90 percent of London's photographs were made outside the United States, the great majority in Asia and the South Seas. But since London was not an anthropologist, these were not scientific photographs, and their subjects were not treated like anthropological samples. Rather, he photographed people going about their daily work in natural or urban settings. He tended to photograph faces and to concentrate on children and the elderly, such as the Korean elders and child beggars in Seoul. He usually photographed his subjects on their level, bringing into public view places and peoples virtually unknown to Western audiences. In close-ups of old men's faces, the lepers of Moloka'i celebrating the Fourth of July with a rodeo and parade, young Samoan mothers with their children, the women's market of Malaita in the Solomon Islands, and the sneering lips of white slave traders, he offered up a full range of humanity.

Before the *Snark*'s two-year voyage to the South Seas, London's view of indigenous peoples and their cultures was tainted by racialist views he had learned in his student days. Racialism was taught as science by influential professors at the University of California and Stanford. After the voyage, his ideas came to more closely resemble those of his contemporary Franz Boas than those of Agassiz and his adherents. Boas argued that culture ("the community of emotional life that rises from our everyday habits") is more important than race or origin for forging a nation—

Jack London and camera at polo match, Honolulu, Hawai'i, June 1907. London photographed Hawai'i's governor Jack Atkinson and the elite of Honolulu at the match.

a lesson that London learned on his voyage and demonstrated in his photographs and stories.[19] At the same time that Boas's culturally sensitive exhibit on Northwest Coast Indians opened at the Museum of Natural History in New York City, across town at the Bronx Zoo, a Pygmy visitor from the Belgian Congo was exhibited for weeks in a cage in the primate house. This was in 1905, the year that London conceived of his plan to build the *Snark* and circumnavigate the globe.

By this time too, London's early interest in the interpretation of Darwinism offered by Herbert Spencer, who saw evolution as ultimately benefiting only the white race, had been supplanted in his mind by Thomas Henry Huxley's more benevolent version of Darwinism, which, for humans, was not taken to imply "the survival of the fittest." (This phrase was actually Spencer's, not Darwin's.) Huxley rejected the Social Darwinism of Spencer and argued that nature is not a model for human behavior: the common human struggle was a call for brotherhood and ethics in the daunting face of the "state of nature."

As a photographer, London also rejected the style of "local color." In Asia, for example, Westerners customarily chose such photographic subjects as rickshaws, sedan chairs, workers and tradespeople in "typical" dress, and elaborately costumed women showing their bound feet. Most such portraits were taken indoors with painted backgrounds. These images appeared on some of the first postcards. In the world of local color, a foreign land was always described as serene and the local inhabitants as content: serene and content, that is, under Western rule or influence. London also portrayed people in traditional garb, and he frequently posed his subjects; but his work is quite distinct from the stock images most people were used to seeing. He respected his subjects, rejecting the rigid and stereotyped poses—bare-breasted women serving food, diseased or dangerous men, side views taken to show skull size, photographs of deformities—typically used to show "natives."

Western science included both the view of non-Europeans as types and the more humanistic view seen in London's work. The National Geographic Society, founded in 1888, took a cue from weekly magazines and newspapers and featured photographs of "natives" in which the primitive was standard. Yet Charles Darwin's *The Expression of the Emotions in Man and Animals* (1872) argued that emotional states (as seen in faces and bodies) were the same in all humans. Jack London took notice of this. Considering the influence of Marx, Huxley, and Darwin on his work, London's photographic choices reflect the ideas of several major thinkers of the period.

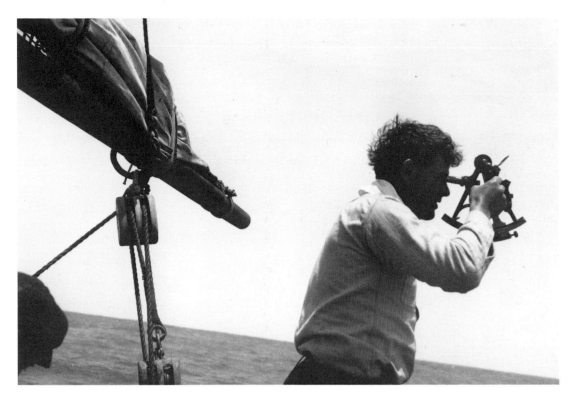

Jack London with sextant on the Snark, *1907.*

Such intellectual adaptation, combined with his socialism and lower-class origins, his journalistic and artistic missions, his naturalism, as well as his curiosity, helped London fulfill a commitment to photographing "human documents." He rarely diminishes his subjects; their individual selfhood predominates, and many are captioned with names and other personal information. In his photographs of people struggling to confront poverty, war, natural disasters, disease, and other hardships, London documents people *as* history.

CHOICES AND CHALLENGES

London primarily used Kodak 3A and 4A roll-film cameras. He also owned a panoramic, a stereoptic, and a view camera. Amazingly, considering the risky environment of the South Pacific and some of the other locales of his adventures, his original nitrate negatives are in fair and stable condition and perfectly sharp. He developed many of his photographs himself, with the assistance on the *Snark* trip of the young photographer and soon-to-be adventurer and cinematographer Martin Johnson; other photographs he mailed back to be developed in San Francisco and Oakland. Many of his letters bemoan the state of his film, developing chemicals, and apparatus, which were constantly subjected to the unpredictable sea and its salty air.

A letter of April 17, 1911, to Harold S. Latham of Macmillan indicates how closely

involved London was in the next phase of photography, photo editing. He wrote to complain about how his *Snark* photographs had gotten mixed up at Macmillan:

Let me tell you that you certainly have got my proud goat. If you know anything at all about my work, you know that I have never been consulted about the illustrations of one of my books, nor about the bookcovers of one of my books. You will know that I never revise. You will know that I never go back over my track again. And you will also know that the wildest, maddest thing I ever did was carefully, painstakingly, heart-breakingly, dismally, to arrange the photographs, by chapter, by consecutive order in the chapter, and by a legend accompanying each film or print, for *The Cruise of the Snark*. I cannot reiterate, nor can I find enough adjectives to describe the perfection of orderliness with which I arranged these illustrations, and forwarded them to you. . . . When I found the mess that had been made of the whole thing, I very nearly abandoned the book. Remember, I never do things a second time. I am not proud of this; I am so made, that is all. You returned the reproductions with envelopes missing. You returned me envelopes with the reproductions missing. You capped the whole mess by so forwarding the empty envelopes with the legends written on them, that the postmaster refused to deliver same to me until I came down to the Post Office in the matter. God knows how many of these envelopes, every one vitally important if I untangle the mess, had been inclosed [*sic*] in a cheap, large envelope. The cheap, large envelope, naturally, had burst into pieces. And from New York to Glen Ellen, every mail transfer point had been littered with a lost inclosed envelope.[20]

Latham had complained in a letter of March 4, 1911, that the illustrations had come to Macmillan in the form of negatives enclosed in envelopes with the legends: "It was absolutely impossible for the engravers to keep films and envelopes together during all the various processes of printing them and of having the electros made."[21]

London didn't buy his explanation:

Possibly you don't know it, but as a professional photographer of fifteen years' experience, let me tell you that every print, film, and plate can be marked legibly without harm (for identification) with a mere lead-pencil. Why this was not done in my case, was beyond me, and up to you. You made this whole thing chaos thrice compounded. . . . [L]et me tell you that you have given me one hell of a time. And let me tell you, that the best dinner New York can provide will

not make up for quite all the havoc you have wreaked on me in this mere matter of a simple detail.[22]

London goes on to enumerate missing photographs or envelopes and to remind Latham of the missing frontispiece, "The *Snark* Lying at the Wharf in Suva, in the Fijis." He adds, "You've got to do your best by me in this matter, because I've got a wild wolf howl coming at the way I've been treated."[23] An expression of outrage followed by a suggestion for a social get-together is typical of his letters to editors when he was upset about something. Even his angriest letters usually end with an invitation to his ranch: "the latch-string is always out."

London was also particular about the quality of his photographic supplies. In a letter to Ninetta Eames, Charmian's aunt, who was helping manage his literary affairs back in California, London wrote from Honolulu on July 11, 1907, asking that she forward to Tahiti thirty rolls of stereoscopic film he had ordered from the H. C. White Company of North Bennington, Vermont, since "I take stereoscopic pictures for them." He also asks her to place an order with Eastman Kodak: "Tell them for whom the FILMS are, and that I am in the tropics, and that these films must be of the VERY LATEST AND FRESHEST, and that they must be sealed in tins for the tropics." He asks for ten rolls of ten exposures each for his "Folding Pocket Kodak No. 3A," twenty rolls of six exposures each for a second 3A, twenty rolls of six exposures each for his "Folding Pocket Kodak No. 4A," and thirty rolls for his two panoramic cameras, one large and one small.

At the turn of the century, the major U.S. stereograph publishers were Underwood and Underwood, the Keystone View Company, and the H. C. White Company. London wrote White on September 13, 1910, to express his regret that "I was unable to get any satisfactory stereoscopes for you" on the *Snark* voyage:

> Films and chemicals on a small boat, cruising in out-of-the-way places in the tropics, are not a success. They deteriorate too rapidly. I carried seven cameras altogether on the boat, and being for so many months at a time away from sources of supply, I carried large supplies of films, etc., with me. And on a single occasion I have thrown overboard as high as $300 or $400 worth of materials, unused, yet wholly ruined by deterioration. Most of the cameras went to smash for the same reason. Mould, salt-water, careless seas shipped through open skylights, cockroaches, etc., were responsible.[24]

White was planning to market postcards and stereographs made by the famous writer.

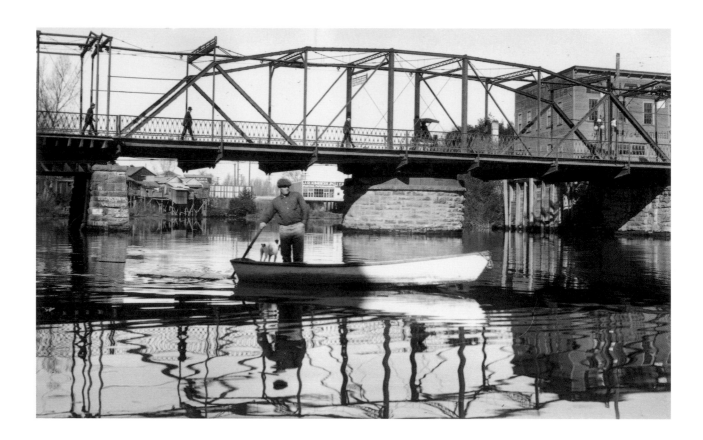

London and one of his dogs make their way down the Napa River in California.

Though one wonders what went overboard and what images London could have made had he not faced the difficulties he did in Korea and the tropics—including extreme cold, damaging saltwater, and problems of exposure in bright light—one has to marvel at his determination to continue creating his photographic record, no matter how challenging the circumstances.

The sections that follow present a sampling of London's photographs in chronological order: *The People of the Abyss* (1903), the Russo-Japanese War (1904), the San Francisco earthquake (1906), the cruise of the *Snark* (1907–9), the rounding of Cape Horn on the *Dirigo* (1912), and the Mexican Revolution (1914). Each photograph is identified by caption (captions enclosed in quotation marks come from the Londons' albums), and many are followed by quotations from one of London's writings or letters. London sometimes made hundreds of photographs, as in Korea and the South Seas, but at other times he seemed selective and made relatively few, as in *The People of the Abyss* and his coverage of the U.S. invasion of Veracruz. But wherever he was, and whomever he encountered, London was usually ready to record historical moments through the faces and bodies of the people who lived them—as moving portraits of individuals whose cultural differences pale beside their common humanity.

n 1902, Jack London arrived in England en route to South Africa to cover the Boer War for Hearst, only to find that the war had ended. He decided to spend six weeks in the impoverished East End of London, disguised as a runaway American sailor, in order to observe and record conditions among the poor. His passionate socialist analysis and dramatic photographs appeared the next year in the volume *The People of the Abyss*.

Though he witnessed such newsworthy events as the coronation of Edward VII, London kept his focus on the bitter struggles of the king's impoverished subjects, who lived in "the abyss" of poverty and homelessness: starving children on the street, men and women degraded by drunkenness or prostitution, denizens of workhouses and Salvation Army barracks, and the exhausted homeless, who nightly tried to find a place to sleep on benches, under bridges, and on the sidewalk. In London's photographs, they are portrayed without sentimentality; the shots are beautifully composed even though candid, and their subjects are not objectified by the lens, as was the case in some other photographic books of the times depicting slum conditions.

To begin his East End sojourn, London found a small out-of-the-way room to rent secretly, then bought used workman's clothes. From time to time he returned to his room to write, but he spent many a night with the homeless on the streets, and he traveled with migrant workers to pick hops in Kent. Early on, he endured a night in the White Chapel workhouse, where he dined on bread and "skilly," a watery oatmeal concoction. He tried to sleep while wedged between fellow inmates on a piece of canvas suspended from rails in a great common room. The next night, he elected to "carry the banner," that is, he walked the streets all night with a seemingly endless stream of people who were trying to find places to sleep away from the cold and rain and the unwanted attentions of police officers. London summarizes these events plainly, without pity for himself or others: "[A]fter carrying the banner all night, I did not sleep in Green Park when morning dawned. I was wet to the skin, it is true, and I had had no sleep for twenty-four hours; but, still adventuring as a penniless man looking for work, I had to look about me, first for a breakfast, and next for the work."[1]

The book powerfully documented a glaring failure of British society and of capitalism in general. Yet in a December 30, 1902, letter to George P. Brett, London's publisher at Macmillan, London agreed with Brett's suggestion to revise the last chapter so that it would be more "optimistic" and would point out "the possibilities of amelioration of the terrible conditions that you set forth."[2] London crafted his last chapter around the idea that the ragged poor of the East End could be freed of

1 :
THE PEOPLE OF THE ABYSS (1903)

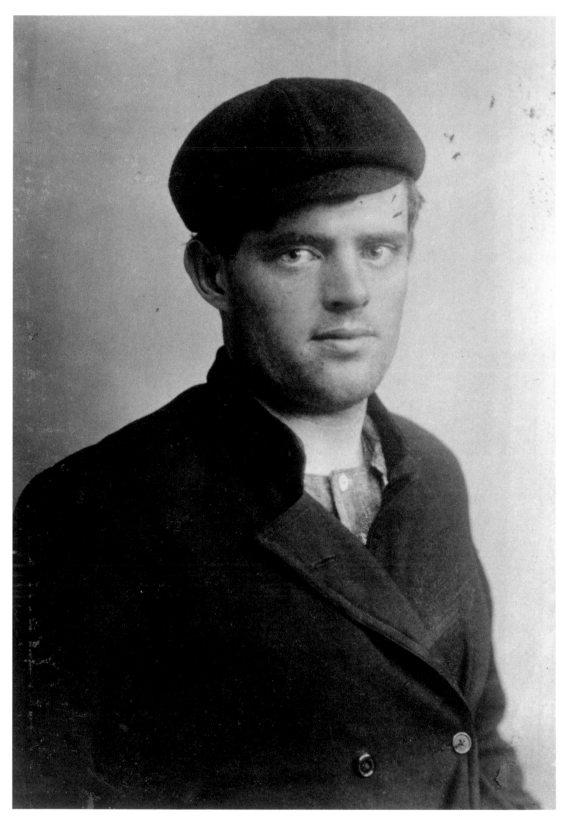
Jack London as an East Ender, London, England, 1902.

their entrapment by being brought to the American West, where the climate and culture would regenerate them, a paradoxical take on the era's racial notions of Anglo-Saxon superiority and fears of immigration.

While gathering material, London was very conscious of his role on the streets, especially when he considered how to approach subjects. His task became much easier after he adopted ragged street clothes:

> No sooner was I out on the streets than I was impressed by the difference in status effected by my clothes. All servility vanished from demeanor of the common people with whom I came in contact. Presto! in the twinkling of an eye, so to say, I had become one of them. My frayed and out-at-elbows jacket was the badge and advertisement of my class, which was their class. It made me of like kind, and in place of the fawning and too-respectful attention I had hitherto received, I now shared with them a comradeship. The man in corduroy and dirty neckerchief no longer addressed me as "sir" or "governor." It was "mate," now—and a fine and hearty word, with a tingle to it, and a warmth and gladness, which the other term does not possess.[3]

He was also conscious of how valuable such lived, firsthand experience was. Four years later, in a letter to Bailey Millard of *Cosmopolitan*, London used his East End apprenticeship to bolster his proposal for some *Snark*-related stories and essays:

> I have a tremendous confidence, based upon all kinds of work I have already done, that I can deliver the goods. Anybody doubting this has but to read *The People of the Abyss* to find the graphic, reportorial way I have of handling things. (Between ourselves, and not to be passed on, I gathered every bit of the material, read hundreds of books and thousands of pamphlets, newspapers and Parliamentary reports, composed *The People of the Abyss*, and typed it all out, took two-thirds of the photographs with my own camera, took a vacation of one week off in the country—and did it all in two months. That's going some, now, isn't it?)[4]

London's mention of having taken only two-thirds of the photographs that appeared in the book gave us pause as we began editing this section. Even though his publisher used some other photographers' works here and there in the book, we realized that the ones London had made were returned to him after the book was

"Eliza forever!" After Jack's return from London, his stepsister (and ranch manager) Eliza London Shepard inscribed the legends for photographs from The People of the Abyss *that are included in his first photo album; were it not for her, we would not have these descriptions, which are sometimes fuller than those in the book. Throughout London's life Eliza was the person he most trusted.*

published, for they were lovingly pasted into his first photo album by his stepsister Eliza London Shepard. She evidently copied his captions from the back of the photographs onto the album pages, and presented the album to him as a gift.

In 1906, after reading John Spargo's *The Bitter Cry of the Children* (1906) and Isador Ladoff's *American Pauperism and the Abolition of Poverty* (1904), London considered doing a study of New York and Boston to be called *The American Abyss*.[5] Earlier, he had read Edward Bowmaker's illustrated *Housing of the Working Classes* (1895) and George Hay's illustrated *No Room to Live: The Plaint of Overcrowded London* (1900); he used statistics from the former in *The People of the Abyss*. *The People of the Abyss* excited a great deal of interest and sold very well. It hit the market at a time when photographers were turning their lenses on Western cities and their factories, industrial sites, laborers, craftspeople, and immigrants. The true reality—and horror—of industrialized urban poverty was graphically shown by Henry Mayhew (1812–87) in *London Labour and the London Poor* (1851), which presented engravings based on daguerreotypes of slums and street scenes. He approached his subjects as ethnographic and anthropological specimens, of a type found in the imperial capital rather than equatorial jungles. Scottish photographer Thomas Annan (1829–87) published a groundbreaking study of urban poverty in *The Old Closes and Streets of Glasgow* (1868–71), which is regarded as a classic. British photographer John Thomson teamed up with writer and activist Adolphe Smith Headingly, whose pen name was Adolphe Smith, for *Street Life in London* (1878), which also exposed the conditions of the poor. As Martin Parr and Gerry Badger note, Thomson treated the residents of South and East London as if they were "almost as alien" as people from the Far East: scenes of street life were presented as staged tableaux because of "the limitations of the equipment—and interviews with subjects." As they observe, these sorts of "social documentaries" had "a complex agenda" motivated by a reforming desire to alleviate the slum conditions of the urban poor but also by "the Victorian urge to typify" and to distance the bourgeois reader from the poor.[6]

But the most important comparison of *The People of the Abyss* is to the work of Jacob Riis, a Danish-born police reporter, author, and reformer who wrote about and photographed conditions in New York slums. London wrote to Brett: "Have just finished reading the *Cecilia* you sent me. Also *The Battle with the Slum*. In this latter I was especially pleased when Riis pointed out the deadness & hopelessness that characterize the East-London slum, and added that there was life & promise in our American slum—'yeast' in our slum, as he called it."[7] London later compared

his book with Riis's most famous work: "*The People of the Abyss*, like *How the Other Half Lives*, etc., is more of a popularly written book," and he advocated for a cheap fifty-cent paper version, "the kind they sell on trains."[8] Unlike earlier studies of the urban poor, Riis's work was instrumental in effecting slum-clearance projects and was thus foundational for other reform-minded writers and photographers.

In seeking to portray the human cost of poverty, Riis assured middle-class Americans that most slum dwellers sought the same kind of life that the mainstream possessed. Indeed, as Sam Bass Warner notes, "[a]rmed with the muckraker's confidence that publicity can solve problems by creating an intelligent public opinion," Riis gave "an ecological definition of the slum" as an environment that "bore in special ways upon the men, women, and children dwelling within it."[9] Riis specifically sought to expose Democratic Party leaders in Tammany Hall, whom he held responsible for the perpetuation of New York's slum conditions, accusing them of buying immigrants' votes with liquor and empty promises of jobs while accepting bribes from slum landlords to overlook violations of the law.[10] In *The Battle with the Slum*, Riis writes:

The slum is as old as civilization. Civilization implies a race to get ahead. In a race there are usually some who for one cause or another cannot keep up, or are thrust out from among their fellows. They fall behind, and when they have been left far in the rear they lose hope and ambition, and give up. Thenceforward, if left to their own resources, they are the victims, not the masters, of their environment; and it is a bad master. They drag one another always further down. The bad environment becomes the heredity of the next generation. Then, given the crowd, you have the slum ready-made.[11]

Riis's social analysis meshed well with the naturalistic movement in literature, the ferment in national and international politics (which saw not only the rise of socialism but also a surge of anarchistic activity and numerous assassinations), and Darwinian, Marxist, and Freudian diagnoses of social ills. As Riis notes,

Put it this way: you cannot let men live like pigs when you need their votes as freemen; it is not safe. You cannot rob a child of its childhood, of its home, its play, its freedom from toil and care, and expect to appeal to the grown-up voter's manhood. The children are our to-morrow, and as we mould them to-day

so will they deal with us then. . . . Unsafest of all is any thing or deed that strikes at the home, for from the people's home proceeds citizen virtue, and nowhere else does it live. The slum is the enemy of home. . . . When this people comes to be truly called a nation without homes there will no longer be any nation.[12]

Such pronouncements resonated with London, a child of poverty who moved dozens of times before he was twenty-one.

Riis's work dramatically portrayed the American poor, especially immigrants. What Ansel Adams said of the power of Riis's vision also evokes London's:

These people live again for you in the print. . . . Their comrades in poverty and suppression live here today, in this city—and in all the cities of the world. I have thought much about this intense, *living* quality in Riis's work; I think I have an explanation of its compelling power. It is because in viewing those prints I find myself identified with the people photographed. I am walking in their alleys, standing in their rooms and sheds and workshops, looking in and out of their windows. And they in turn seem to be aware of me.[13]

Adams also could be referring to London when he describes Riis's photographs as intimate and empathetic and sees his writing and photography as "a *unit statement*, a consuming life work. This is what photography should be—an integrated creative and constructive statement, not a series of disconnected and unorganized images of more or less superficial appeal."[14]

The People of the Abyss can now be seen as part of a tradition that includes the work of later photographers who sought to portray the common man and woman within limiting social conditions. In *A Night in London* (1938), Bill Brandt, though of a privileged background, focused on working-class subjects without the condescension that, as Parr and Badger remark, "frequently accompanied the middle-class Englishman investigating the lower order"; "something of an outsider in his own society," Brandt grew up on the Continent and "photographed all classes with an unusual degree of sympathy."[15] Brandt's *The English at Home* (1936) sought to show the cramped living conditions of working-class life, and the book came as a shock to readers who expected from the title "a cosy, conventional look at the old country."[16] At the same time, Berenice Abbott, who promoted the work of Eugène Atget, published *Atget: Photographe de Paris* (1930) and *Changing New York*

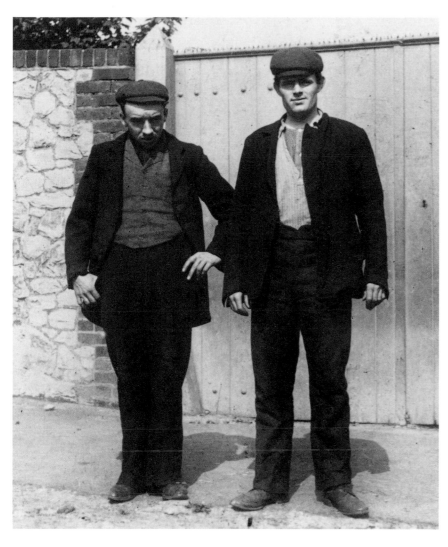

Jack London and Bert, a cobbler, London, 1902.

"'Can yer give us a job, governor?' Bert asked the bailiff, a kindly faced and elderly man who was very busy.

"His 'No,' was decisively uttered; but Bert clung on and followed him about, and I followed after, pretty well all over the field. Whether our persistency struck the bailiff as anxiety to work, or whether he was affected by our hard-luck appearance and tale, neither Bert nor I succeeded in making out; but in the end he softened his heart and found us the one unoccupied bin in the place—a bin deserted by two other men, from what I could learn, because of inability to make living wages."
(The People of the Abyss, *chapter 14*)

(1939).[17] Atget's "lyrical understanding of the street, trained observation of it, special feeling for patina, eye for revealing detail," as Walker Evans described it, reveals similarities with London's.[18] The photographs in *The People of the Abyss* might also be compared with the work of such later artists as Margaret Bourke-White and Erskine Caldwell in their *You Have Seen Their Faces* (1937), which depicts the hardships of southern tenant farmers.[19] Evans's *American Photographs* (1938) includes a wide array of scenes of life in the 1930s, ironic and poignant testaments of violence and poverty.[20] A classic of American literature and photography, Evans and James Agee's *Let Us Now Praise Famous Men*, which originated as a Farm Security Administration (FSA) project for *Fortune Magazine*, reported in excruciating detail the bleak lives of southern tenant farmers, in photographs by Evans and text by Agee.[21] Other landmark volumes in this tradition include Lewis Hine's *Men at Work*, a

study of the heroism of workingmen, and the FSA photography of Dorothea Lange and Paul S. Taylor, whose *An American Exodus: A Record of Human Erosion* depicts the rural poor.[22]

We are not suggesting that London inspired these more photographically important artists, but we wish to draw connections between his attitude toward the East Enders in *The People of the Abyss* and the choices made by later socially aware photographers to present subjects without diminishing them. Perhaps it is fitting that abysmally poor Londoners of 1900 found artistic reconfirmation among destitute Americans of the Great Depression. It is interesting to speculate about what London might have produced as a photographer had he lived into the 1930s.

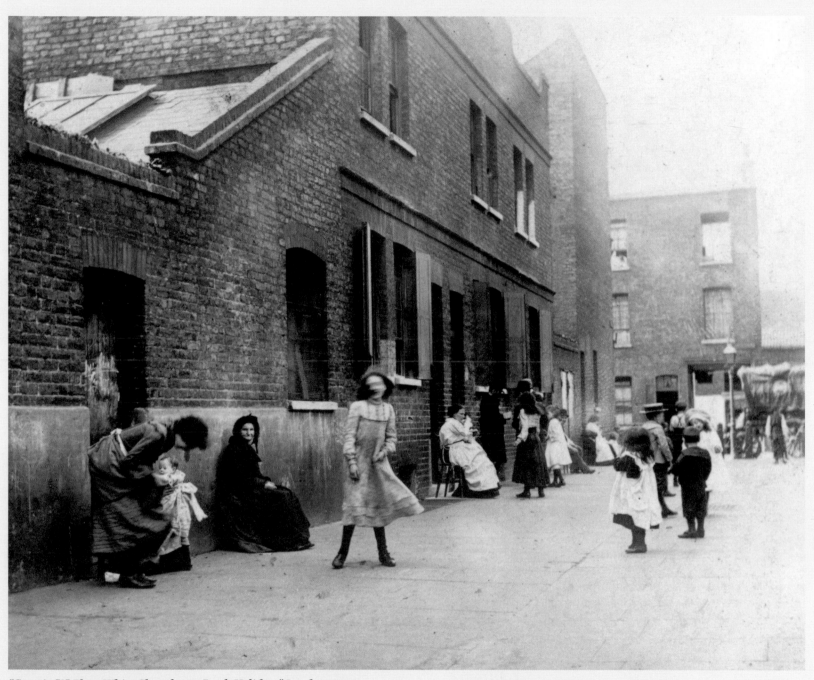

"Grostic [?] Place White Chapel on a Bank Holiday." London, 1902.

"Small Doss House."
A lodging house, London,
1902.

"And I thought of my own
spacious West, with room
under its sky and unlimited
air for a thousand Londons;
and here was this man, a
steady and reliable man,
never missing a night's work,
frugal and honest, lodging in
one room with two other men,
paying two dollars and a half
per month for it, and out of
his experience adjudging it
to be the best he could do! And
here was I, on the strength of
the ten shillings in my pocket,
able to enter in with my rags
and take up my bed with him.
The human soul is a lonely
thing, but it must be very
lonely sometimes when there
are three beds to a room, and
casuals with ten shillings are
admitted." (The People of the
Abyss, *chapter 4*)

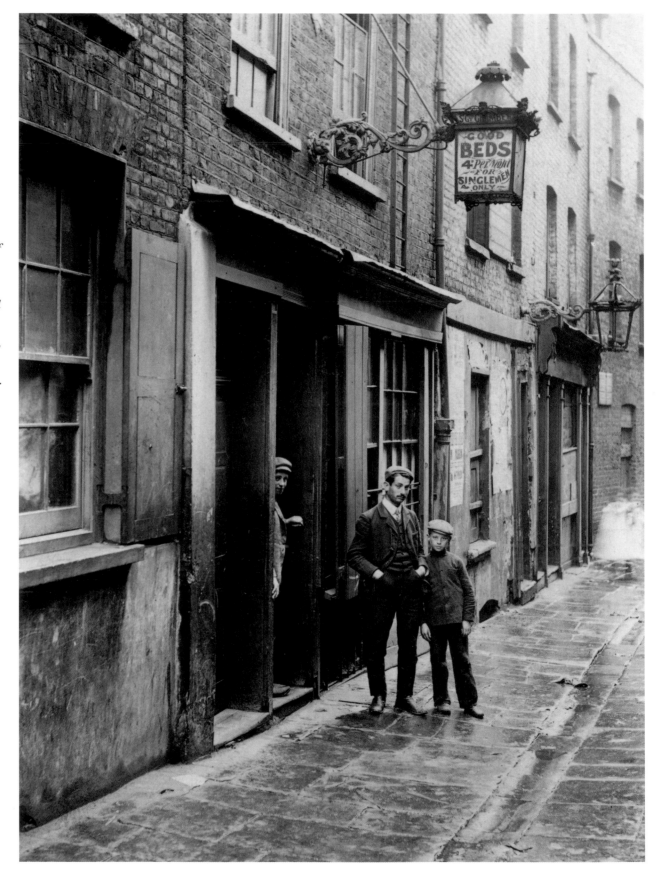

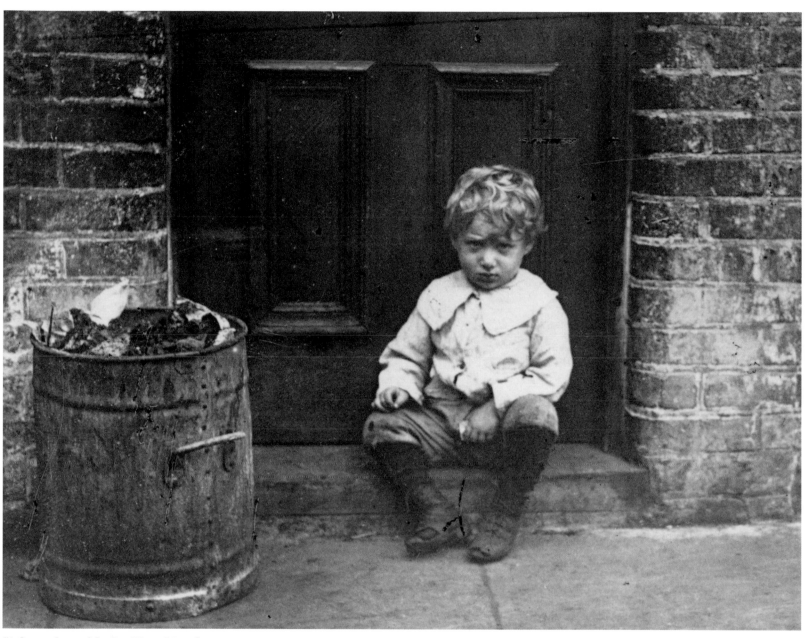

"A descendant of the Sea Kings." London, 1902.

"And day by day I became convinced that not only is it unwise, but it is criminal for the people of the Abyss to marry. They are the stones by the builder rejected. There is no place for them in the social fabric, while all the forces of society drive them downward till they perish. At the bottom of the Abyss they are feeble, besotted, and imbecile. If they reproduce, the life is so cheap that perforce it perishes of itself. The work of the world goes on above them, and they do not care to take part in it, nor are they able. Moreover, the work of the world does not need them." (The People of the Abyss, *chapter 4*)

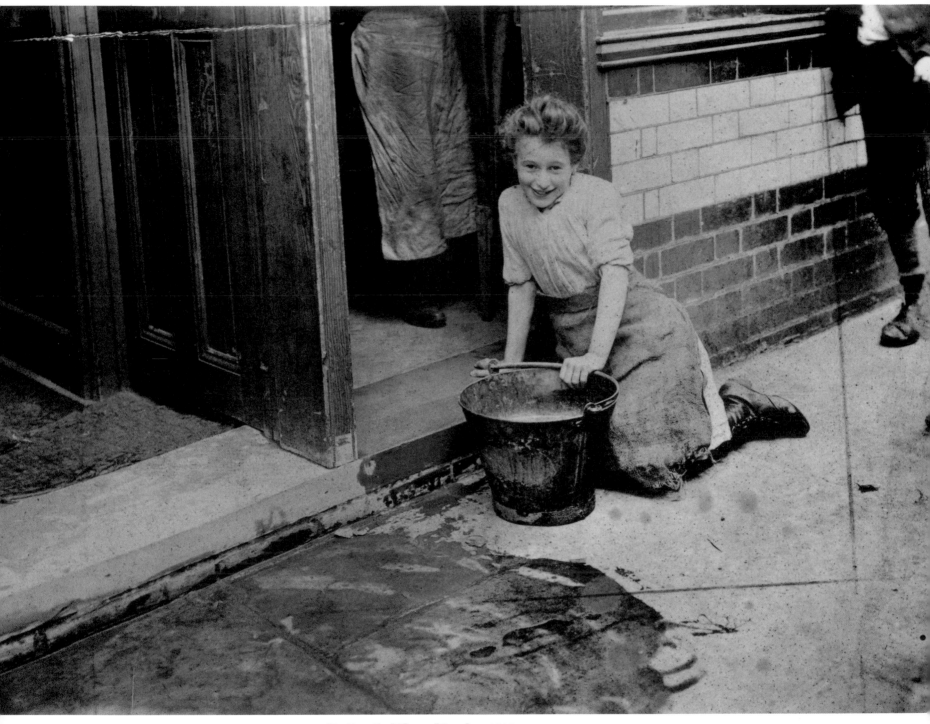

"An East End Slavey." London, 1902.

"Each house on this street, as on all the streets, is shoulder to shoulder with its neighbors. To each house there is but one entrance, the front door, and each house is about eighteen feet wide, with a bit of a brick-walled yard behind, where, when it is not raining, one may look at a slate-colored sky. But it must be understood that this is East End opulence we are now considering. Some of the people on this street are even so well-to-do as to keep a 'slavey.' Johnny Upright keeps one, as I well know, she being my first acquaintance in this particular portion of the world." (The People of the Abyss, *chapter 2*)

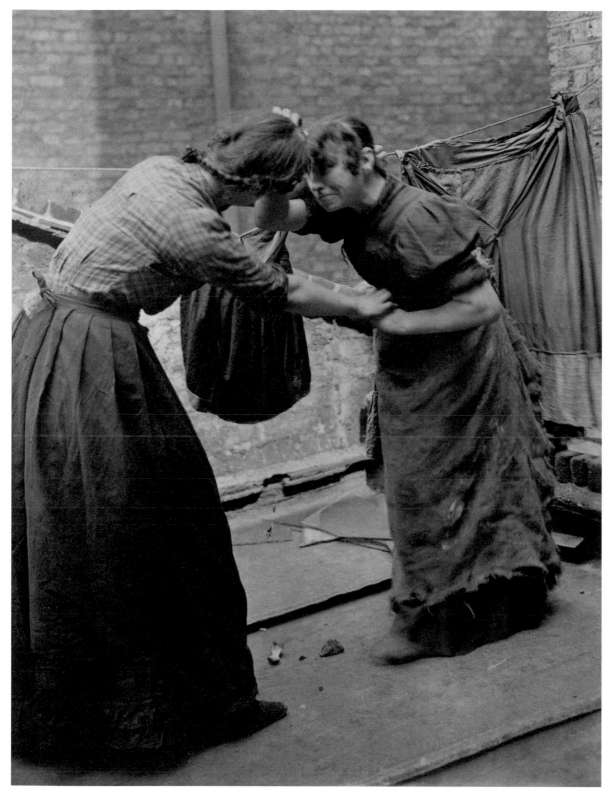

"Drunken facory [sic] girls fighting."
London, 1902.

"Drunken women fighting! It is
not nice to think of; it is far worse
to listen to. Something like this it
runs:—Incoherent babble, shrieked
at the top of the lungs of several
women; a lull, in which is heard
a child crying and a young girl's
voice pleading tearfully; a woman's
voice rises, harsh and grating, 'You
'it me! Jest you 'it me!' then, swat!
challenge accepted and fight rages
afresh. . . . 'You'll git this rock on
the 'ead!' and then rock evidently
on the head from the shriek that
goes up. . . . One combatant gets
overwhelming advantage, and
follows it up from the way other
combatant screams bloody murder.
Bloody murder gurgles and dies out,
undoubtedly throttled by a strangle
hold. Entrance of new voices; a
flank attack; strangle hold suddenly
broken from way bloody murder
goes up half an octave higher
than before; general hullaballoo,
everybody fighting." (The People of
the Abyss, *chapter 5*)

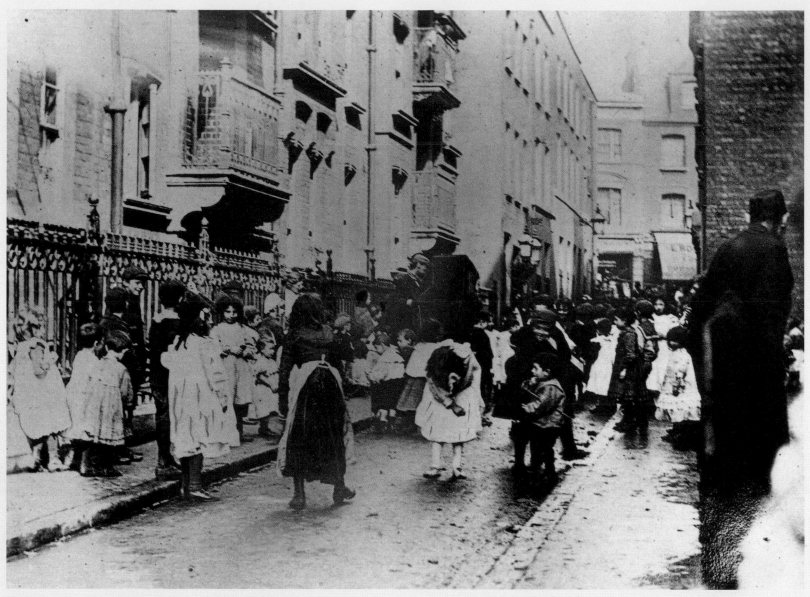

"Children dancing to street organ." London, 1902.

"There is one beautiful sight in the East End and only one, and it is the children dancing in the street when the organ-grinder goes his round. It is fascinating to watch them, the new-born, the next generation, swaying and stepping, with pretty little mimicries and graceful inventions all their own, with muscles that move swiftly and easily, and bodies that leap airily, weaving rhythms never taught in dancing school. . . . They delight in music, and motion, and color, and very often they betray a startling beauty of face and form under their filth and rags.

"But there is a Pied Piper of London Town who steals them all away. They disappear. One never sees them again, or anything that suggests them. You may look for them in vain amongst the generation of grown-ups. Here you will find stunted forms, ugly faces, and blunt and stolid minds. Grace, beauty, imagination, all the resiliency of mind and muscle, are gone. Sometimes, however, you may see a woman, not necessarily old, but twisted and deformed out of all womanhood, bloated and drunken, lift her draggled skirts and execute a few grotesque and lumbering steps upon the pavement. It is a hint that she was once one of those children who danced to the organ-grinder. Those grotesque and lumbering steps are all that is left of the promise of childhood." (The People of the Abyss, chapter 23)

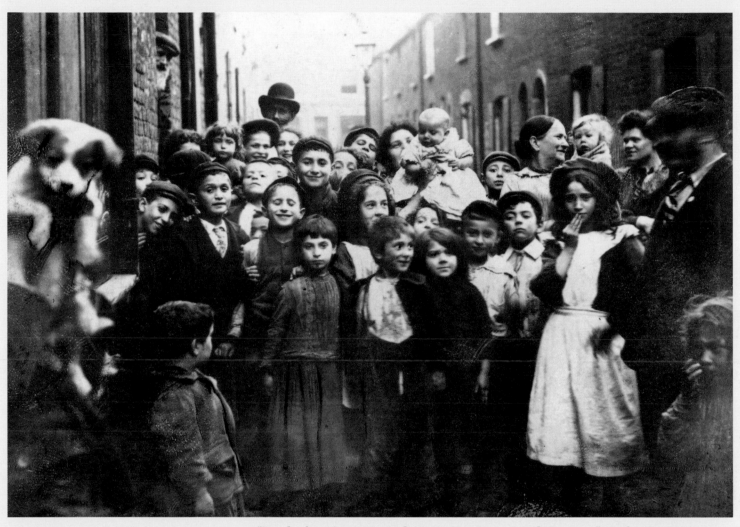

"Result of putting up a stand camera in a Court Jewish Quarters." London, 1902.

"The people who try to help gather up the Ghetto children and send them away on a day's outing to the country. They believe that not very many children reach the age of ten without having had at least one day there. . . .

"One day in the fields and woods, if they are lucky enough to be picked up by the people who try to help! And they are being born faster every day than they can be carted off to the fields and woods for the one day in their lives. One day! In all their lives, one day! And for the rest of the days, as the boy told a certain bishop, 'At ten we 'ops the wag; at thirteen we nicks things; an' at sixteen we bashes the copper.'" (The People of the Abyss, *chapter 23*)

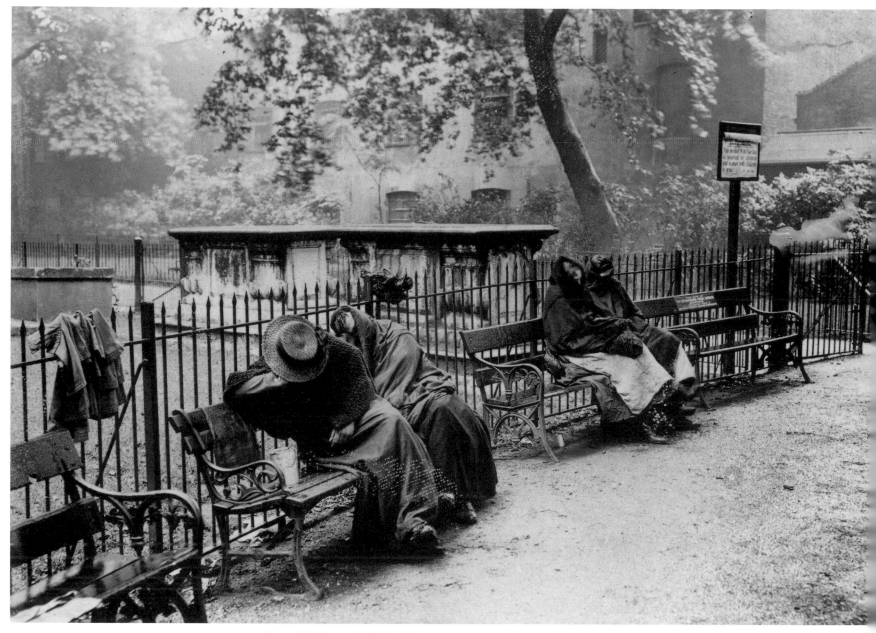

"Spitalfield's Garden": "A chill, raw wind was blowing, and these creatures huddled there . . . sleeping . . . or trying to sleep." London, 1902.

"We went up the narrow gravelled walk. On the benches on either side was arrayed a mass of miserable and distorted humanity, the sight of which would have impelled Doré to more diabolical flights of fancy than he ever succeeded in achieving. It was a welter of rags and filth, of all manner of loathsome skin diseases, open sores, bruises, grossness, indecency, leering monstrosities, and bestial faces. A chill, raw wind was blowing, and these creatures huddled there in their rags, sleeping for the most part, or trying to sleep. Here were a dozen women, ranging in age from twenty years to seventy. . . . It was this sleeping that puzzled me. Why were nine out of ten of them asleep or trying to sleep? But it was not till afterward that I learned. It is a law of the powers that be that the homeless shall not sleep by night." (The People of the Abyss, chapter 6)

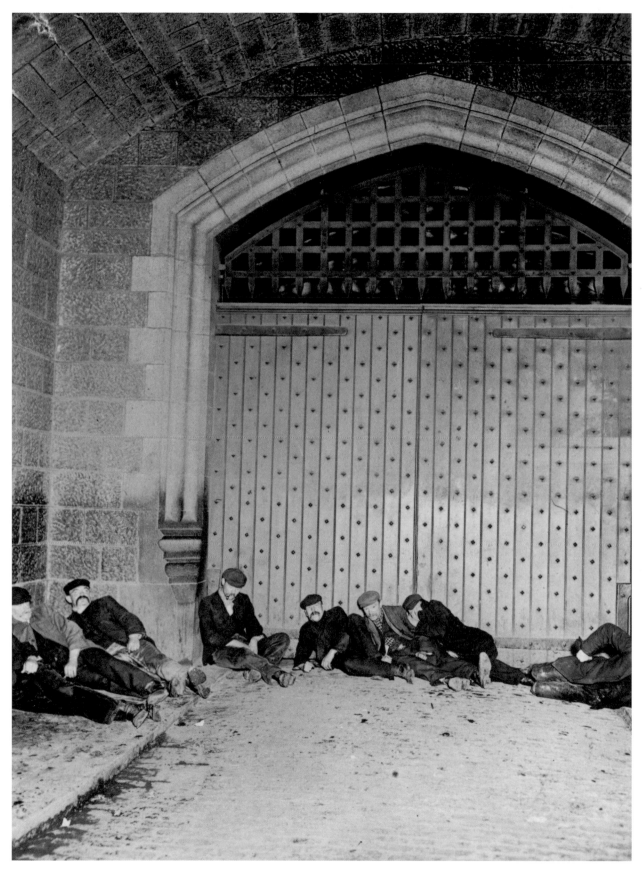

"Under the arches of the bridges that span the Thames." London, 1902.

"'I was down under the arches,' grumbled another young fellow. By 'arches' he meant the shore arches where begin the bridges that span the Thames. 'I was down under the arches, w'en it was ryning its 'ardest, an' a bobby comes in an' chyses me out. But I come back, an' 'e come too. "Ere," sez 'e, "wot you doin' ere?" An' out I goes, but I sez, 'Think I want ter pinch [steal] the bleedin' bridge?'" (The People of the Abyss, chapter 10)

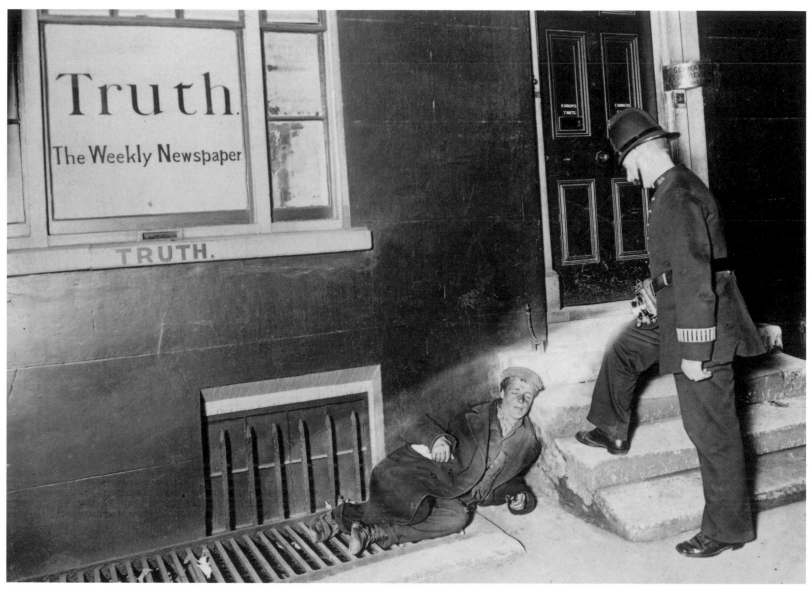

Truth: The Weekly Newspaper. *London, 1902.*

*"From the slimy sidewalk, they were picking up bits of orange peel, apple skin, and grape stems, and they were eating them. The pips of green gage plums they cracked between their teeth for the kernels inside. They picked up stray crumbs of bread the size of peas, apple cores so black and dirty one would not take them to be apple cores, and these things these two men took into their mouths, and chewed them, and swallowed them; and this, between six and seven o'clock in the evening of August 20, year of our Lord 1902, in the heart of the greatest, wealthiest, and most powerful empire the world has ever seen." (*The People of the Abyss, *Chapter 8)*

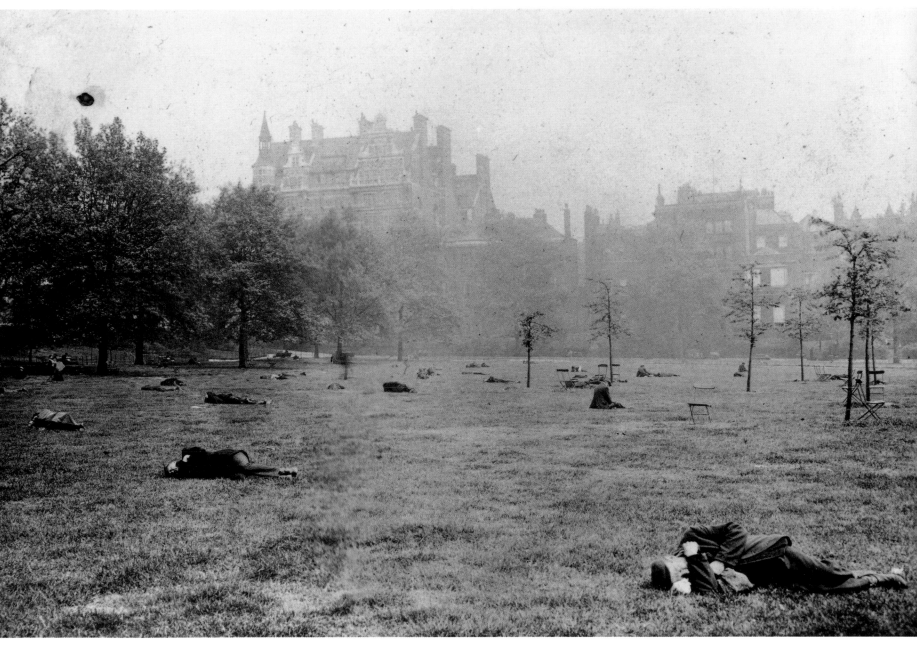

"View in Green Park, men sleeping." London, 1902.

"Among those who carry the banner, Green Park has the reputation of opening its gates earlier than the other parks, and at quarter-past four in the morning, I, and many more, entered Green Park. It was raining again, but they were worn out with the night's walking, and they were down on the benches and asleep at once. Many of the men stretched out full length on the dripping wet grass, and, with the rain falling steadily upon them, were sleeping the sleep of exhaustion. . . . And so, dear soft people, should you ever visit London Town, and see these men asleep on the benches and in the grass, please do not think they are lazy creatures, preferring sleep to work. Know that the powers that be have kept them walking all the night long, and that in the day they have nowhere else to sleep."
(The People of the Abyss, *Chapter 10)*

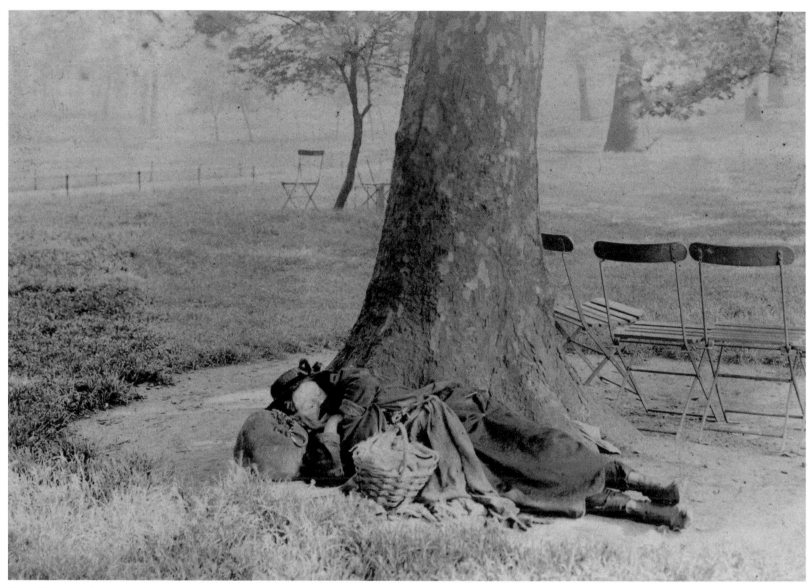

"An old woman between fifty & sixty a sheer wreck sleeping soundly." London, 1902.

"One old woman, between fifty and sixty, a sheer wreck, I had noticed, earlier in the night, standing in Piccadilly, not far from Leicester Square. She seemed to have neither the sense nor the strength to get out of the rain or keep walking, but stood stupidly, whenever she got the chance, meditating on past days, I imagine, when life was young and blood was warm. But she did not get the chance often. She was moved on by every policeman, and it required an average of six moves to send her doddering off one man's beat and on to another's. By three o'clock she had progressed as far as St. James Street, and as the clocks were striking four I saw her sleeping soundly against the iron railings of Green Park. A brisk shower was falling at the time, and she must have been drenched to the skin." (The People of the Abyss, chapter 10)

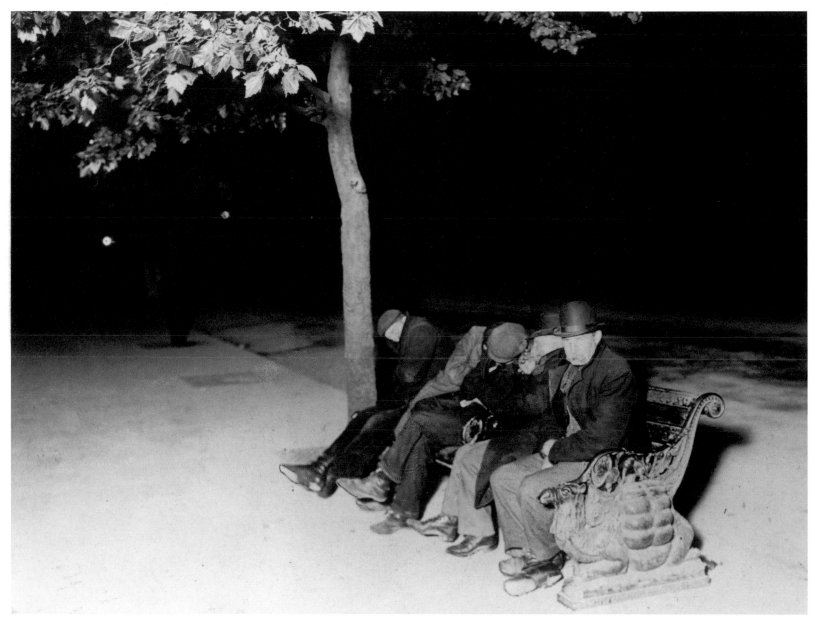

"View on Thames Embankment." London, 1902.

*"It seems that not only the man who becomes old is punished for his involuntary misfortune, but likewise the man who is struck by disease or accident. Later on, I talked with another man,—'Ginger' we called him, who stood at the head of the line—a sure indication that he had been waiting since one o'clock. A year before, one day, while in the employ of a fish dealer, he was carrying a heavy box of fish which was too much for him. Result: 'something broke,' and there was the box on the ground, and he on the ground beside it." (*The People of the Abyss, *chapter 9*)

"Which? The casual or the work house?" London, 1902.

"A woman of the lower Ghetto classes is as much the slave of her husband as is the Indian squaw. And I, for one, were I a woman and had but the two choices, should prefer being the squaw. The men are economically dependent on their masters, and the women are economically dependent on the men. The result is, the woman gets the beating the man should give his master, and she can do nothing. There are the kiddies, and he is the breadwinner, and she dare not send him to jail and leave herself and children to starve. Evidence to convict can rarely be obtained when such cases come into the courts; as a rule the trampled wife and mother is weeping and hysterically beseeching the magistrate to let her husband off for the kiddies' sakes." (The People of the Abyss, *chapter 19)*

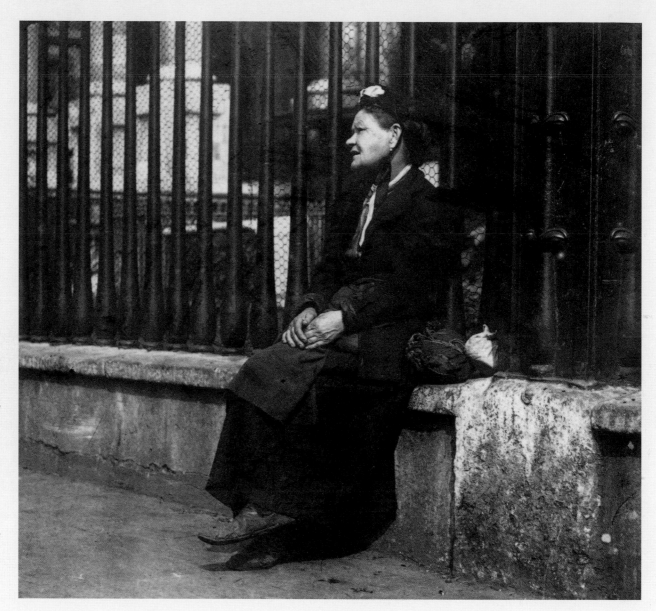

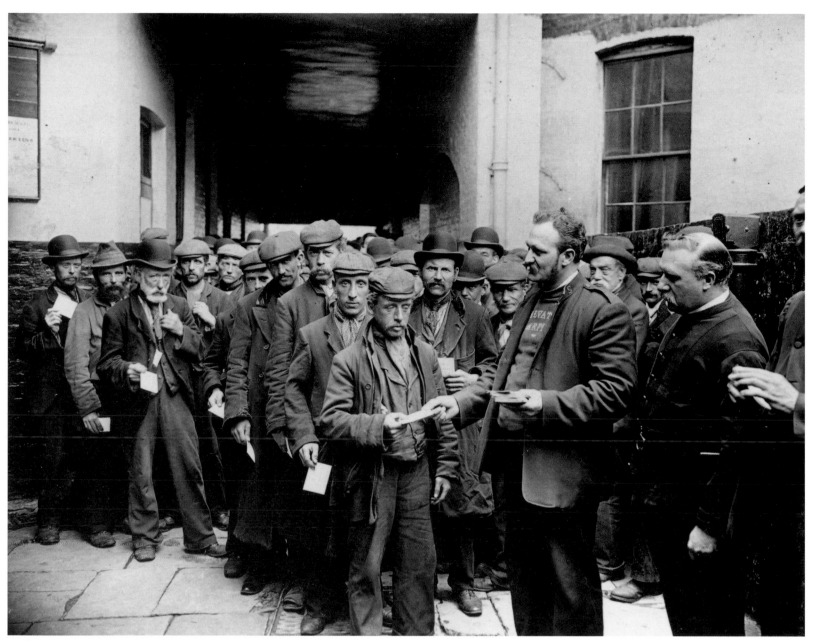

"Court Yard Salvation Army Barracks Sunday Morning rush—men who had had tickets given them during the night for free Breakfast." London, 1902.

"It was a weary walk. . . . I . . . arrived at the Salvation Army barracks before seven o'clock. This was 'the peg.' And by 'the peg' in the argot, is meant the place where a free meal may be obtained. Here was a motley crowd of woebegone wretches who had spent the night in the rain. Such prodigious misery! and so much of it! Old men, young men, all manner of men, and boys to boot, and all manner of boys. Some were drowsing standing up; half a score of them were stretched out on the stone steps in most painful postures, all of them sound asleep, the skin of their bodies showing red through the holes and rents in their rags. And up and down the street and across the street for a block either way, each doorstep had from two to three occupants, all asleep, their heads bent forward on their knees. . . . At half-past seven a little door opened, and a Salvation Army soldier stuck out his head. 'Ayn't no sense blockin' the wy up that wy,' he said. 'Those as 'as tickets cawn come hin now, an' those as 'asn't cawn't colme hin till nine.'" (The People of the Abyss, chapter 11)*

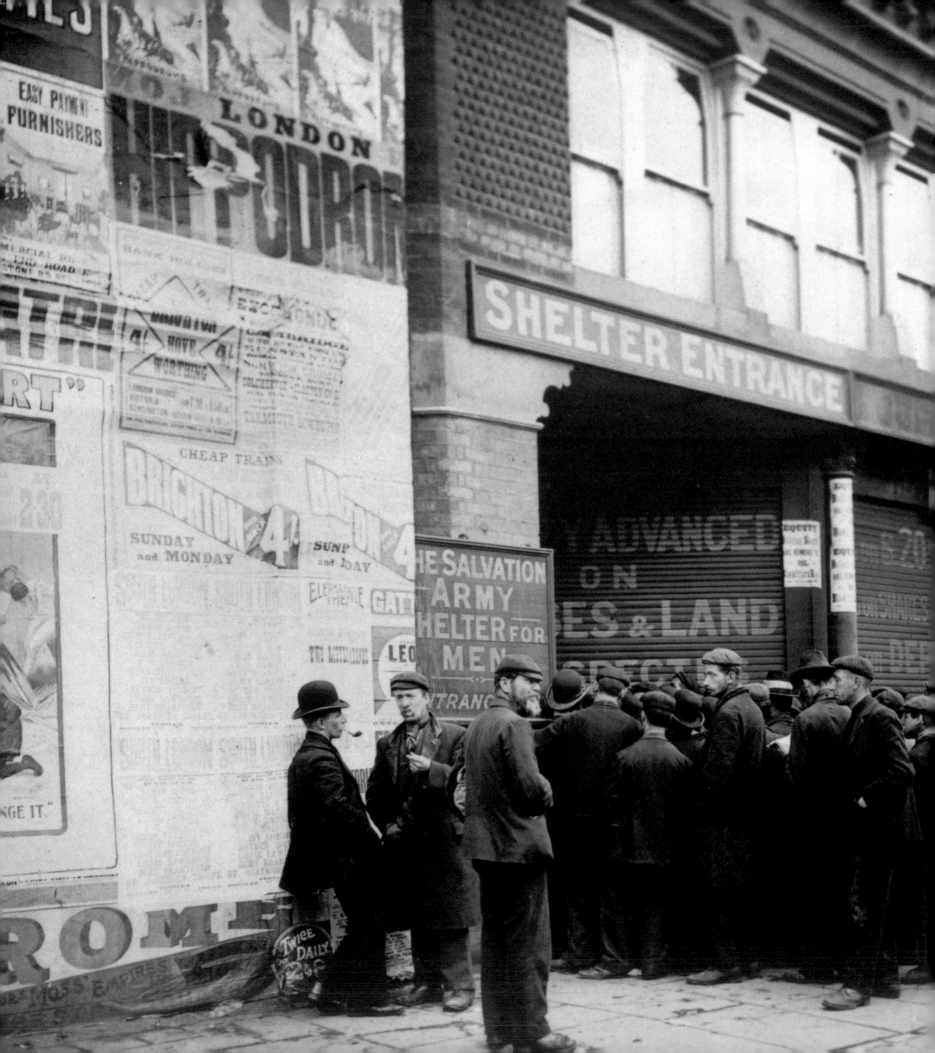

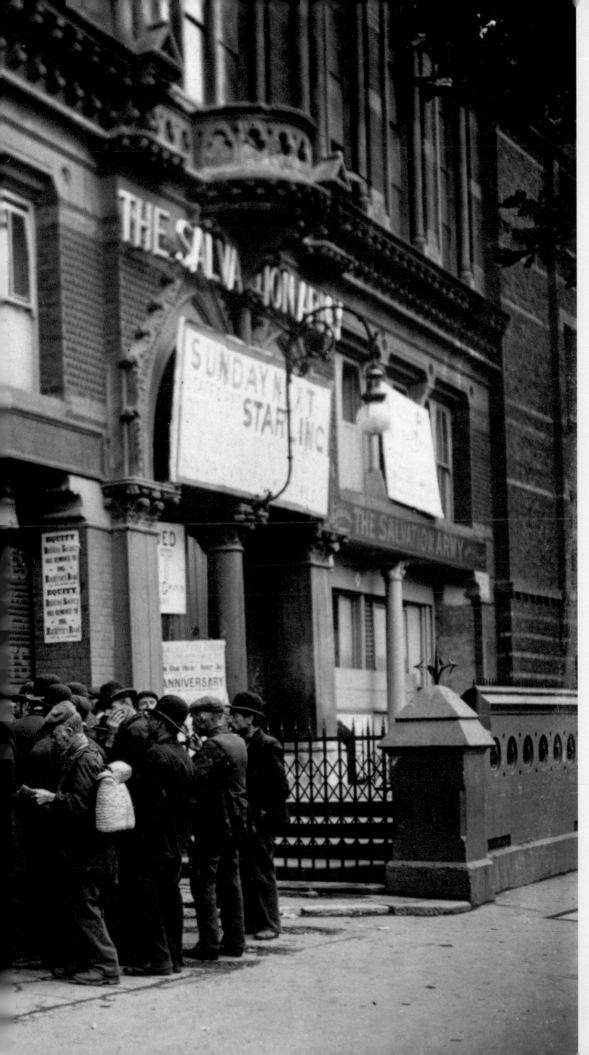

Weary and hungry men line up outside the entrance to Salvation Army shelter, London, 1902.

Casual ward of White Chapel Workhouse, London, 1902. Beds are rolled up on left and right.
When in use, they were unrolled and fastened to the iron supports in the middle of the room.

"For the benefit of gently nurtured and innocent folk, let me explain what a casual ward is. It is a building where the homeless, bedless, penniless man, if he be lucky, may casually rest his weary bones, and then work like a navvy next day to pay for it. It was a few minutes past five in the afternoon, but already a long and melancholy line was formed, which strung out around the corner of the building and out of sight. . . . I confess it almost unnerved me. Like the boy before the dentist's door, I suddenly discovered a multitude of reasons for being elsewhere. . . . 'How many more do they want?'

"'Twenty-four,' came the answer.

"We looked ahead anxiously and counted. Thirty-four were ahead of us. Disappointment and consternation dawned upon the faces about me. . . . But we hoped against hope, till, when ten stood outside the wicket, the porter turned us away." (The People of the Abyss, *Chapter 7)*

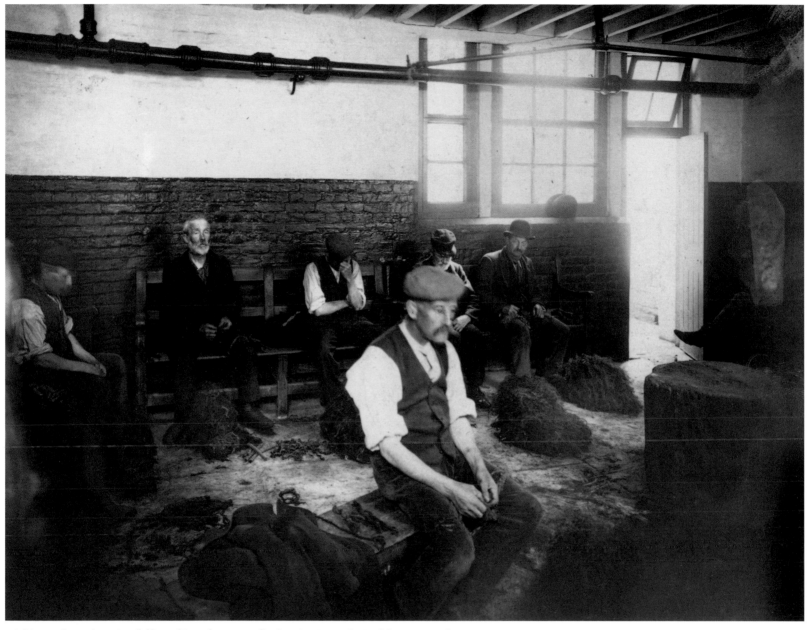

Picking oakum (a twisted fiber of jute, hemp, or flax) at St. George's Workhouse. London, 1902.

"'What I don't like,' grumbled the Carter, 'is to be locked up in a cell to pick oakum. It's too much like prison.'

"'But suppose, after you've had your night's sleep, you refuse to pick oakum, or break stones, or do any work at all?' I asked.

"'No fear you'll refuse the second time; they'll run you in,' answered the Carpenter. 'Wouldn't advise you to try it on, my lad.'

"'Then comes dinner,' he went on. 'Eight ounces of bread, one and a arf ounces of cheese, an' cold water. Then you finish your task an' 'ave supper, same as before, three parts o' skilly an' six ounces o' bread. Then to bed, six o'clock, an' next mornin' you're turned loose, provided you've finished your task.'" (The People of the Abyss, *chapter 8)*

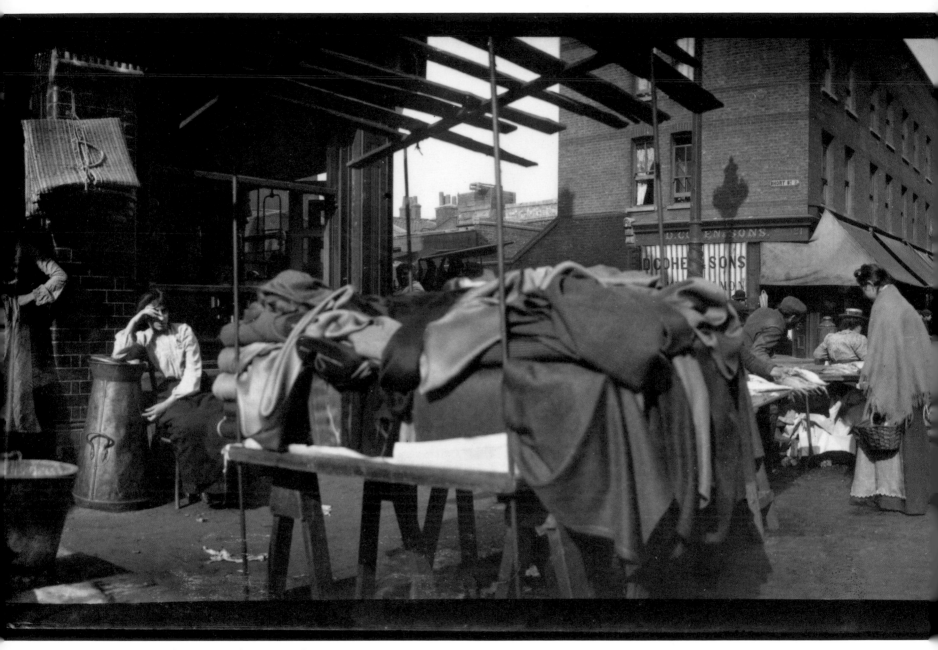

Panoramic view of an East End street, London, 1902.

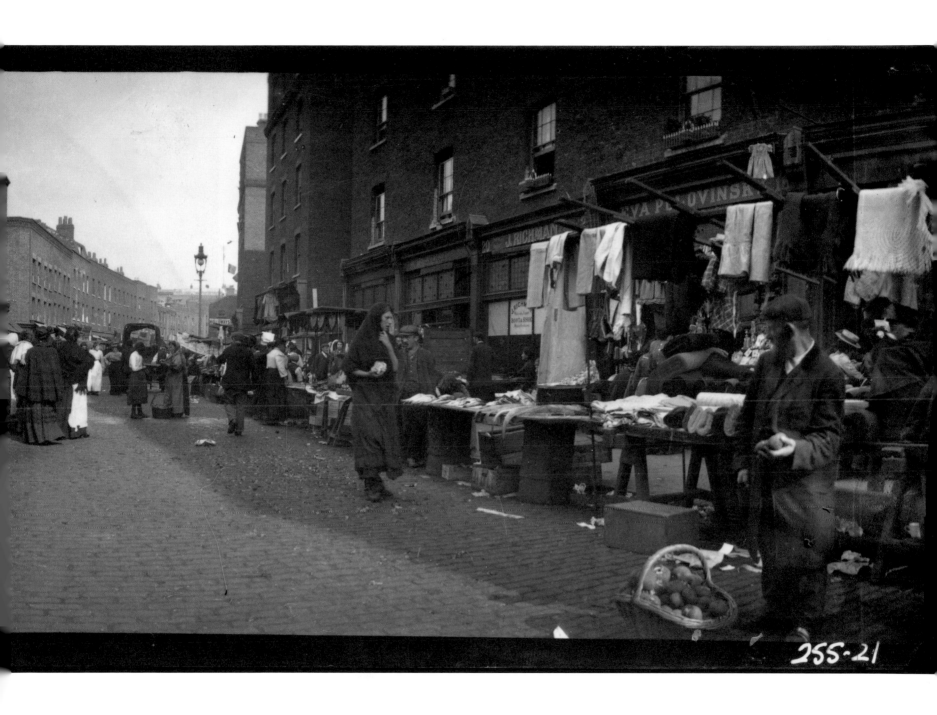

255·21

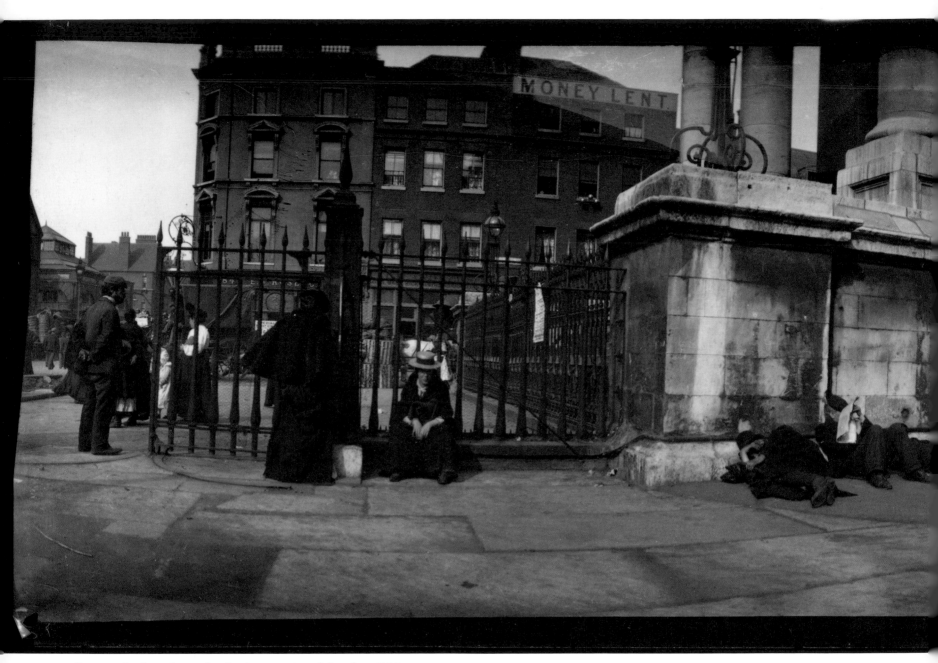

Panoramic view of men sleeping in a courtyard, London, 1902.

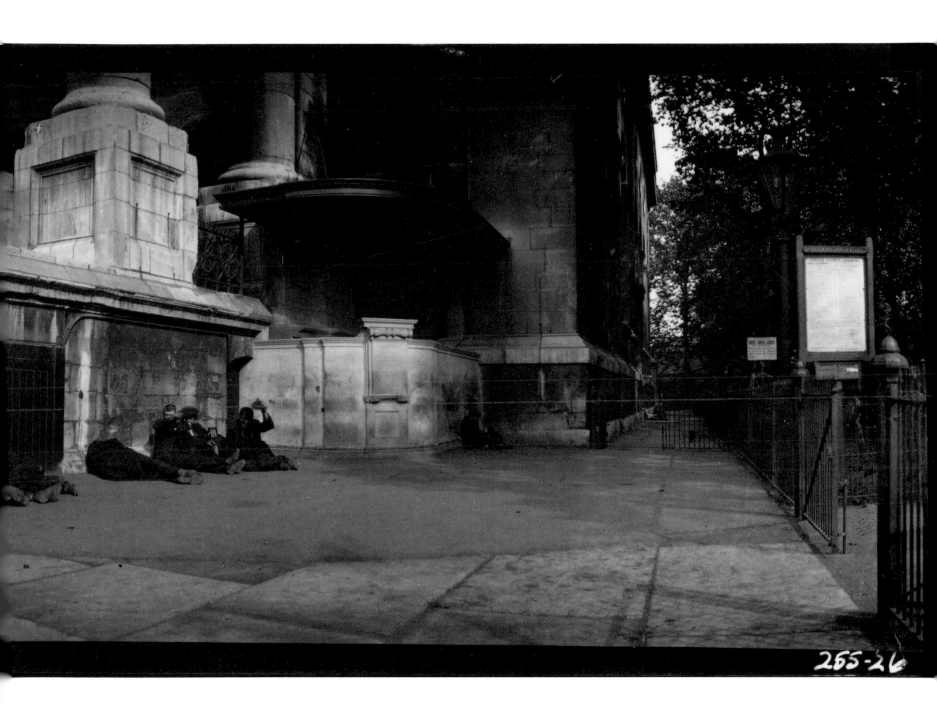

255-26

2 : THE RUSSO-JAPANESE WAR, 1904

When asked in January 1904 to cover the Russo-Japanese War for the Hearst Syndicate, Jack London wasted little time. Still basking in worldwide fame as the author of *The Call of the Wild* (1903), which sold ten thousand copies the day of its first printing, he turned his affairs over to his stepsister Eliza London Shepard and entrusted the manuscript of *The Sea-Wolf* to his soon-to-be wife, Charmian Kittredge, and his poet friend George Sterling. For the next several months, he traveled by steamer, train, junk, sampan, horseback, and foot to reach the battles raging on the frozen Korean peninsula.

London's trip started on January 7, 1904, on the ss *Siberia* to Yokohama. On the ship with London were such well-known correspondents as Frederick Palmer and war photographer James H. Hare of the *New York Globe*, Willard Straight for Reuters, Lionel James of the *Times* of London, and the celebrated British journalist Ashmead Bartlett. For London, this was the beginning of a lengthy, frustrating, and perilous journey to get to the front lines. On the ship, he suffered from influenza and two broken ankles, but once ashore he visited the Yokohama bars that he recalled from his days of hunting seals in the northern Pacific, experiences recounted in *The Sea-Wolf* (1904).

In Tokyo, he heard that the Japanese army would make a surprise landing in Korea. He also heard that the army would not issue the correspondents travel permits, so on January 28 he left his comrades waiting around in the Imperial Hotel bar and headed out on his own on a train from Kobe to find a ship. From there, he traveled by train to Nagasaki and Moji, where he booked passage on a steamer leaving February 1 for Chemulpo (Incheon), Korea, where the Japanese army was preparing for an attack. However, he was arrested in Moji for unwittingly photographing a military installation, so he missed the steamer. On February 8, the same day the Japanese navy officially started the war by torpedoing Russian ships at Port Arthur (today Lüshun Port, near Dalian, China), he boarded a small steamer for Fusan, and then chartered a junk and crew on February 14 to sail up Korea's freezing, storm-tossed Yellow Sea coast. "The wildest and most gorgeous thing ever!" he wrote to Charmian. "If you could see me just now, captain of a junk with a crew of three Koreans who speak neither English or Japanese and with five Japanese guests (strayed travelers) who speak neither English nor Korean—that is, all but one, which last knows a couple of dozen English words. And with this polyglot following I am bound on a voyage of several hundred miles along the Korean coast to Chemulpo."[1] For six long days he and the crew fought the storms.

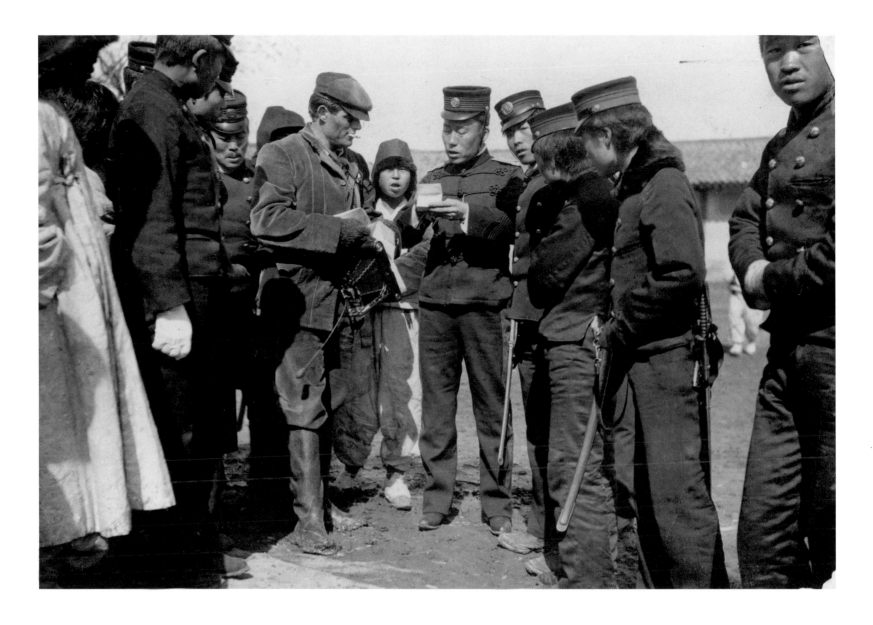

Collier's correspondent Robert L. Dunn, who had made Chemulpo a few days earlier, recorded his impressions of London's arrival:

Jack London is one of the grittiest men that it has been my good fortune to meet. He is just as heroic as any of the characters in his novels. He is a man who will stay with you through thick and thin. He doesn't know the meaning of fear and is willing to risk his life. . . . I did not recognize him. He was a physical wreck. His ears were frozen; his fingers were frozen; his feet were frozen. He said that he didn't mind his condition so long as he got to the front. He said his physical collapse counted for nothing. He had been sent to the front to do newspaper work and he wanted to do it. London was absolutely down and out, to

London had his camera confiscated in Japan and was often detained by Japanese officials when he got too close to the front lines, especially as the war spread to the Yalu River, the boundary between Korea and Manchuria. Korea, 1904.

use the slang expression. He had to undergo medical treatment for several days. As soon as he was able to move about he and I started for the front.[2]

Another correspondent, F. A. McKenzie of London's *Daily Mail*, recalled that Jack London came to them "with the halo of adventure around his head. . . . On the days of our trip north whatever came (and we had our share of the very rough), his open, frank face never lost its laugh. He had to learn riding, and before many days his flesh was raw with saddle soreness. Then he laughed the more, even though his teeth were clenched, only insisting that we should ride harder, and himself hardest of all."[3]

London linked up with the Japanese army and marched with it nearly two hundred miles to the north to Ping Yang (today Pyongyang), where the Russian army was waiting and where London would write his first dispatch. To prepare for the trip, London bought the former Russian ambassador's horse, which he named "Belle." He also bought pack animals and hired an interpreter and two *mapus* (grooms). A

London's dispatches from Korea during the Russo-Japanese War were run above the fold of the San Francisco Examiner, *with elaborate layouts and line art, and were syndicated in other newspapers. London was apparently as much news as what he reported.*

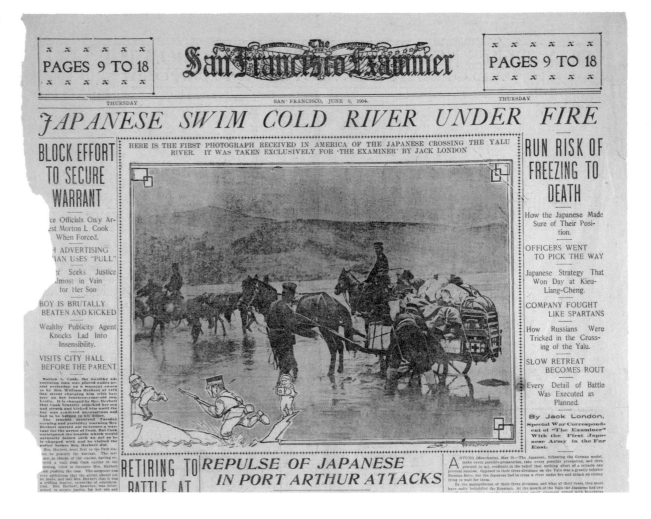

Korean youth named "Manyoungi" became London's body servant, accompanying London home to California after the war, as did the horse. London and his entourage struck out northward, reaching Ping Yang on March 5, making London the first correspondent to reach that far north into the war zone. London's dispatch of March 2 described the first clash between Japanese and Russian land forces, focusing on an advance by a detachment of Cossacks:

> The Russians are boldly and fiercely pushing forward their advance south of
> the Yalu. . . . There has been no attempt by the Japanese as yet to dislodge the
> daring advance guard of the Russians. . . . The country between Anju and Ping
> Yang is very mountainous, and campaigning there will be conducted under
> the greatest difficulties. But as the Japanese are in force here, a collision can-
> not be long deferred. How far behind the Russian advance is the main body of
> the invading army is not known here, but fleeing Koreans declare the invaders
> are in great force. . . . Ping Yang is in a state of panic so far as the natives are
> concerned.[4]

London spent several months frustrating and being frustrated by Japanese officers, who continued to bar correspondents from the scene of the fighting, delaying them with waits for permits and arresting them if they slipped through. Several times London got close to the front, as when he made it to Sunan, only to be captured and returned to Seoul, where he spent his time investigating the area and its inhabitants. From there he sent dispatches that resembled short stories instead of the hoped-for battle coverage. Onstage at the Seoul YMCA, he donned coat and top hat one evening for a command performance reading of *The Call of the Wild* for Japanese officers. In late April, he departed Seoul for Wiju (Uiju, North Korea). Then, from Antung, Manchuria, during the first week of May, he was able to witness the Battle of the Yalu River, since the Japanese, expecting a major victory, had decided to allow correspondents to cover the fighting there. The press corps—now swollen to include reporters and observers from the United States, France, England, Germany, and Italy—were gathered into an isolated center near Antung.

According to London's reportage, the Russians were "sluggish" in battle, while "[t]he Japanese [understood] the utility of things."[5] His biggest story was dated June 4: "JACK LONDON'S GRAPHIC STORY OF THE JAPS DRIVING RUSSIANS ACROSS THE YALU RIVER, First Pen Picture Presented by Any Correspondent Eyewitness of the Remarkable Bravery and Skillful Tactics of the Victorious Japanese Army at Antung."[6] The Japanese suffered nine hundred casualties while inflicting four thousand casualties on the Russians, taking more than five hundred prisoners, and capturing guns and ammunition. London criticized the Japanese for sending in

more men than necessary—perhaps for show—and getting many of them needlessly killed.

London became the most famous correspondent of the war, sending hundreds of photos and dozens of dispatches to the *San Francisco Examiner*, though not knowing whether any were making it through. They did, and his photos and stories of battles, Russian prisoners of war, Japanese troops, Korean peasant families, and the daily life of war made headlines the world over. And yet the dispatch on the Yalu River battle was his only real battlefield reporting.

The Russo-Japanese War is not well remembered today, but its repercussions were felt for a long time. Japan had defeated China in the Sino-Japanese War in 1895, but France and Germany helped Russia pressure Japan into accepting an indemnity instead of claiming captured territory. At the same time, Czar Nicholas II borrowed money from France to finish the Trans-Siberian Railway, which would open up badly needed trade routes across Asia. The railway's eastern terminus was Vladivostok, but the harbor there was iced in except during the summer. In his quest for a warm-water Pacific port, the czar settled on Port Arthur, in southern Manchuria, which Russia had more or less occupied since 1898. Russia constructed a spur line of the railway from Port Arthur to Vladivostok, occupying Manchuria all the way to the Yalu River, the border with Korea, in the process.

Japan, which had long tried to control Korea, feared Russia's imperialist ambitions in the area, and both countries secretly built up arms. The United States and Great Britain lent Japan financial and diplomatic support. At the same time, the domestic political situation in Russia was headed toward open revolt. The czar's advisers saw a war with the "heathen" Japanese as an ideal distraction, and Russians in general believed the small country would be crushed. They did not dream Japan would make the first move, but Japan, feeling secure in its support from the United States and Great Britain, broke off relations and invaded Port Arthur, sinking a good part of the Russian navy and setting up an island base nearby. The Japanese victory was major news around the world. Among other things, the loss of Port Arthur helped ignite the 1905 Russian revolution. Though early in the war the American position was pro-Japanese and anti-Russian, Americans turned anti-Japanese after the war, echoing the anti-Asian panic of the 1880s and 1890s.

London did not seem to value his work in Korea. He felt constantly frustrated by the restrictions imposed by Japanese army officers and government officials, and he sorely resented being kept away from much of the battlefield action. As he wrote in one dispatch:

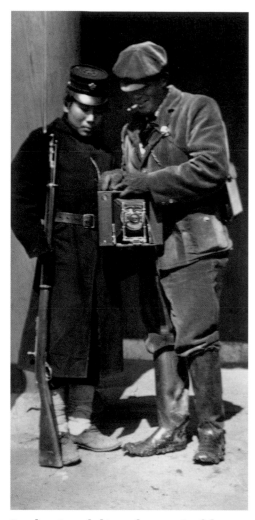

London struggled to make meaningful photographs despite censorship by the Japanese Army. Korea, 1904.

Even before the taking of photographs was absolutely forbidden I once had the temerity to take a snap of an army farrier and his bellows. "Here at last was something that was not a military secret," I had thought in my innocence. Fifteen minutes' ride away I was stopped by a soldier who could not speak English. I showed my credentials and on my arm the official insignia of my position in the Japanese army. But it was no use. . . . After much delay an officer was brought to me. He was a captain, and his English was excellent—a great deal purer and better than my own. "You have taken a photograph of an army blacksmith," he said accusingly and reproachfully. With a sinking heart I nodded my head to acknowledge my guilt. "You must give it up," he said. . . . I came to war expecting to get thrills. My only thrills have been of indignation and irritation.[7]

Hemmed in by prohibitions and hounded by censors, he turned to photographic and journalistic subjects behind the lines. Most of London's dispatches and photographs were vignettes of the lives of the villagers and soldiers around him: Korean village *yangbans* (chiefs), weary peasants serving as *mapus* or laboring on roads for the Japanese army, refugee families, high-ranking Japanese officers, their footsore but determined soldiers, captured Cossacks. In Korea, London completed his first portrait series, one of elderly Korean village men and another of beggar children. Eventually London would fill nearly twenty albums with photographs of these "human documents"; only during the cruise of the *Snark* did he make a larger batch of photographs.

London's fame and impact were helped immeasurably by the emerging mass-market technologies of publishing. Led by the Hearst papers, front-page newspaper layouts became larger, more dramatic, with huge photographs splashed across them. Such treatment perfectly suited London's adventures, colorful writing, and dramatic photographs. Accompanying his war dispatches were sidebars showing him at work with his camera. On January 7, 1904, the front page of the *San Francisco Examiner*, in announcing London as its war correspondent in Korea, ran gigantic studio portraits of him and a biography of his earlier personal adventures. For months afterward, his photos and stories from Korea appeared in many papers in full-page layouts complete with cartoons. On February 7, 1904, the *New York American* announced London's arrest and release in Moji with a front-page story headlined "JACK LONDON FREE! HE WAS NOT A SPY!" On March 3, 1904, the front page of the *Chicago Examiner* ran the banner headline "KOREANS FLEE IN TERROR FROM RUSSIANS,"

with several subtitles to London's story, such as "Famous Author Tells of Daring Advance of Cossacks on Anju and Failure of Japanese to Try to Check Their Onward March" and "Foremost of America's Younger Writers, Author of 'A Daughter of the Snows,' 'Children of the Abyss [*sic*],' 'Kempton-Wace Letters,' 'The Call of the Wild,' 'The Son of the Wolf,' 'The Sea-Wolf,' and other stories,'" before presenting the actual dispatch. On April 4, 1904, a *San Francisco Examiner* headline read, "STRAIGHT FROM THE SEAT OF WAR: Glimpses of the Japanese Army."

This newspaper publishing history is a reminder of London's importance as an American author and a representative of his country. After his return home, he was celebrated as someone to be consulted about "the Yellow Peril." Yet London's own treatment of this sensational topic in two well-known essays, "The Yellow Peril" and "If Japan Awakens China," is quite nuanced; in both essays, he argues for the equality of Western and Asian "souls" and advocates that the Orient and Occident come to a better understanding, mainly by learning each other's languages.

In photos and stories, the *San Francisco Examiner* not only illustrated the war using material supplied by London but also presented him as a story in his own right. For example, on April 25, 1904, the entire front-page headline reads: "Jack London the Victim of Jealous Correspondents" and "Punished for Alertness." The story relates how "discomfited and disgruntled war correspondents sitting around in

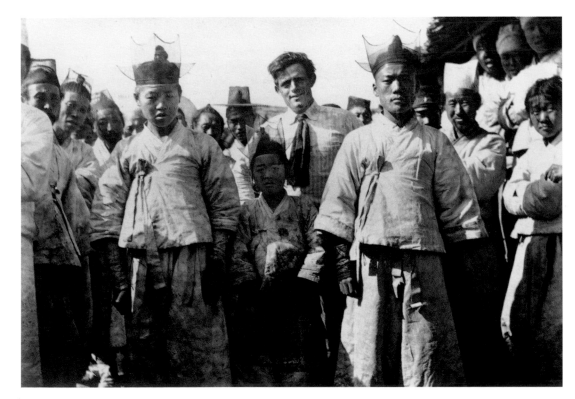

London with Korean dignitaries, 1904.

remote Japanese towns have raised a protest that has resulted in Jack London being ordered back from the front." As "the only representative sent out by the American or British press who succeeded in getting close to the firing line," London "was the only war correspondent who sent authentic news from the front, and he has sent the only real photographs from the seat of war. Of course the exclusive matter sent by London to the Hearst newspapers raised a tremendous commotion in the home offices. Angry inquiries were sent out to the correspondents, complaining that they had allowed themselves to be beaten ignominiously. If London could get the real news what were they about?" According to the *Examiner*, the offended correspondents "united in a tearful protest to the Japanese military censorship at Tokio, begging that London be recalled from Sunan, so as to save the reputation of the long lost correspondents. Their humble petition was granted. London was ordered back from Sunan to Seoul" (this was not the real reason). But the *Examiner* was determined to distinguish him from the rest: "As a matter of fact, Jack London took serious risks in getting to the front and underwent severe hardships. He made his way north in an open boat with the thermometer fourteen degrees below zero at the risk of his life. The other correspondents for the most part sat around in the clubs at Tokio and cultivated a rumor factory. The village of Sunan, in Korea, from which Jack London was ordered back to Seoul, is the farthest point north reached by an American or English correspondent. It is within a comparatively short distance of the Japanese firing line."

London's wartime experiences also became the subject of others' stories. As mentioned earlier, London was arrested in Moji, Japan, on February 1, 1904, for taking photographs of laborers and children in what was, unbeknownst to him, a restricted area; during the arrest, his camera was confiscated. According to London, Japanese journalists, whom he called "brothers in craft," banded together to persuade a judge to return his camera. However, there are other accounts of how London got his camera back. His version comports with that of a reporter for the *Osaka Asahi*. As Eiji Tsujii notes, this reporter, who may have been the agent responsible for organizing a group of Moji and Shimonoseki newspapermen to effect the camera's restoration, "updated local readers on London's situation and ended several days of reportage with news that the camera had been released for a fine of ten yen."[8] However, London's younger daughter, Becky London Fleming, had her own (mostly inaccurate) version: "Daddy wasn't afraid. He talked to people and became buddy-buddies with the man in charge. He was out of jail and later rode the general's horse in Seoul."[9] The most entertaining version is that of U.S. minister to Japan, Lloyd Griscom. Ac-

cording to him, London sent a telegram to fellow writer Richard Harding Davis, who was still in Tokyo, asking for help. Davis interceded with Griscom: "One day I had a frantic appeal from Jack London. He was in jail; I must have him released immediately. Investigation showed that he, with his camera, had strayed by mistake into one of the fortified areas along the Inland Sea; and on my assurance that he intended no harm the Japanese released him." London returned to Tokyo, says Griscom, "sputtering with wrath because his valuable camera had been confiscated; he could not replace it; it was essential to his livelihood." Griscom visited Baron Komura, the foreign minister, who, after conferring with his legal adviser, refused to release the camera, on the grounds that it had been used in commission of a crime and hence was state property. Griscom then asked whether that applied to every crime: "'Yes, to every crime of every description.' 'If I can name a crime to which this does not apply, will you release the camera?' Regarding me doubtfully for a few seconds, Baron Komura replied, 'Yes, I will.' 'Well, what about rape?' Baron Komura's Oriental stolidity dissolved in a shout of laughter." London got his camera back.[10]

By the summer of 1904, tired of censorship and his lack of access to battles, London decided to request that Hearst bring him home. But before this could occur, he was arrested again—this time for striking a *mapu* who, he claimed, stole from him. To avoid a Japanese court-martial, London again appealed to Davis, who came to London's aid by cabling a friend from his Cuban days, President Theodore Roosevelt. Roosevelt then intervened through the U.S. ministry in Tokyo. Whether London was expelled from or left Korea voluntarily, by July 1, he had passed through Yokohama and returned to California.

London's photographs from Korea signal his developing photographic goals and his compassionate view of humanity. His socialist views on labor and class are illustrated in his many images of people at work, and the images of war orphans echo the suffering of the children he observed in London's East End. His photographs preserve the dignity of even the most destitute subjects, such as refugees. He many times photographed subjects from two of the groups hit hardest by the war—old men and young girls. At the same time, he made numerous photographs of Japanese soldiers as they readied for battle, but his focus was often on their humanity. A unifying theme in these photographs is the road, which appears in many of them. In images of oxcarts struggling through the mud, peasants carrying huge loads, Koreans digging trenches, lines of artillery snaking across the snowy landscape, and refugees heading south, the road emerges as a metaphor for the transitions imposed by war.

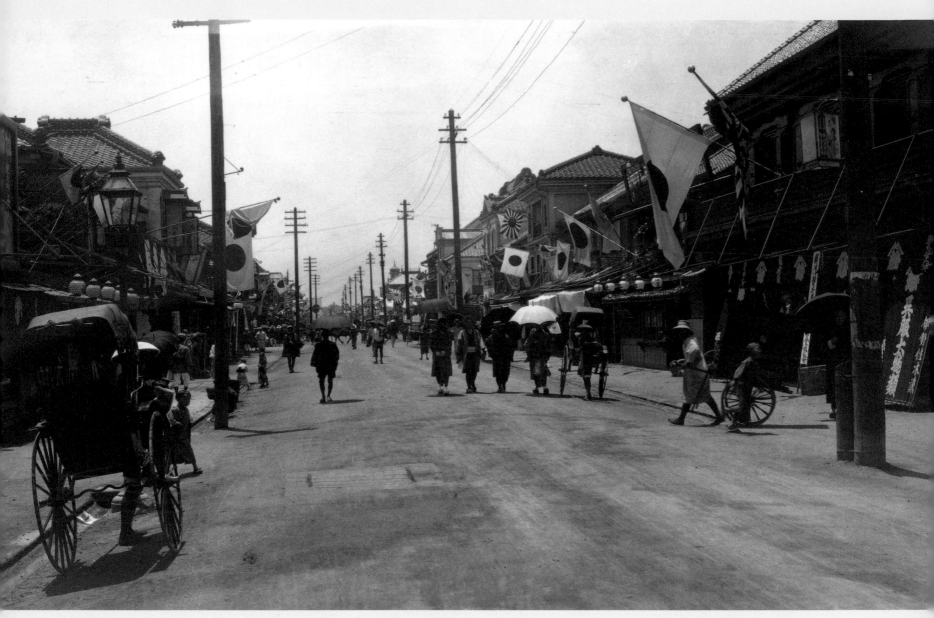

Yokohama, Japan, 1904.

"*I am bound for Seoul, the capital. Was pretty busy in Yokohama and Tokio. Arrived Monday, and have been on the jump until now. . . . You should have seen me plunging out of Kobe this morning, myself and luggage in three rickshaws, with push-boys and pull-boys and the rest, and racing to catch the express for Nagasaki.*" (*Jack London to Charmian Kittredge, Kobe and Nagasaki, Japan, January 28–29, 1904*)

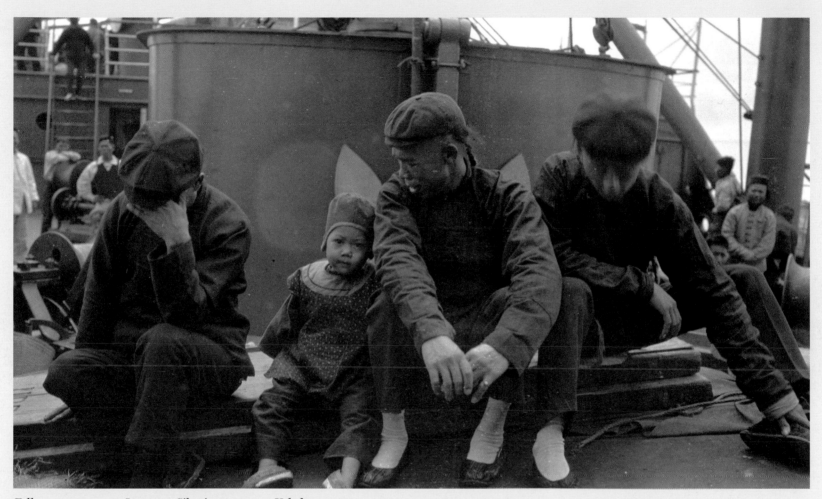

Fellow passengers to Japan, ss Siberia *en route to Yokohama, 1904.*

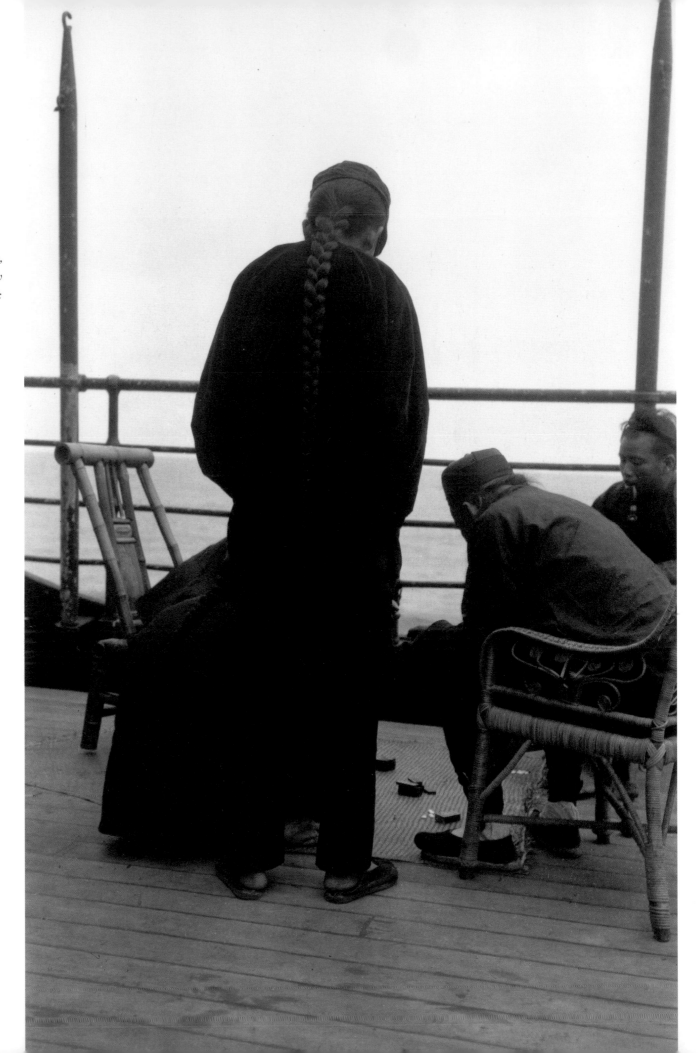

"Dominoes."
ss Siberia *en route to*
Yokohama, *1904.*

"*Had some fun. I
bucked a game run by
the Chinese firemen
of the* Siberia, *and in
twenty-five minutes
broke three banks and
won $14.85! So, you see,
I have discovered a new
career for myself." (Jack
London to Charmian
Kittredge, ss* Siberia,
January 15, 1904)

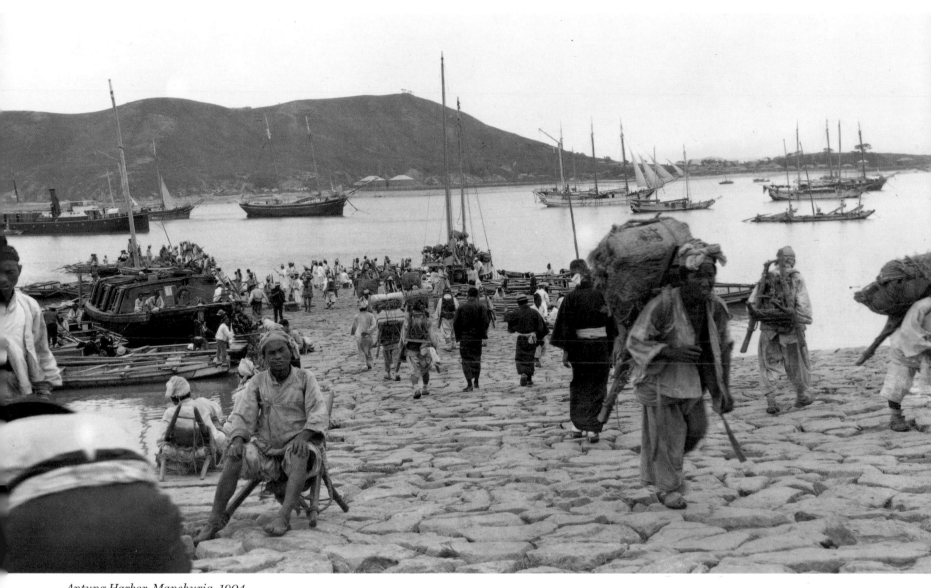

Antung Harbor, Manchuria, 1904.

Antung Harbor, Manchuria, 1904.

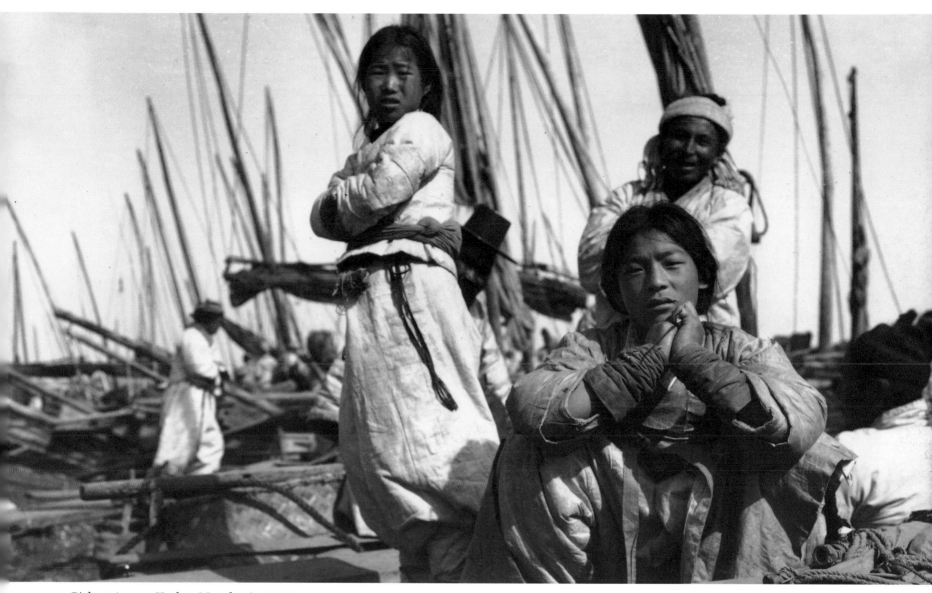

Girls at Antung Harbor, Manchuria, 1904.

(overleaf)
Boats at anchor at Antung Harbor, Manchuria, 1904.

Pipe maker, Seoul, Korea, 1904.

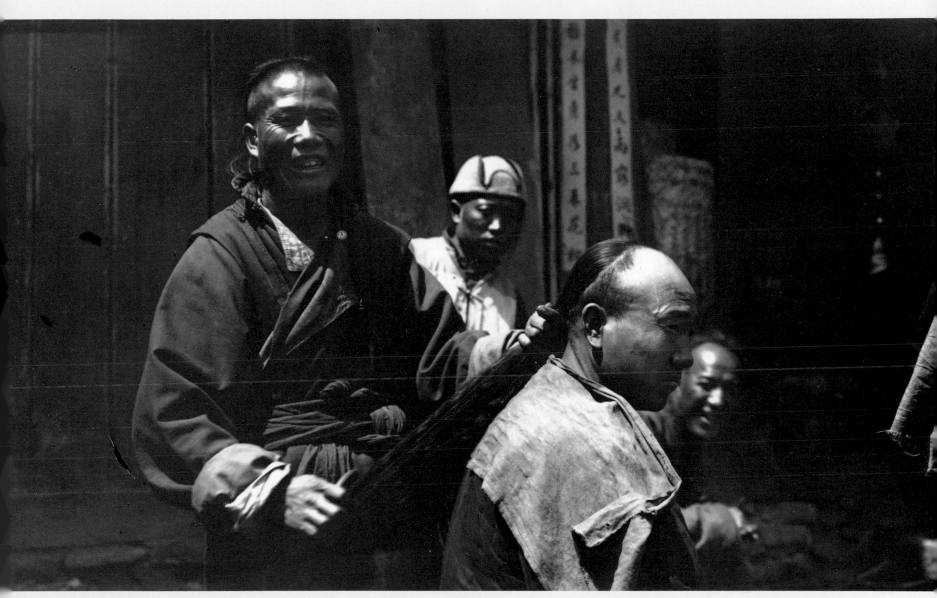

"Manchurian barber, 1904."

"Japanese Infantry." Korea, 1904.

"I think as to the quietness, strictness and orderliness of Japanese soldiers it is very hard to find any equals in the world. If it were our boys they would have gone on lightheartedly to all the places and we would surely have heard for many a time about them kicking up a row, but such things never happen in Japanese. . . . Therefore no citizen in the town has any fear at all about them and women, bar, property and all the rest are quite safe. . . . Japanese is the race who can produce real fighting-men." (Jack London to Charmian Kittredge, March 4, 1904)

Japanese troops and Korean coolies digging a road, Korea, 1904.

"If age and history are to be taken into account, it is a royal road that leads out of Seoul through the gap of Pekin Pass. North it leads half the length of the Peninsula to the Yalu, and then, sweeping westward, rounds the head of the Yellow Sea and finally arrives at Pekin. Up the length of this road and down have passed countless Chinese imperial envoys in splendor of tinsel and barbaric trappings.

"Indeed a royal road, and yet, to the western eye and judgment, a bog hole and travesty of what he has understood 'road' to mean. The least rain and it is a river of mud. Horse and rider must beware on its crumbled bridges. . . . It is a dirt road to begin with, and the Korean method of repairing it is to shovel in more dirt. I use 'in' advisedly, for too many a weary mile of it is worn far down beneath the level of the rice fields on either side." ("'Royal Road a Sea of Mud,' Ping Yang, March 5 [1904]," in Jack London Reports, *42)*

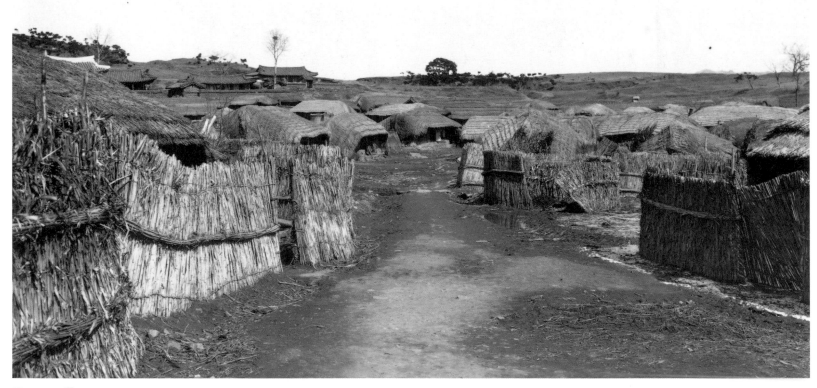

Korean village, 1904.

"Arrive at this forlorn village; people scared to death. Already have had Russian and Japanese soldiers—we put the finishing touch to their fright. They swear they have no room for us, no fuel, no charcoal, no food for our horses. . . . We storm the village—force our way into the stables—capture 25 lbs. barley hidden in man's trousers—and so forth and so forth, for two mortal hours. . . . And this is but one of the days." (Jack London to Charmian Kittredge, Poval Colli, Korea, March 8, 1904, *in* Jack London Reports, *14)*

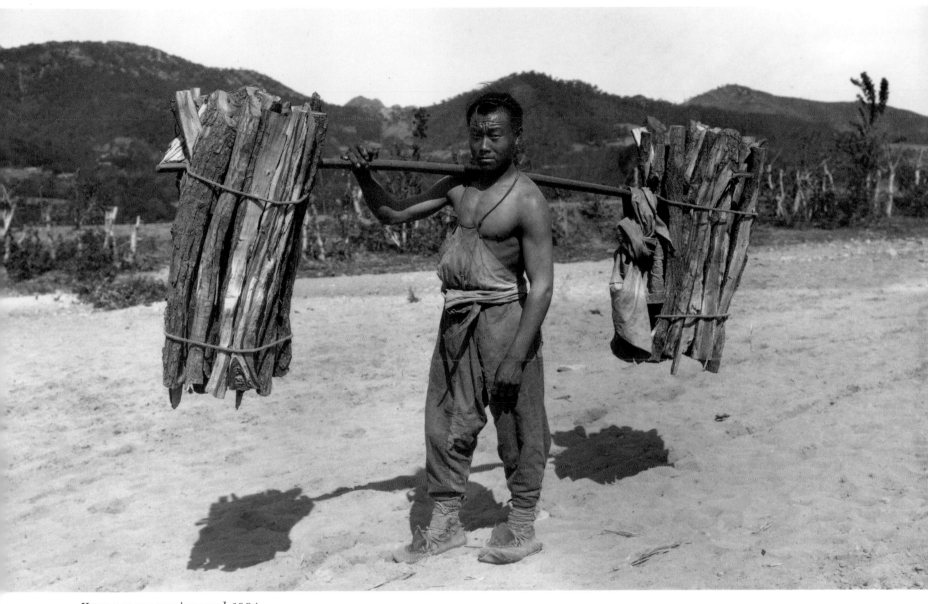

Korean man carrying wood, 1904.

"So there are no army wagons nor army mules. Pack horses and coolies
do the work; and, though many Korean bullock carts have been put into
service, there is no necessity for them. The rice, which is the staple food,
is done up in sixty-pound sacks. One coolie can carry a sack all day
over the most rugged country." ("'Americans Praise Japan's Army,'
Ping Yang [Korea], March 5 [1904]," in Jack London Reports, 48)

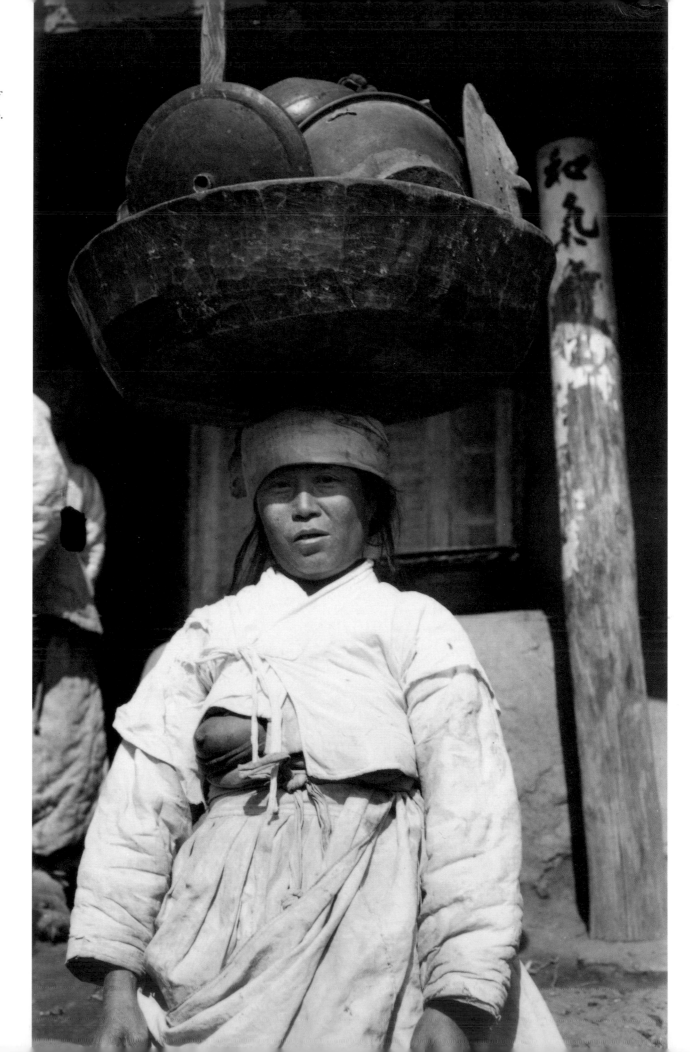

Female Korean villager carrying a heavy load of dishes on her head, 1904.

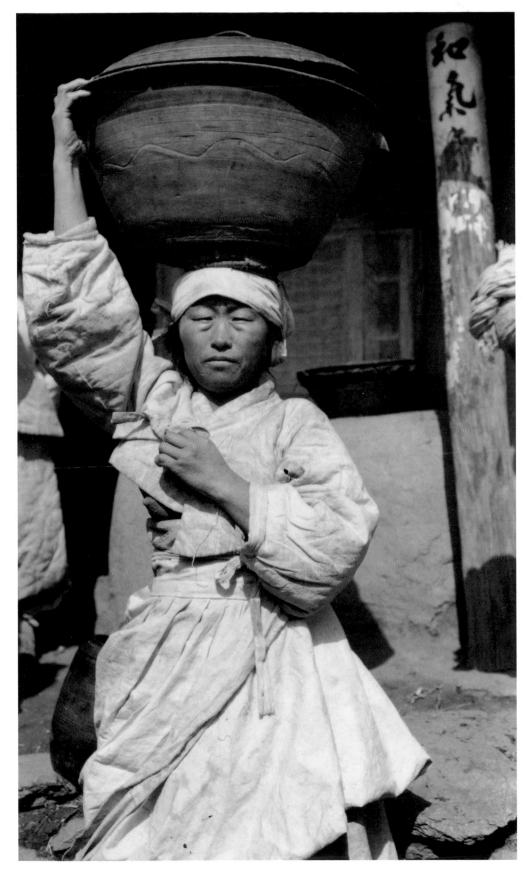

*Female Korean villager
carrying a pot on her head,
1904.*

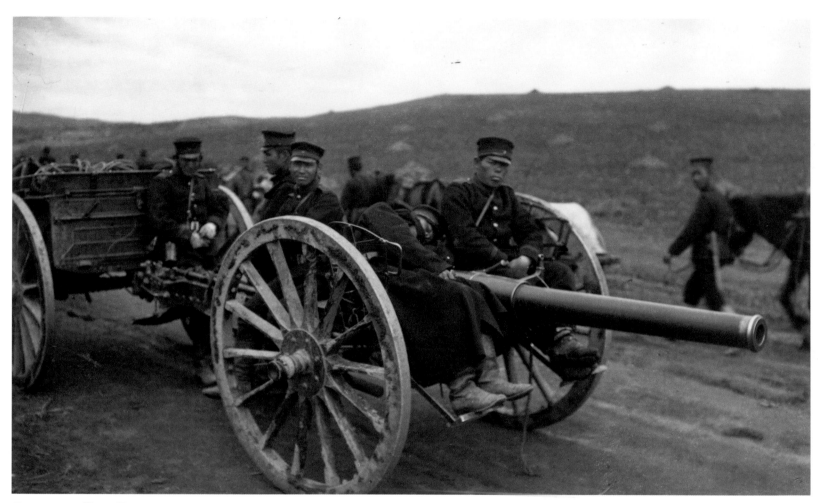

Japanese artillery, Korea, 1904.

"At this time a dark line, thin as a hair, was observed crawling along the base of the rugged mountains which rise to the eastward on the Manchurian shore. This line was hugging the shore and moving westward toward the burning houses and Tiger Hill. The Japanese had effected their lodgment on the north bank. The Mikado's troops were in Manchuria." ("'Give Battle to Retard Enemy,' Antung [Manchuria], May 1 [1904]," in Jack London Reports, *101)*

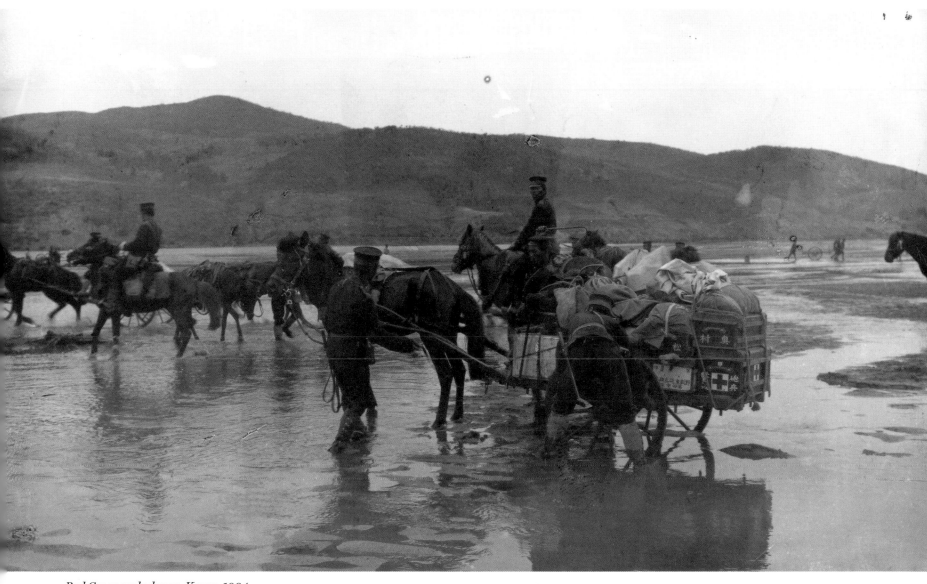

Red Cross ambulance, Korea, 1904.

(overleaf)
"Chow." Korea, 1904.

"In small cotton bags, weighing little and occupying less space, are emergency rations. This ration is made of rice, boiled and then dried in the sun till each grain has shrunk to the size of a pinhead. Each soldier carries six of these rations in his knapsack. On a pinch they would suffice him for days." ("'Americans Praise Japan's Army,' Ping Yang [Korea], March 5 [1904]," in Jack London Reports, *49)*

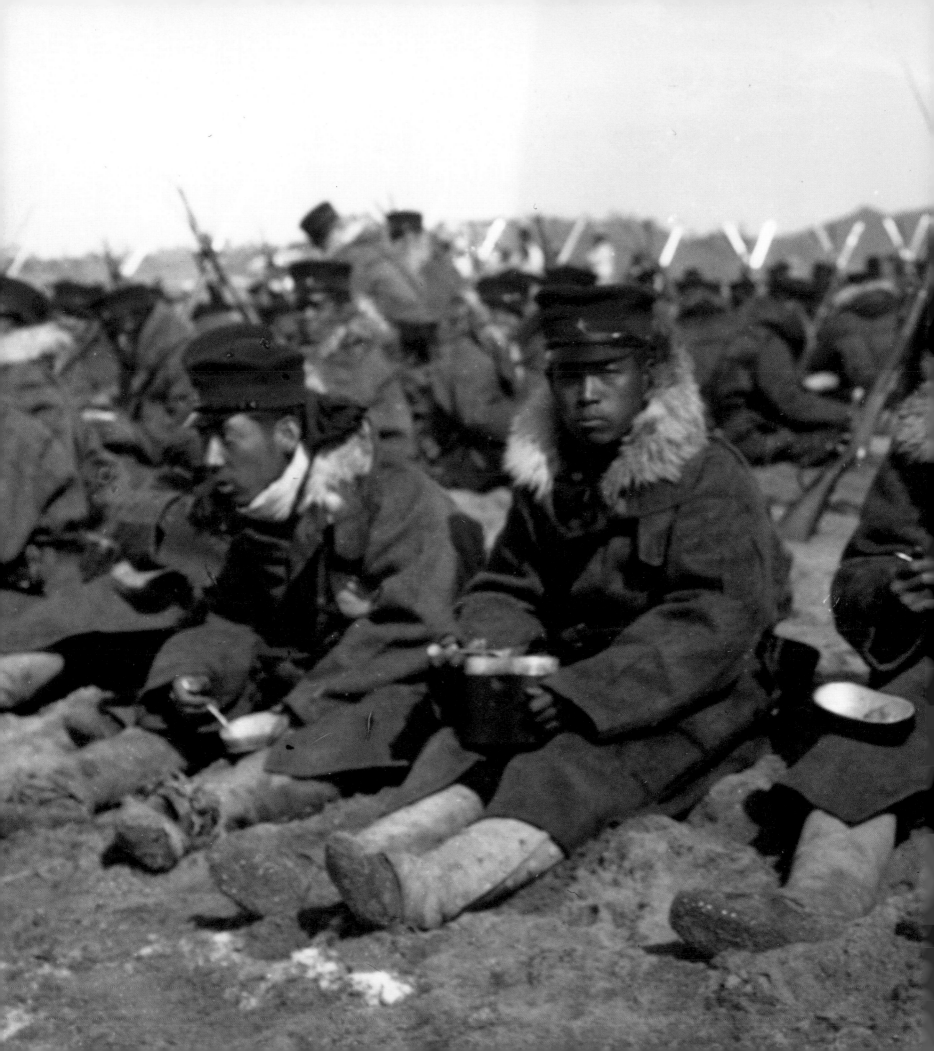

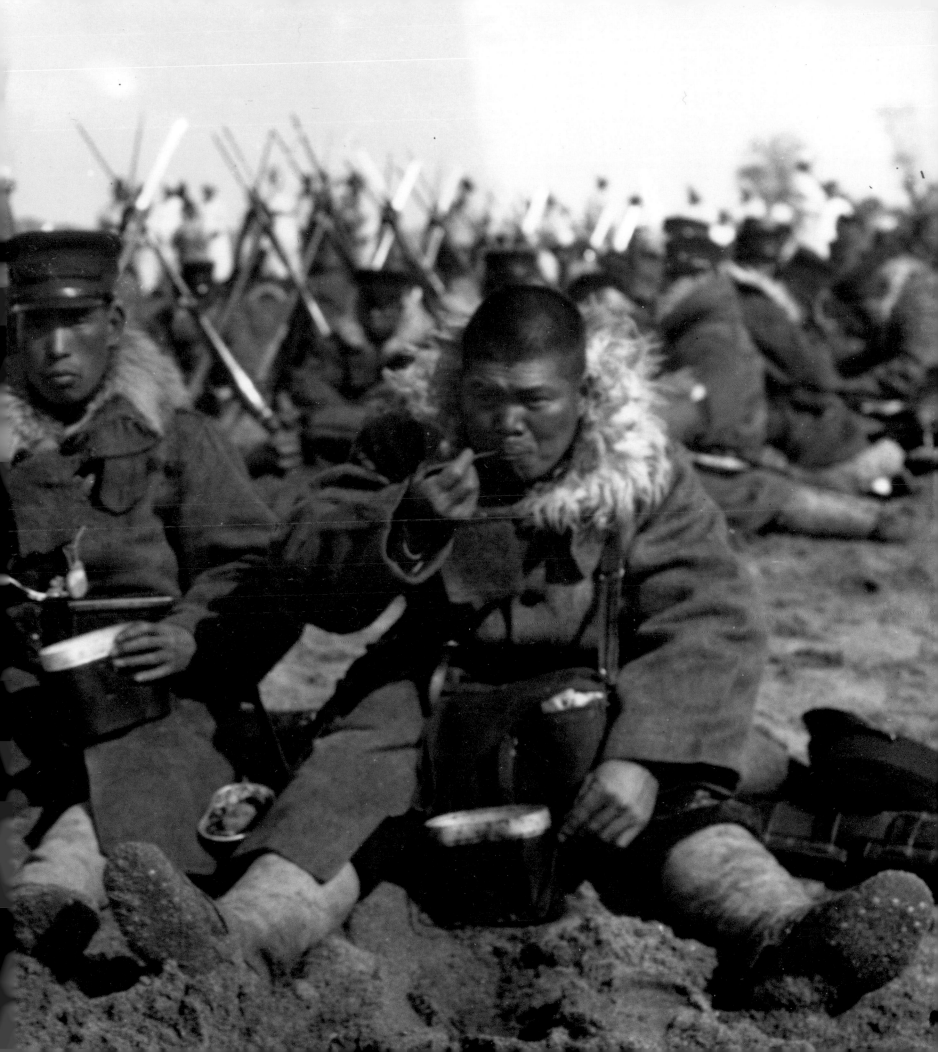

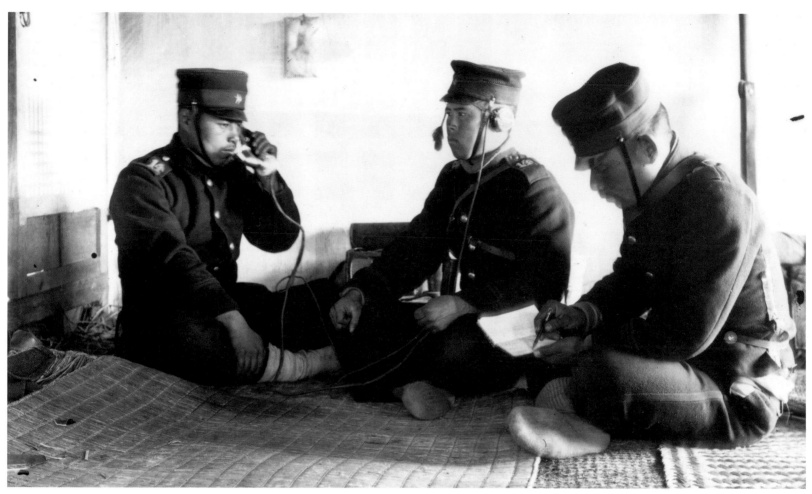

Japanese soldiers with a field radio, Korea, 1904.

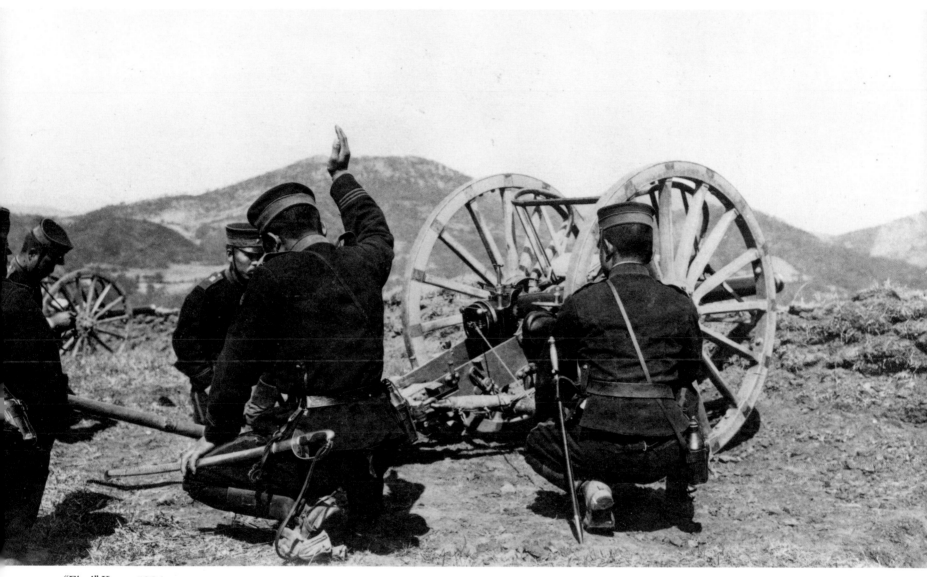

"Fire!" Korea, 1904.

"At 10 o'clock the Japanese battery on the right fired the first gun. Following the report was a sound as of the violent ripping of a vast sheet of cloth, as the shell tore through the atmosphere and sighed away in the distance. Two miles away, across the river and to the right of Tiger Hill, there was a bright flash, a puff of smoke and a dust-cloud rose where the flying shrapnel tore the earth." ("'Give Battle to Retard Enemy,' Antung [Manchuria], May 1 [1904]," *in* Jack London Reports, *100–101*)

(overleaf)
"Watching the Battle of the Yalu." Korea, 1904.

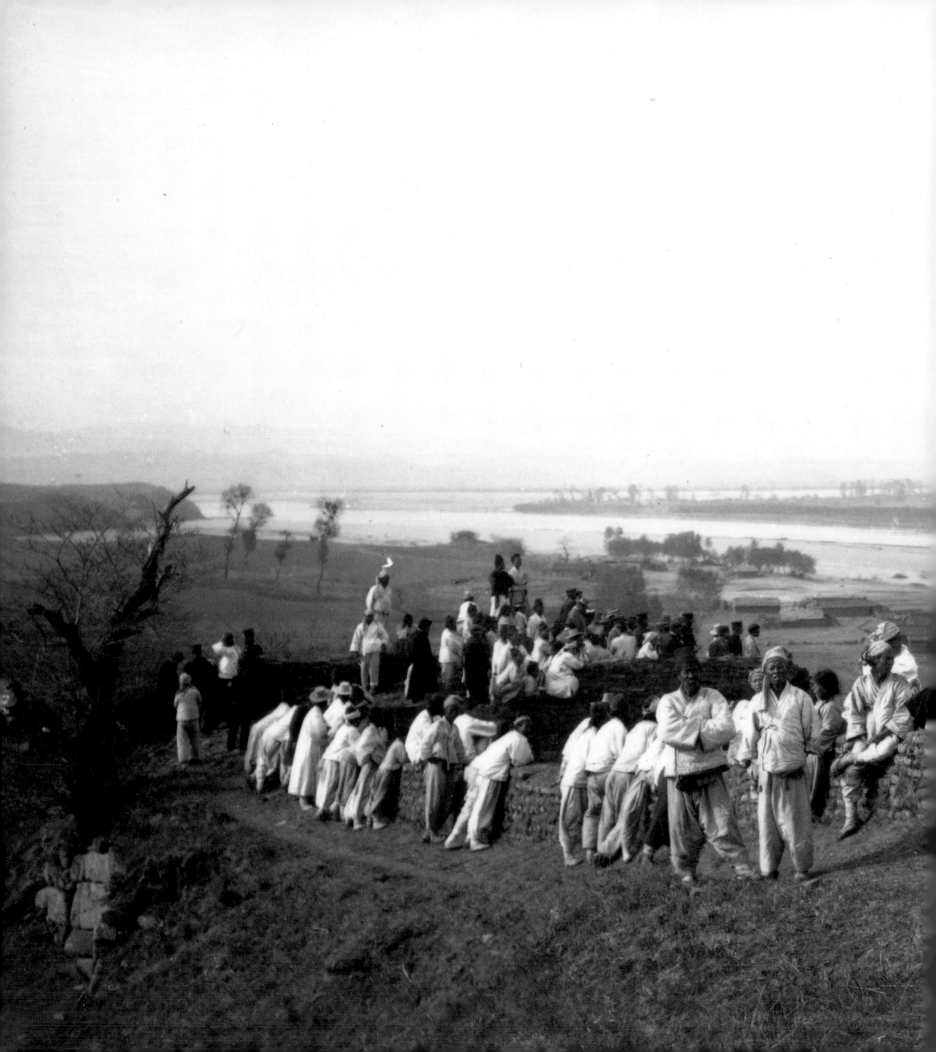

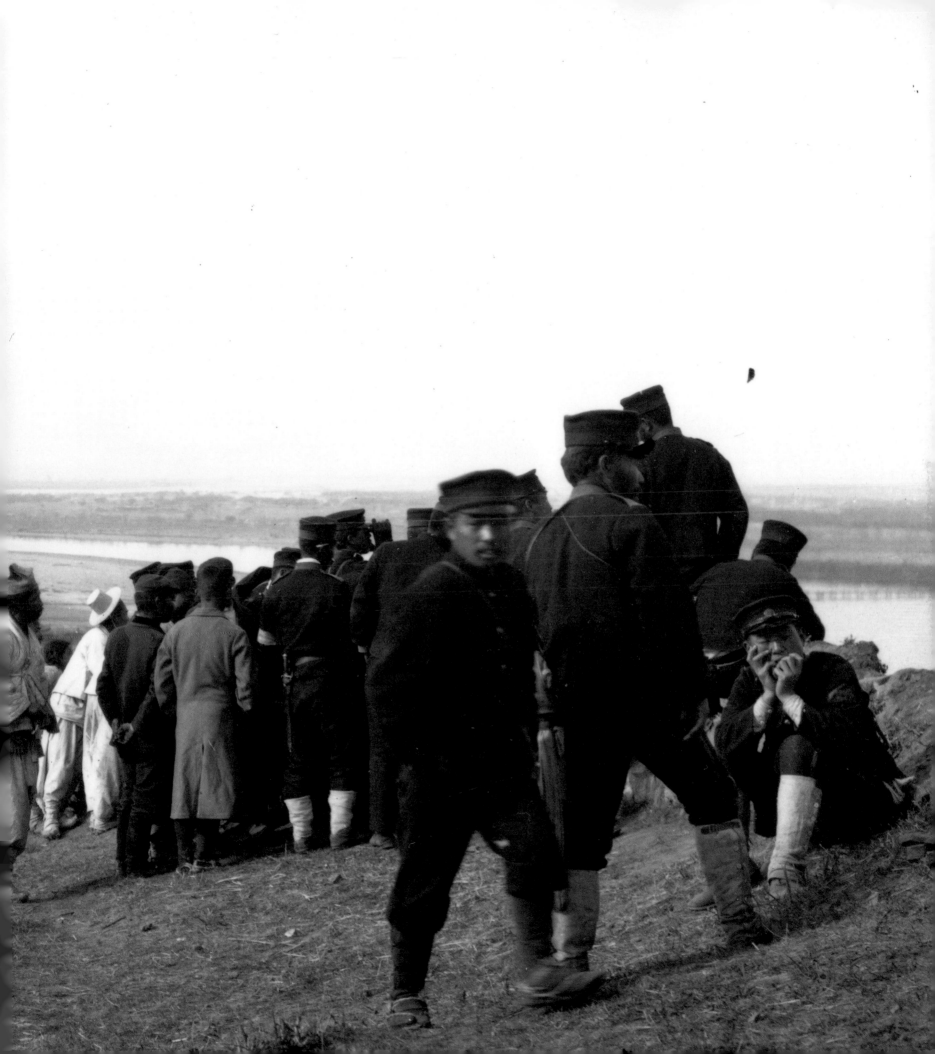

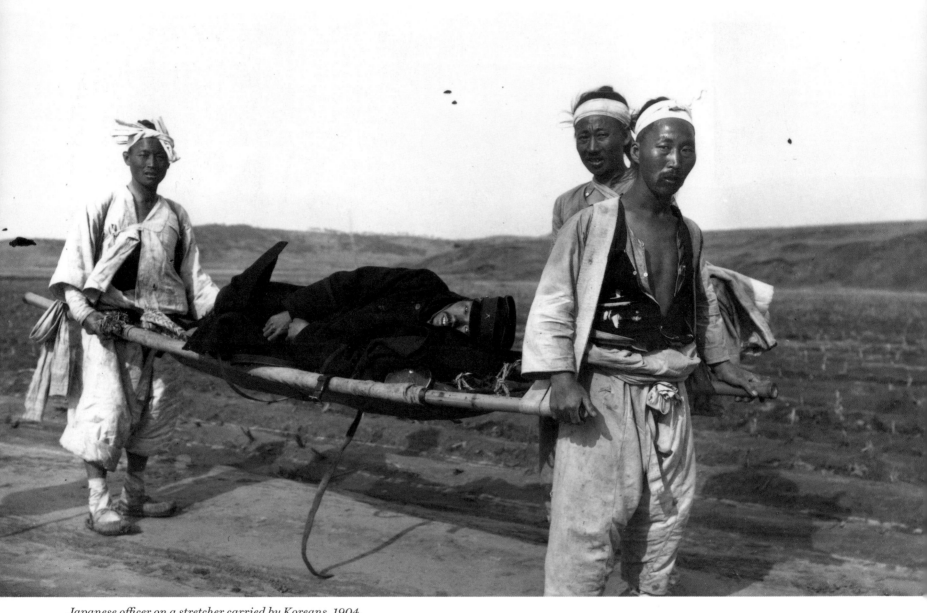

Japanese officer on a stretcher carried by Koreans, 1904.

"There were open sores, on which the burdened men had walked day after day. Such sores, anywhere from the size of a ten-cent piece to a half-dollar, were open with hard edges and filled with proud flesh.... And the next man would exhibit a little toe, quite deformed and shapeless, or a hole in a toe into which another toe had worked nearly to the bone.... These men, used to the straw sandal all their lives, had been summoned to join their colors and to incase their feet in the harsh leather boot of the West." ("The Sufferings of the Japanese,' Sunan, March 13 [1904]," in Jack London Reports, *80–81)*

Temple gate and landscape, Korea, 1904.

"Well does Korea merit its ancient name, Chosen-land of the morning calm. There was not a breath of air, the land shimmered in the heat and the valleys and distant mountains were vague and indistinct in the blue, summer haze. Nothing moved in all that wide expanse, and the peace and quietness of it conveyed not a hint of war." ("'Japanese Supplies Rushed to Front by Man and Beast,' Wiju [Korea], April 21 [1904]," in Jack London Reports, *95).*

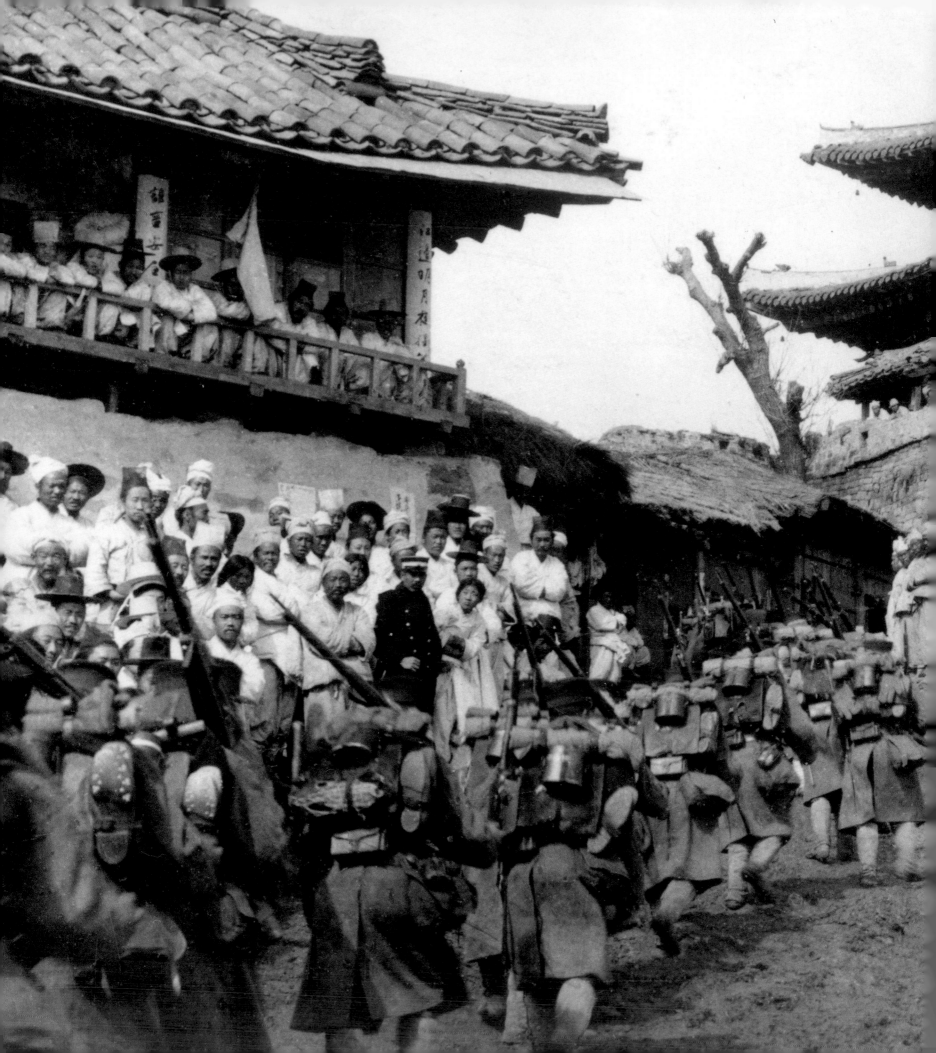

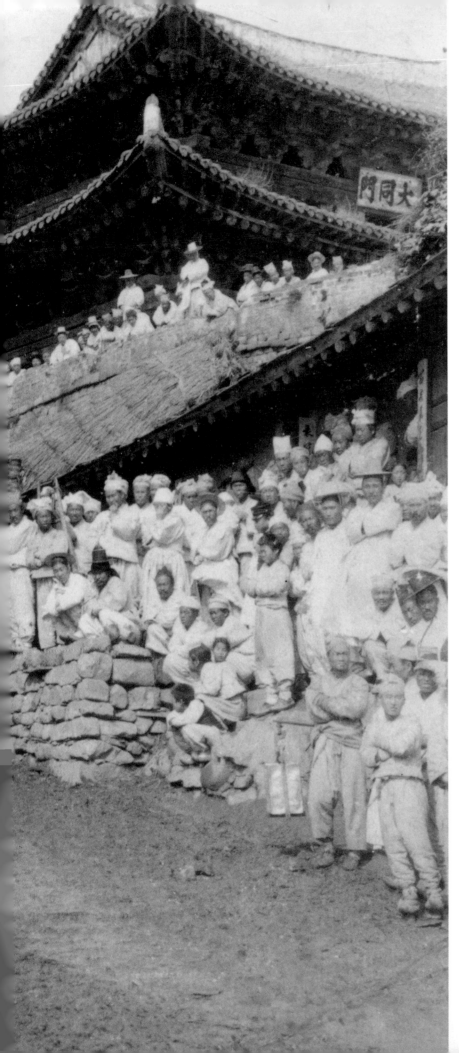

Japanese Army entering
Ping Yang, Korea, 1904.

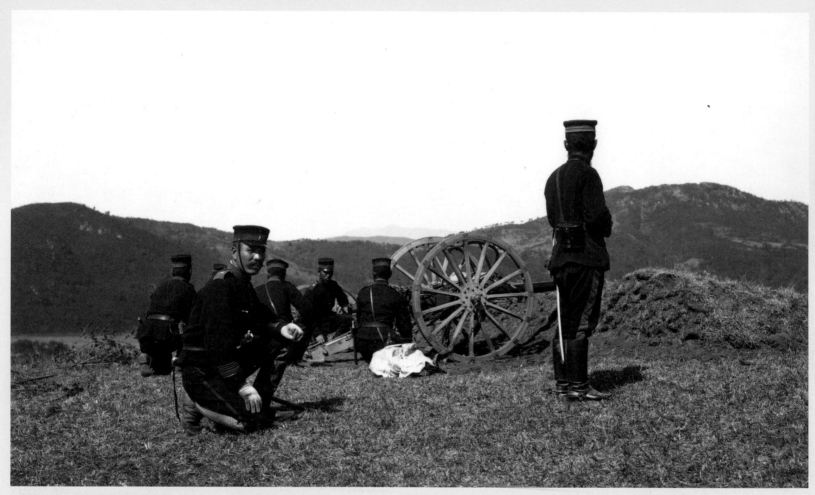

"Feng Wang Chen." Korea, 1904.

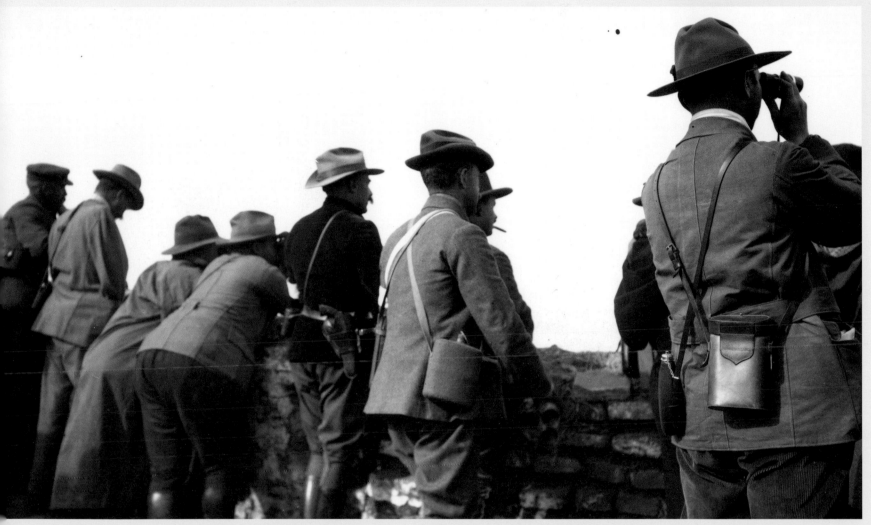

"War Correspondents at Battle of Yalu River." Korea, 1904. The correspondents pictured included Walter Kirton, Frank Palmer, F. F. Knight (London Post), Charles-Victor Thomas (Le Gaulois), and Martin Donohoe (London Daily Chronicle).

"Art. 7. Press correspondents shall not go about in the battle field except at the time and place shown by the supervising officer or the detachment commander." (Japanese First Army regulations for press correspondents, Korea, 1904)

Russian iron cook stove, Korea, 1904.

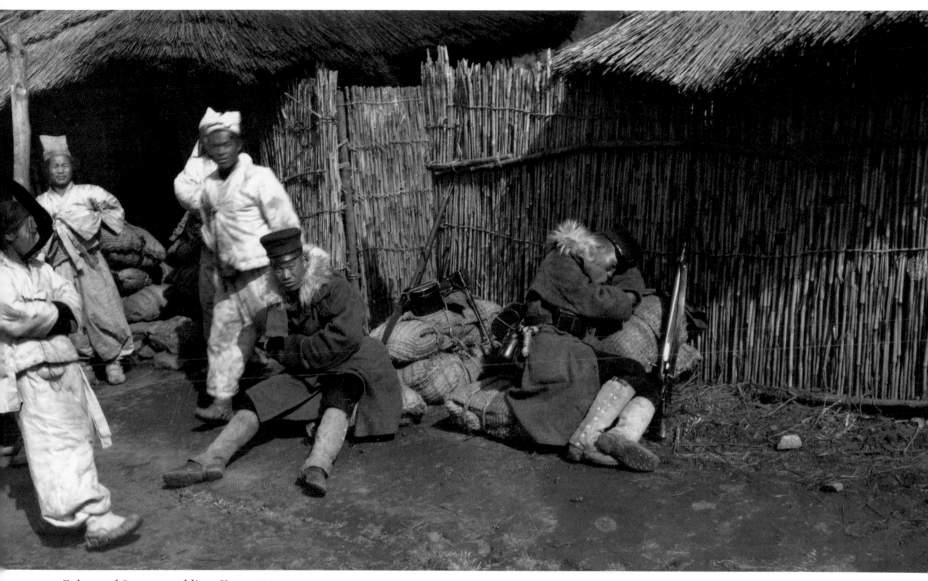

Exhausted Japanese soldiers, Korea, 1904.

"The Japanese surely are a military race. Their men are soldiers, and their officers are soldiers. I called upon Captain Kauchiba of the Pioneers who lives in the room adjoining mine. . . . His men had marched up on Seoul averaging twenty miles a day; and on my inquiring about sore feet he reluctantly admitted that some of his men were suffering, but added immediately that they were so fired with love of country that sore feet did not matter when it came to fighting the Russians." ("'Cossacks Fight Then Retreat,' Ping Yang, March 5 [1904]," in Jack London Reports, *53)*

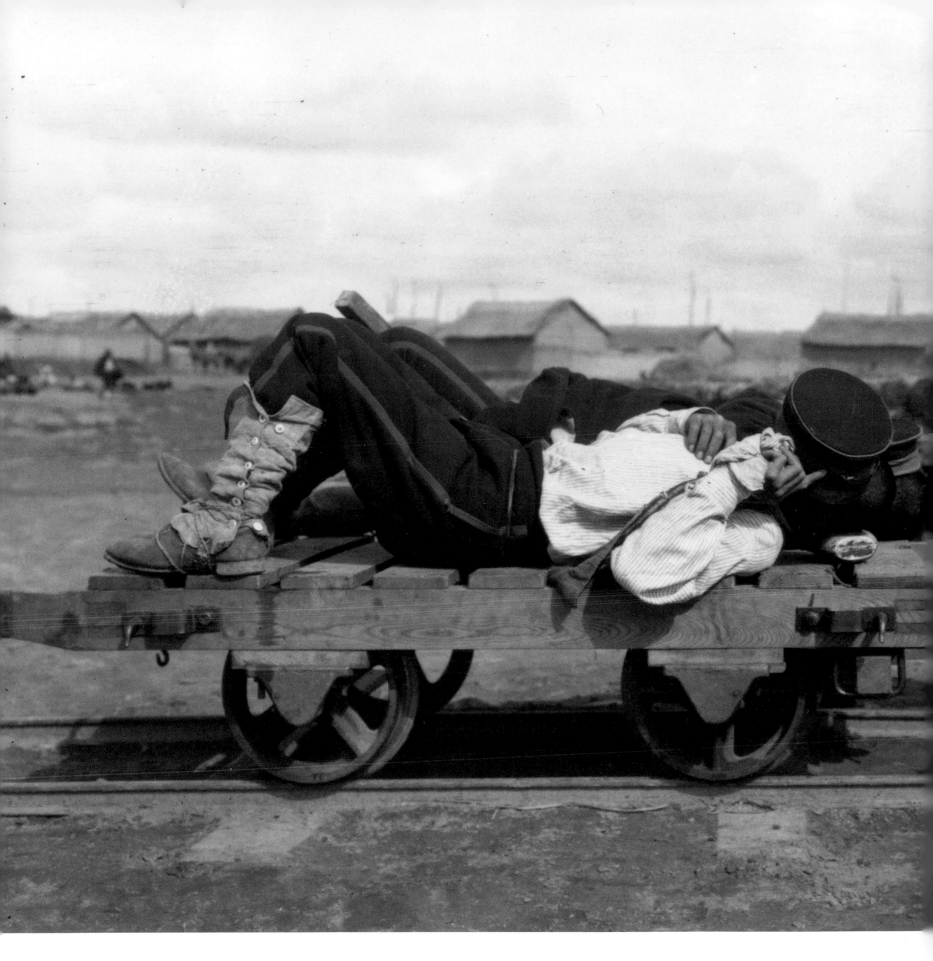

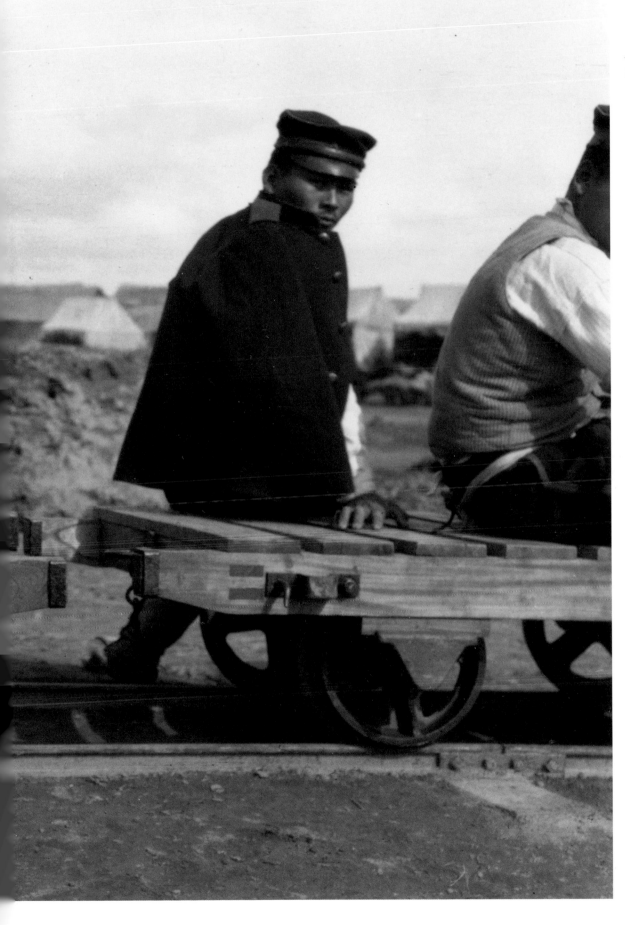

Japanese soldier at rest, Korea, 1904.

Captured Russian guns, Korea, 1904.

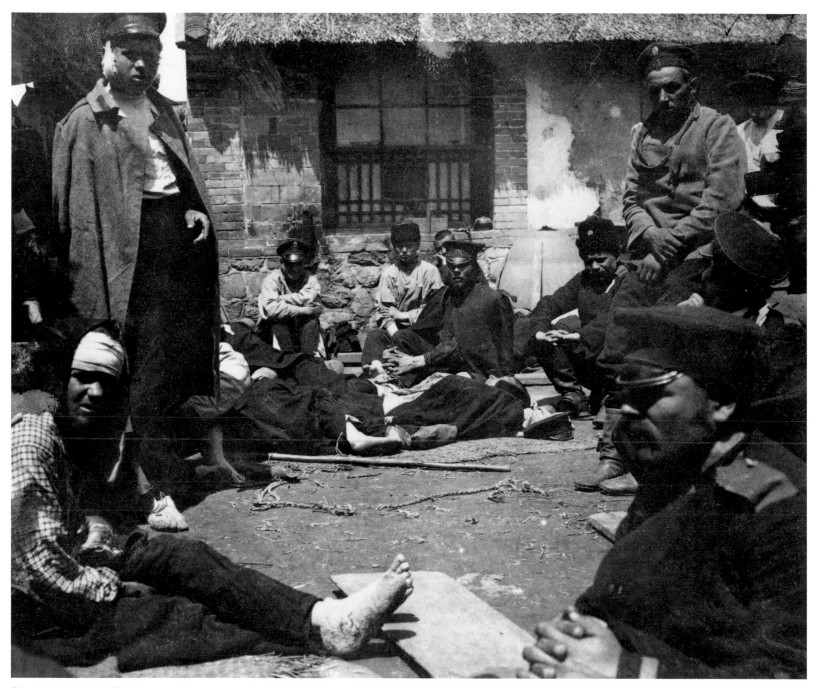

"Russian Prisoners." Korea, 1904.

"And there were other white men in there . . . many white men. I caught myself gasping. A choking sensation was in my throat. These men were my kind. I found myself suddenly and sharply aware that I was an alien amongst these brown men. . . . And I felt myself strangely at one with those other men . . . felt that my place was there inside with them in their captivity, rather than outside in freedom amongst aliens." ("'Give Battle to Retard Enemy,' Antung [Manchuria], May 1 [1904]," in Jack London Reports, *106)*

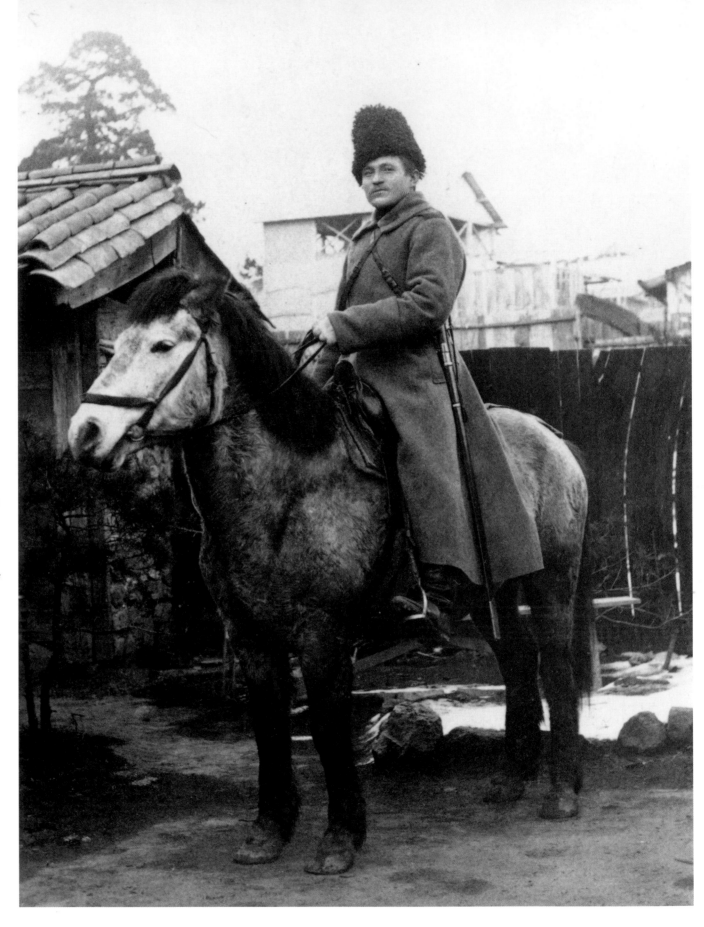

Cossack officer on horse, Seoul, Korea, 1904.

"I read your letters in the saddle as I rode along to-day, and it reminded me of a letter of mine you once read in the saddle. And the horse you were astride of was named Belle. The horse I was astride of to-day is named Belle. I named her. She is as sweet and gentle as yours, and she is the only sweet and gentle horse in Korea. She is an Australian barb, and have I told you she was the Russian minister's at Seoul? She is gigantic compared with all other horses in Korea—Chinese, Japanese, and Korean horses— and excites universal wonder and admiration." (Jack London to Charmian Kittredge, Poval Colli, Korea, March 8, 1904)

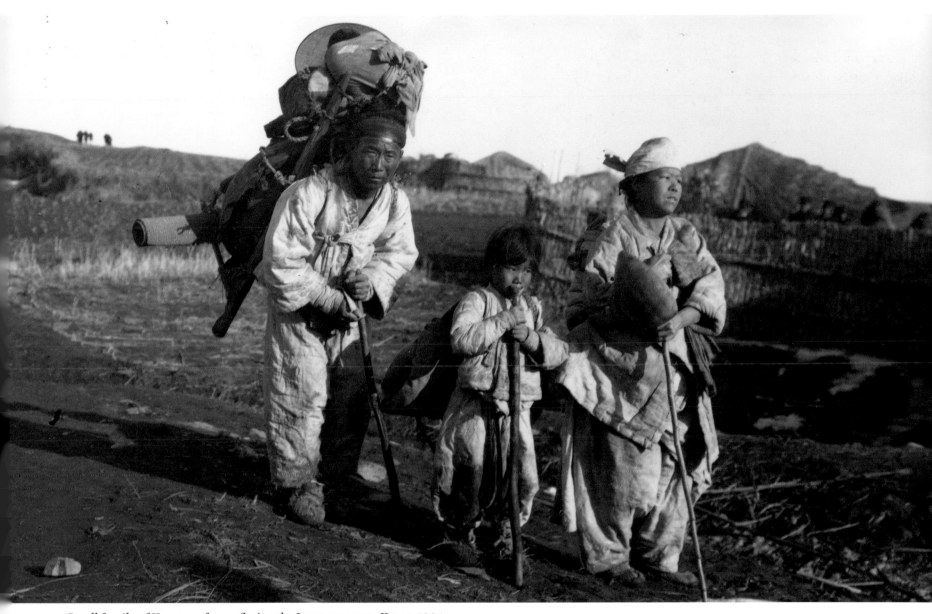

Small family of Korean refugees fleeing the Japanese army, Korea, 1904.

"And the troops stream by, the horses fight—mapus, cook, and interpreter are squabbling 4 feet away from me. And the frost is in the air. I must close my doors and light my candles. A Korean family of refugees—their household goods on their backs, just went by." (Jack London to Charmian Kittredge, Sunan, Korea, March 9, 1904)

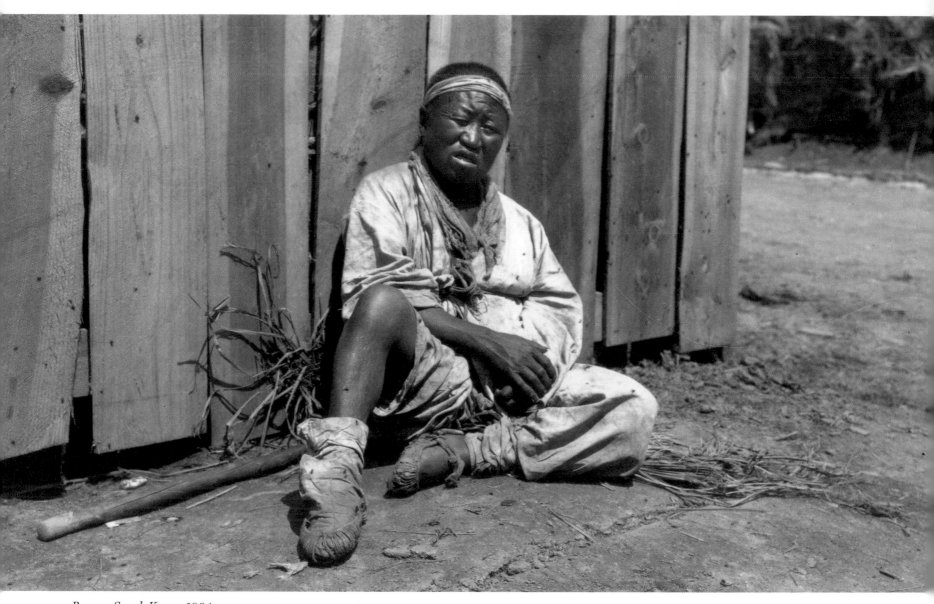

Beggar, Seoul, Korea, 1904.

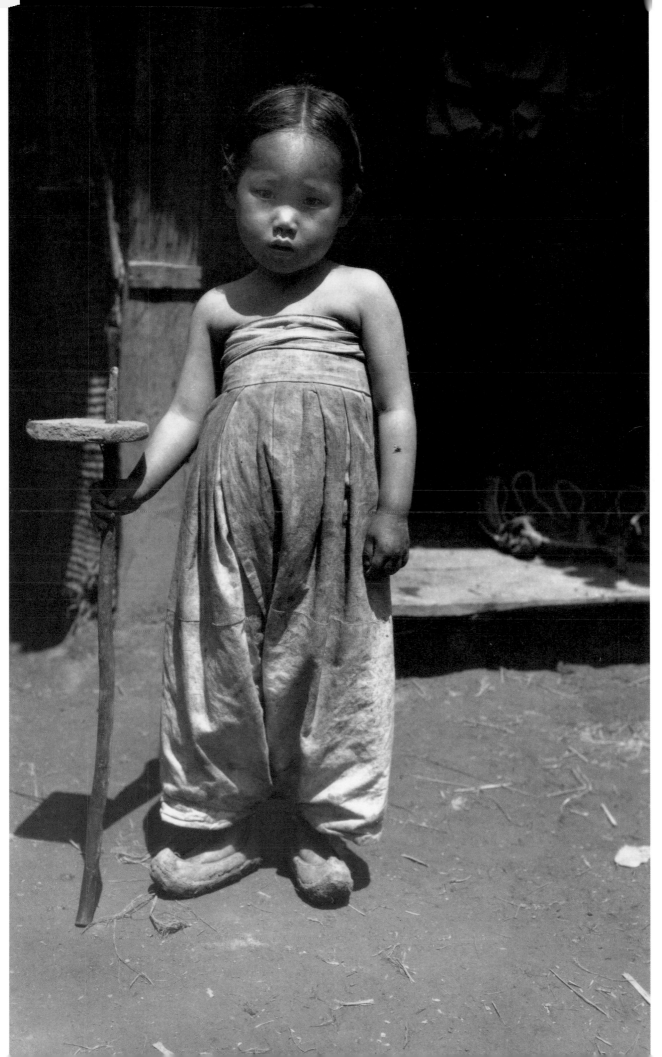

A Korean girl made homeless by war, Seoul, Korea, 1904.

"For days we had forced our horses along a road which swarmed with white-clad coolies. Their shoulders were stooped forward, their faces bent toward the ground, their backs burdened with rice and fish, soy and saki, and all the food supplies of an Oriental army. The villages were deserted. All doors and windows were missing and the houses appeared blank and sightless, mutely protesting against the general devastation. Here and there, along the road, old men and women and children sold food to the toiling coolies." ("Japanese Supplies Rushed to Front by Man and Beast,' Wiju [Korea], April 21 [1904]," *in* Jack London Reports, *93*)

Young girl with a baby,
Seoul, Korea, 1904.

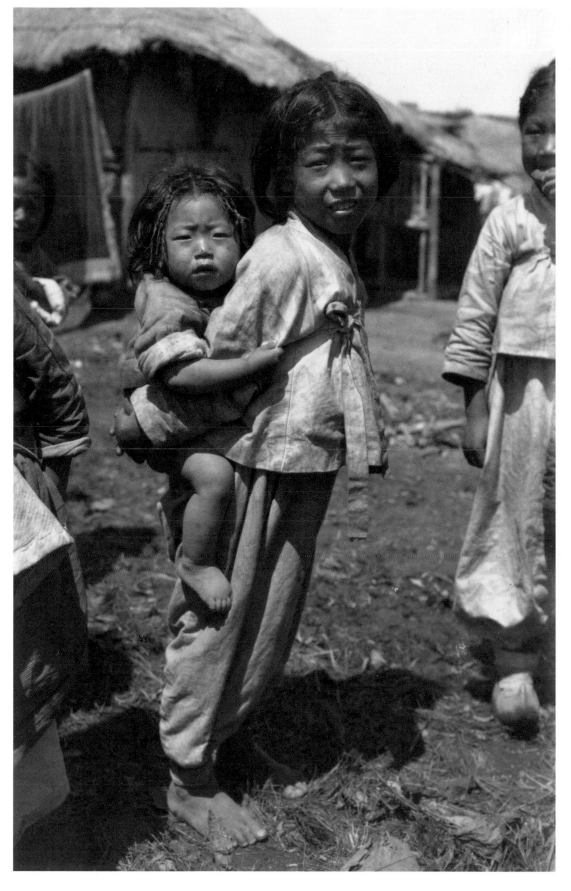

*Village girl with
a child on her back,
Seoul, Korea, 1904.*

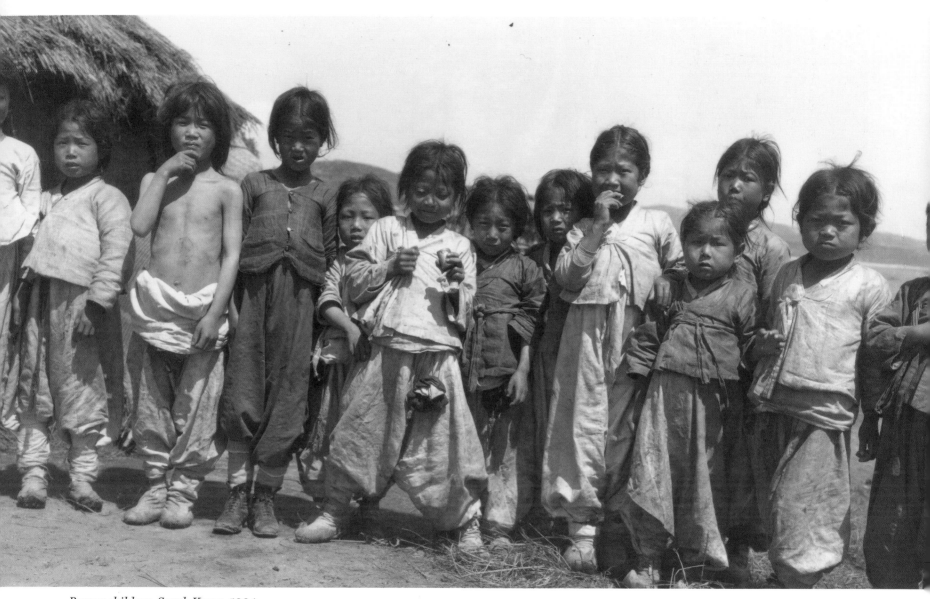

Beggar children, Seoul, Korea, 1904.

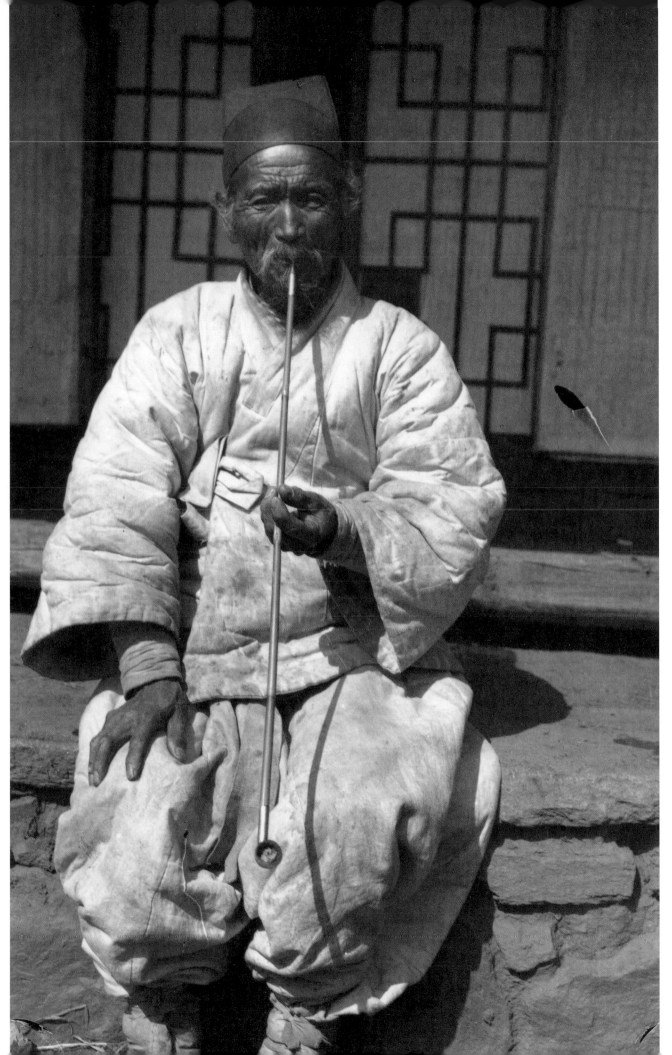

Portrait of a Korean man, Seoul, Korea, 1904.

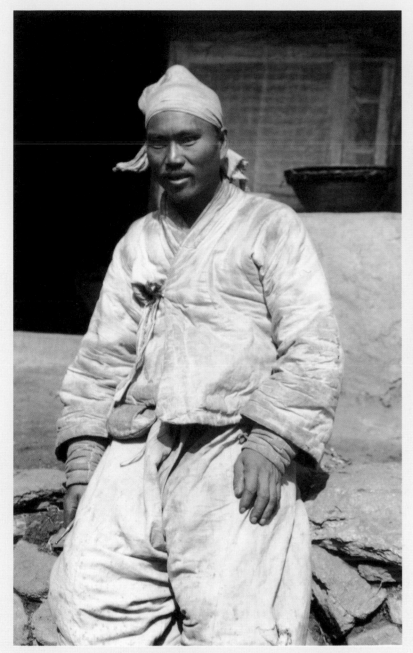

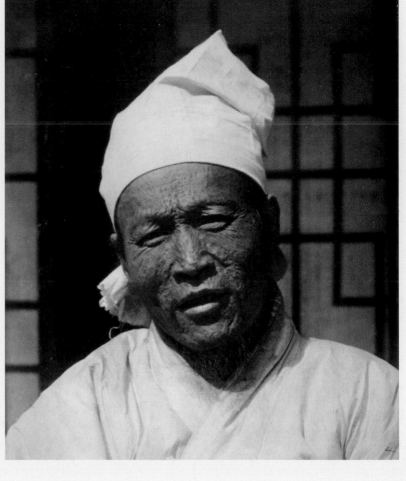

London made a series of portraits of mostly elderly men in Seoul and in the Korean villages visited by the Japanese army.

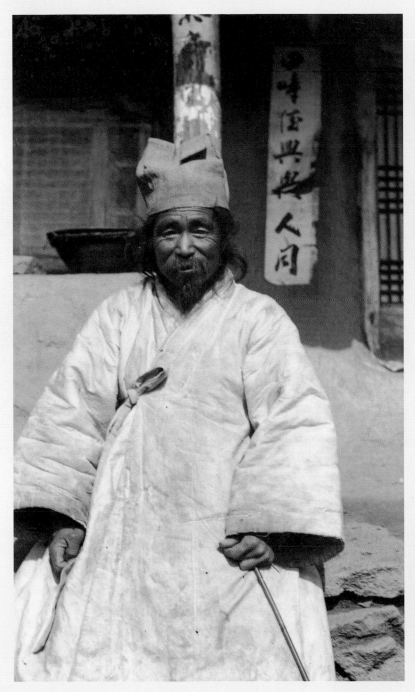

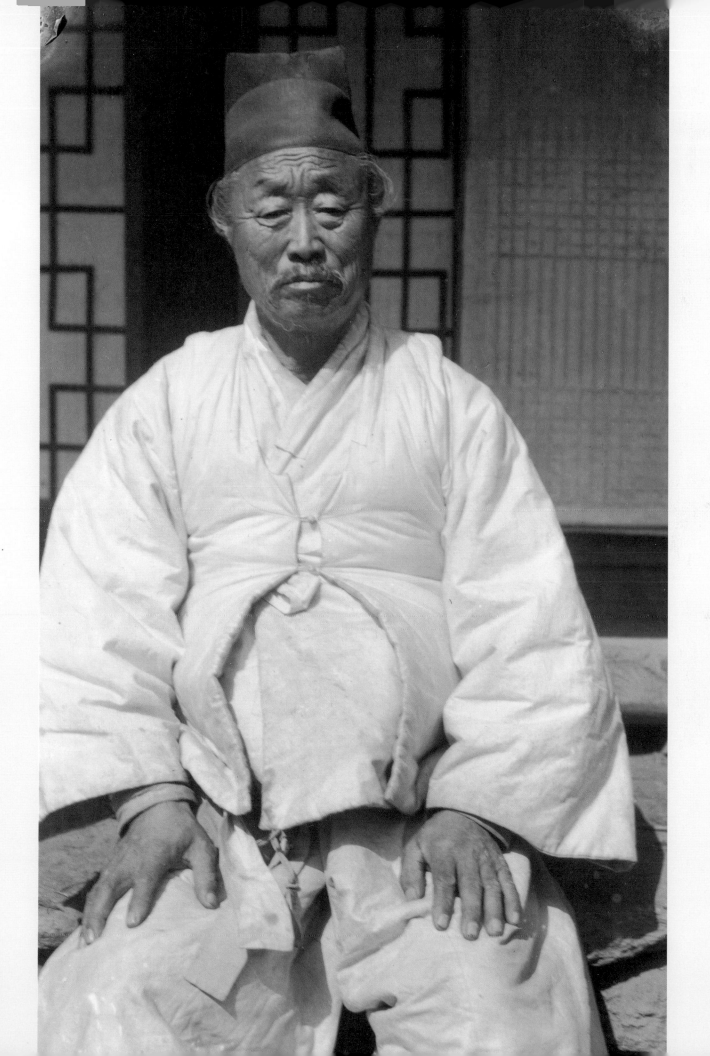

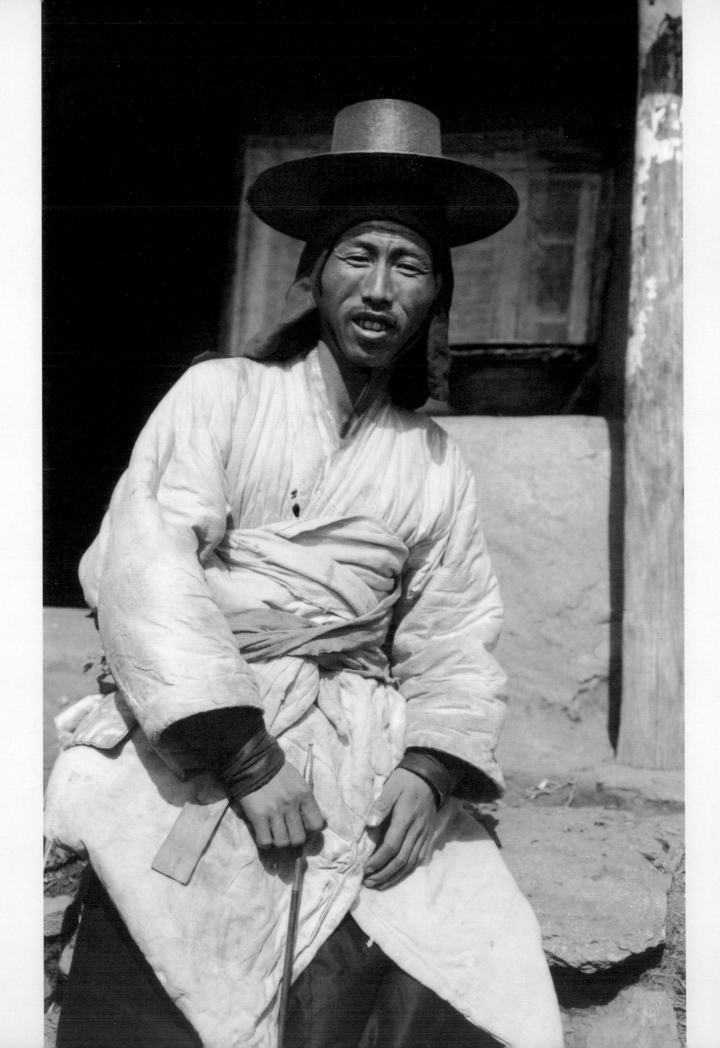

At 5:13 on the morning of April 18, 1906, San Francisco was wrecked by a great earthquake and then almost totally destroyed by raging fires that burned for four days. Hundreds, perhaps thousands, of people died when tenements south of Market collapsed as the ground liquefied beneath them. Damage at the time was estimated at five hundred million dollars. The earthquake awakened Jack and Charmian London at their Sonoma Valley ranch. They rode their horses to the top of Sonoma Mountain and were astonished to see a blistering red sky above San Francisco, burning fifty miles away; they also were shocked at the damage to the nearby county seat, Santa Rosa. In a letter dated May 1, 1906, London wrote to Merle Maddern (his first wife's niece) about the earthquake: "You bet I was in the thick of it. Routed out of bed at quarter past five, half an hour later Mrs. London and I were in the saddle. We rode miles over the surrounding country. An hour after the shock, from a high place in the mountains, we could see at the same time the smoke of burning San Francisco and of burning Santa Rosa. Caught a train to Santa Rosa—Santa Rosa got it worse than San Francisco. Then in the afternoon, Wednesday afternoon, we got into San Francisco [via ferry] and spent the whole night in the path of the flames. You bet, I saw it all! Am glad all of you escaped ok."[1] Despite the horror they witnessed in San Francisco, Jack photographed the terrible effects of the quake and returned later to document the city's slow recovery.

Charmian's diary entry for the day begins with the word "Earthquake" and continues: "Mate [Jack] and I spent night in burning streets," she wrote, "terrific experience. Napped on a doorstep til dawn."[2] She recorded their impressions of Broadway after they left the ferry and "all night roamed the city of hills, prey to feelings that cannot be described": "We must have tramped forty miles that night. Jack's feet blistered, my ankles were become almost useless."[3] She mourned, "Oh, the supreme ruth of desolation and pain, that night of fire and devastation." She recalls a young man with mortal injuries:

In my eyes there abides the face of a stricken man, perhaps a fireman, whom we saw carried into a lofty doorway in Union Square. His back had been broken, and as the stretcher bore him past, out of a handsome, ashen young face, the dreadful, darkening eyes looked right into mine. All the world was crashing around him, and he, a broken thing, with death awaiting him inside the granite portals, gazed upon the last woman of his race he was ever to see. Jack, with tender hand, drew me away.[4]

3 : THE SAN FRANCISCO EARTHQUAKE, 1906

Page from Charmian London's diary, April 18, 1906.

When Charmian asked her husband how he would write about the disaster, he denied that he would, emphasizing the ineffectiveness of language when confronted with such a cataclysm.

"I'll never write about this for anybody," he declared, as we looked our last upon one or another familiar haunt, soon to be obliterated by the ravaging flames that drove us ever westward to safer points, on and on, in our ears the muffled detonations of dynamite, as one proud commercial palace after another sank on its steel knees, in the desperate attempt of the city fathers to stay the wholesale conflagration. And no water.

"No," Jack reiterated, "I'll never write a word about it. What use trying? One could only string big words together, and rage at the futility of them."[5]

Collier's magazine, however, had other ideas, and begged for twenty-five hundred words from London; though still averse, the author was persuaded by his mounting ranch and *Snark*-building debts. His account, "The Story of an Eye-Witness," ran on May 5, 1906.

After their first visit, the couple left San Francisco for a ten-day journey on horseback through the surrounding rubble-strewn countryside. They visited Fort Bragg, which had been totally destroyed by the quake. A month after the disaster, they returned to San Francisco, visited Oakland and Berkeley, and toured the San Mateo County coast, where London photographed huge landslides near what is now Daly City and Pacifica. London's words and images focused attention on other outlying areas, including Marin, Sonoma, and Mendocino counties.

London's written and photographic accounts of the earthquake convey his ability to see what was in front of him with both a telling eye for details and a comprehensive vision of what had happened. One senses the immediacy of his encounter with the earthquake and his insights on what it meant for cities, progress, and humankind. The photographs he made in San Francisco are among his best. The scale of urban disaster they captured makes them much more dramatic than any of those he made elsewhere in the weeks following the quake.

Until the California Historical Society's exhibit "Jack London and the Great Earthquake and Firestorms of 1906," which was held as part of the citywide earthquake centennial in 2006, very few people alive today had seen London's photographs of the devastation. Reviewing the exhibit, which was curated by Philip Fradkin and featured fine prints by Philip Adam, Carl Nolte wrote in the *San Francisco Chronicle*:

It is still magic after all these years: Slowly the black and white image comes to life in the darkroom tray at the headquarters of the California Historical Society in San Francisco. The picture is from another time, but it is sharp and

Manuscript page of "The Story of an Eye-Witness," which was published in Collier's *on May 5, 1906.*

London's circle frequented the famous Coppa Restaurant at the intersection of Montgomery and Merchant streets, which survived the earthquake and fire. Today this is the site of the Transamerica Pyramid. Jack London is at the wheel, sitting with an unidentified man; in the back seat are his friend Xavier Martinez (an artist) and Charmian London, ca. 1905.

clear—it is of a huge domed building, all in ruins, as if it had been bombed. It is the wreckage of San Francisco's City Hall, destroyed in an earthquake a century ago this spring. It is a remarkable picture, but the photographer was even more remarkable. He was Jack London.[6]

London's eyewitness account of the disaster is now "a classic of magazine reporting," Nolte observes. The earthquake photographs reproduced for this book are the first fine prints of London's photographs to be published. The quotations accompanying many of the photographs are from London's "The Story of an Eye-Witness."

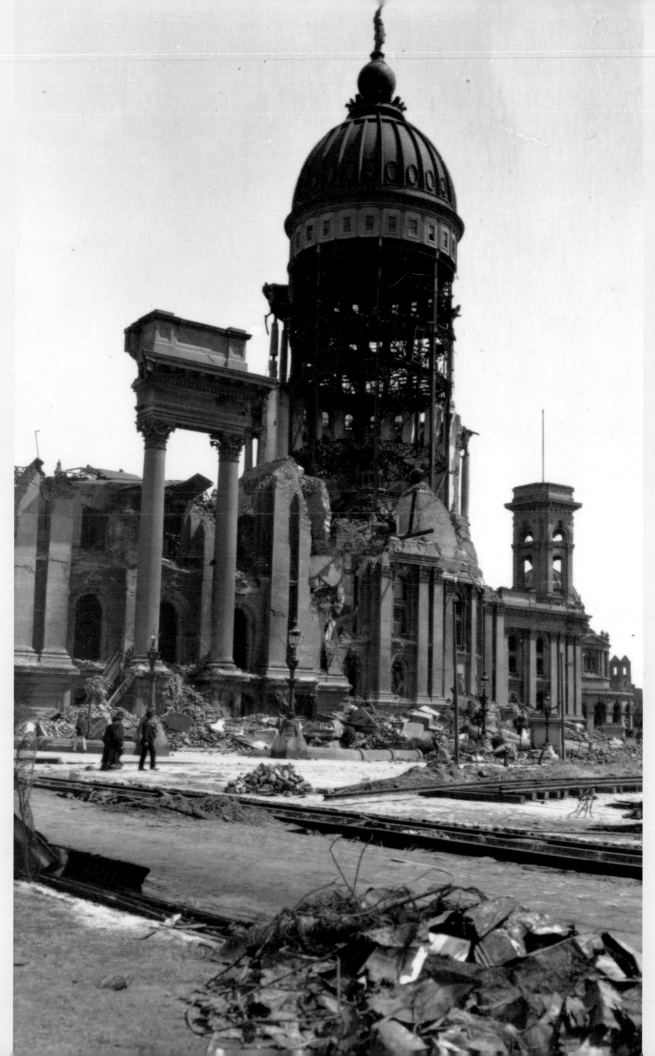

*Ruins of city hall,
looking east down
City Hall Avenue
from Larkin Street,
San Francisco, 1906.*

View of city hall from the southeast at Stevenson Street, west of Seventh Street, San Francisco, 1906. London captured a unique viewpoint, looking over the site of burnt structures across to the north side of Market Street with the vertical ruins of city hall rising above the devastation in the foreground.

"Not in history has a modern imperial city been so completely destroyed. San Francisco is gone. Nothing remains of it but memories and a fringe of dwelling-houses on its outskirts. Its industrial section is wiped out. Its business section is wiped out. Its social and residential section is wiped out. The factories and warehouses, the great stores and newspaper buildings, the hotels and the palaces of the nabobs, are all gone. Remains only the fringe of dwelling houses on the outskirts of what was once San Francisco." ("The Story of an Eye-Witness," 486)

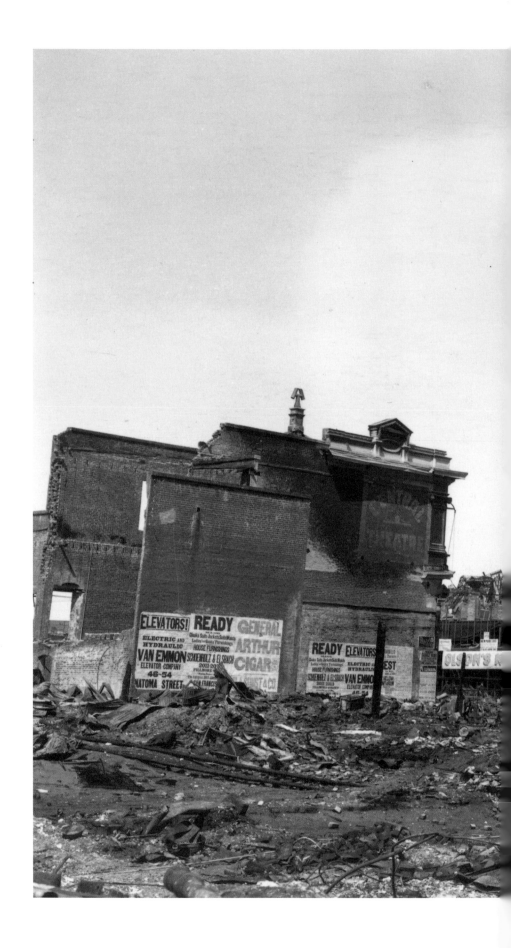

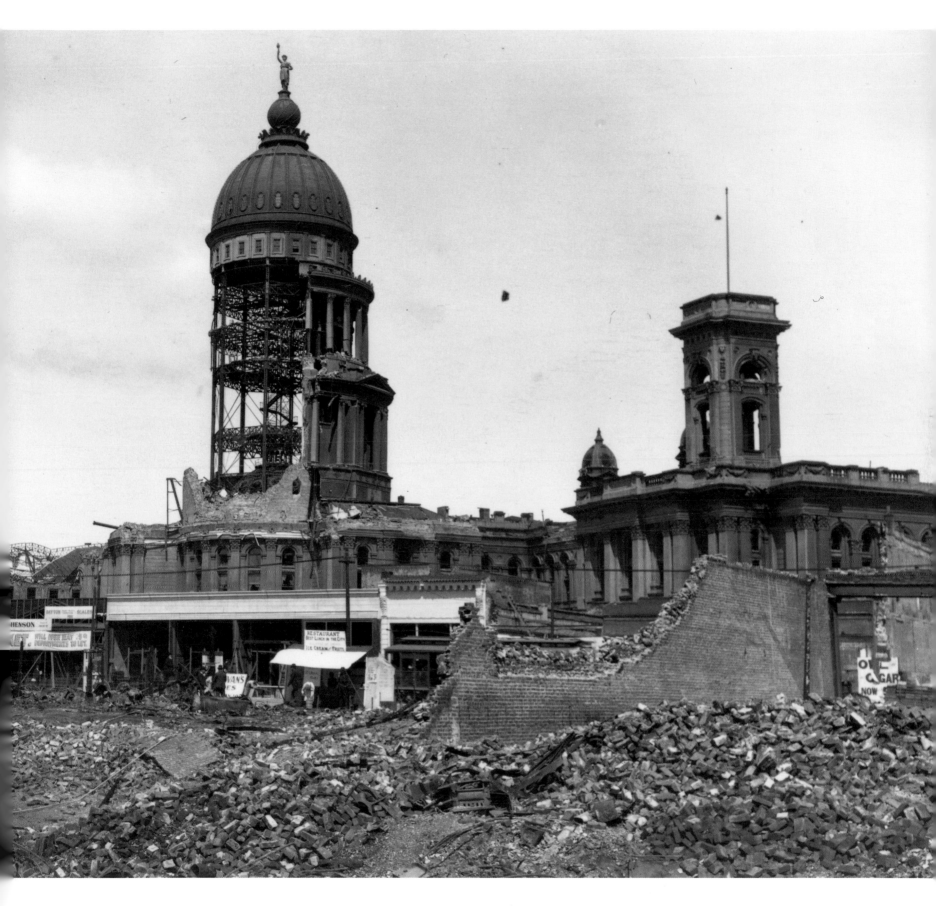

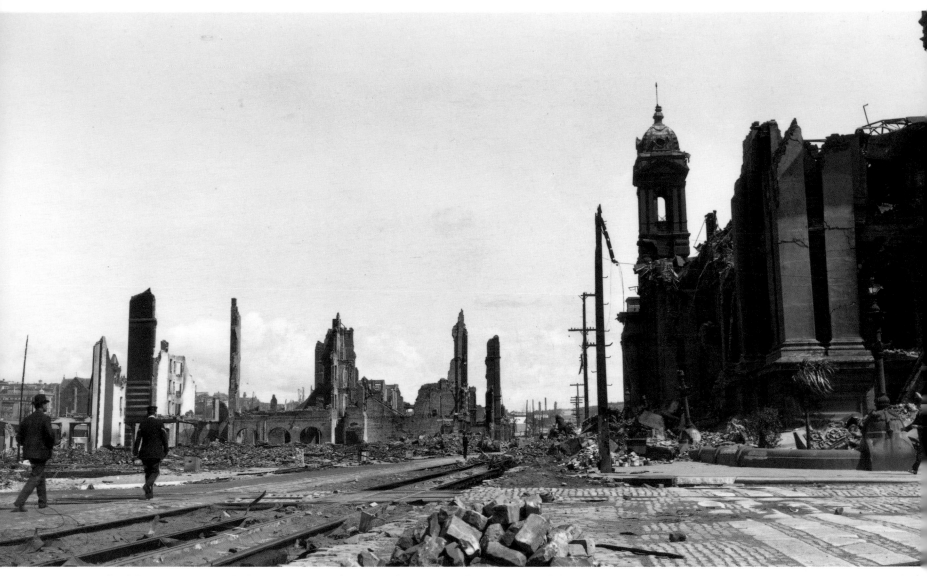

West side of the city hall ruins, looking north on Larkin Street from City Hall Avenue toward the ruins of the California State Supreme Court Building in the center, San Francisco, 1906.

"An hour later I was creeping past the shattered dome of the City Hall. Than it there was no better exhibit of the destructive force of the earthquake. Most of the stone had been shaken from the great dome, leaving standing the naked framework of steel. Market Street was piled high with the wreckage, and across the wreckage lay the overthrown pillars of the City Hall shattered into short crosswise sections." ("The Story of an Eye-Witness," 489)

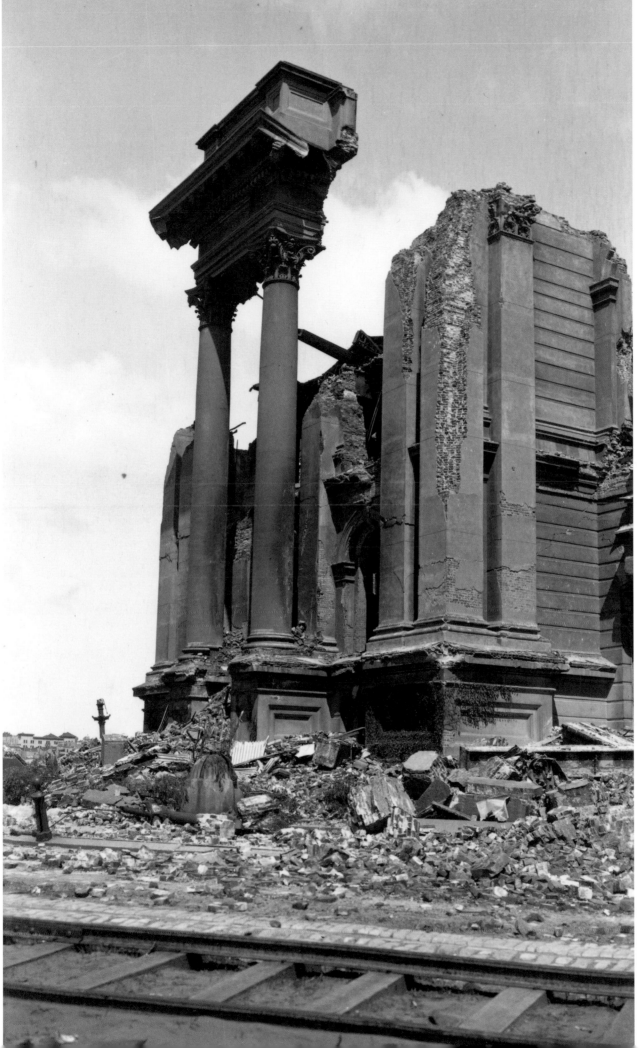

City hall ruins from City Hall Avenue near Larkin Street, San Francisco, 1906. The rails and ties in the foreground were placed on top of the pavement for debris removal.

123

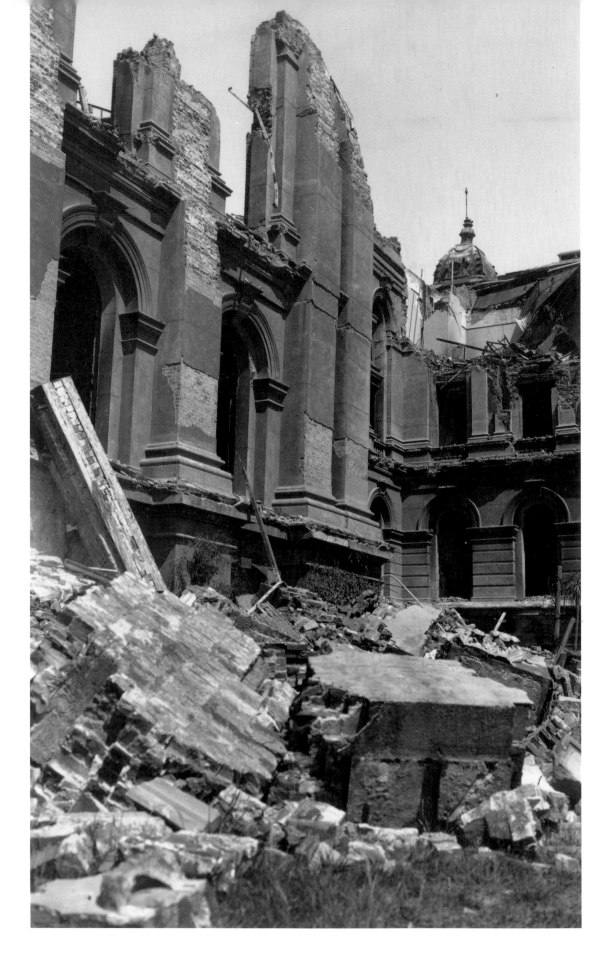

City hall ruins from City Hall Avenue, looking toward the southwest wing and capturing a view of the top of the one surviving tower, San Francisco, 1906.

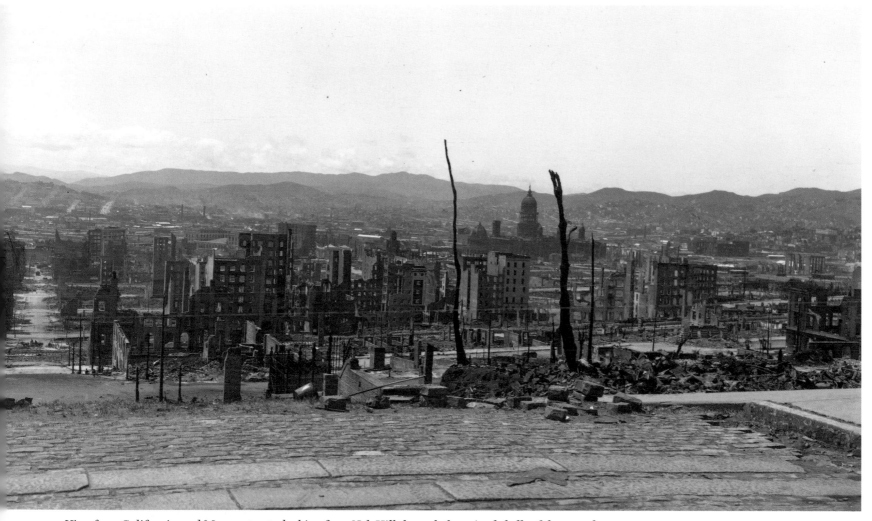

View from California and Mason streets, looking from Nob Hill through the ruined shells of the upscale residence-hotel district toward the ruins of city hall and beyond to the destruction in the Mission District, San Francisco, 1906.

"The following will illustrate the sweep of the flames and the inability of men to calculate their spread. At eight o'clock Wednesday evening I passed through Union Square. It was packed with refugees. Thousands of them had gone to bed on the grass. Government tents had been set up, supper was being cooked, and the refugees were lining up for free meals. At half past one in the morning three sides of Union Square were in flames. The fourth side, where stood the great St. Francis Hotel was still holding out. An hour later, ignited from top and sides the St. Francis was flaming heavenward. Union Square, heaped high with mountains of trunks, was deserted. Troops, refugees, and all had retreated." ("The Story of an Eye-Witness," 491)

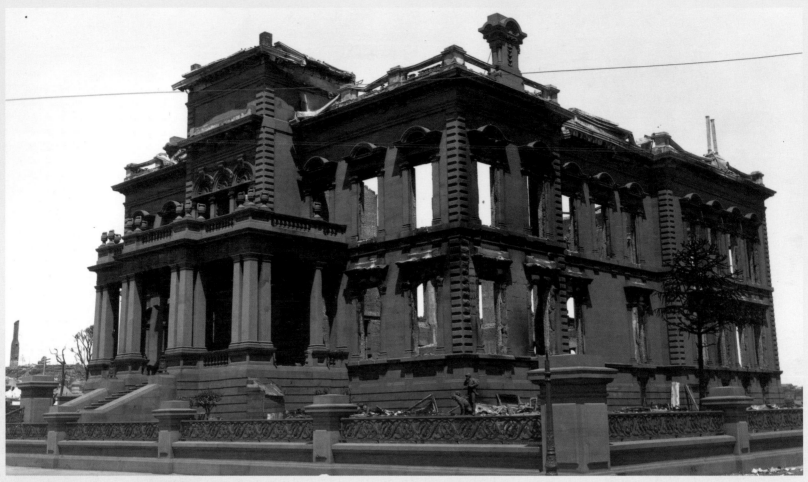

1010 California Street at Mason Street, built by James C. Flood, was occupied by his daughter
Cora Jane Flood in April 1906. The most valued art treasures from the Mark Hopkins
Institute of Art, which was across the intersection, had been hurriedly moved into the Flood
residence, whose stone walls, it was hoped, would protect them from the advancing fire. The
Pacific Union Club restored the structure and remains its occupant today.

"Outside the old Mark Hopkins residence a palace was just catching fire. The troops were
falling back and driving the refugees before them. From every side came the roaring of flames,
the crashing of walls, and the detonations of dynamite." ("The Story of an Eye-Witness," 356)

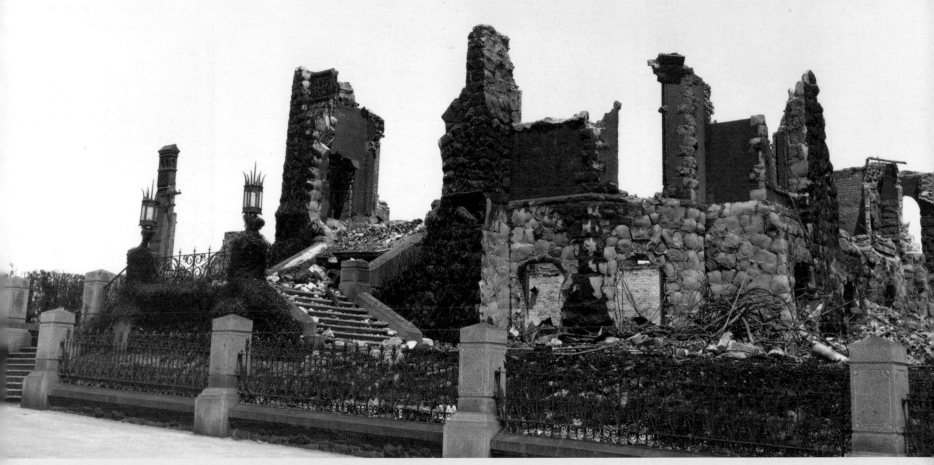

The William H. Crocker Mansion on Nob Hill at the corner of California and Jones,
San Francisco, 1906. Today, portions of the fence encircle Grace Cathedral.

"[On] Nob Hill. . . . I went inside with the owner of the house on the steps of which I sat. He
was cool and cheerful and hospitable. 'Yesterday morning,' he said, 'I was worth six hundred
thousand dollars. This morning this house is all I have left. It will go in fifteen minutes.' He
pointed to a large cabinet. 'That is my wife's collection of china. This rug upon which we
stand is a present. It cost fifteen hundred dollars. Try that piano. Listen to its tone. There
are few like it. There are no horses. The flames will be here in fifteen minutes.'" ("The Story
of an Eye-Witness," 493)

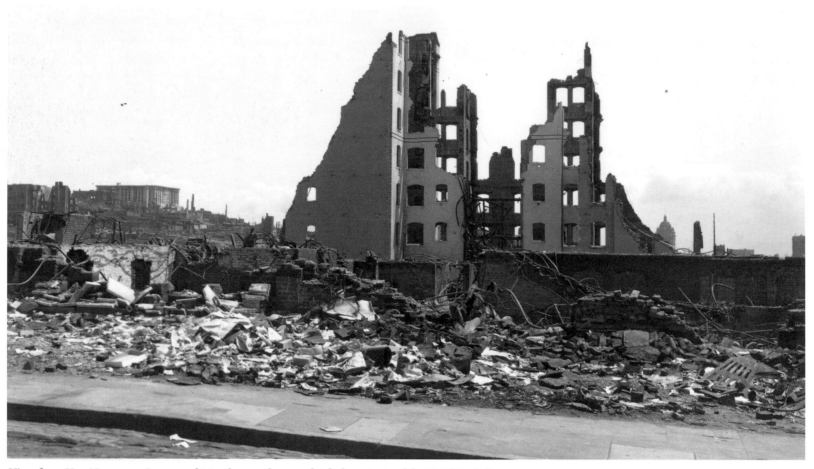

*View from Van Ness near Geary and Myrtle over the completely burnt site of the Hotel Richelieu to
the ruins of the Hotel Charlemagne, which had been open for only one year, San Francisco, 1906. The
Fairmont Hotel on Nob Hill is visible to the left, and the San Francisco Call Building is just to the right
of the ruins.*

*"Surrender was complete. There was no water. The sewers had long since been pumped dry. There was
no dynamite. Another fire had broken out further uptown, and now from three sides conflagrations were
sweeping down. The fourth side had been burned earlier in the day. In that direction stood the tottering
walls of the Examiner building, the burned-out Call building, the smoldering ruins of the Grand Hotel,
and the gutted, devastated, dynamited Palace Hotel." ("The Story of an Eye-Witness," 494)*

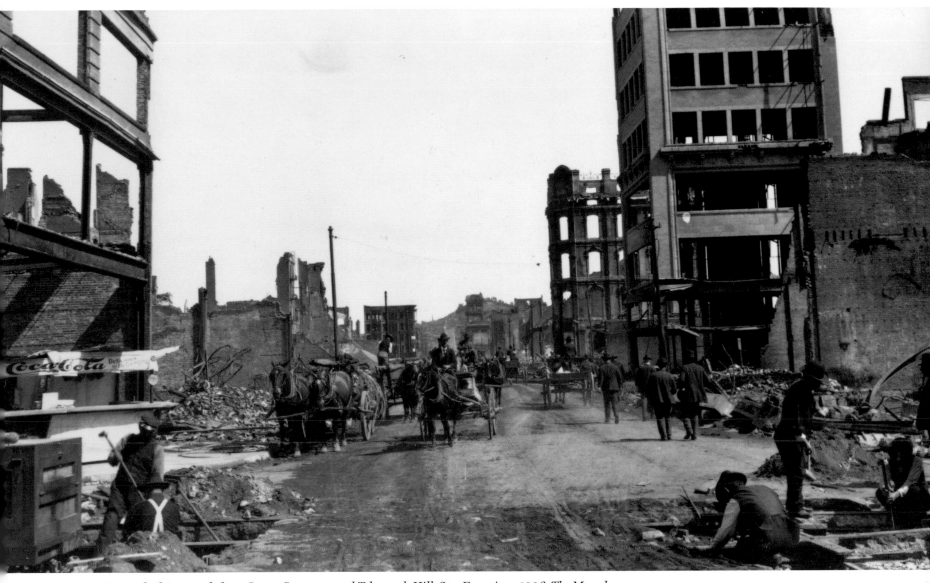

Kearny Street, looking north from Sutter Street, toward Telegraph Hill, San Francisco, 1906. The Marsden building at Hardie Place rises out of the photograph's frame, and behind it toward the center is the shell of the San Francisco Evening Post Building, which had been originally built as the San Francisco Chronicle Building.

"An enumeration of the buildings destroyed would be a directory of San Francisco. An enumeration of the buildings undestroyed would be a line and several addresses. An enumeration of the deeds of heroism would stock a library and bankrupt the Carnegie medal fund. An enumeration of the dead will never be made. All vestiges of them were destroyed by the flames. The number of the victims of the earthquake will never be known. South of Market Street, where the loss of life was particularly heavy, was the first to catch fire." ("The Story of an Eye-Witness," 487)

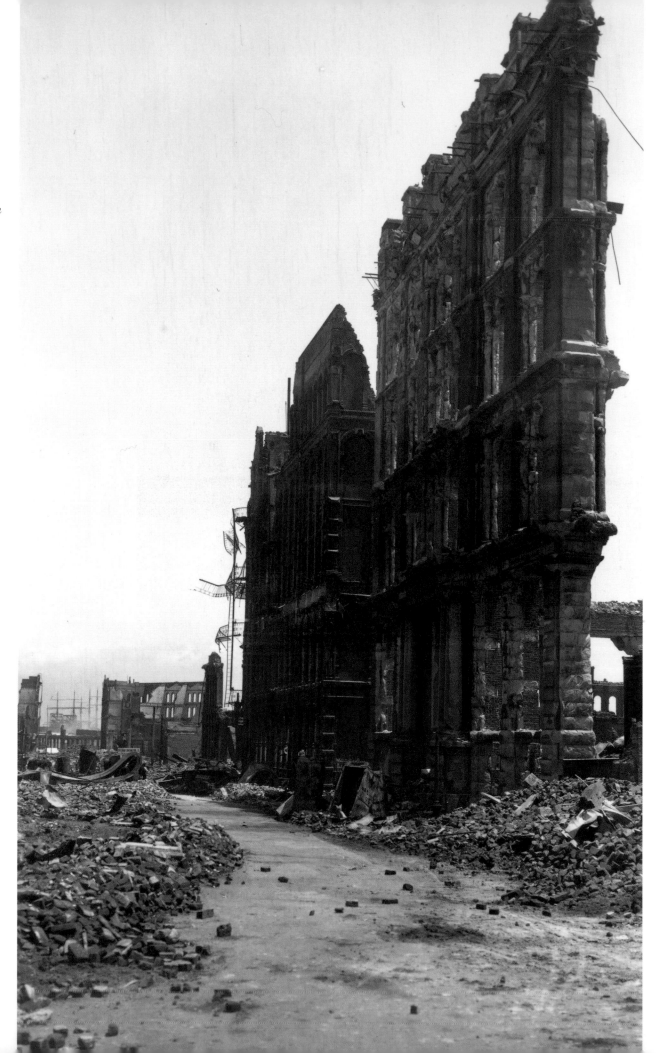

Ruins of the San Francisco Stock Exchange at 331 Pine Street, between Sansome and Montgomery, looking east down Pine Street toward the bay, San Francisco, 1906. Immediately to the left is 315–325 Pine, which had been home to financial, stock, and insurance companies.

130

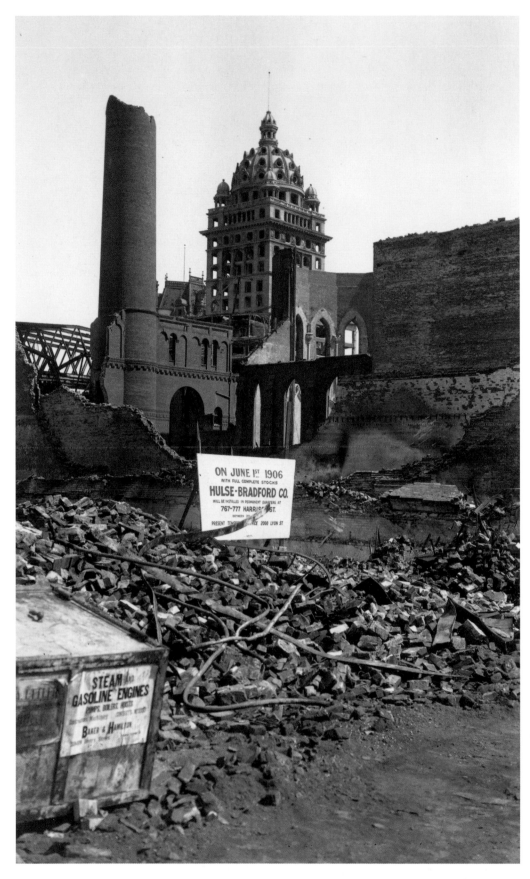

View from Mission Street to the ruin of the smokestack of the San Francisco Gas and Electric Company Station A on Jessie Street, San Francisco, 1906. The utility had just become a part of Pacific Gas and Electric; today the site is home to the Jewish Museum. In the middle of the background, the San Francisco Call Building rises above the substation. In front of both is the altar end of St. Patrick's Church. The Hulse-Bradford Company, which was located on the site in the foreground, sold carpets and upholstery; it eventually relocated to Mission Street, two blocks west.

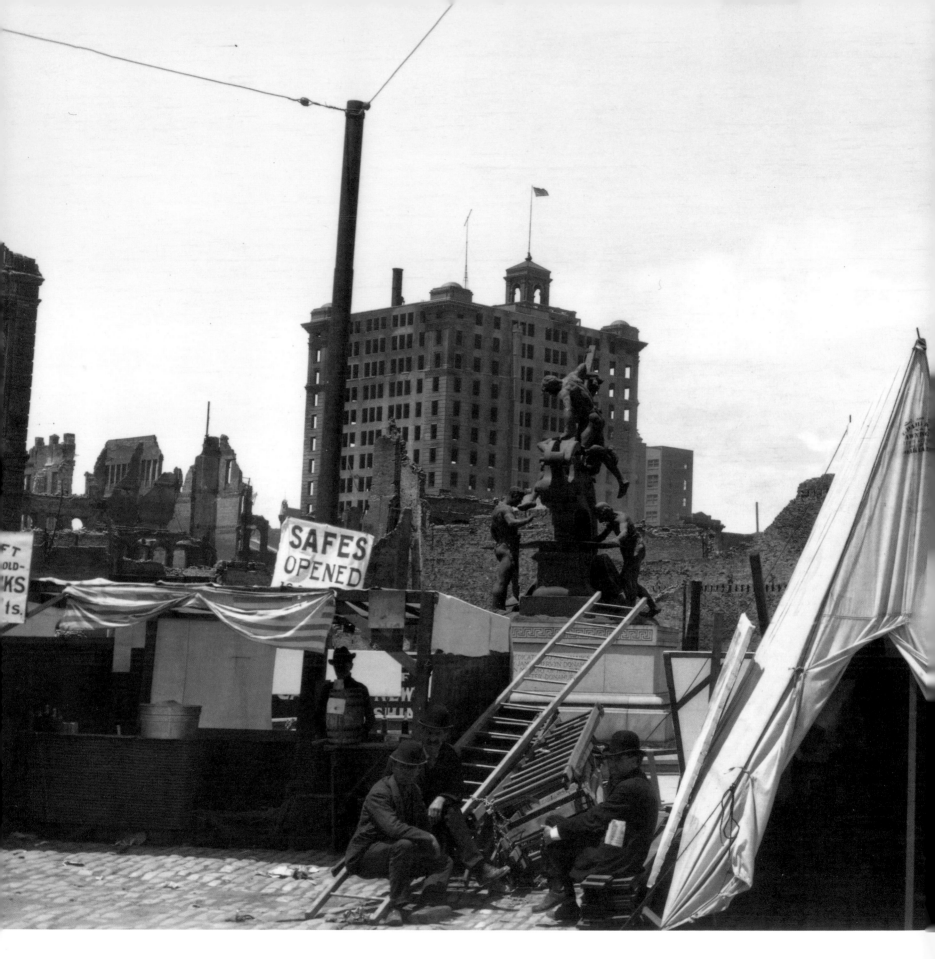

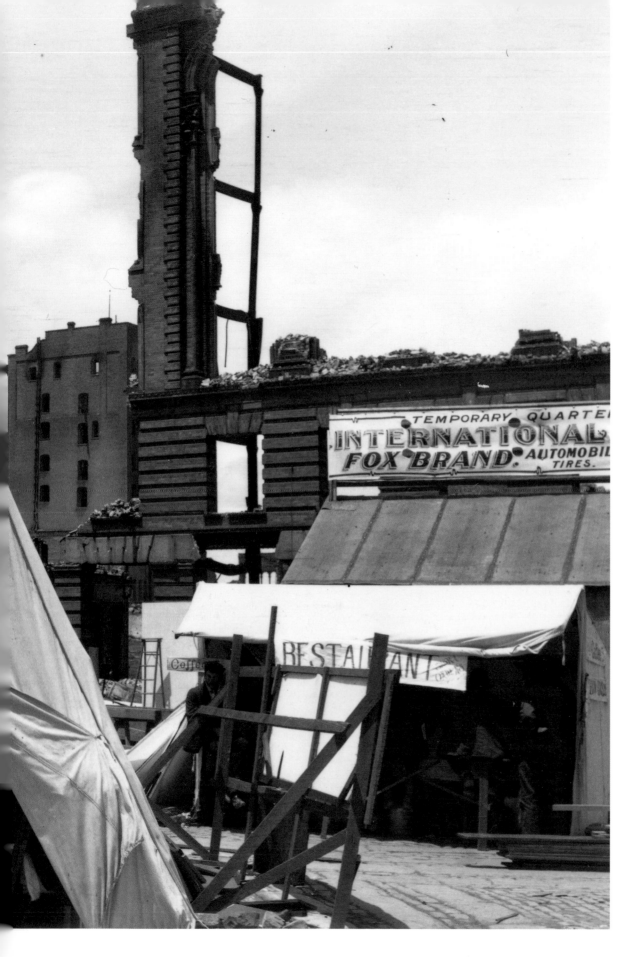

Market Street between Battery and Front, looking north, San Francisco, 1906. The Donahue Mechanics Monument is silhouetted by the burnt-out mass of the Merchants Exchange Building on California Street. To the right, the sign for the International Automobile and Vehicle Tire Company marks its temporary relocation from Front and Pine. Its more substantial shack contrasts with the flimsier tents and shacks of neighboring restaurants and commercial establishments.

"Wednesday night saw the destruction of the very heart of the city. Dynamite was lavishly used, and many of San Francisco's proudest structures were crumbled by man himself into ruins, but there was no withstanding the onrush of the flames. Time and again successful stands were made by the fire-fighters, and every time the flames flanked around on either side or came up from the rear, and turned to defeat the hard-won victory." ("The Story of an Eye-Witness," 487)

The northwest corner of Second and Mission, San Francisco, 1906. The scaffolding was for the repair of the Atlas Building, an office tower that was restored early. Corey and Phillips was in the liquor business, but also sold meals during the extremity after the quake.

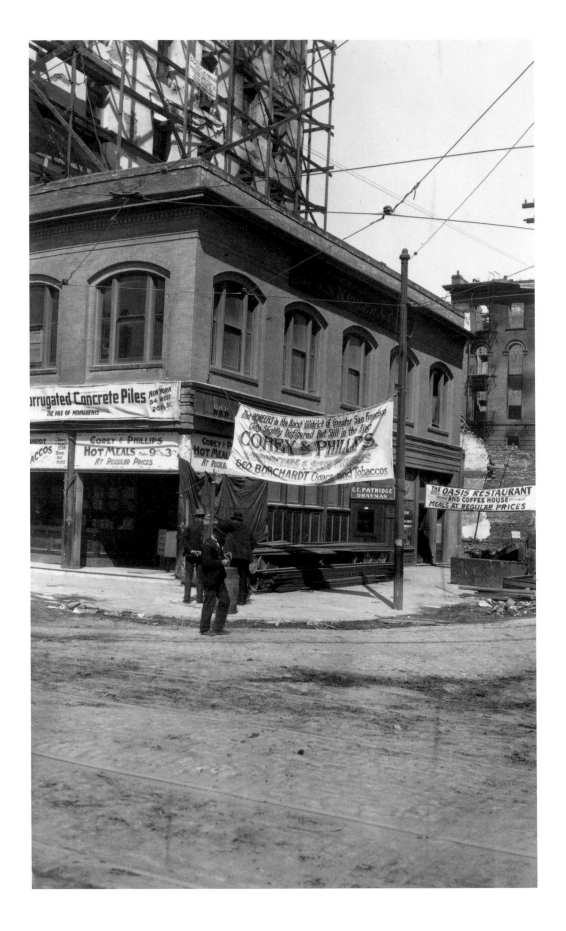

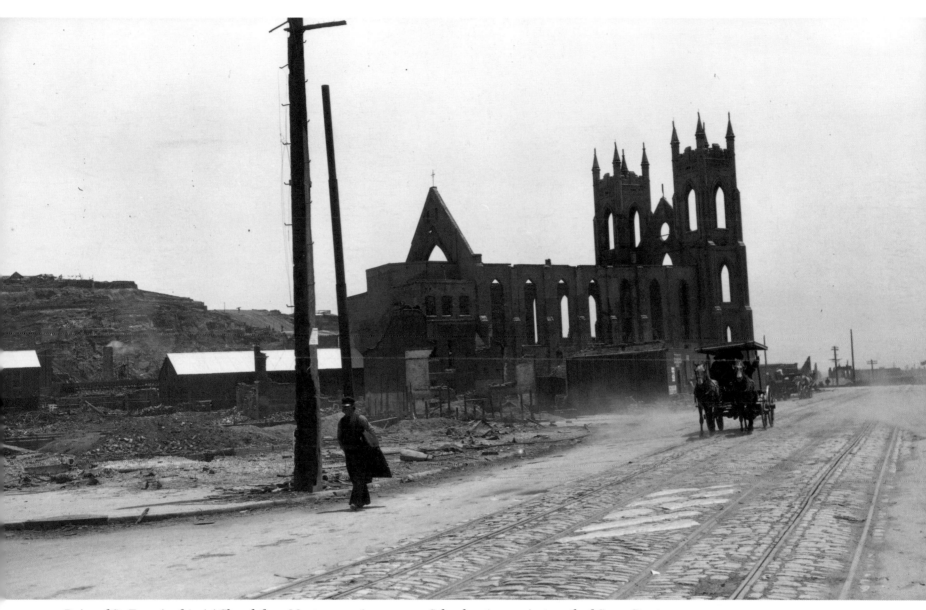

Ruins of St. Francis of Assisi Church from Montgomery Avenue, now Columbus Avenue, just north of Green Street,
San Francisco, 1906. Telegraph Hill is to the left with a group of surviving houses at the crest. At the far right rises
Columbus Tower, which was under construction in 1906. Today the Columbus Tower is the headquarters of Francis
Ford Coppola, and this area is the heart of North Beach.

(overleaf)
Ruins of the Barbary Coast, looking toward Pacific Avenue from near Grant, Broadway, and Columbus, San Francisco,
1906. The scaffolded San Francisco Ferry Building tower is at the center. To the right is the Columbus Tower, the
Flatiron structure with the outline of the dome.

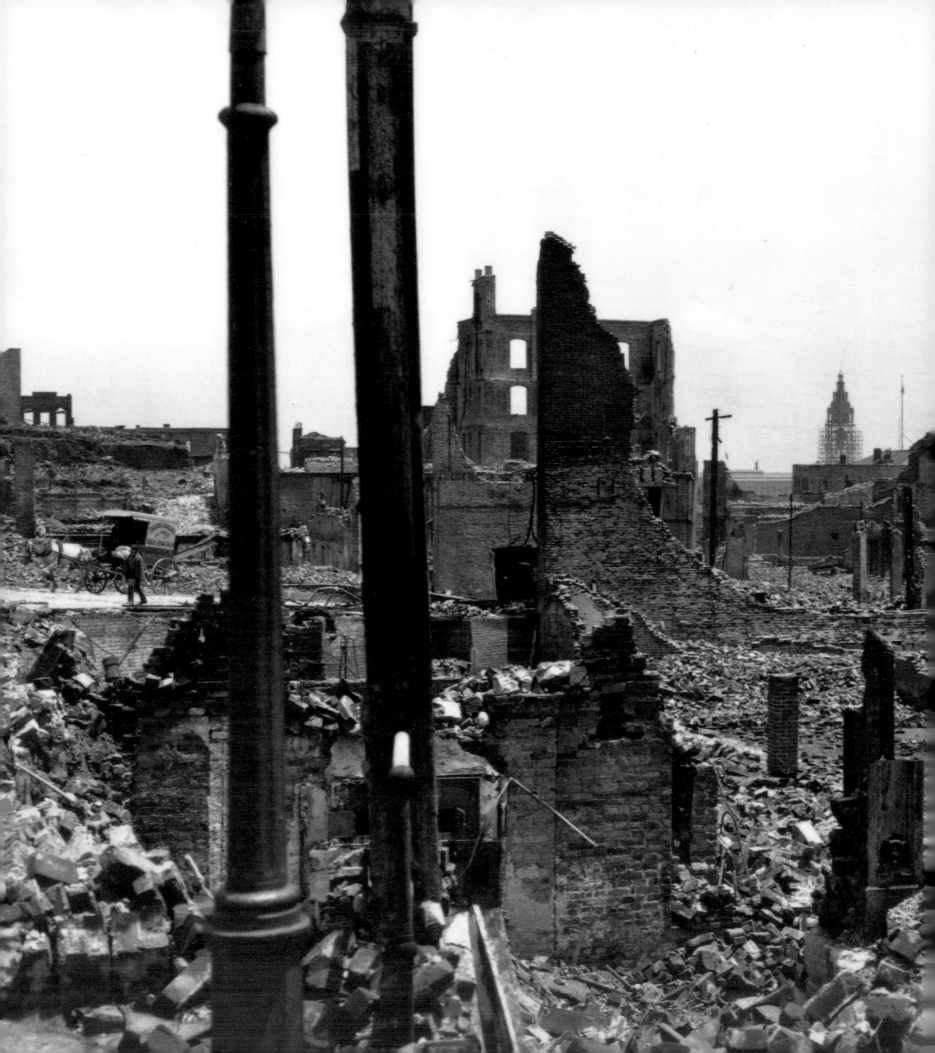

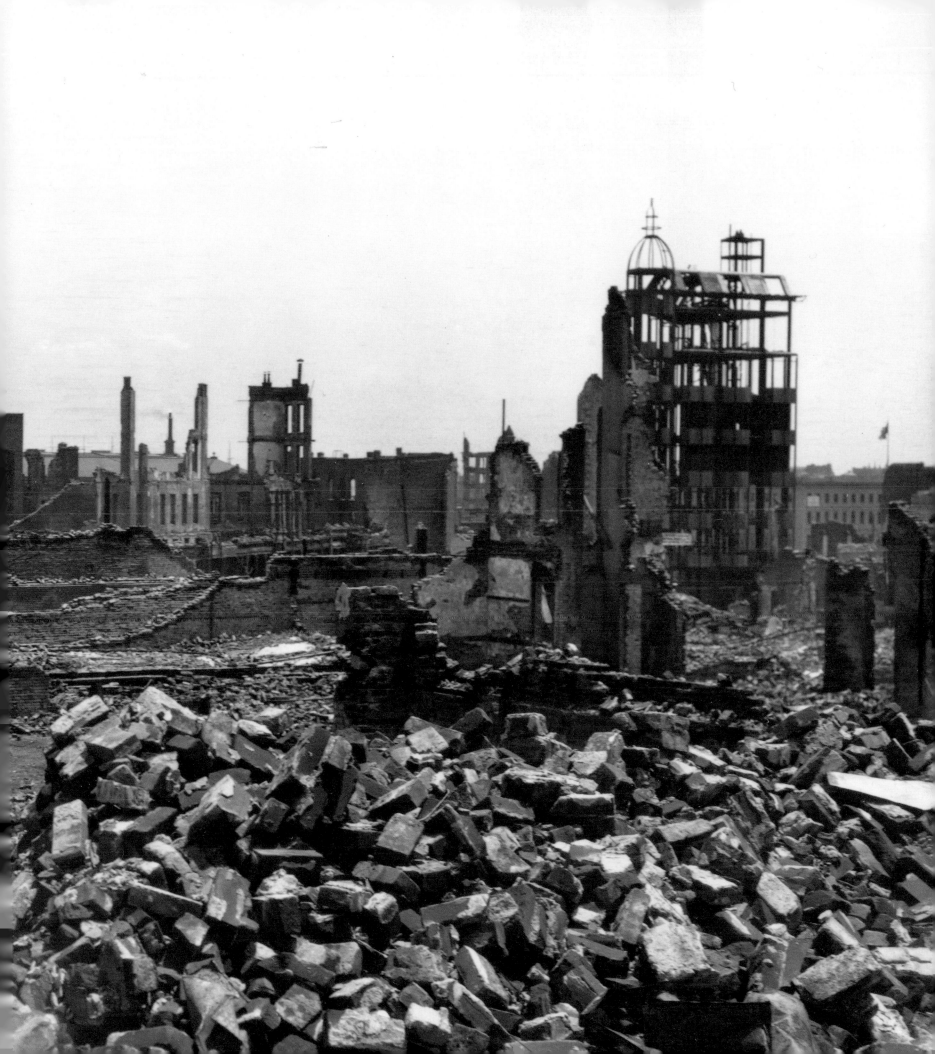

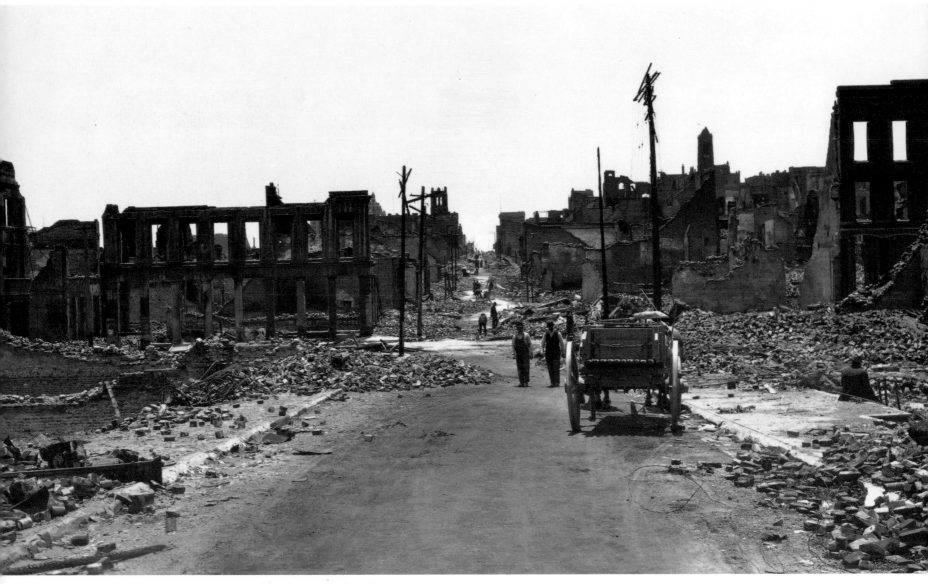

Dupont Street, now Grant Avenue, from the north of Pacific Avenue, San Francisco, 1906. The square tower of St. Mary's Church is at the center on the left side of the avenue. The pointed tower of Grace Episcopal Church is to the right. Chinatown now extends to these blocks.

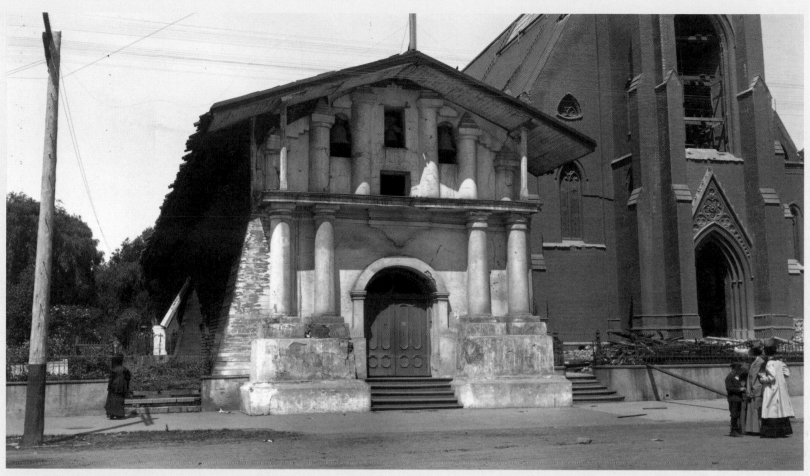

Mission Dolores, showing the grave monument of Luis Arguello, the first Mexican-era governor of California, leaning against the mission wall, San Francisco, 1906. The 1876 parish church to the right was so damaged that it had to be demolished and replaced. Parts of the church tower fell through the roof and in front and to the right of the entrance.

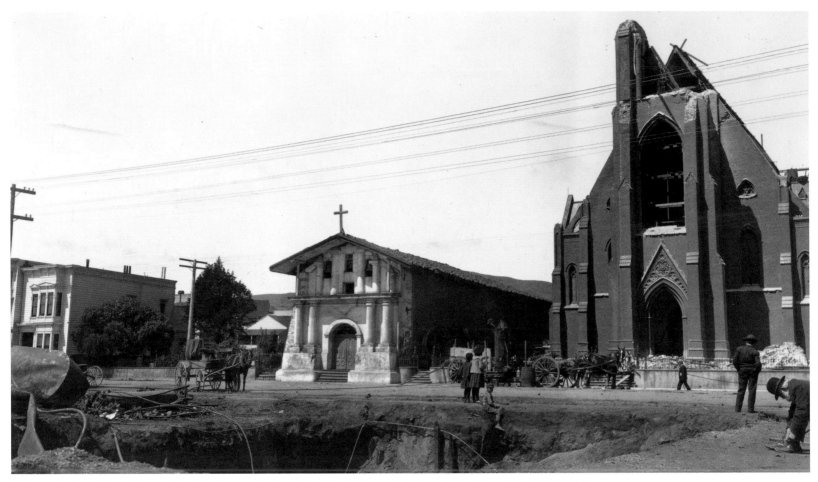

Mission Dolores from Sixteenth and Dolores, showing the ruins of the parish church, San Francisco, 1906. Dolores Street had been recently regraded, necessitating the addition of steps to the front of the old mission building.

"On Mission Street lay a dozen steers, in a neat row stretching across the street just as they had been struck down by the flying ruins of the earthquake. The fire had passed through afterward and roasted them. The human dead had been carried away before the fire came. At another place on Mission Street I saw a milk wagon. A steel telegraph pole had smashed down sheer through the driver's seat and crushed the front wheels. The milk cans lay scattered around." ("The Story of an Eye-Witness," 357)

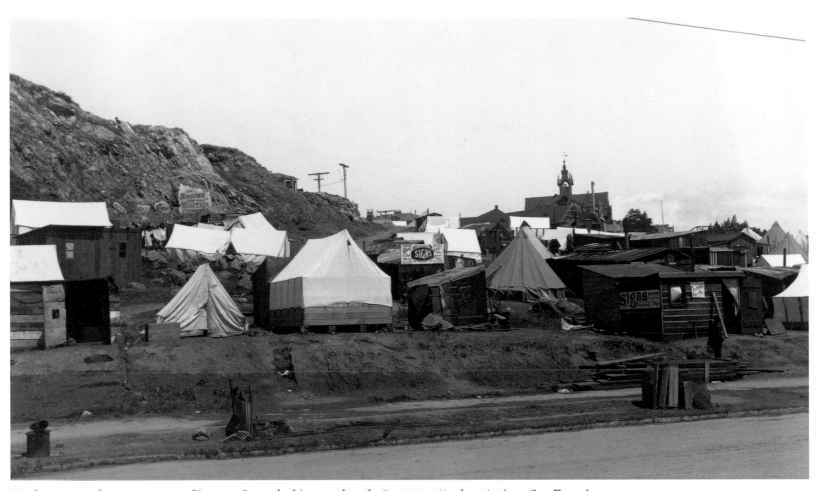

Market Street refugee camp west of Laguna Street, looking north to the Protestant Orphan Asylum, San Francisco, 1906. Until recently, this was the site of a University of California Extension Campus; previously, it had been the campus of San Francisco State College.

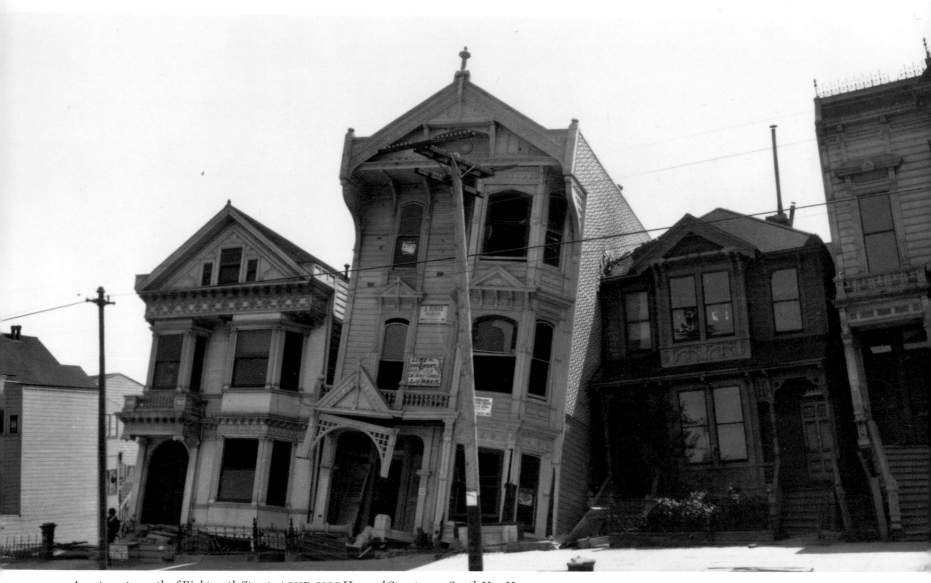

Apartments north of Eighteenth Street at 2117–2125 Howard Street, now South Van Ness Avenue, showing subsidence, San Francisco, 1906. The gap to the left marks where a residence collapsed. Across Howard Street from these ruins spread more than a score of burnt blocks in the Mission District.

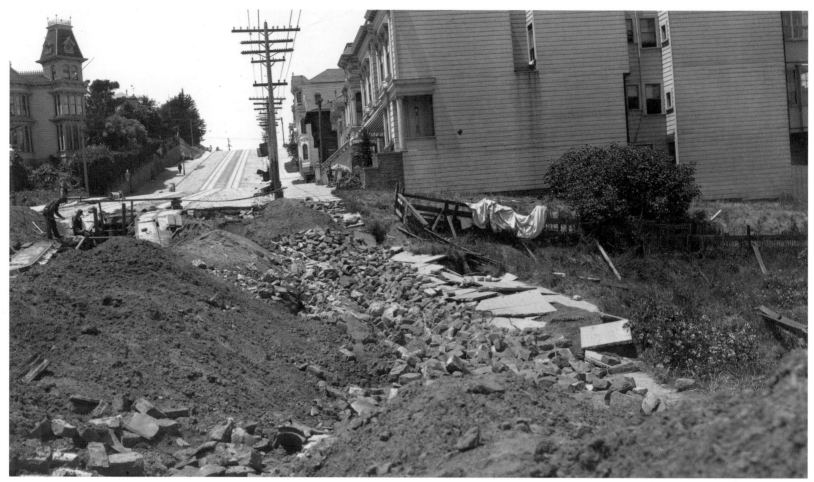

Cowhollow, Union Street, in the middle of the block between Steiner and Pierce, looking west, San Francisco, 1906. London recorded the extreme surface dislocation evident from the temblor, noting that tracks had been twisted and portions of the street undermined. The apartments to the right, 2376–2378 and 2382–2386 Union Street, remain today.

"All the cunning adjustments of a twentieth century city had been smashed by the earthquake. The streets were humped into ridges and depressions, and piled with the debris of fallen walls. The steel rails were twisted into perpendicular and horizontal angles. The telephone and telegraph systems were disrupted. And the great water-mains had burst. All the shrewd contrivances and safeguards of man had been thrown out of gear by thirty seconds' twitching of the earth-crust." ("The Story of an Eye-Witness," 352)

(overleaf)
Mountains of debris covering entire blocks in the wake of early cleanup efforts, San Francisco, 1906.

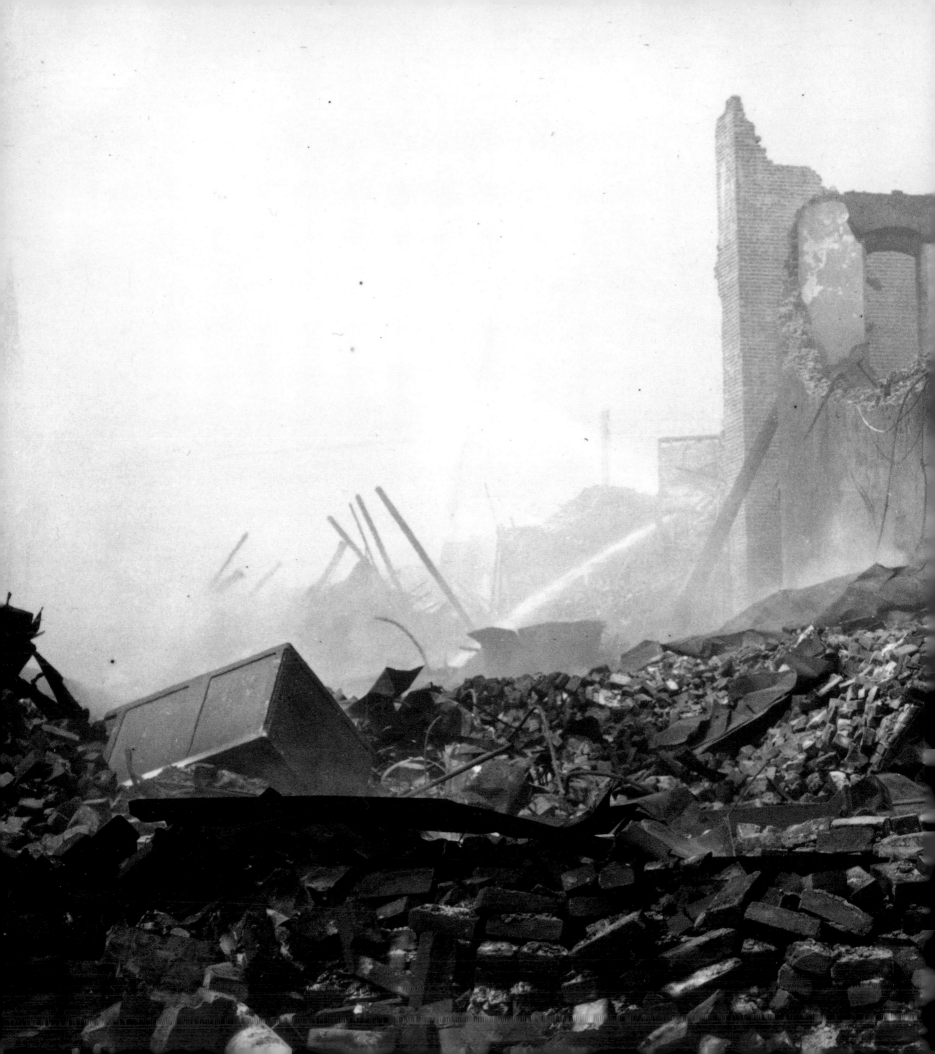

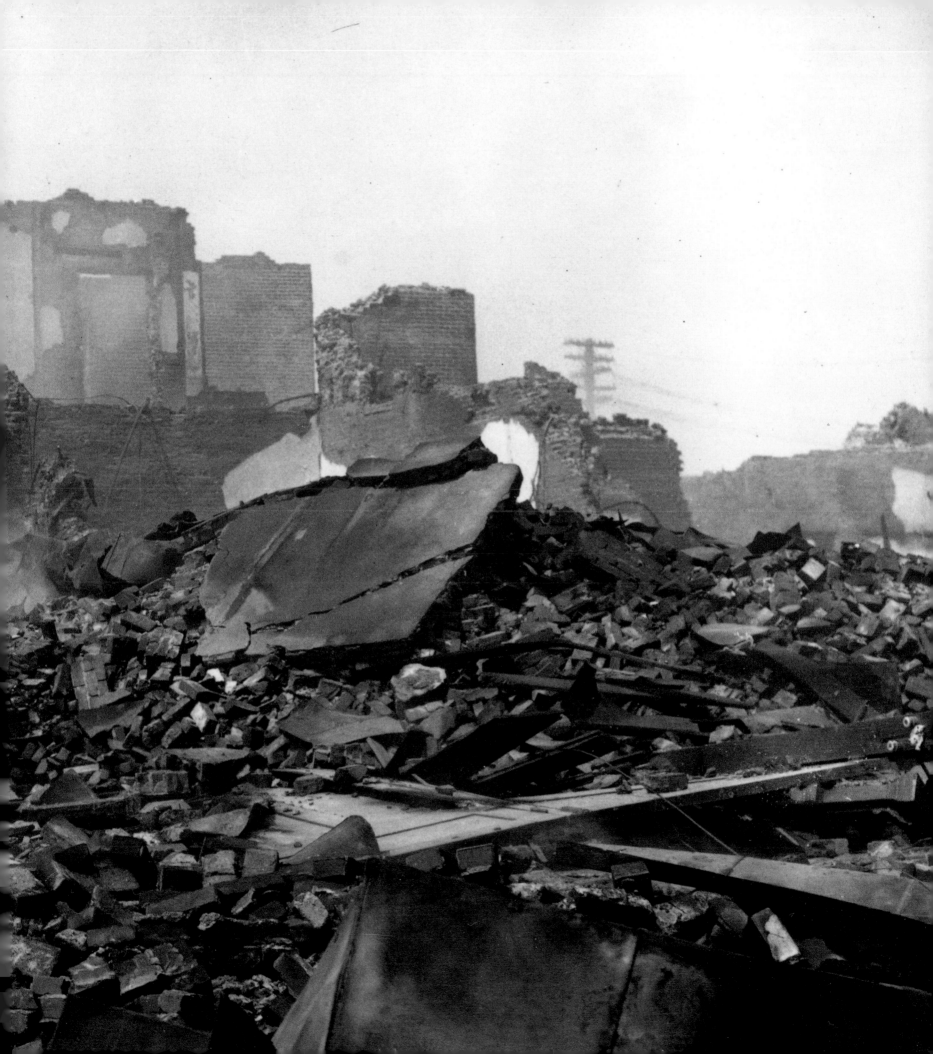

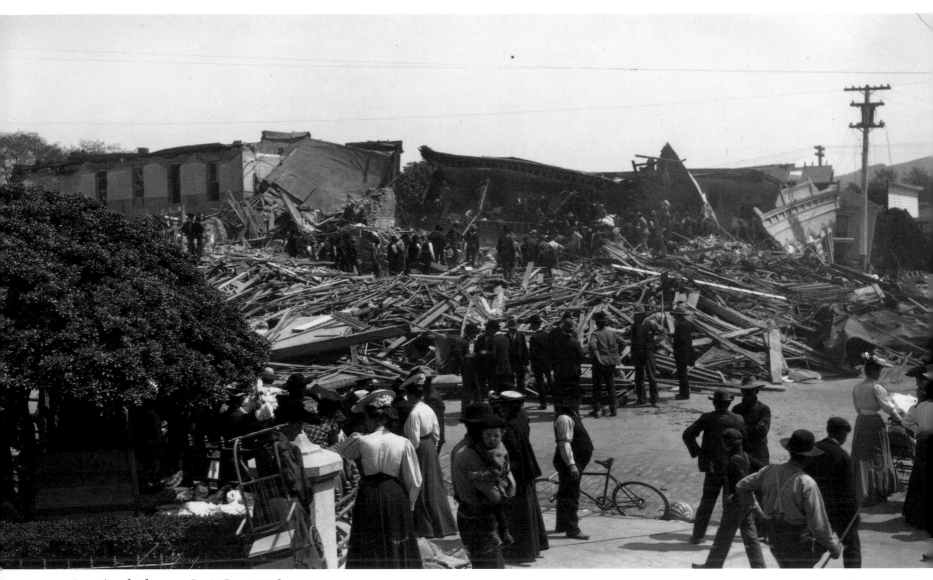

Assessing the damage, Santa Rosa, 1906.

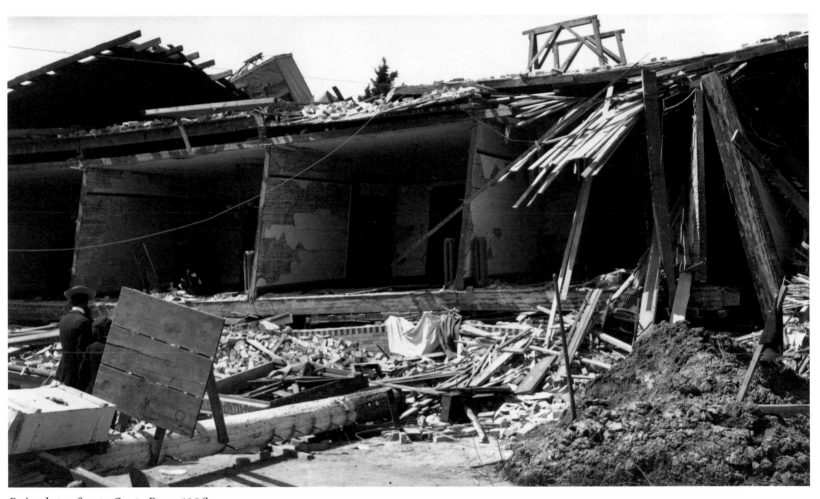

Ruined storefronts, Santa Rosa, 1906.

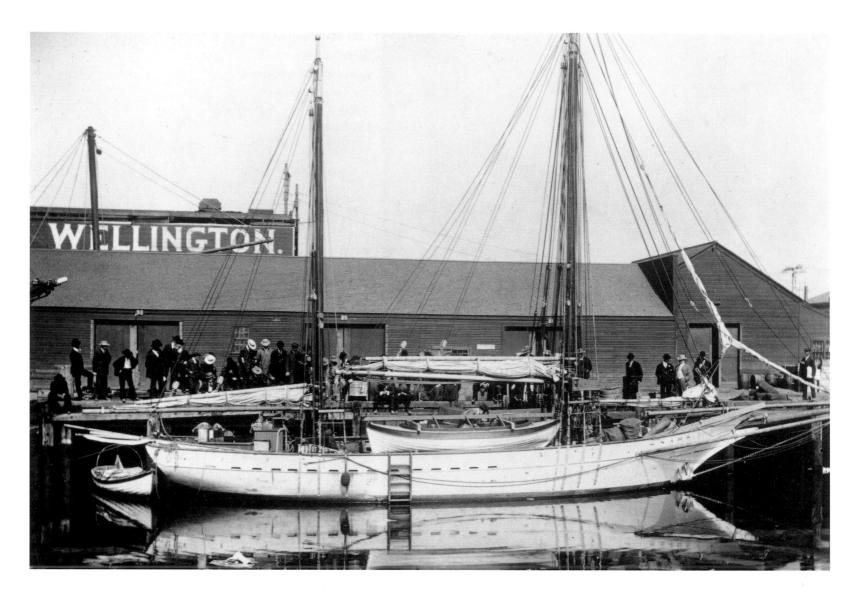

The Snark *prepares to sail,*
San Francisco, 1907.

By 1906, London had conceived his plan to build a sailboat and sail around the world in seven years. As he explains in the opening pages of *The Cruise of the Snark*: "When I have done some such thing I am exalted. I glow all over. I am aware of a pride in myself that is mine, and mine alone. It is organic. Every fibre of me is thrilling with it. It is a mere matter of satisfaction at adjustment to environment. It is success. Life that lives is successful, and success is the breath of its nostrils. . . . The trip around the world means big moments of living."[4]

London, his wife, and a small crew sailed for two years against long odds, starting with the Londons' near bankruptcy. On the initial voyage to Hawai'i—when everyone aboard was dreadfully seasick—the engine fell off its mount, they found the boat leaked and wouldn't come about or heave to, much of their food and fuel was spoiled by saltwater, the head failed to work, the launch engine failed, and more. The hired

captain (his wife's uncle) was ignorant of navigation, so London taught himself how to navigate, a skill he remained proud of. Other setbacks included tropical diseases, madness among the crew, and a supposedly impossible southeast traverse of sixty-one days from Hawai'i to the Marquesas.

London's powerful curiosity about other communities took them west from the Marquesas to the Paumotus (the "Dangerous Archipelago"), Tahiti and the other Society Islands, Samoa, Fiji, the New Hebrides, the Solomons, the Gilbert Islands, and finally Australia. Along the way, he photographed men, women, and children in a variety of settings, along with the whites who controlled much of their lives: missionaries, traders, and government officials.

Upon its arrival in Hawai'i, the *Snark* docked for extensive repairs. The captain, Roscoe Eames, was fired, and a new captain and cabin boy were signed

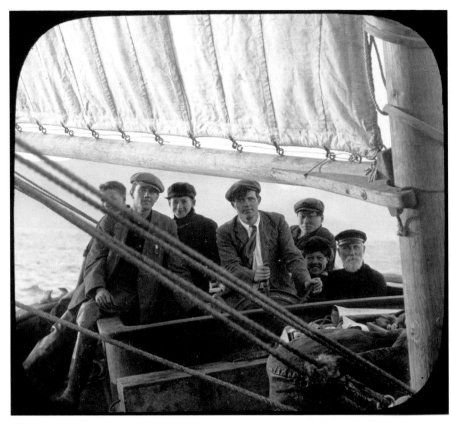

The Snark *crew on a preliminary sail, February 10, 1907. Lantern slide by Martin Johnson.*

on. (The cabin boy was Yoshimatsu Nakata, who became the Londons' longtime valet and later a memoirist.) The five months the Londons spent in Hawai'i proved to be happier than they had dreamed. Wherever they went, they were welcomed and entertained, even by Hawaiian royalty. They stayed in a cottage at Pearl Lochs and in a spacious tent-cabin on Waikiki, near the site of the original Outrigger Club (now occupied by the Outrigger Waikiki Hotel). They visited Maui, the Big Island, and Moloka'i; separately, London visited Kaua'i. On Maui, they rode over the Von Tempsky ranch on the slopes of the volcano Haleakala, and on the Big Island they were guests of the Balding family at Wainaku, where they tried the dangerous pastime of riding bundles of sugarcane down steep flumes to the mills on the valley floor. London learned to surf; his article "A Royal Sport" (chapter 6 of *The Cruise of the Snark*) helped popularize surfing in the United States. He was asked to be a founder of the Outrigger Canoe Club.

A new friend in Honolulu, Alexander Hume Ford, who was a young entrepreneur and promoter of Hawai'i, arranged a visit to Ewa Plantation on Oahu. The plantation manager, H. H. Renton, gave a tour to the Londons; Joseph P. Cooke, the head of Alexander & Baldwin (which had interests in shipping, sugarcane, and real estate); Lorrin A. Thurston, the publisher of the *Honolulu Advertiser*; and Senhor

away from that"; but, he pointed out, worse sights can been seen in any major city in the United States.[6]

London approached the residents of Moloka'i with openness and respect, and without the usual fear and hysteria that leprosy evoked: "Leprosy is not so contagious as imagined. I went for a week's visit to the Settlement, and I took my wife along—all of which would not have happened had we had any apprehension of contracting the disease. Nor did we wear long, gauntleted gloves and keep apart from the lepers. On the contrary, we mingled freely with them, and before we left, knew scores of them by sight and name."[7] The Londons' visit to Moloka'i's Kalaupapa peninsula was one they thought of as among their most meaningful, and they visited it again in 1915. Like his visit to Ewa Plantation, London's time in Moloka'i had a transforming effect on his writings and photographs from the Pacific, which confronted questions of identity, race, health, disease, colonialism, rebels, and the establishment.

In his essay, London is at pains to show that the colony was not the hell on earth it had been described as. He wrote of and photographed the residents' Fourth of July parade, bands, horsemanship contests, and "Parade of the Horribles," which featured colorful costumes. Describing a donkey race, he confesses, "I tried to check myself. I assured myself that I was witnessing one of the horrors of Molokai, and that it was shameful for me, under such circumstances, to be so light-hearted and light-headed. But it was no use. . . . And all the while nearly a thousand lepers were laughing uproariously at the fun. Anybody in my place would have joined with them in having a good time."[8]

In addition, London's firsthand reporting served as a corrective to unfounded rumors about the colony:

[T]he horrors of Molokai, as they have been painted in the past, do not exist. The Settlement has been written up repeatedly by sensationalists, and usually by sensationalists who have never laid eyes on it. Of course, leprosy is leprosy, and it is a terrible thing; but so much that is lurid has been written about Molokai that neither the lepers, nor those who devote their lives to them, have received a fair deal. Here is a case in point. A newspaper writer, who, of course, had never been near the Settlement, vividly described Superintendent McVeigh, crouching in a grass hut and being besieged nightly by starving lepers on their knees, wailing for food. This hair-raising account was copied by the press all over the United States and was the cause of many indignant and protesting

editorials. Well, I lived and slept for five days in Mr. McVeigh's grass hut (which was a comfortable wooden cottage, by the way; and there isn't a grass house in the whole Settlement), and I heard the lepers wailing for food—only the wailing was peculiarly harmonious and rhythmic, and it was accompanied by the music of stringed instruments, violins, guitars, *ukuleles*, and banjos. Also, the wailing was of various sorts. The leper brass band wailed, and two singing societies wailed, and lastly a quintet of excellent voices wailed. So much for a lie that should never have been printed. The wailing was the serenade which the glee clubs always give Mr. McVeigh when he returns from a trip to Honolulu.[9]

On Moloka'i, London observed people going about their daily lives; his writing and photographs emphasize their normalcy by describing residents swimming, playing in bands, riding in a rodeo, working, preparing a luau:

Everywhere are grassy pastures over which roam the hundreds of horses which are owned by the lepers. . . . In the little harbour of Kalaupapa lie fishing boats and a steam launch, all of which are privately owned and operated by lepers. . . . Their fish they sell to the Board of Health, and the money they receive is their own. While I was there, one night's catch was four thousand pounds.

And as these men fish, others farm. All trades are followed. One leper, a pure Hawaiian, is the boss painter. He employs eight men, and takes contracts for painting buildings from the Board of Health. He is a member of the Kalaupapa Rifle Club, where I met him, and I must confess that he was far better dressed than I. . . . Major Lee, an American and long a marine engineer for the Inter-Island Steamship Company, I met actively at work in the new steam laundry, where he was busy installing the machinery. I met him often, afterwards, and one day he said to me:

"Give us a good breeze about how we live here. For heaven's sake write us up straight. Put your foot down on this chamber-of-horrors rot and all the rest of it. We don't like being misrepresented. We've got some feelings. Just tell the world how we really are in here."[10]

London tried to do just that in his writings and in his photographs of the lepers; the insights and images he made are without parallel for the time.

After leaving Hawai'i, the *Snark* make the traverse from northwest to southeast across the Pacific, which, because of tides and winds, was not supposed to be

possible. When the boat arrived in Taiohae Bay on the island of Nuku Hiva in the Marquesas, the site of Melville's famed Typee Valley, London found a community much worse off than the leper colony: "There are more races than there are persons, but it is a wreckage of races at best. Life faints and stumbles and gasps itself away. . . . [A]sthma, phthisis, and tuberculosis flourish as luxuriantly as the vegetation. Everywhere, from the few grass huts, arises the racking cough or exhausted groan of wasted lungs."[11] London quotes Melville's hero Tommo on his first view of Typee Valley, "'Had a glimpse of the gardens of paradise been revealed to me I could scarcely have been more ravished with the sight,'" but where Melville "saw a garden," wrote London, "We saw a wilderness."[12] As Charmian put it, "[W]e were too late." In Typee Valley, they encountered only a few dozen inhabitants, all wasting from Western diseases: "[T]he houses and the people were gone, and huge trees sank their roots through the platforms and towered over the under-running jungle. . . . Once or twice, as we ascended the valley, we saw magnificent *pae-paes* bearing on their general surface pitiful little straw huts, the proportions being similar to a voting booth perched on the broad foundation of the pyramid of Cheops."[13] (*Pae-paes* were large stone platforms upon which the Marquesans erected huts, temples, and storehouses.)

The Tahiti chapter of *The Cruise of the Snark* begins in a lighthearted way but ends on a melancholy note. London focuses on "Nature Man," an American living in Papeete, whom he photographed several times. Nature Man's name was Ernest Darling, and London had met him years before in California. At first glance, he seemed to be a prototype of the healthy beachcomber who, though white, could adapt to the tropics and thrive. Darling had been ill as a young man, on the verge of a mental and physical breakdown at his physician father's home in Oregon. His illness resembled neurasthenia, which was a fashionable affliction of sensitive young men around 1900. Darling cured himself by bolting to Tahiti, where he went about in a red loincloth and preached vegetarianism and socialism to the islanders. On his fabulously productive terraced farm, where he grew papayas, avocados, breadfruit, mangoes, bananas, and coconuts in the wilds above the harbor, he posted his own version of the Ten Commandments in phonetic spelling: "Thous shalt not eet meet" and "Vizit troppikle cuntriz." The Londons admired Darling's "Return-to-Nature life," as Charmian called it.[14]

However his dream was not to last: during the *Snark*'s visit, alarmed at his lifestyle, which was unconventional even for Tahiti, and his socialism (the red flag in front of his shack was visible in much of Papeete), the local French authorities seized

Darling's farm and blocked his road. London recalls: "'Never mind their pesky road,' he said to me as we dragged ourselves up a shelf of rock and sat down, panting, to rest. 'I'll get an air machine soon and fool them. I'm clearing a level space for a landing stage for the airships, and next time you come to Tahiti you will alight right at my door.'"[15] London concludes the chapter: "And I shall see you always as I saw you that last day, when the *Snark* poked her nose once more through the passage in the smoking reef, outward bound, and I waved good-by to those on shore. Not least in goodwill and affection was the wave I gave to the golden sun-god in the scarlet loincloth, standing upright in his tiny outrigger canoe."[16]

One of London's favorite South Seas places was Bora Bora, which seemed as yet untouched by the ills of the Marquesas and Tahiti. The Londons were hosted by a man from Tahaa named Tehei and his wife, Bihaura; Tehei joined the *Snark* as a pilot for a time:

[O]f all the entertainment I have received in this world at the hands of all sorts of races in all sorts of places, I have never received entertainment that equalled this at the hands of this brown-skinned couple of Tahaa. I do not refer to the presents, the free-handed generousness, the high abundance, but to the fineness

of courtesy and consideration and tact, and to the sympathy that was real sympathy in that it was understanding. . . . Perhaps the most delightful feature of it was that it was due to no training, to no complex social ideals, but that it was the untutored and spontaneous outpouring from their hearts.[17]

Tehei stayed on the *Snark* as the crew explored the Society and Paumotan islands.

As the boat sailed west, the crew encountered the most dangerous and troubled islands on their voyage, the Solomons, where tropical diseases put an end to the voyage. The Londons stayed on a copra plantation called Penduffryn on the island of Guadalcanal in October and November 1908. London based his novel *Adventure* (1913) on what he witnessed there between the plantation owners—George Darbishire and his partner Tom Harding—and the enslaved workers. He and Charmian also went aboard a slaver ship, the *Minota*, on a trip to Malaita. By 1900, slavery had all but disappeared around the world except in the Middle East, India, Africa, and parts of the South Seas. In Melanesia, which includes Fiji, the New Hebrides, and the Solomons, representatives of European and American companies employed "recruiters," also known as "blackbirders," who signed up islanders to work on company plantations, sometimes simply kidnapping them, particularly from sites considered unusually savage. The Solomon Islands were a preferred hunting ground for blackbirders like crew of the *Minota*. When the *Minota* ran aground and was attacked by islanders, headlines around the world screamed that the Londons had been captured by cannibals, but disaster was averted when a local missionary and a Captain Keller of the nearby *Eugénie* came and quelled the riot. In 1915, the Londons learned by letter from a missionary that Darbishire, his wife, and Tom Harding were all massacred by their workers a few years after the Londons' visit.[18] London devoted many South Seas stories to the plight (and sometimes the successful rebellion) of slaves in the South Pacific, as in "The Chinago," "Mauki," and "The Feathers of the Sun," all highly ironic critiques of whites in the Pacific. In "The Red One," one of his final stories, he revisits the site of the failure of his health and his voyage, but with a sense of kinship with the Solomon Islanders, a remarkable reversal of his former views.

Jack London at the grave of Robert Louis Stevenson, Apia, Samoa, 1908.

"The first experience can never be repeated. The first love, the first sunrise, the first South Sea island, are memories apart and touched a virginity of sense. . . . For the cocoa-tree and the island man are both lovers and neighbours of the surf. 'The coral waxes, the palm grows, but man departs,' says the sad Tahitian proverb; but they are all three, so long as they endure, co-haunters of the beach. The mark of anchorage was a blow-hole in the rocks, near the south-easterly corner of the bay. Punctually to our use, the blow-hole spouted; the schooner turned upon her heel; the anchor plunged. It was a small sound, a great event; my soul went down with these moorings whence no windlass may extract nor any diver fish it up." (Stevenson, In the South Seas, *chapter 1)*

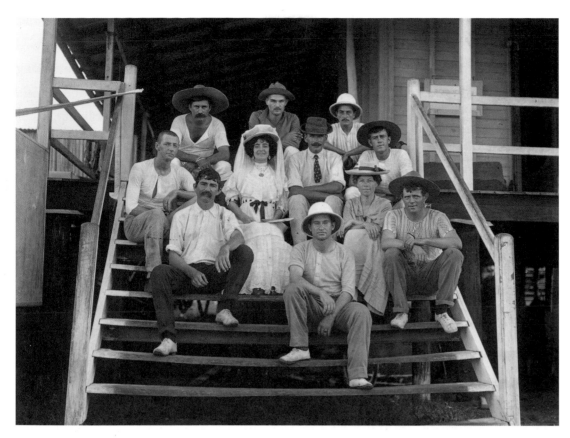

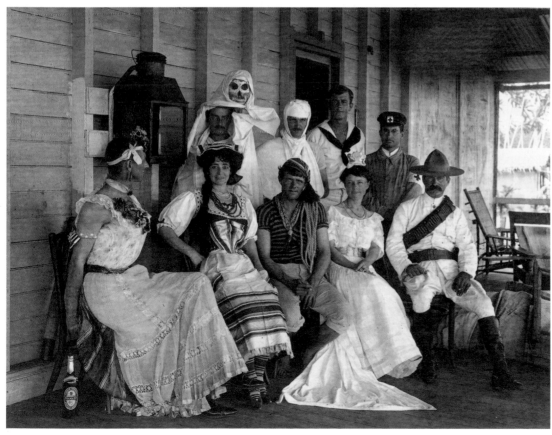

(top)

The crew of the Snark *with the masters and mistress of Penduffryn, Guadalcanal, 1908.*

(bottom)

A costume party at Penduffryn, Guadalcanal, Solomon Islands, October 28, 1908. Front row, left to right: *George Darbishire, Baroness Eugenie, Jack London, Charmian London, and Tom Harding. Back row:* Snark *crew members. Darbishire had a habit of getting drunk or smoking hashish and dressing in Charmian's clothing. Jack and Charmian are supposed to be an organ grinder and an invalid.*

He also mentions that neither he nor Captain Roscoe Eames "knows anything about navigation. Mr. Eames is going to study it up, if he gets time, before we start, and I am so dreadfully busy that I do not expect to study it up until after we start." To be able to envision the venture photographically but set sail on it without a navigator? Such contradictions absolutely characterized London.

At the end of 1906, Perriton Maxwell became the editor of *Cosmopolitan*, and he too disappointed London with his terms. In an angry letter, London accused him of bad faith and of treating him "scurvily" and suggested they drop the whole contract: "Your proposition to me, to render an itemized bill for my photography expense is a hair-raiser. . . . [D]on't think for one moment that I am any kind of tu'penny dub to furnish itemized accounts to you of my own expenses" (the East End slang recalls *The People of the Abyss*). He demanded a $5,000 advance for photographs and a "definite and satisfactory scale of payments for photographs."[24] Eventually they settled on five dollars a photograph.

To Arthur T. Vance, the editor of the *Woman's Home Companion*, which also ran stories about the *Snark* trip, London sent some photos of the crew from a trial sailing. He notes of one: "Mrs. London says, 'For heaven's sake, doctor my nose up if you reproduce this one!' She really had a nice nose, but the camera will play tricks."[25] London also had trouble getting Vance to pay five dollars a photograph. On October 25, 1908, London sent Hayden Carruth, at the *Woman's Home Companion*, a letter from Penduffryn Plantation: "I sent you a howl from Papeete, Tahiti, under date of February 15, 1908. And you haven't sent me a word in reply. . . . [a]bout compensation for photographs. I need only tell you one thing: traveling in the tropics is very bad for photographic material. Up to date I have thrown overboard between $300 and $400 worth of ruined films, printing papers, chemicals, developers, etc., etc., So no matter what you or anybody pays me for a picture, I shall certainly not make a profit out of them."[26]

To Lucius "Lute" Pease, a Klondike gold prospector, newspaperman, political cartoonist, and editor of the *Pacific Monthly* (1906–13), London wrote to ask that payment for an article about the voyage take into account the cost of the photographs—in time, effort, and materials—as well as the value of his prose:

Between the cost of the cameras, the loss of films and chemicals, etc., through deterioration in the tropics, and leaving out of account any personal work on my part in taking the photo's, my photographic expenses for the voyage have been over $1,500. Now I am not suggesting this $1,500 as a price to you—far from it;

I am merely pointing out that the photo's are worth something. In this connection, more of my films are arriving within a few days (in baggage that was sent from the Isthmus of Panama to South America by mistake). When these films arrive I shall be able to dig up some more good illustrations for the article.[27]

Perhaps at this point, London thought it would be easier to secure payment if he argued about the cost of his materials rather than the artistic worth of the photographs.

London's correspondence with one of the crew members, which lasted until London's death, in 1916, also gives us hints about how London approached his photography in the South Seas. Martin Johnson (1884–1937) was the only crew member of the *Snark* who made the entire trip with the Londons. After growing up in Rockford, Illinois, and Lawrence, Kansas, he was a newsboy in New York and Chicago. From an early age, he was fascinated with tales of adventure in the West. Martin's father was in the jewelry business in Independence, Kansas, and he sold film as well. Martin became interested in photography, though he had little luck selling the photos he made. When he read of London's proposed adventure and learned that there was still one spot on the crew to fill, he wrote to London and asked to be taken on. He was surprised by London's five-word telegram in response: "Can you cook? Jack London." Martin went to Milton Cook's White Front Quick Lunch Room in Independence and persuaded the chef to teach him to cook. He then wired London back: "Sure, just try me." Martin was on.

Martin's letter to Jack London expressed not only his enthusiasm for adventure but also his willingness to develop film on the voyage:

Have just finished reading of your proposed trip around the world and am writing you with the forlorn hope of you needing an extra man. . . . You mention being "there" at photography—well I'm rather conceited about my ability in that line too. I have just received a new No 3A Kodak with a Plastigmat house and as we handle Eastman products I can get credit at any Kodak repository in the world. . . . I want to see things and places other people don't see and besides they only see our side of life—I want to see both. . . . [G]uess I'm a regular rolling stone.[28]

In her memoir *I Married Adventure* (1940), Johnson's wife, Osa, quotes him on his first impression of London: "At that moment, a striking young man of 30, with very broad shoulders, a mass of wavy auburn hair and a general atmosphere of boyishness—and that is how, for the first time, I really ran shoulder to shoulder with

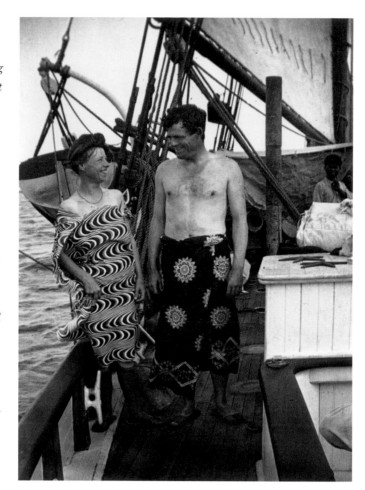

The Londons in lava-lavas aboard the Snark, *1908.*

"Then came the rush of years, filled brimming with projects, achievements, and failures; but Typee was not forgotten, and here I was now, gazing at its misty outlines till the squall swooped down and the Snark dashed on into the driving smother. Ahead, we caught a glimpse and took the compass bearing of Sentinel Rock, wreathed with pounding surf. Then it, too, was effaced by the rain and darkness. We steered straight for it, trusting to hear the sound of breakers in time to sheer clear. We had to steer for it. We had naught but a compass bearing with which to orientate ourselves, and if we missed Sentinel Rock, we missed Taiohae Bay, and we would have to throw the Snark up to the wind and lie off and on the whole night—no pleasant prospect for voyagers weary from a sixty days' traverse of the vast Pacific solitude, and land-hungry, and fruit-hungry, and hungry with an appetite of years for the sweet vale of Typee." (The Cruise of the Snark, chapter 10)

Adventure."[29] After the *Snark* voyage, Martin rented a store with his friend Charlie Kerr and had the front rebuilt to resemble the bow of the *Snark*; he hand-tinted glass slides from the voyage and, augmented with photos borrowed from London, showed them as a travelogue, which also ran in a new theater, the Snark #2, that he built with the help of loans from London (London lent Martin films to show as well). Martin also showed the slides on tours around the Midwest and the East Coast. Despite these business ventures, Martin borrowed money from London constantly, apologizing in dozens of letters for not repaying the debts. Finally, on September 14, 1915, London wrote Johnson to settle the matter: "Now here's my consistent reply. Do not bother any more with paying me what you owe me. The account is done with. Keep the change, and go to hell."[30]

The Johnsons and the Londons remained close friends. Martin and Osa spent part of their honeymoon on the Londons' ranch, and they regarded Jack and Charmian as role models, though the release of Martin's book *Through the South Seas with Jack London* just before Charmian's *The Log of the Snark* annoyed the Londons.[31]

The Johnsons went on to become a celebrity adventure couple who explored and filmed some of the remotest regions of the world from 1917 to 1936, including nine expeditions to Africa, Borneo, and New Guinea. They developed new techniques for wildlife photography and film that made them world famous. After London's death, Martin and Osa continued to write to and visit Charmian. In 1937, Martin died in a plane crash en route to the London ranch; Osa survived. She wrote about their lives until her death in 1953.

At the end of the *Snark* voyage, overcome by tropical diseases, London entered a hospital in Sydney, Australia, in December 1908, though he was well enough to cover the Jack Johnson–Tommy Burns heavyweight fight on December 26. In January 1909, London issued a statement to the press. In it, he notes that after arriving at the hospital in Australia, he was so confident of a quick recovery that he agreed to a series of lectures across the continent. But he soon realized he wasn't up to it. He details his manifold ailments, especially the peeling of the hands (which medical experts now suspect was due to corrosive sublimate of mercury, which he was applying for yaws, a tropical disease marked by ulcerative skin lesions): "The biggest specialist in Australia in this branch, confesses that not only has he never observed anything like it, but that not a line has been written about it by other observers." He adds, "There are many boats and many voyages, only one set of toe-nails but I have only one body; and . . . I have prescribed myself my own climate and environment, where always before my nervous equilibrium has been maintained. . . . There is nothing more for me to say except this, namely, a request to all my friends. Please forego congratulating us upon our abandonment of the voyage. We are heart-broken."[32]

In an unpublished letter to the H. C. White Company, one of his photo suppliers, London wrote,

Unfortunately, I do not possess even the wreck of the camera. I left the yacht at anchor in the Solomon Islands, and went down to Australia, where I spent five months of sickness in hotels and hospitals. It was there that I abandoned the voyage, because of the fact that the doctors could do nothing for me. I had left the SNARK in charge of a drunken master, and when I sent a navigator up to the Solomons to bring the SNARK down to Australia, she arrived with damn little left upon her. I am still wondering what became of scores of things—of my automatic rifles, of my ship's stores, of my tinned provisions, of my naturalist's shotgun, of my automatic Winchester, of 300 francs of French money, etc., etc. Incidentally, I wonder what became of the camera in question, and of another camera.[33]

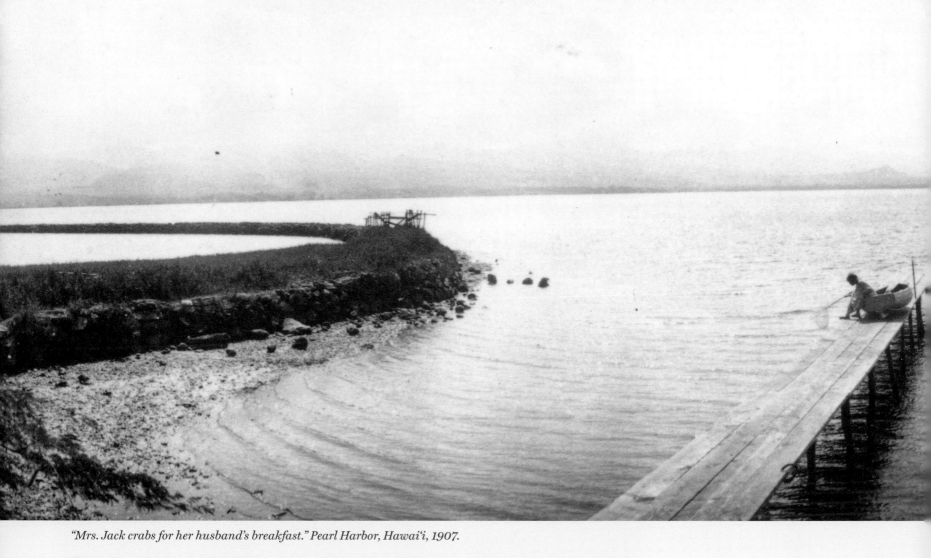

"Mrs. Jack crabs for her husband's breakfast." Pearl Harbor, Hawai'i, 1907.

"So we went ashore . . . across a level flashing sea to the wonderful green land. We landed on a tiny wharf, and the dream became more insistent; for know that for twenty-seven days we had been rocking across the ocean on the tiny Snark. *Not once in all those twenty-seven days had we known a moment's rest, a moment's cessation from movement. This ceaseless movement had become ingrained. Body and brain we had rocked and rolled so long that when we climbed out on the tiny wharf kept on rocking and rolling. This, naturally, we attributed to the wharf. It was projected psychology. I spraddled along the wharf and nearly fell into the water. I glanced at Charmian, and the way she walked made me sad. The wharf had all the seeming of a ship's deck. It lifted, tilted, heaved and sank; and since there were no handrails on it, it kept Charmian and me busy avoiding falling in. I never saw such a preposterous little wharf. Whenever I watched it closely, it refused to roll; but as soon as I took my attention off from it, away it went, just like the* Snark. *Once, I caught it in the act, just as it upended, and I looked down the length of it for two hundred feet, and for all the world it was like the deck of a ship ducking into a huge head-sea." (The Cruise of the Snark, chapter 5)*

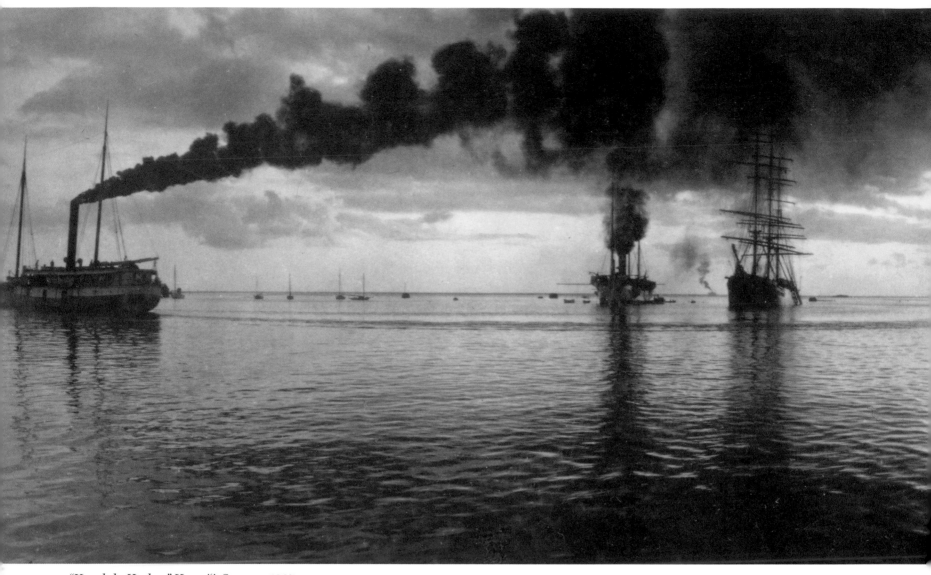

"Honolulu Harbor." Hawai'i, Summer 1907.

"Twenty-seven days out from San Francisco we arrived at the island of Oahu, Territory of Hawaii. In the early morning we drifted around Diamond Head into full view of Honolulu; and then the ocean burst suddenly into life. Flying fish cleaved the air in glittering squadrons. In five minutes we saw more of them than during the whole voyage. Other fish, large ones, of various sorts, leaped into the air. There was life everywhere, on sea and shore. We could see the masts and funnels of the shipping in the harbour, the hotels and bathers along the beach at Waikiki, the smoke rising from the dwelling-houses high up on the volcanic slopes of the Punch Bowl and Tantalus. The custom-house tug was racing toward us and a big school of porpoises got under our bow and began cutting the most ridiculous capers. The port doctor's launch came charging out at us, and a big sea turtle broke the surface with his back and took a look at us. Never was there such a burgeoning of life. Strange faces were on our decks, strange voices were speaking, and copies of that very morning's newspaper, with cable reports from all the world, were thrust before our eyes. Incidentally, we read that the Snark *and all hands had been lost at sea, and that she had been a very unseaworthy craft anyway." (*The Cruise of the Snark, *chapter 6)*

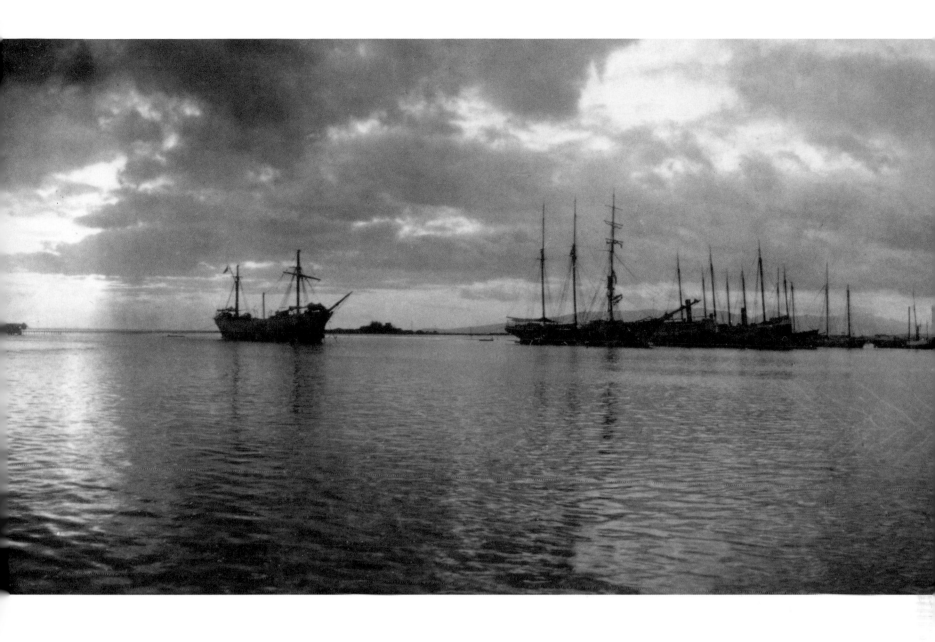

Armine and Gwen von Tempsky, Haleakala Ranch, Maui, Hawai'i, 1907. The Londons visited Louis von Tempsky and his family on his 50,000-acre cattle ranch on the slopes of Mt. Haleakala. Later, Armine wrote about her friendship with London in her best seller Born in Paradise *(1940). After their father's death, Armine and Gwen were briefly sent to live on the Londons' ranch.*

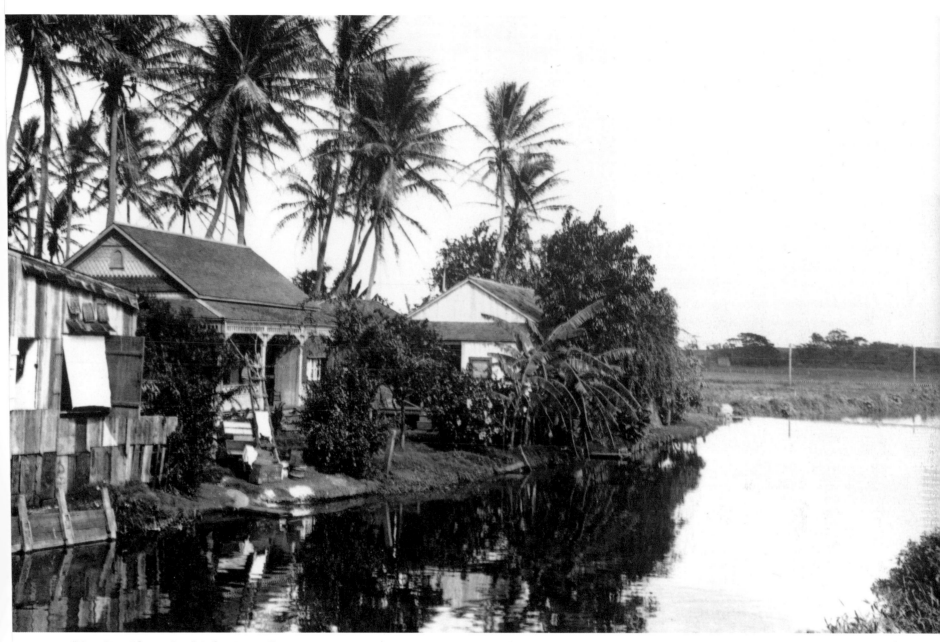

"Near Ewa Plantation." Oahu, Hawai'i, May 1907.

"Ah Chun was observant. He perceived little details that not one man in a thousand ever noticed. Three years he worked in the field, at the end of which time he knew more about cane-growing than the overseers or even the superintendent, while the superintendent would have been astounded at the knowledge the wizened little coolie possessed of the reduction processes in the mill. But Ah Chun did not study only sugar processes. He studied to find out how men came to be owners of sugar mills and plantations. One judgment he achieved early, namely, that men did not become rich from the labor of their own hands." ("Chun ah Chun," 1908)

"Portuguese."
A Portuguese
fieldworker and
her children,
Oahu, Hawai'i,
May 1907.

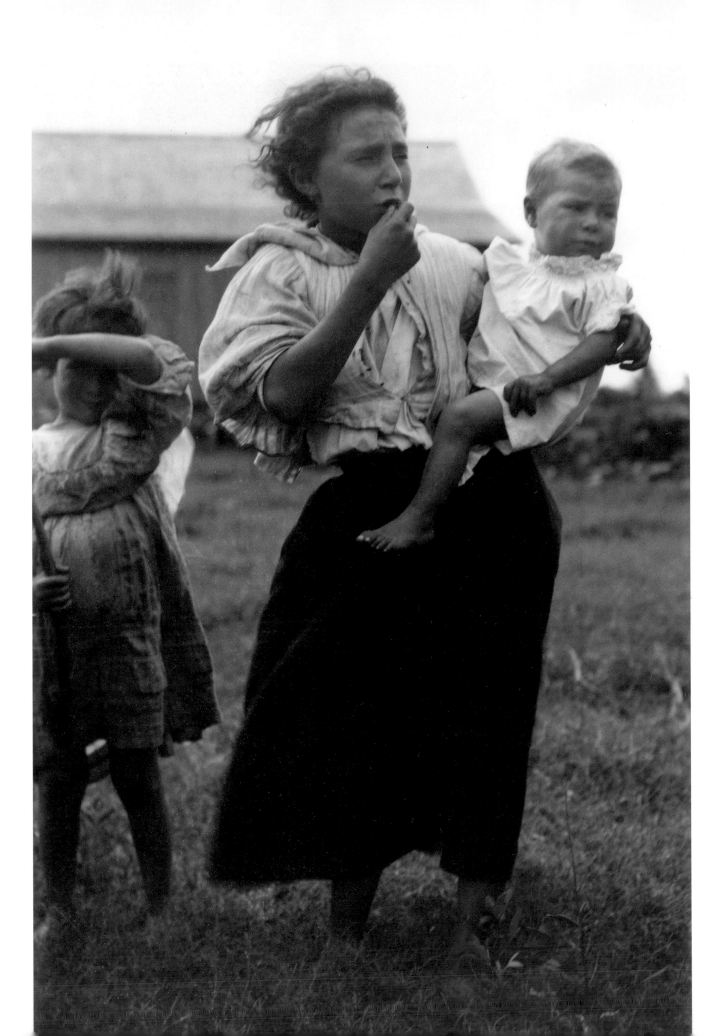

176

Leper boys at a window, Kalaupapa leper settlement,
Moloka'i, Hawai'i, July 1907.

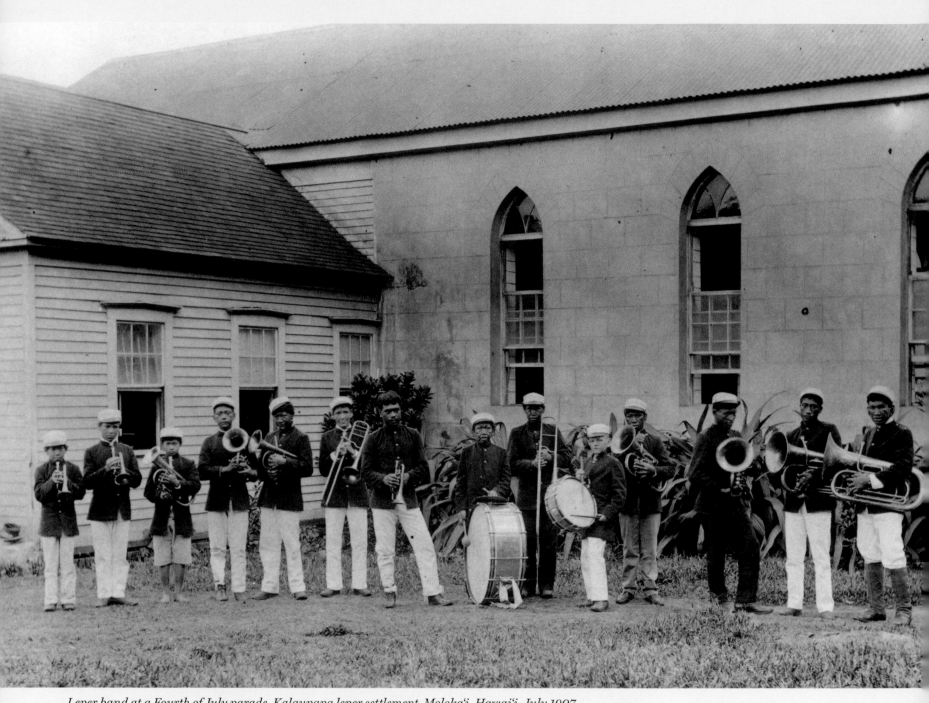

Leper band at a Fourth of July parade, Kalaupapa leper settlement, Moloka'i, Hawai'i, July 1907.

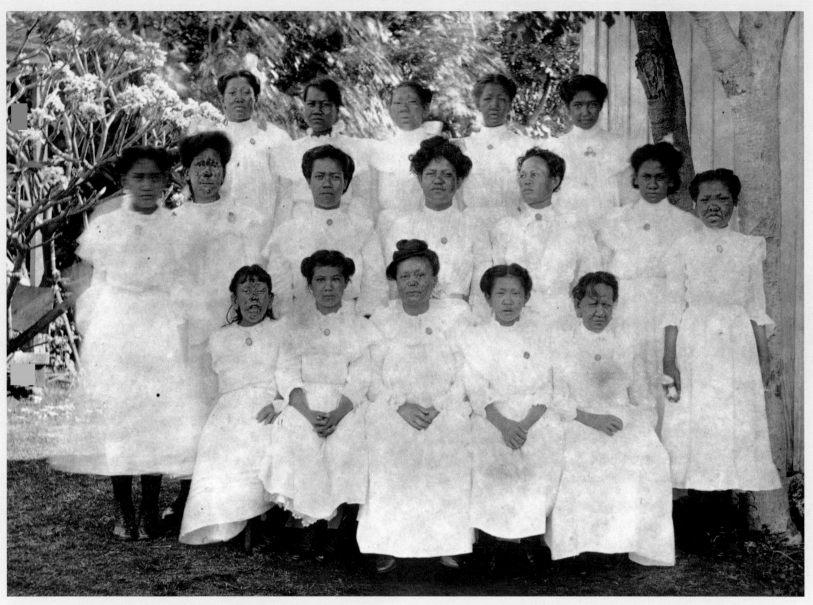

Leper nurses, Kalaupapa leper settlement, Moloka'i, Hawai'i, July 1907.

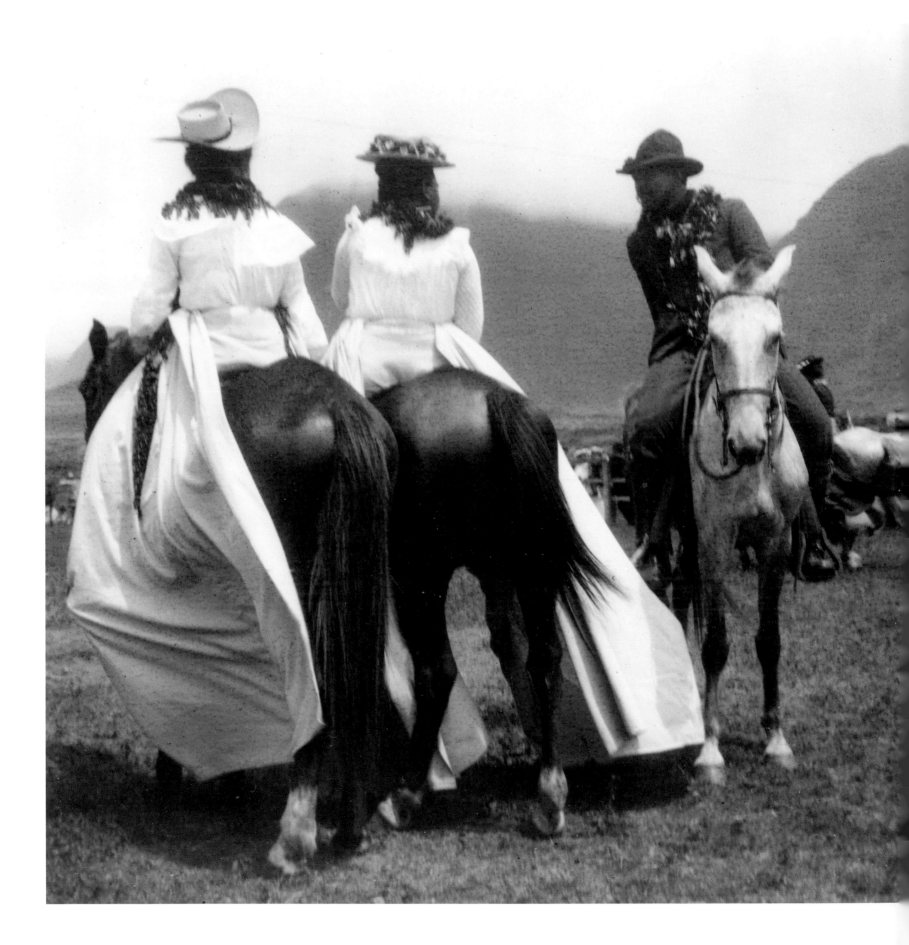

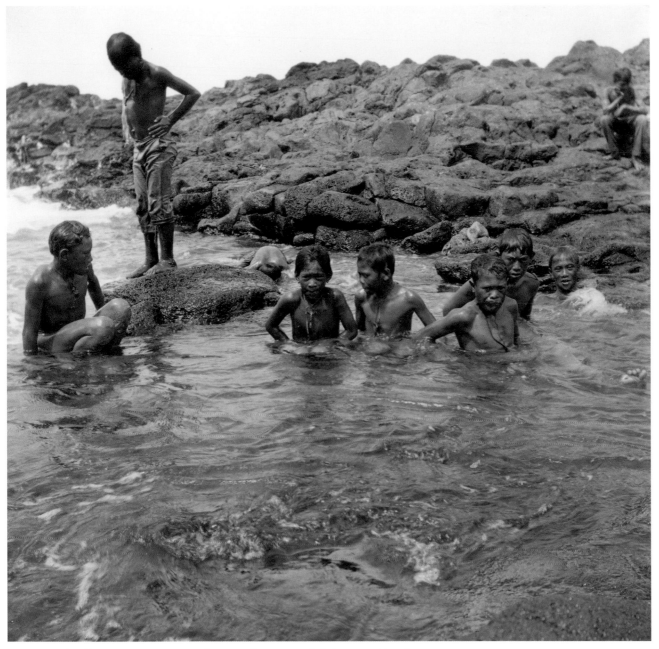

Stereograph of leper boys swimming, leper settlement, Moloka'i, Hawai'i, July 1907.

(facing page)
Pa'u riders at a Fourth of July rodeo, Kalaupapa leper settlement,
Moloka'i, Hawai'i, 1907. Pa'u riders were trick rodeo riders.

"Then there were the pa-u riders, thirty or forty of them, Hawaiian women all, superb horsewomen dressed gorgeously in the old, native riding costume, and dashing about in twos and threes and groups. In the afternoon Charmian and I stood in the judge's stand and awarded the prizes for horsemanship and costume to the pa-u *riders. All about were the hundreds of lepers, with wreaths of flowers on heads and necks and shoulders, looking on and making merry. And always, over the brows of hills and across the grassy level stretches, appearing and disappearing, were the groups of men and women, gaily dressed, on galloping horses, horses and riders flower-bedecked and flower-garlanded, singing, and laughing, and riding like the wind." (*The Cruise of the Snark, *chapter 7)*

The pali (cliff) trail, Kalaupapa, Moloka'i, Hawai'i, July 1907.

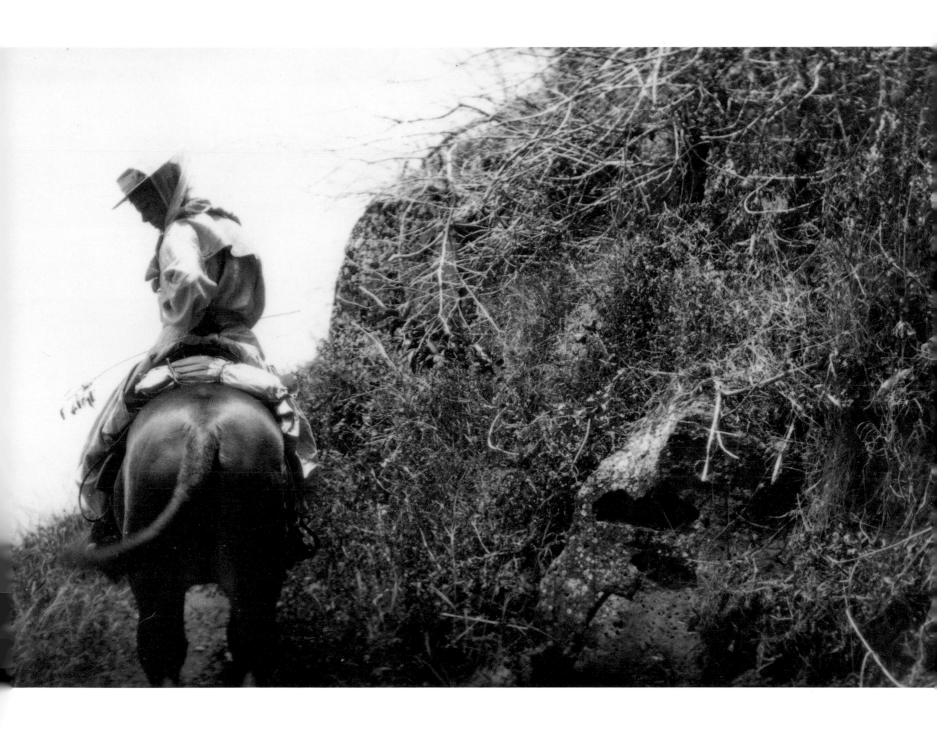

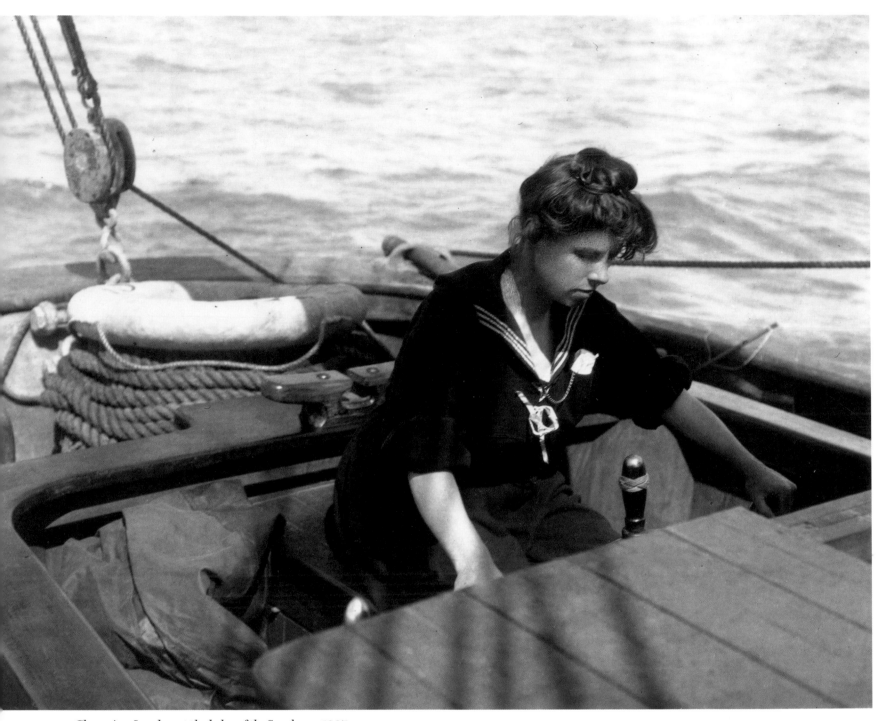

Charmian London at the helm of the Snark, *ca. 1907.*

"It was upon a midnight in the Solomon Islands, dark as a hat, and Jack, sick and apprehensive, was trying to make out a certain plantation anchorage on Guadalcanal. Suddenly, though the shore signal lights were identical, he discovered that we were almost on the rocks. It eventuated that another plantation than the one we sought had irresponsibly copied the other's lights. I started to put the wheel hard down at Jack's swift, tense command. 'Hard down! Hard down! quick!' he repeated. Then I, like an idiot, 'Oh, I am! I am!' It was too much for the disciplined sailorman. Not of babbling courtesies nor babies nor women was he thinking, but of saving the vessel that insured the safety of all the souls on board." (Charmian London, The Book of Jack London, *2:166*)

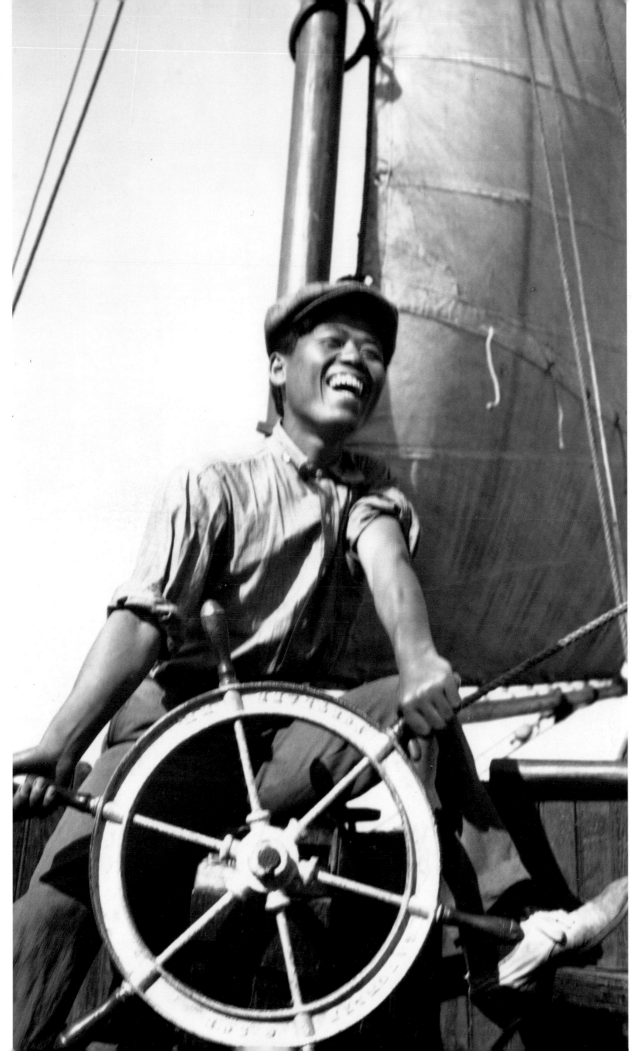

Yoshimatsu Nakata at the wheel of the Roamer, *ca 1910. On September 28, 1907, London hired a new valet, Nakata, who became an invaluable part of the crew, eventually helping type London's manuscripts and returning to Glen Ellen after the trip. He also accompanied the Londons on their* Dirigo *voyage in 1912.*

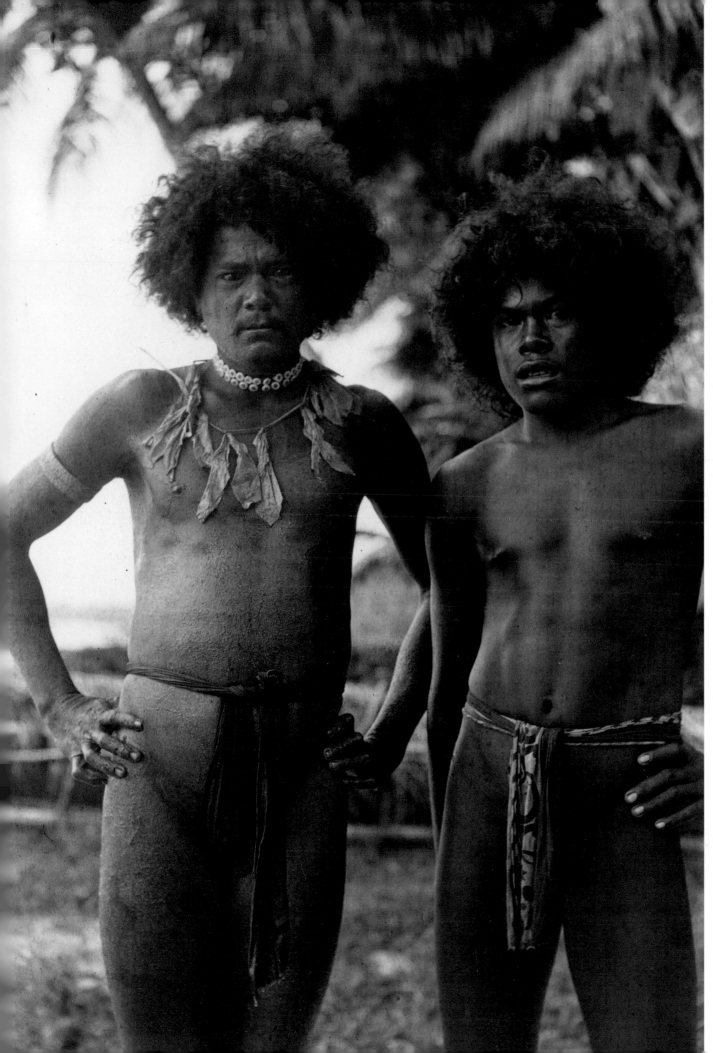

Two men, Nuku Hiva,
1907.

(facing page)
Pae-paes (stone platforms)
and houses, Nuku Hiva,
Marquesas, 1907.

187

"A Prince of Polynesia."
Nuku Hiva, 1907.

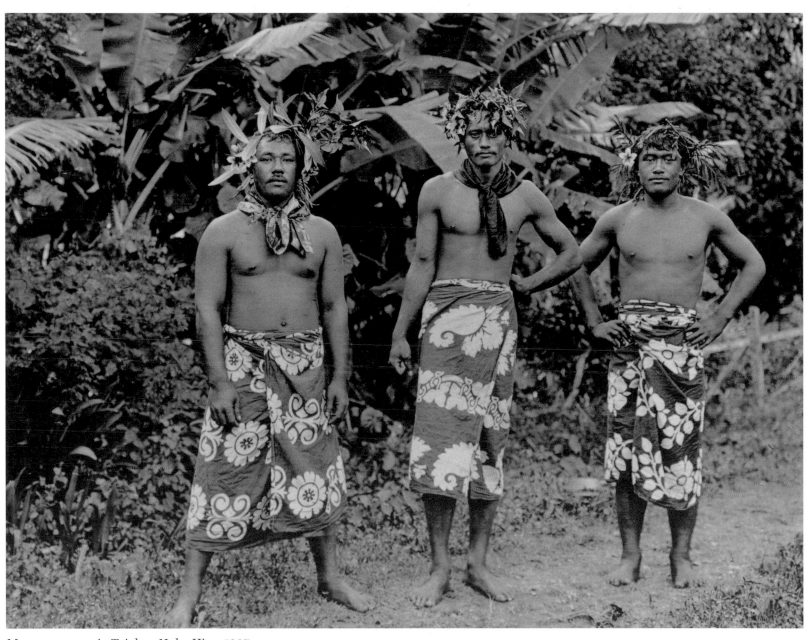

Marquesan men in Taiohae, Nuku Hiva, 1907.

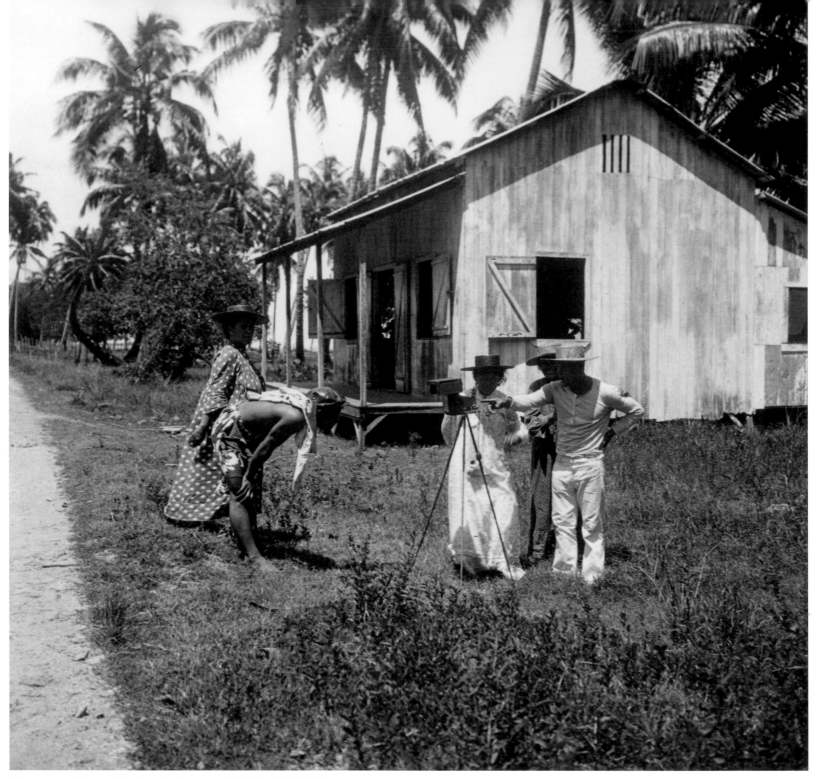

Marquesans inspecting London's camera, Taiohae, Nuku Hiva, 1907.

"I suppose I shall not have the chance in these degenerate days to see any long-pig eaten, but at least I am already the possessor of a duly certified Marquesan calabash, oblong in shape, curiously carved, over a century old, from which has been drunk the blood of two shipmasters. One of those captains was a mean man. He sold a decrepit whale-boat, as good as new what of the fresh white paint, to a Marquesan chief. But no sooner had the captain sailed away than the whale-boat dropped to pieces. It was his fortune, some time afterwards, to be wrecked, of all places, on that particular island. The Marquesan chief was ignorant of rebates and discounts; but he had a primitive sense of equity and an equally primitive conception of the economy of nature, and he balanced the account by eating the man who had cheated him." (The Cruise of the Snark, chapter 10)

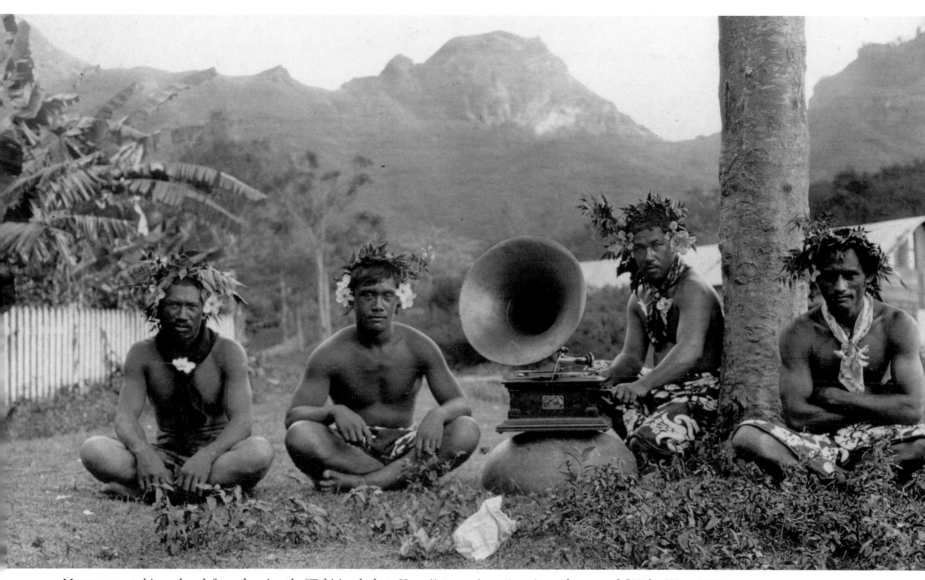

Marquesans taking a break from dancing the "Tahitian hula to Hawaiian music on American phonograph," Nuku Hiva, 1907.

"We rode on to Ho-o-u-mi. So closely was Melville guarded that he never dreamed of the existence of this valley, though he must continually have met its inhabitants, for they belonged to Typee. We rode through the same abandoned pae-paes, but as we neared the sea we found a profusion of cocoanuts, breadfruit trees and taro patches, and fully a dozen grass dwellings. In one of these we arranged to pass the night, and preparations were immediately put on foot for a feast." (The Cruise of the Snark, *chapter 10*)

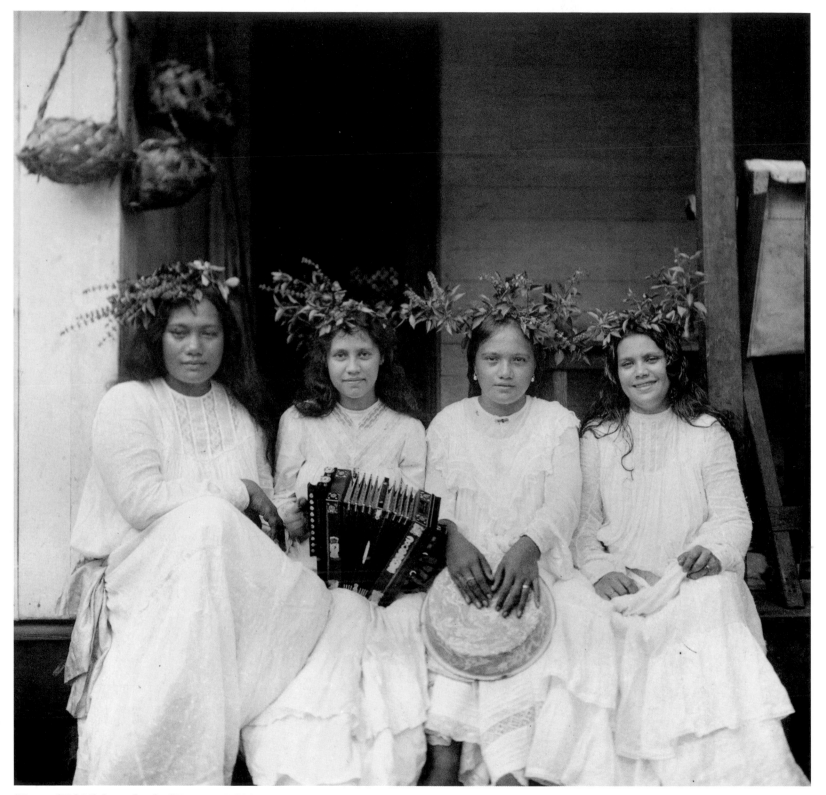

"Some of Tahiti's hapa-haoles." Papeete, Tahiti, 1907.

(facing page)
Ernest Darling, called "Nature Man" by London, was an inspiring though defeated figure, Papeete, Tahiti, 1907.

Bora Borans fishing with coconut-leaf nets and stones, 1908.

"Still the circle narrowed, till canoes were almost touching. There was a pause. A long canoe shot out from shore,
following the line of the circle. It went as fast as paddles could drive. In the stern a man threw overboard the long,
continuous screen of cocoanut leaves. The canoes were no longer needed, and overboard went the men to reinforce
the palisade with their legs. For the screen was only a screen, and not a net, and the fish could dash through it
if they tried. Hence the need for legs that ever agitated the screen, and for hands that splashed and throats that
yelled. Pandemonium reigned as the trap tightened." (The Cruise of the Snark, *chapter 13)*

"Hula in the Bow": Bora Borans with a U.S. flag, 1908.

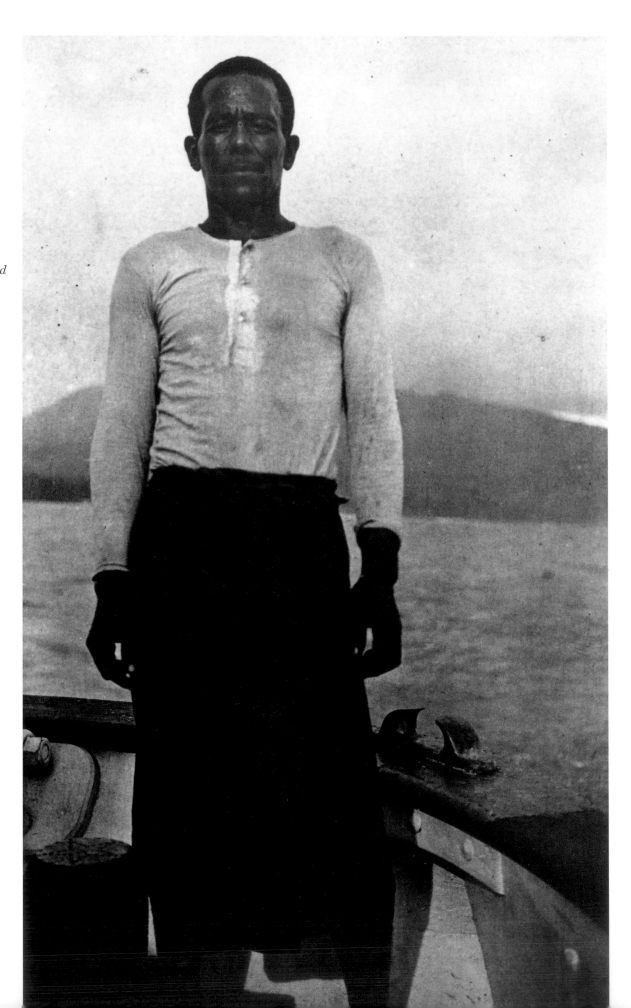

Tehei of Tahaa, 1908.

"Close to the beach, amid cocoanut palms and banana trees, erected on stilts, built of bamboo, with a grass-thatched roof, was Tehei's house. And out of the house came Tehei's vahine. . . . 'Bihaura,' Tehei called her. . . .

"She took Charmian by the hand and led her into the house, leaving Tehei and me to follow. Here, by sign-language unmistakable, we were informed that all they possessed was ours. No hidalgo was ever more generous in the expression of giving, while I am sure that few hidalgos were ever as generous in the actual practice. We quickly discovered that we dare not admire their possessions, for whenever we did admire a particular object it was immediately presented to us. The two vahines, according to the way of vahines, got together in a discussion and examination of feminine fripperies, while Tehei and I, manlike, went over fishing-tackle and wild-pig-hunting, to say nothing of the device whereby bonitas are caught on forty-foot poles from double canoes." (The Cruise of the Snark, *chapter 12)*

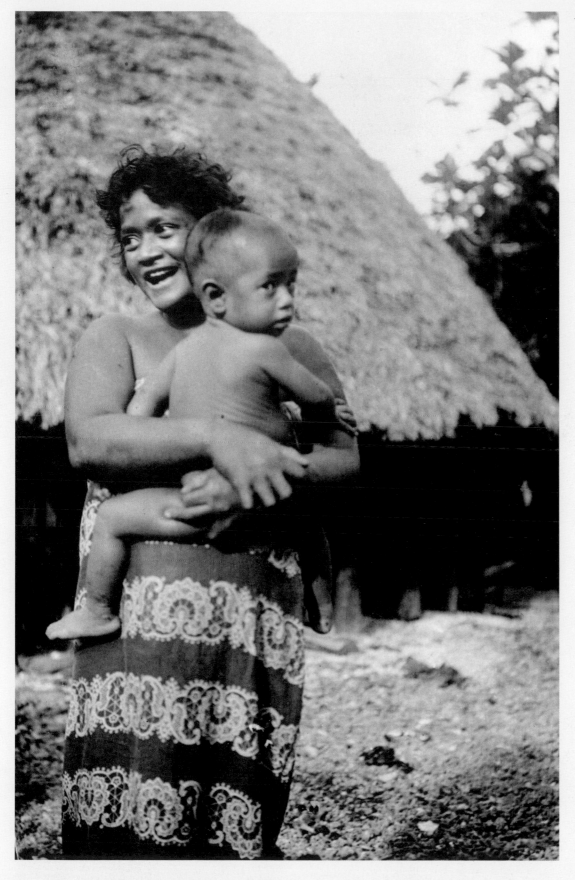

Mother and child, Samoa, 1908.

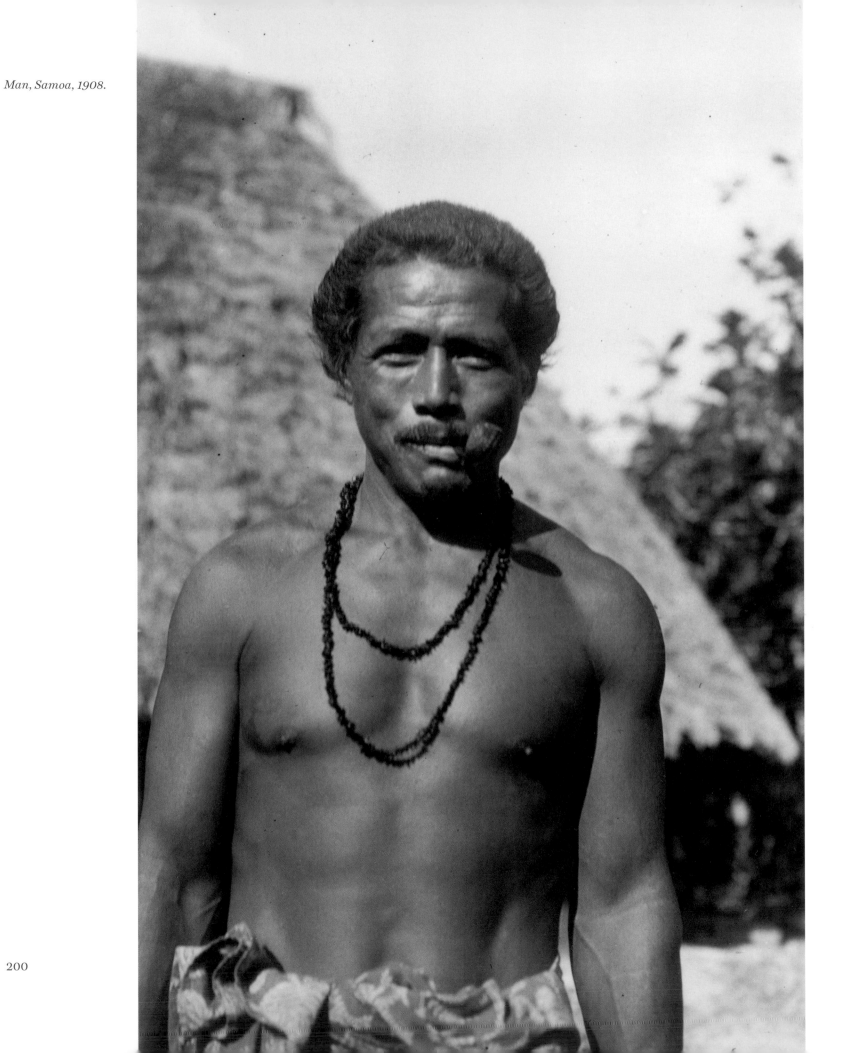

Man, Samoa, 1908.

200

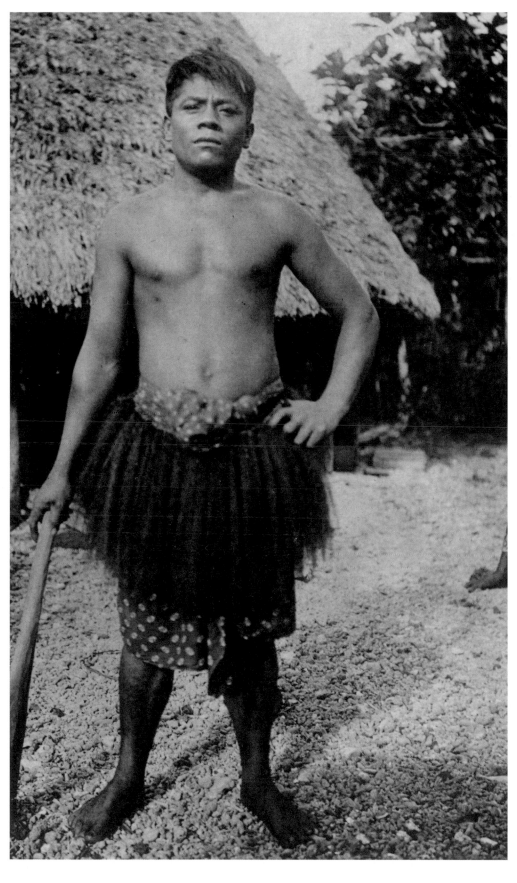

Youth, Samoa, 1908.

"His name was Mauki, and he was the son of a chief. He had three tambos. Tambo is Melanesian for taboo, and is first cousin to that Polynesian word. Mauki's three tambos were as follows: first, he must never shake hands with a woman, nor have a woman's hand touch him or any of his personal belongings; secondly, he must never eat clams nor any food from a fire in which clams had been cooked; thirdly, he must never touch a crocodile, nor travel in a canoe that carried any part of a crocodile even if as large as a tooth." ("Mauki," 1909)

Bob, a steward on Lord Howe Atoll, 1908.

"Mauki had no idea of the sort of master he was to work for. He had had no warnings, and he had concluded as a matter of course that Bunster would be like other white men, a drinker of much whiskey, a ruler and a lawgiver who always kept his word and who never struck a boy undeserved. Bunster had the advantage. He knew all about Mauki, and gloated over the coming into possession of him. The last cook was suffering from a broken arm and a dislocated shoulder, so Bunster made Mauki cook and general house-boy." ("Mauki," 1909)

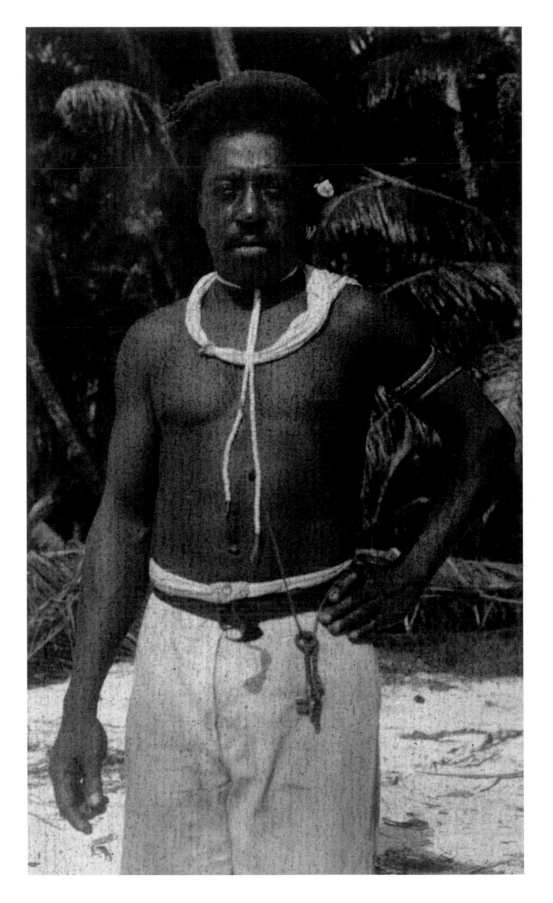

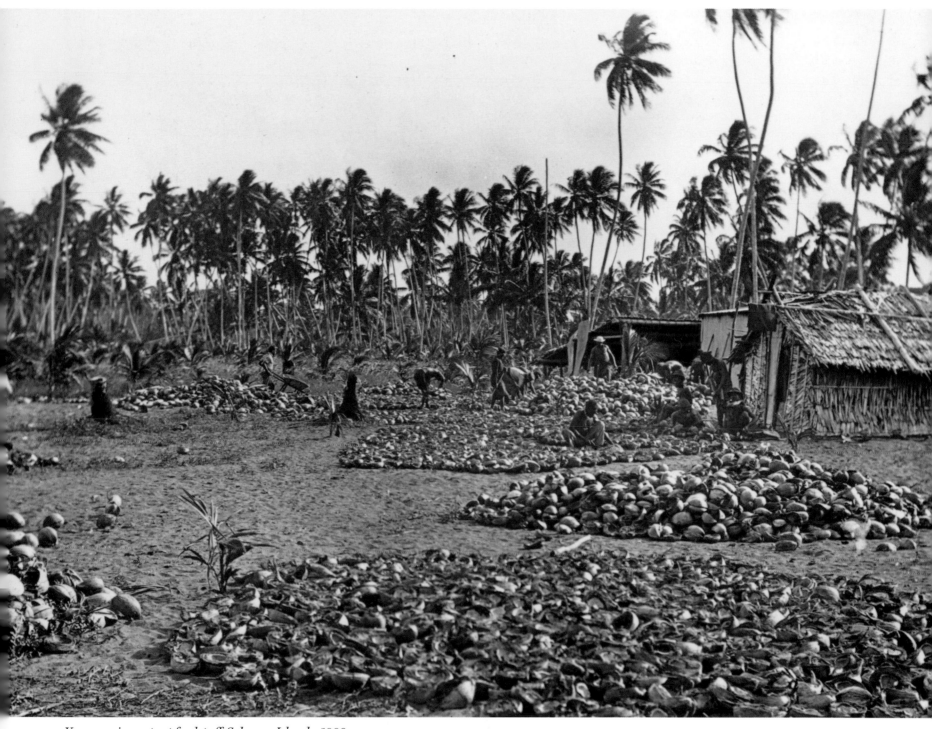

Yams, an important foodstuff, Solomon Islands, 1908.

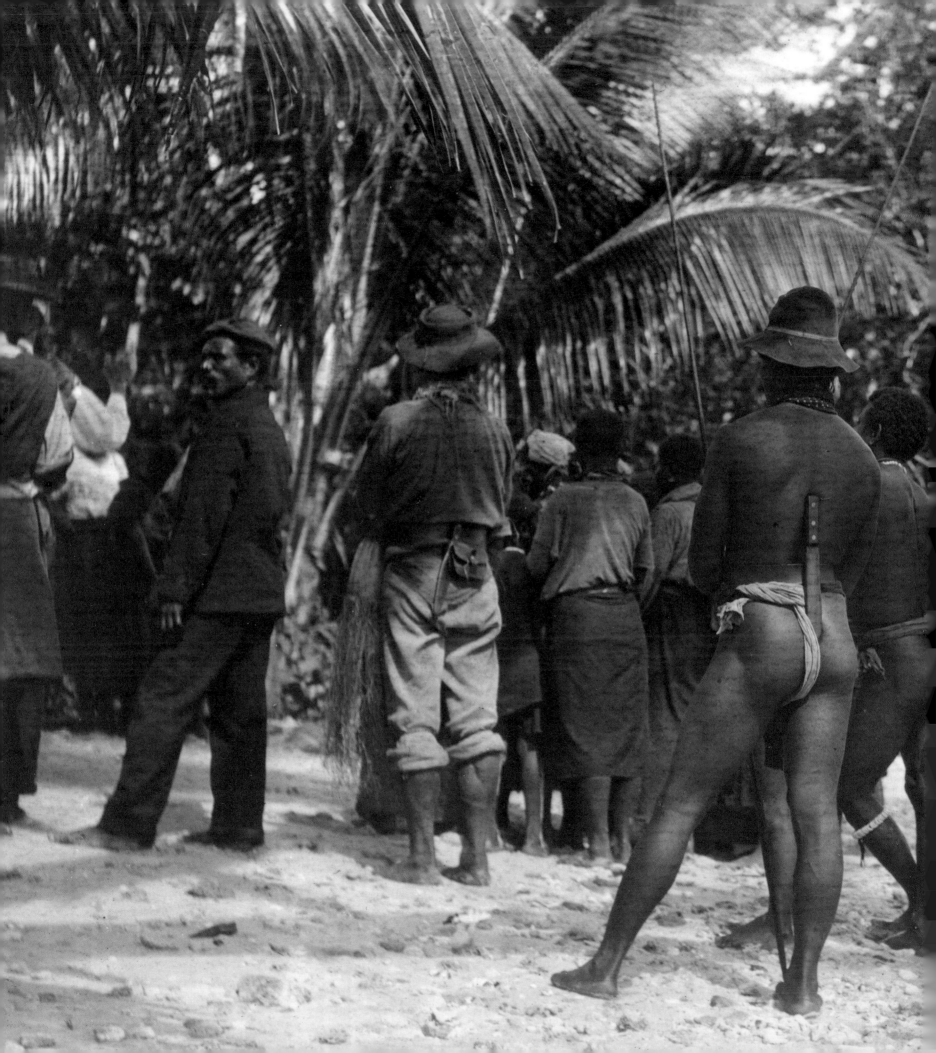

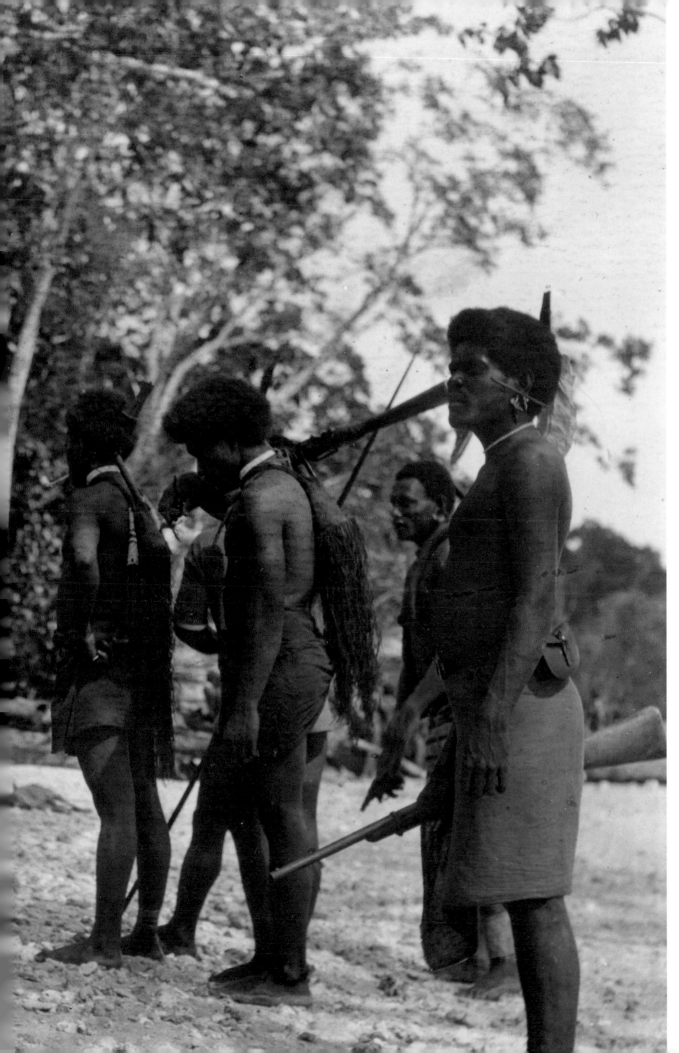

At the women's market,
Malaita, Solomon Islands,
1908.

"Some wild women Charmian their first white woman." Malaita, Solomon Islands, 1908. This photograph of Charmian caused problems between Jack and both the Woman's Home Companion *and Macmillan, which at first refused to print it in the published version of* The Cruise of the Snark. *The controversy did not involve naked villagers, but the fact that a white woman did not seem repulsed by them. (Note Charmian's bandage for yaws, or Solomon Island sores, and her revolver.)*

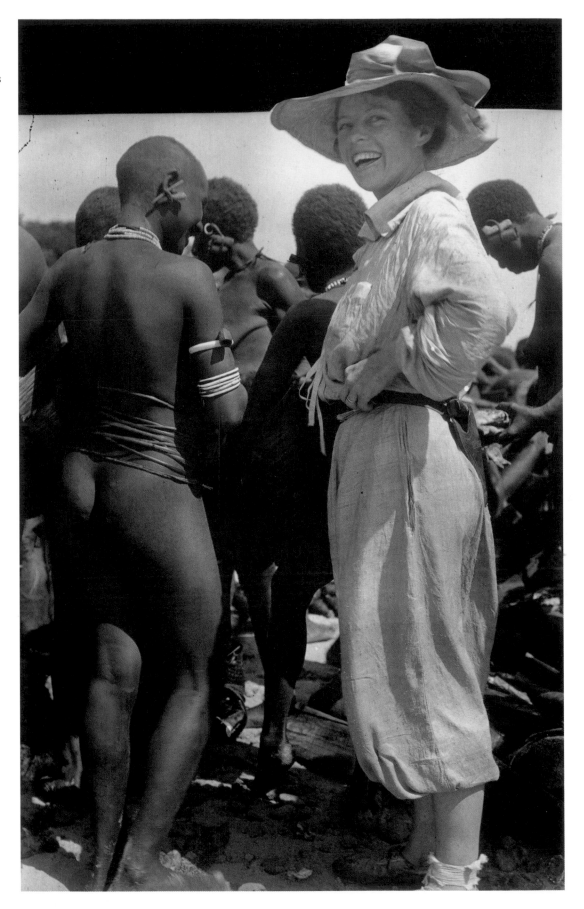

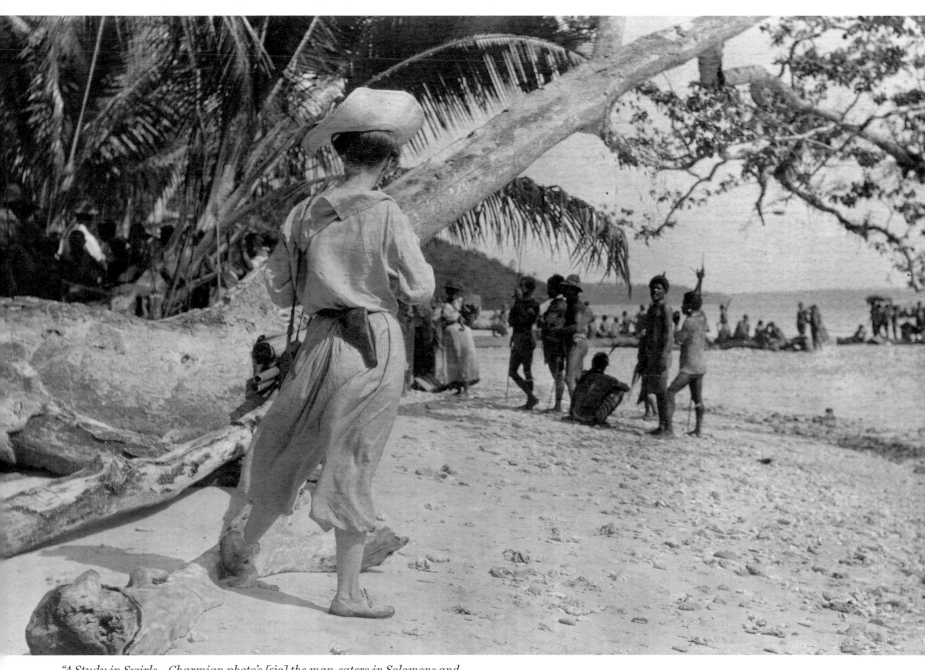

"A Study in Swirls—Charmian photo's [sic] the man-eaters in Solomons and Jack's not far behind her with his camera." Malaita, Solomon Islands, 1909.

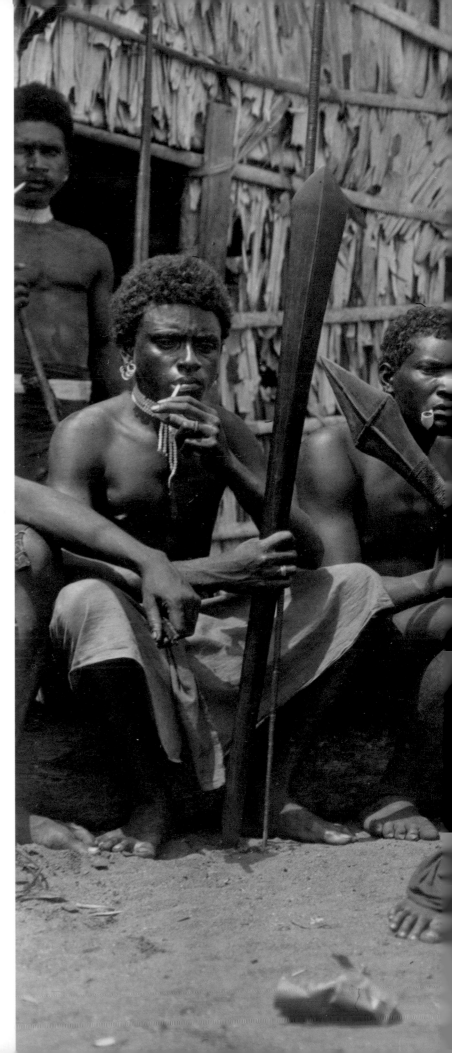

A family in front of their home, showing their prized possessions, including tobacco leaves, New Hebrides, 1908. London's photographic approach—a low-placed lens and a wide frame—captures the subjects' dignity.

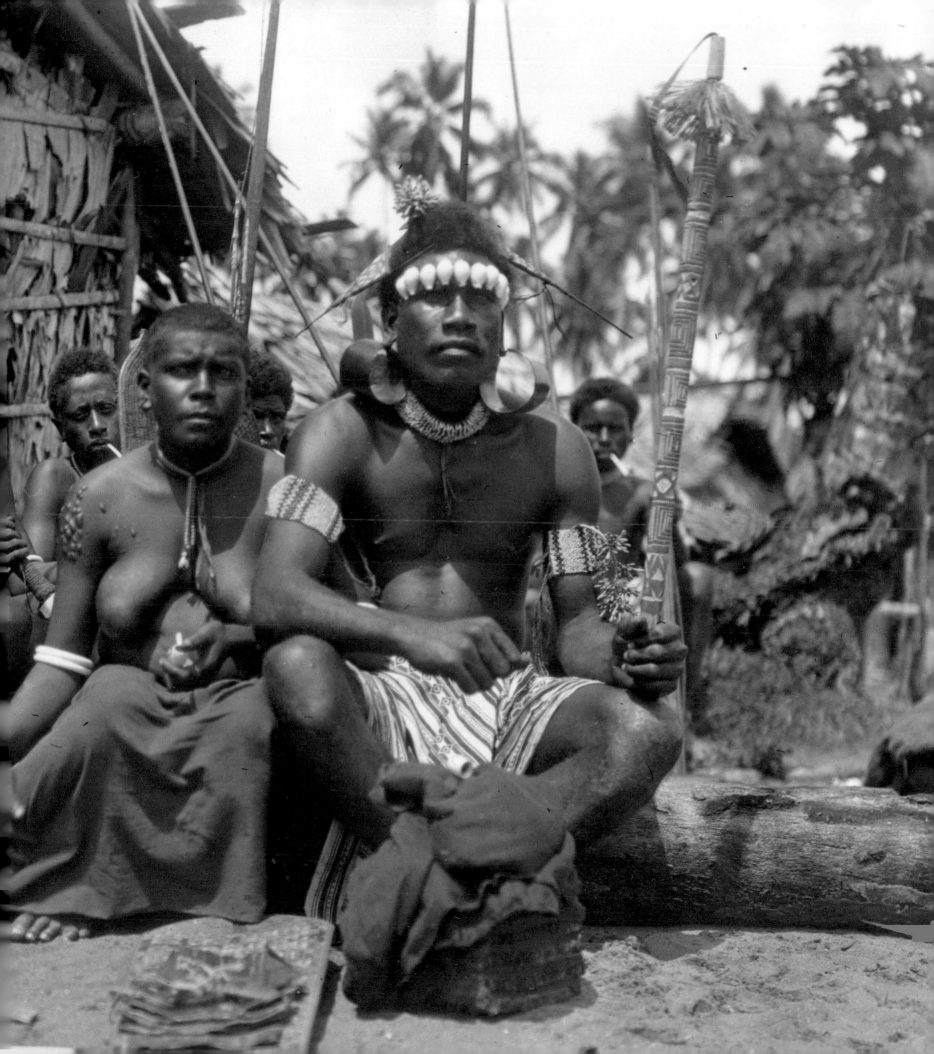

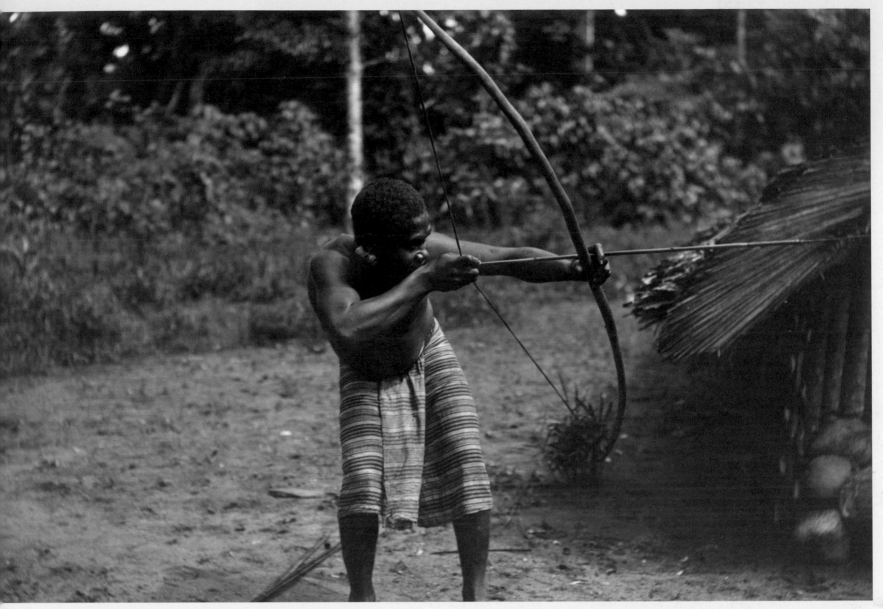

Boy with a bow, Solomon Islands, 1908.

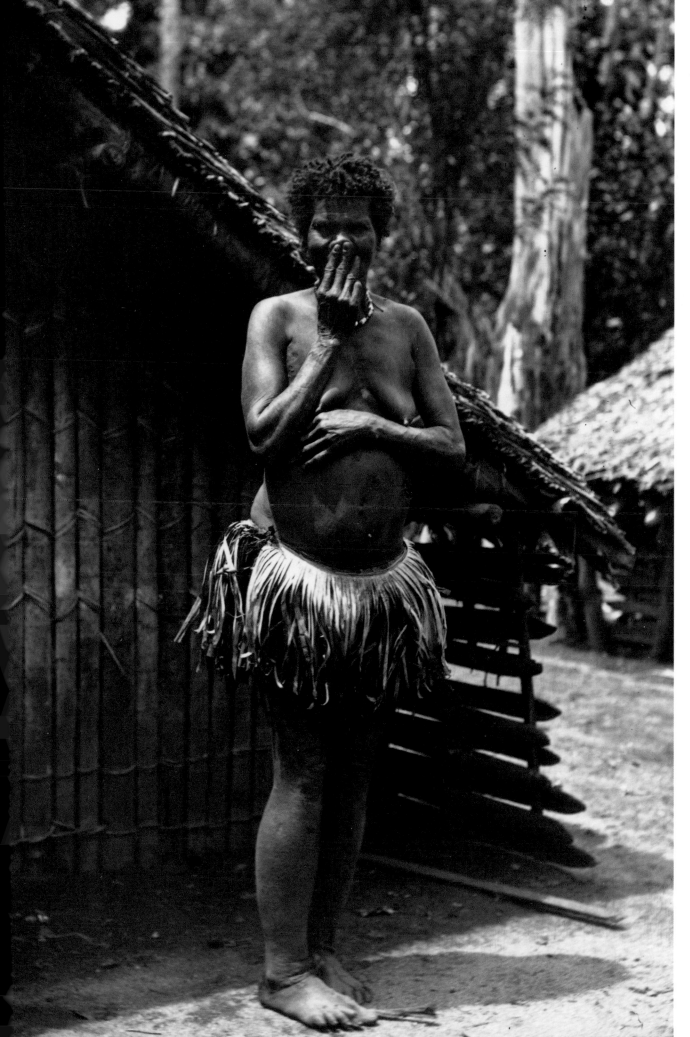

Three boys with game birds,
Solomon Islands, 1908.

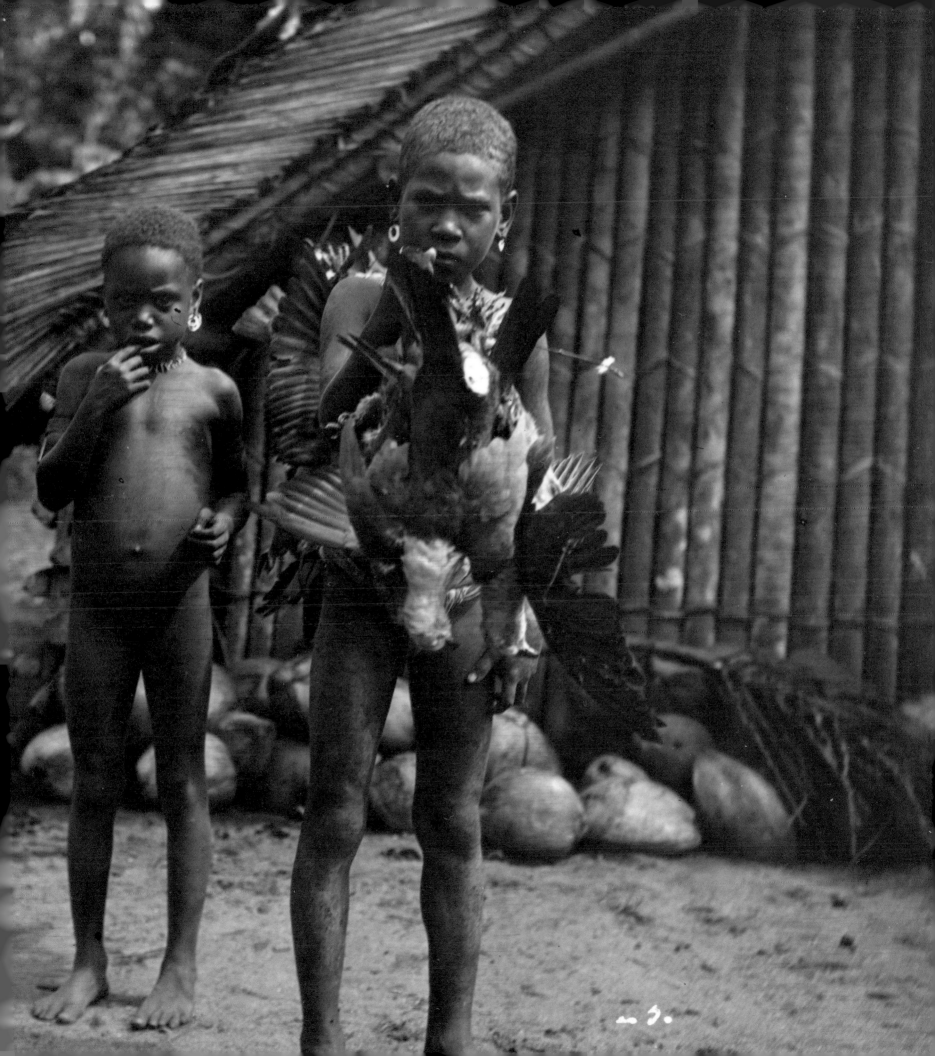

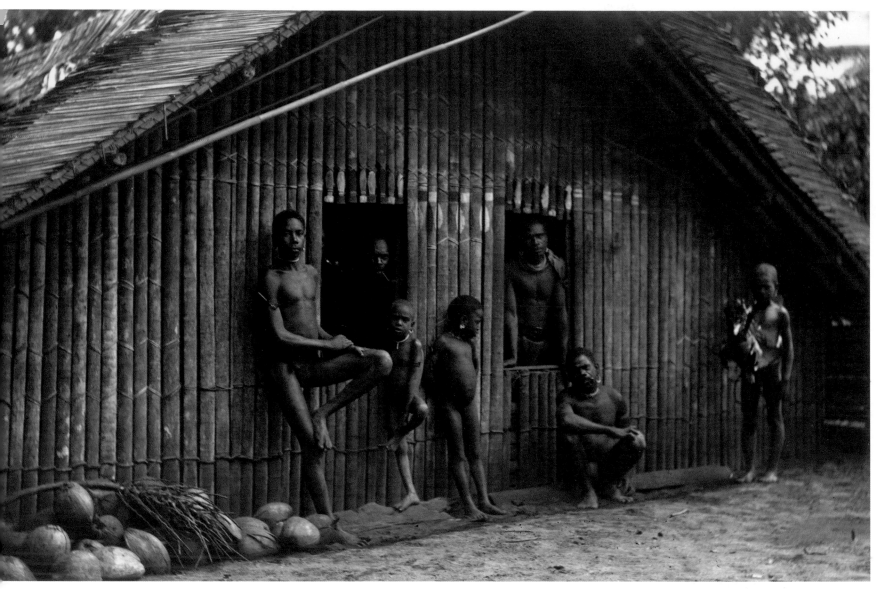

A family at home, Solomon Islands, 1908.

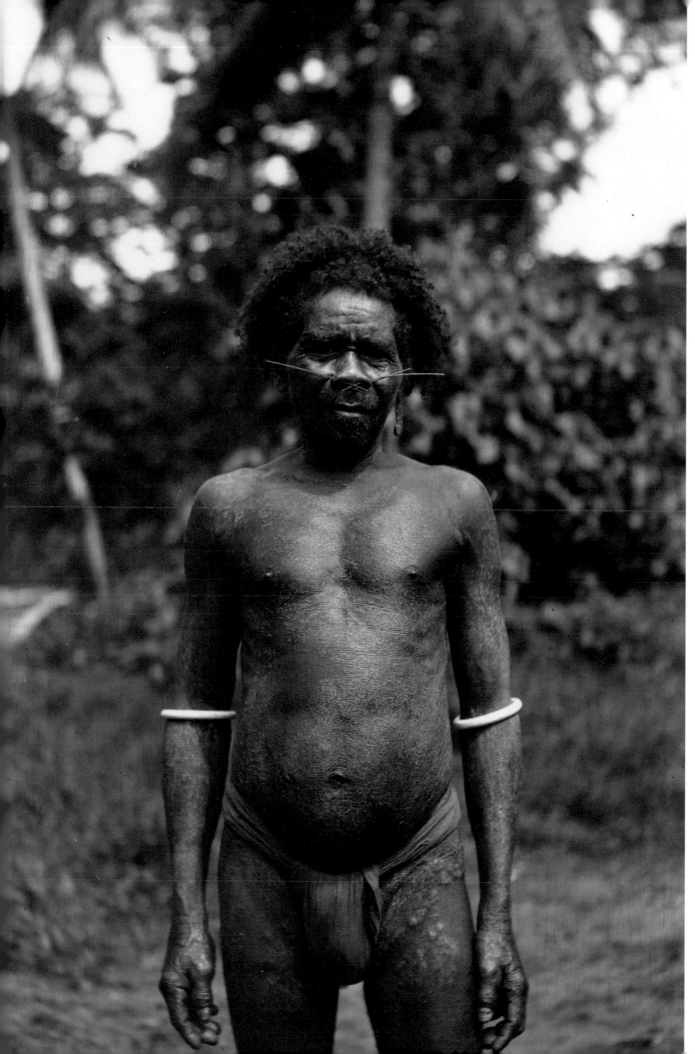

Solomon Islander with piercings and bracelets, Port Mary, Santa Anna Island, Solomon Islands, 1908.

"[His] ears were pierced, not in one place, nor two places, but in a couple of dozen places. In one of the smaller holes he carried a clay pipe. The larger holes were too large for such use. The bowl of the pipe would have fallen through. In fact, in the largest hole in each ear he habitually wore round wooden plugs that were an even four inches in diameter. . . . In the various smaller holes he carried such things as empty rifle cartridges, horseshoe nails, copper screws, pieces of string, braids of sennit, strips of green leaf, and, in the cool of the day, scarlet hibiscus flowers. From which it will be seen that pockets were not necessary to his well-being." ("Mauki," 1909)

George Darbishire and Tom Harding
in lava-lavas, Penduffryn Plantation,
Guadalcanal, Solomon Islands, 1908.

"Nevertheless, at Goboto, they tried to be gentlemen.
. . . That was why the great unwritten rule of Goboto
was that visitors should put on pants and shoes.
Breech-clouts, lava-lavas, and bare legs were not
tolerated. When Captain Jensen, the wildest of the
Blackbirders though descended from old New York
Knickerbocker stock, surged in, clad in loin-cloth,
undershirt, two belted revolvers and a sheath- knife,
he was stopped at the beach. . . . Captain Jensen
stood up in the sternsheets of his whaleboat and
denied the existence of pants on his schooner. Also,
he affirmed his intention of coming ashore. They of
Goboto nursed him back to health from a bullet-hole
through his shoulder, and in addition handsomely
begged his pardon, for no pants had they found on
his schooner." ("A Goboto Night," 1911)

(facing page)
Tom Harding, a partner in Penduffryn Plantation,
Guadalcanal, Solomon Islands, 1908.

"Schemmer, Karl Schemmer, was a brute, a brutish
brute. But he earned his salary. He got the last
particle of strength out of the five hundred slaves;
for slaves they were until their term of years was
up. Schemmer worked hard to extract the strength
from those five hundred sweating bodies and
to transmute it into bales of fluffy cotton ready
for export. His dominant, iron-clad, primeval
brutishness was what enabled him to effect the
transmutation. Also, he was assisted by a thick
leather belt, three inches wide and a yard in length,
with which he always rode and which, on occasion,
could come down on the naked back of a stooping
coolie with a report like a pistol-shot. These reports
were frequent when Schemmer rode down the
furrowed field." ("The Chinago," 1909)

Martin Johnson and a Solomon Islander, Guadalcanal, 1908. (Note Martin's bandage for yaws.)

"Now folks I will need a big enlargement of the Snark, and I want to enlarge several of the pictures that I am using in slides, these pictures are all for lobby display, then I MUST have something to fill out my men[-]only show for I have not enough and it means big money to me to get it in good shape and I want something that I know you put a high value on but I want them bad, in fact if I cant get them it will seriously cripple my new show, you know I cant fake so much in New York for some one is liable to catch me and I have got to have everything strictly South Sea Island." (Martin Johnson to Jack London, December 7, 1912)

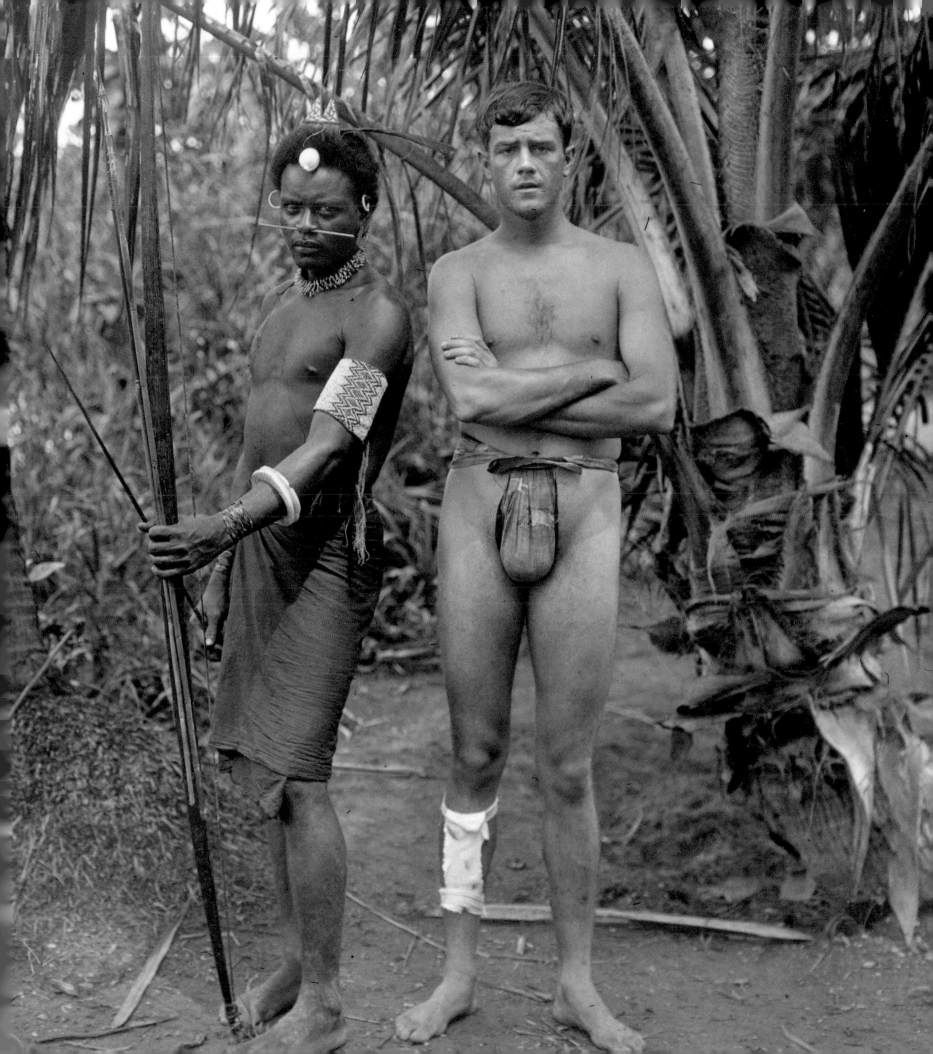

5 :
THE VOYAGE OF THE *DIRIGO*, 1912

I n 1911, the Londons decided to enlist as crew members aboard a sailing ship that was to round Cape Horn on a five-month trip from Baltimore to Seattle. They wanted to get away from the distractions of letters and telegrams, parties and alcohol, the press, lawyers, and publishers—and their decision seems to have come in the nick of time. Once they were underway, Charmian threw Jack's cigarettes and liquor overboard, and after bitter complaints, he joined her in boxing, reading, climbing the yardarms, and, finally, relaxing. His old productivity returned.

The ship was the *Dirigo*, a three-thousand-ton four-masted barque that had been launched seventeen years before in Maine as the first steel windjammer—in fact, it was the first steel sailing vessel built in the United States. Constructed by Arthur Sewall and Company in Bath, Maine, the ship measured 3,005 gross tons, had a registered length of 312 feet, and held masts that were 200 feet tall. "*Dirigo*" is the state motto of Maine (Latin for "I direct" or "I lead"). Jack was third mate, Charmian was a stewardess, and their valet, Yoshimatsu Nakata, was assistant steward.

On the day before they were to sail from Baltimore, after an all-night bender, Jack showed up at the hotel rooms with his head shaved. Charmian was furious. What, she wondered, would people think? According to her, Jack merely "tittered" at her reaction. He said, "'Oh, now, don't feel badly, Mate Woman. . . . It is such a good rest for my head—I often did it in the old days, at sea and around.'"[1] His bow to the hygiene of the seas (sailors shaved their heads to keep away lice and other pests) and his gesture of self-abnegation were lost on her: "It was the last straw in a hard winter, to mix a metaphor. I wept uncontrollably for nearly three hours." She grabbed a pair of scissors and sheared off eight inches of her own hair in retaliation. She records that "I did not look directly at Jack again until there was at least half an inch of hair on his head."[2] In a photograph taken that afternoon at a ceremony honoring Edgar Allan Poe's grave, Jack wears a sheepish expression and a hat that appears to be a couple of sizes too big for him, resting on his ears almost down to his eyes. The only ray of light on that day was a new puppy they purchased, Possum, a fox terrier that became a favorite pet at the ranch. On March 1, after stopping to buy Jack a stocking cap, they caught up with the *Dirigo* a few miles out in Chesapeake Bay.

The *Dirigo* was under the command of Captain Omar E. Chapman, who died of stomach cancer shortly after the ship's arrival in Seattle. He was nursed by Charmian on the voyage, and the Londons were very fond of him. The *Dirigo* arrived in Seattle on July 26, 1911.

On this adventure, Jack enjoyed mingling with the crew and also gathered ideas

for *The Mutiny of the Elsinore* (1914), made notes for *John Barleycorn* (1913), and finished *The Valley of the Moon* (1913) and shorter works. Charmian typed his manuscripts and made notes for him on a character's pregnancy in *The Valley of the Moon*; Nakata was proud that he too started doing some of the typing for London. They all enjoyed the voyage, but were ill early on (with what they thought was hives but turned out to be only bedbugs); memories of the serious diseases caught on the *Snark* trip gave them a fright. They survived several gales and spent two weeks trying to round Cape Horn, repeatedly getting close but then being blown backward by storms. On May 20, they at last succeeded.

In Charmian's unpublished diary of the voyage, she writes how, for the two of them, on the *Dirigo* "our machinery of life, shot with love, resumes." She nostalgically compares the trip to the *Snark* voyage, grateful that "[w]e move in beauty" under southern sunsets and constellations. She records their reading to each other August Strindberg and Henry James. She relates their feelings over the loss of their infant, Joy, in 1910 and of their hope to conceive another child. One of her most characteristic passages depicts the two of them on deck late at night:

(right)
The Dirigo. *(Used by permission of the Maine Maritime Museum)*

(below)
Jack London aboard his sailboat the Roamer, *ca. 1910.*

I went on the main deck later and found it bright moonlight. So I had to rout my man. Together we trudged to the fore, to look back upon the swaying sprays of tight white pearls gleaming in the dazzling radiance. One simply is cowed by the impossibility of wording what one sees and feels in the bows of a wind-propelled vessel. The first means made by man, by man the sailor—himself the original adventurer in the civilizing of other peoples. I looked at Jack London, there beside me. His short-Greek face was upturned, and his deep-sea eyes were wide upon the unspeakable glory from deck to maintruck, of those snowy flowering petals of pearl. Presently he came back and looked at me. Jack said: "*Is* it *Possible*, Mate Woman, that we are seeing this together, and have been together on this full-rigged ship, have made our Westing around Cape Horn— our dream since childhood?"[3]

Charmian's touching word-picture is a fitting tribute to the photographs and stories Jack made about the trip. He made dozens of photographs aboard the *Dirigo*, including shots that capture terrifying storms, gigantic seas, and the rounding of Cape Horn, but also photographs of men working on the ship (repairing sails, hauling long lines, removing and replacing sails, and making the dizzying climbs to the crossbeams to let down or draw up huge mainsails) as well as portraits of officers and crewmen. Jack shared in the common workload: even though he was third mate, he helped turn the capstan to raise or lower the anchor and to haul in line for the sails. It is ironic that he later portrayed the crew of the fictional *Elsinore* as mutinous misfits, for his actual experience on the *Dirigo* gave him nothing but respect for the multicultural crew he knew, worked alongside with, and photographed.

Many of London's photographs from the *Dirigo* could not be reproduced for this book, because of damage or poor exposure, but the few that were salvageable are arresting.

Cape Horn from the Dirigo, *May 1912.*

"'Cape Horn on the starboard bow!' on May 10, was the most exciting tocsin, next to a savage war conch, I had ever awakened to.

"'Gee—you folks are lucky,' Mr. Mortimer exclaimed, as, wrapped in heavy coats, we clung to the poop-rail and actually gazed upon the Cape. 'I tell you, I've made this passage more times than I can remember, and I haven't laid eyes on that there island since 1882! The fog has never raised.' And the day before, conditions being favorable for the risky feat, the Captain had been able to reduce time by passing through the Straits of Lemaire, instead of going around Staten Island. It was exciting business, made more breathless by sight of a great wreck, standing stark upright in her doom of shallow water off the mainland.

"'Our farthest south was Lat. 57°32', Lon. 67°28'. And though we had some little difficulty 'making westing' and were driven back time and again, our traverse 'from 50 to 50' was but fifteen days, which is almost better than a master mariner dare hope." (Charmian London, The Book of Jack London, *2:241)*

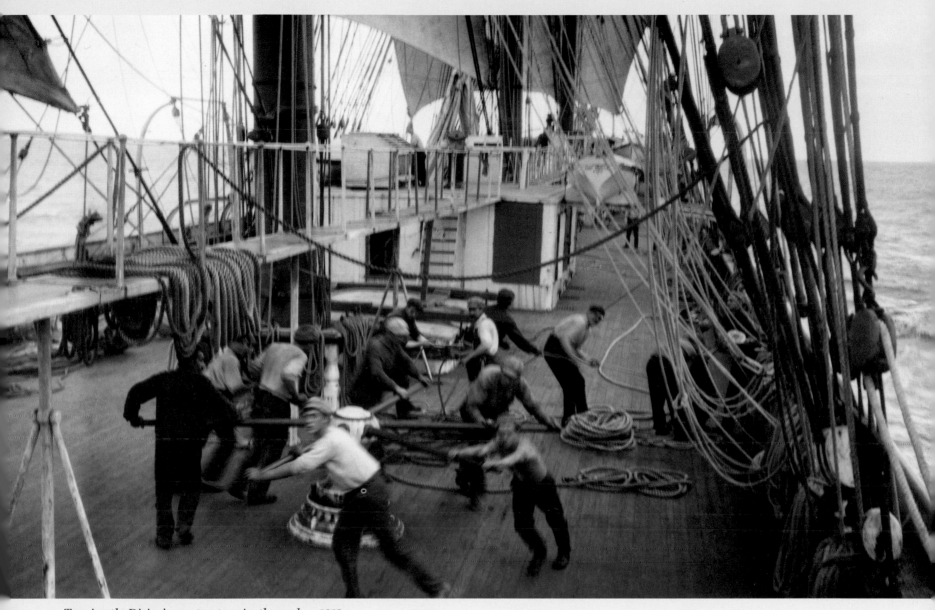

Turning the Dirigo's *capstan to raise the anchor, 1912.*

The Dirigo's *Chinese sailmaker, 1912.*

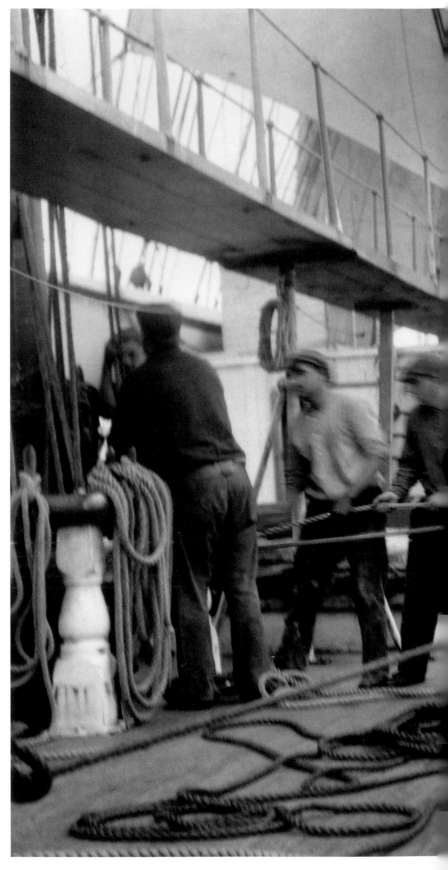

Hauling line on the Dirigo, 1912.

"Mr. Pike's voice interrupted my musings. From for'ard, on the main deck, I heard him snarl:

"'On the main-topsail-yard, there!—if you cut that gasket I'll split your damned skull!'

"Again he called, with a marked change of voice, and the Henry he called to I concluded was the training-ship boy.

"'You, Henry, main-skysail-yard, there!' he cried. 'Don't make those gaskets up! Fetch 'em in along the yard and make fast to the tye!'

"Thus routed from my reverie, I decided to go below to bed. As my hand went out to the knob of the chart-house door again the mate's voice rang out: 'Come on, you gentlemen's sons in disguise! Wake up! Lively now!'" (The Mutiny of the Elsinore, *1914*

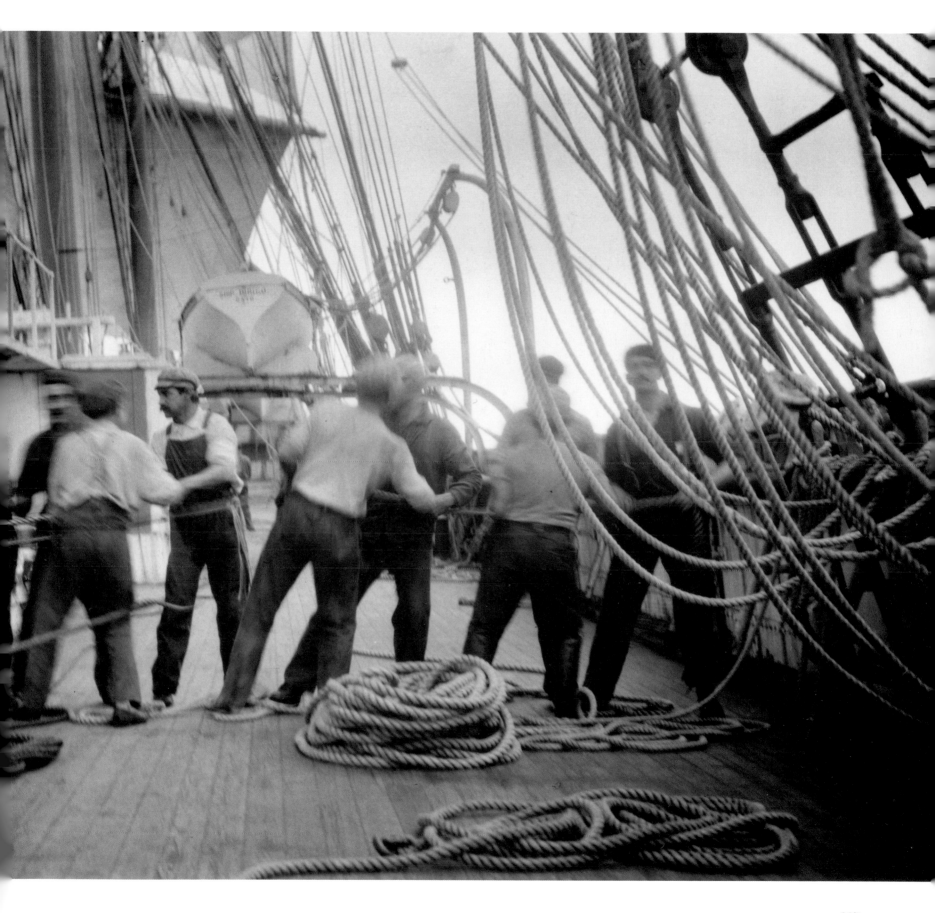

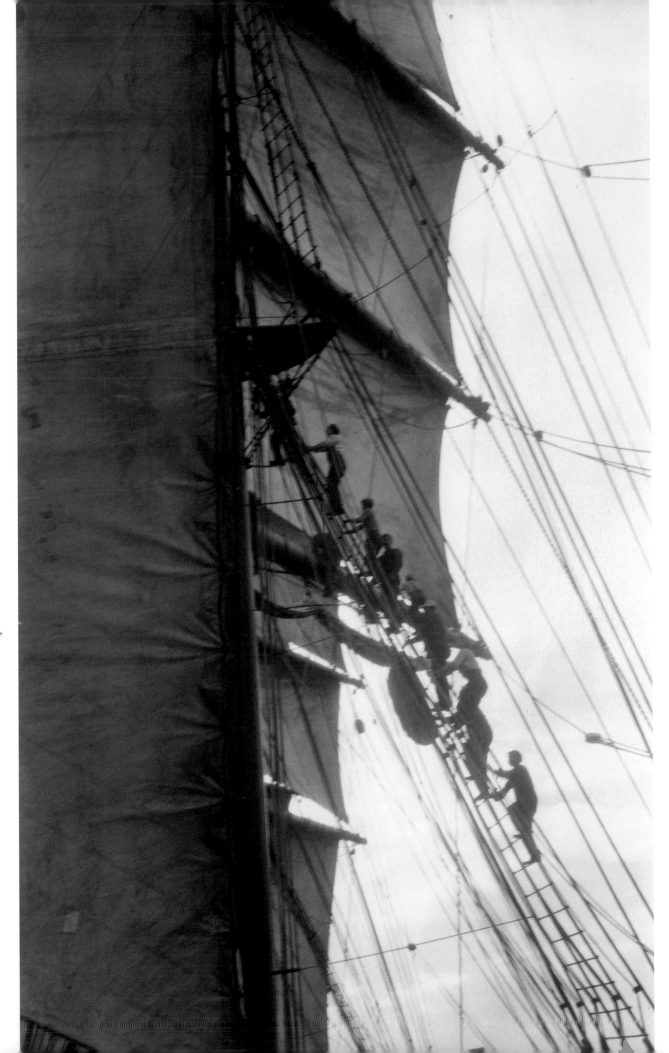

Sailors climbing the *Dirigo's* rigging, 1912.

"'Better rig that storm-trysail on the main, and a storm-jib,' Grief said to the mate. 'And put all the reefs into the working canvas before you furl down. No telling what we may need. Put on double gaskets while you're about it.'

"In another hour, the sultry oppressiveness steadily increasing and the stark calm still continuing, the barometer had fallen to 29.70. The mate, being young, lacked the patience of waiting for the portentous. He ceased his restless pacing, and waved his arms.

"'If she's going to come let her come!' he cried. 'There's no use shilly-shallying this way! Whatever the worst is, let us know it and have it! A pretty pickle—lost with a crazy chronometer and a hurricane that won't blow!'" ("A Little Account with Swithin Hall," 1911)

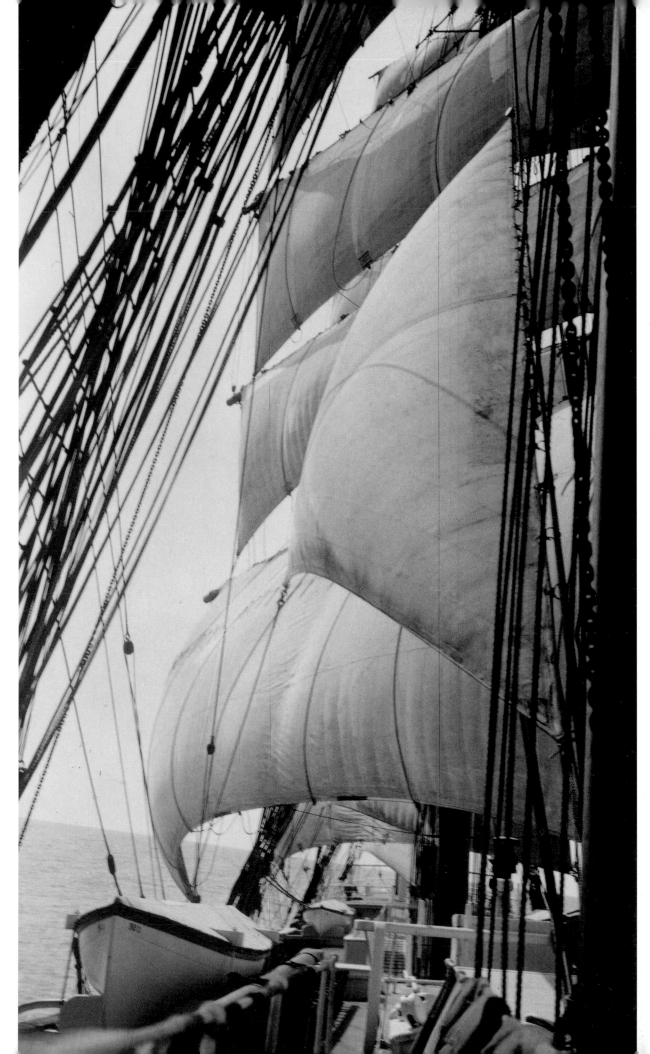

The Dirigo's sails
and deck, 1912.

"Day had come, and the
sun should have been up an
hour, yet the best it could
produce was a sombre semi-
twilight. The ocean was a
stately procession of moving
mountains. A third of a mile
across yawned the valleys
between the great waves. Their
long slopes, shielded somewhat
from the full fury of the wind,
were broken by systems of
smaller whitecapping waves,
but from the high crests of
the big waves themselves the
wind tore the whitecaps in the
forming. This spume drove
masthead high, and higher,
horizontally, above the surface
of the sea." ("A Little Account
with Swithin Hall," 1911)

229

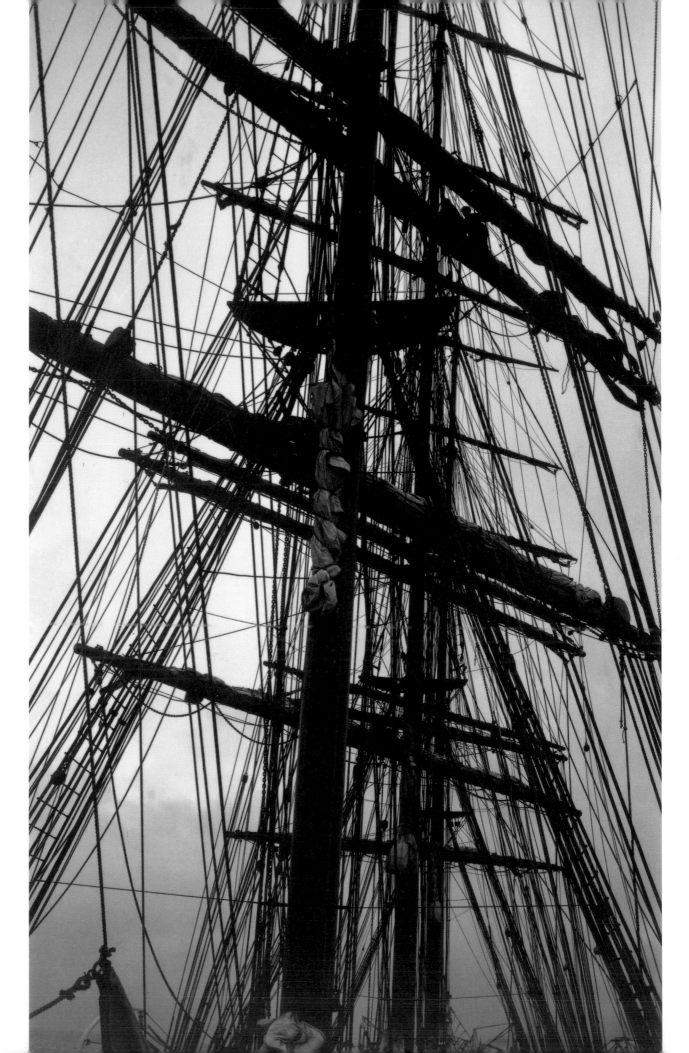

The Dirigo's *rigging, 1912.*

*"Here is the sea, the wind,
and the wave. Here are
the seas, the winds,
and the waves of all the
world. Here is ferocious
environment. And here
is difficult adjustment,
the achievement of which
is delight to the small
quivering vanity that is I.
I like. I am so made. It is
my own particular form
of vanity, that is all."*
(The Cruise of the Snark,
chapter 1)

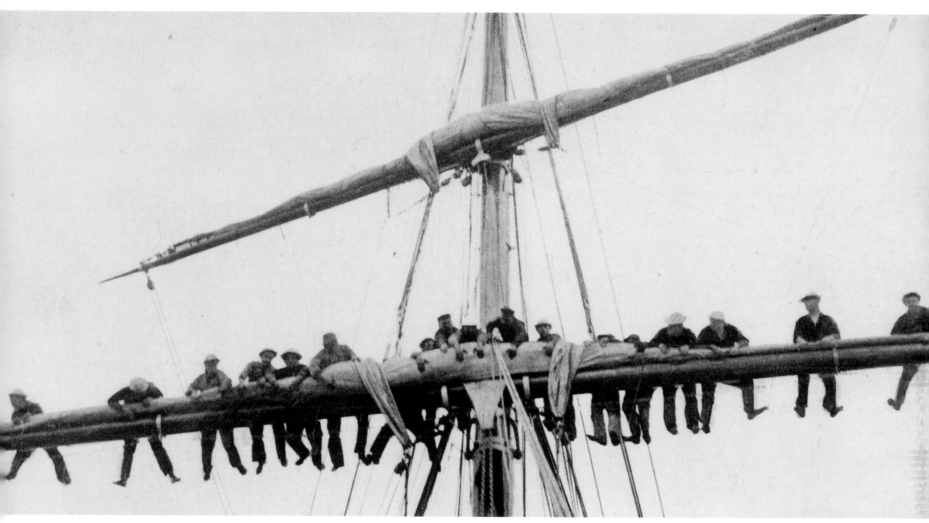

On the crossbeam of the Dirigo, *1912.*

"I looked aloft at the vast towers of canvas. Our four masts seemed to have flowered into all the sails possible, yet the sailors beneath us, under Mr. Mellaire's direction, were setting triangular sails, like jibs, between the masts, and there were so many that they overlapped one another. The slowness and clumsiness with which the men handled these small sails led me to ask:

"'But what would you do, Mr. Pike, with a green crew like this, if you were caught right now in a storm with all this canvas spread?'

"He shrugged his shoulders, as if I had asked what he would do in an earthquake with two rows of New York skyscrapers falling on his head from both sides of a street.

"'Do?' Miss West answered for him. 'We'd get the sail off. Oh, it can be done, Mr. Pathurst, with any kind of a crew. If it couldn't, I should have been drowned long ago.'" (The Mutiny of the Elsinore, chapter 9)

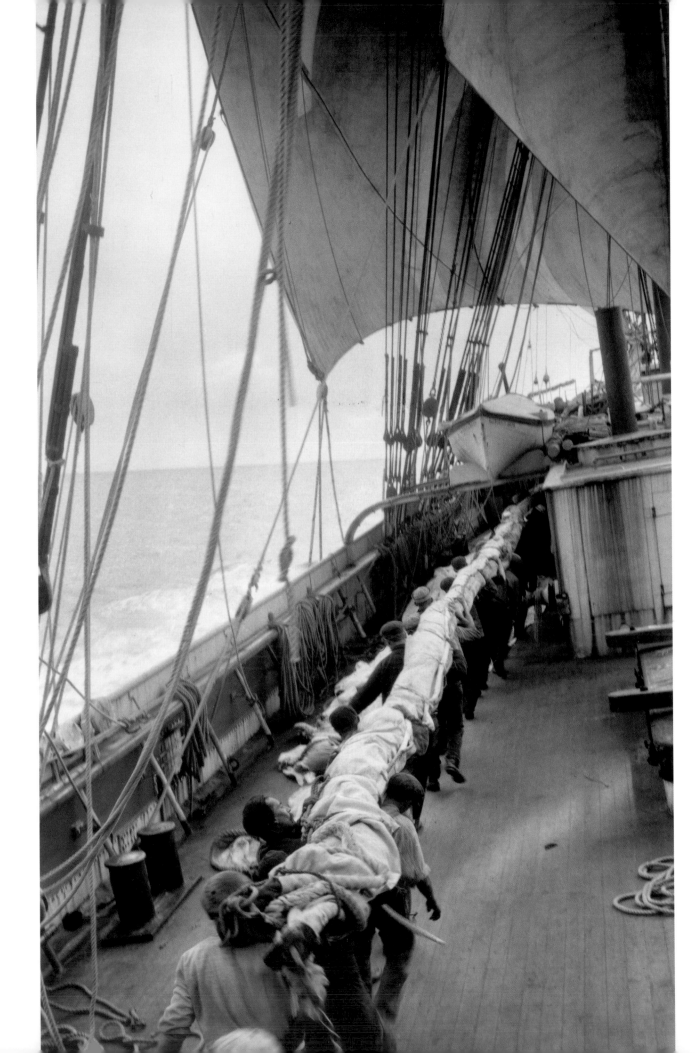

Carrying a furled sail on the Dirigo, *1912.*

Dirigo *mate, 1912.*

Dirigo *crewman, 1912.*

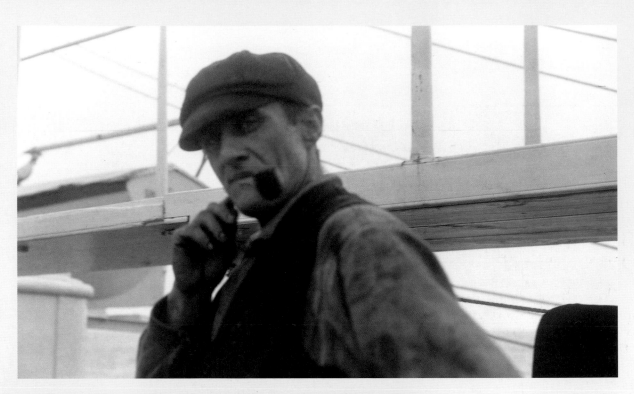

(right)
Dirigo *sailor, 1912.*

(below)
Dirigo *cook, 1912.*

234

Young Dirigo *crew member, 1912.*

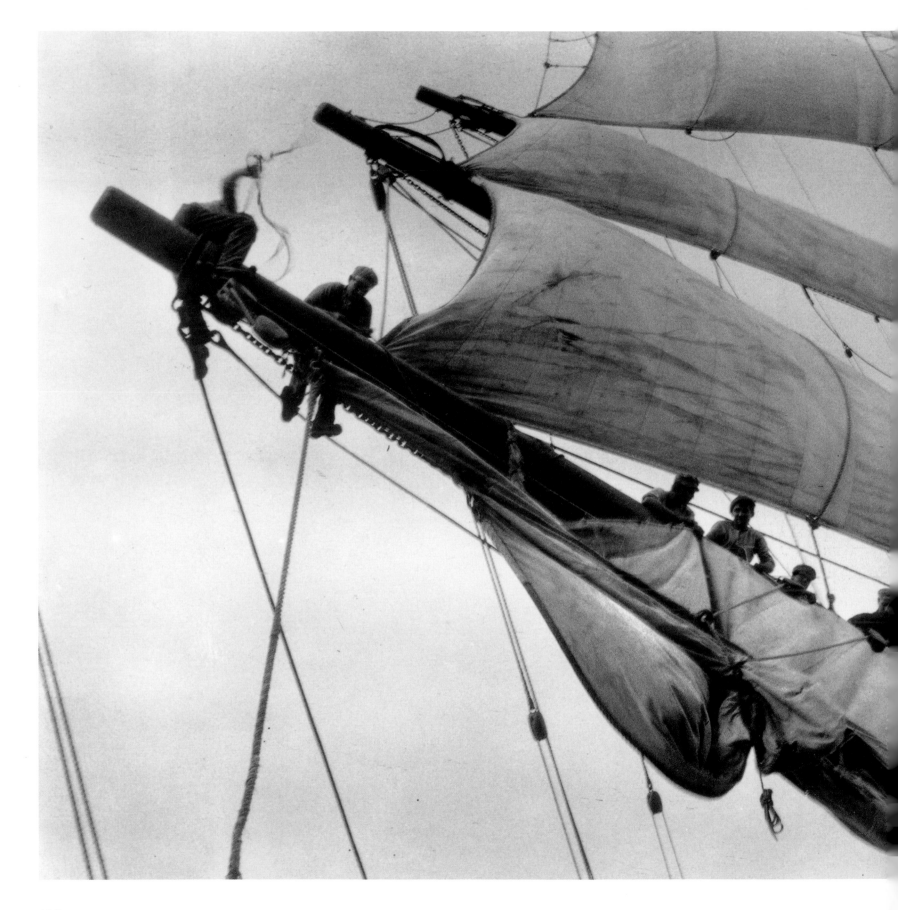

Sailors on a crossbeam of the Dirigo, *1912.*

Climbing one of the Dirigo's four tall masts, 1912.

The Londons had planned a long trip to Japan for 1914, but on April 15, *Collier's* offered London eleven hundred dollars a week plus expenses to go to Veracruz and cover the likely American occupation of the port.[1] When the magazine agreed to pay for Charmian too, he took the job. They would remain in Mexico until June of that year. With Nakata, they left from Oakland on the Southern Pacific for Los Angeles, El Paso, and Galveston. London was glad to meet up with war correspondent friends from the Russo-Japanese War days, including Richard Harding Davis, Jimmie Hare, Robert Dunn, and Frederick Palmer. Yet he almost didn't make it to Mexico: some socialists had circulated a pamphlet titled "The Good Soldier," which attacked the armed forces and bore London's name. Davis, who had helped London get out of a court-martial in Japan, again came to London's defense and managed to convince General Frederick Funston, the leader of the U.S. forces, that London should be allowed aboard the transport ship assigned to carry correspondents to Veracruz. As proof that London was not the author of the broadside, Davis explained that London not only disavowed it, but he also couldn't have written it because of its poor grammar.

London's public position vis-à-vis the war was important to several groups, as would be his stance on World War I. Socialists expected London to condemn U.S. intervention, but he supported it because he felt the Mexican rulers had made a mess of their country, especially for the peasants. To complicate matters, as Charmian records in her biography,

All this time, busy working and playing in Vera Cruz, waiting while Washington held the army and navy bound in port, Jack, according to rumor in the capitalist press of the United States, was leading a band of insurrectos somewhere in the north of Mexico! Rumor, did I say? The large headlines read: JACK LONDON LEADS ARMY OF MEXICO REBELS. That some one was making use of his name, however, seems probable; for later on we heard of persons who had met "Jack London" in Mexico and in Lower California. And an American firm dealing in artist's materials, waited for years for this or another spurious Jack London in Mexico to settle his account.[2]

In the end, there turned out to be little military action for London to cover—most of the fighting took place during a single day, April 21—and he was beginning to suffer from kidney disease, which would kill him two years later. Beyond the initial

6 :
THE
MEXICAN
REVOLUTION,
1914

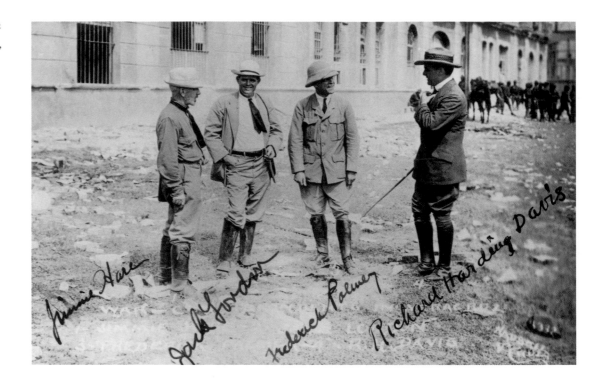

"The same old bunch." Mexican Revolution correspondents (left to right) *Jimmie Hare, Jack London, Frederick Palmer, Richard Harding Davis. Signed by each. Veracruz, Mexico, 1914. Unknown photographer.*

shelling of the Naval Academy and various raids and arrests by the Americans, and some skirmishes between the Federals and the Constitutionalists on the Mexican side, London again had to seek out the "human documents" or details of life during wartime in the streets, the prisons, and the law courts. As far as "action shots," he made a few when he helped rescue American and Constitutionalist refugees in Tampico and participated in some minor raids:

> Before I knew what was happening, I found myself in the company of 500 of the Constitutionalists, dispatched to aid in the pursuit of General Zaragoza and his 4,000 Federals. . . . There were boys of ten, eleven, and twelve, magnificently and monstrously spurred, astride lifted broncos, with pictures of saints in their sombreros and looted daggers and bowie knives in their leggings. . . . And there were women, young women all, mere soldaderas as well as amazons, the former skirted and on sidesaddles, the latter trousered and cross saddled, and all of them wickedly armed like their male comrades, and none of them married. When a soldadera comes along I should not like to be a stray chicken on the line of march nor a wounded enemy on the field of battle.[3]

In Veracruz, he photographed prisoners in San Juan de Ulúa prison, Mexican and American military officers, soldiers, and various politicians. Most of his pho-

tographs were taken at the dismal and deadly prison, where Huerta's soldiers were keeping revolutionary prisoners awaiting execution. It was truly an eye-opening experience, but, unfortunately, the negatives are scarce and much damaged (as reflected in the few printed here). As Charmian records in her biography, "There were visits to San Juan de Ulua, with its spew of filthy, dehumanized prisoners, whom, with their unthinkable dungeons, our navy cleansed and deodorized. Some of these unfortunates had no faintest notion as to what, if any, offense had condemned them to that living burial below sea level. Others recited haltingly the most trivial of incidents that had doomed them to exist for years without standing-room or light."[4] But she also records London's comparison of Mexican and U. S. prisons: "'Pretty awful, isn't it? — But don't forget, Mate,' Jack, who never forgot anything, would point out, 'that we ourselves aren't half-civilized yet, in our treatment of convicts.'"[5]

London was able through interpreters to interview some of the prisoners, and his photographs reflect that interaction. Rather than reflecting some "official" point of view of a white American, the photographs speak to London's sense of humanity and his role as a social documentarian.

In his written dispatches for *Collier's*, London attacks the rulers of Mexico but expresses sympathy for its peasants, whom he calls "peons": "Changes of government mean to the peon merely changes of the everlasting master. His harsh treatment and poorly rewarded toil are ever the same, unchanging as the sun and seasons. He has little to lose and less to gain. He is born to an unlovely place in life. It is the will of God, the law of existence."[6] Upon visiting San Juan de Ulúa, he was led to observe:

Jack London in Veracruz, Mexico, 1914. Photograph by J. H. Hare.

All over Mexico they gather the peons into the jails and force them to become soldiers. Sometimes they are arrested for petty infractions of the law. A peon seeks to gladden his existence by drinking a few cents' worth of half-spoiled pulque. The maggots of intoxication begin to crawl in his brain, and he is happy in that for a space he has forgotten in God knows what dim drunken imaginings. Then the long arm of his ruler reaches out through the medium of many minions, and the peon, sober with an aching head, finds himself in jail waiting

the next draft to the army. Often enough he does not have to commit any petty infraction. He is railroaded to the front just the same.

He does not know whom he fights for, for what, or why. He accepts it as the system of life. It is a very sad world, but it is the only world he knows. . . . Also it is why, in the midst of battle or afterward, he so frequently changes sides. He is not fighting for any principle, for any reward. It is a sad world, in which witless, humble men are just forced to fight, to kill, and to be killed. The merits of either banner are equal, or, rather, so far as he is concerned, there are no merits to either banner.[7]

London made only a handful of photographs in Mexico. It would have improved his articles for *Collier's* if he had illustrated them with the pictures he made, for his reports were too dry and analytical for most readers, and they bristle with racialism. Readers wanted to see and read about the firebrand London's daring adventures in Mexico, but instead they got economic history and ethnographic theory. Worse for the socialists, none of London's articles expressed any real support for the revolution. He had begun to drift away from his socialist comrades, and it showed. How one wishes that he had been able to photograph the occupation of Veracruz as he had the fighting in Korea or the beauty and corruption of the South Seas. As had happened in the past, when his physical condition deteriorated, so did his art; in Mexico not only was he suffering from kidney disease, but his alcoholism had also gotten much worse. In addition, he returned home to his ranch in Glen Ellen, California, quite ill from dysentery.

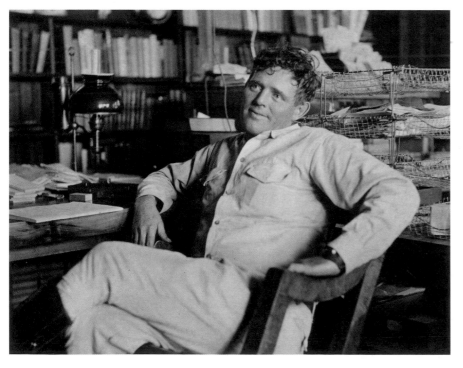

Jack London at home in his office, ca. 1914. Unknown photographer.

Charmian records in her diary that when it was too hot in Veracruz to write in their rooms, he would sit in a café and talk to whomever was there, then, bored, would go looking for something else to do. Though Charmian records going with Jack to "provost's court" to hear civil and criminal cases being tried, there just wasn't enough going on in Veracruz to occupy her husband. London wished to stay on to witness the further unfolding of the revolution but returned to California because he was so ill. This was the last photographic assignment he had, and nearly the last photographs he ever made.

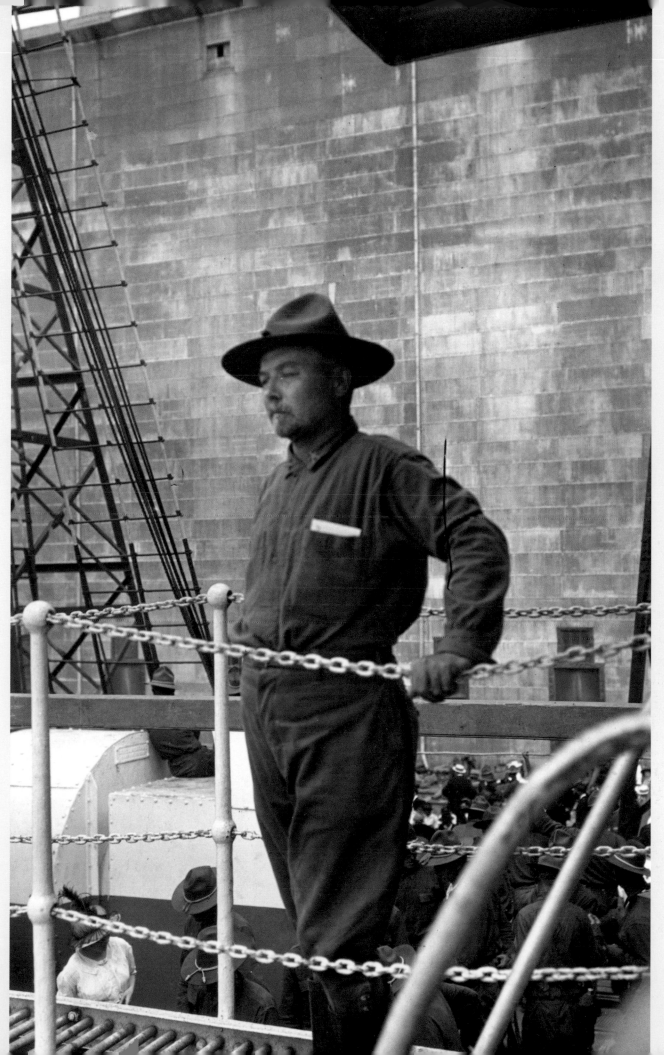

"Brig. Genl F [Frederick] Funston on the ss Kilpatrick, Galveston, TX, April 28, 1914."

"He wrote a series of articles that caused certain radicals to turn from him in rage. But I felt certain that the exponent of capitalist efficiency who counted upon Jack London's backing was a child playing in a dynamite factory. . . . If a naval officer took him over a battleship, he would perceive that it was a marvelous and thrilling machine; but let the naval officer not forget that in the quiet hours of the night Jack London's mind would turn to the white-faced stokers, to whom as a guest of an officer he had not been introduced!" (Upton Sinclair, quoted in Charmian London, The Book of Jack London, 2:300)

U.S. troops drilling, Veracruz, Mexico, 1914.

"Our soldiers and sailors are markedly different in type. It must be curious how this happens to be so. Do land life and sea life make the difference? Or does one common type of man elect the sea and another common type elect the land? The sailors are shorter, broader shouldered, thicker set. The soldiers are taller, leaner, longer legged. . . . Most notable is the difference when they are grouped into marching masses. The sailors have a swinging, springing, elastic stride. The soldiers' legs move more mechanically, more like clockwork legs, with a very tiny minimum of waste motion. It is prettier to watch the sailors marching with all the swaying elasticity of their bodies, and yet one receives the impression that, when it comes to the long killing hiking, the soldiers would easily outwalk their comrades of the sea." ("Mexico's Army and Ours," Collier's, *May 30, 1914)*

U.S. soldiers awaiting train transport, Veracruz, Mexico, 1914.

"Down in the railroad station, where I boarded the rescue train that runs out each day to the Federal lines, our sailors and marines were cooking, washing clothes, and teaching the Mexican youth how to pitch baseball. All along the track, until the country was reached, our men were encamped and performing sentry duty." ("With Funston's Men," Collier's, May 23, 1914)

(overleaf)
San Juan de Ulúa, a former fort used as a prison during the revolution, Veracruz, Mexico, 1914.

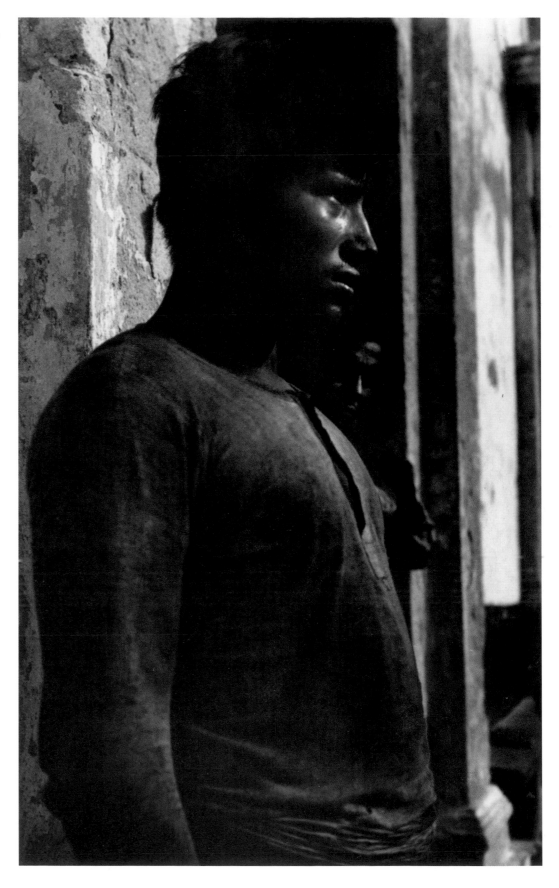

*"Many of them did not know for what they had
been doomed to the horrors of San Juan de Ulua."
Veracruz, Mexico, 1914.*

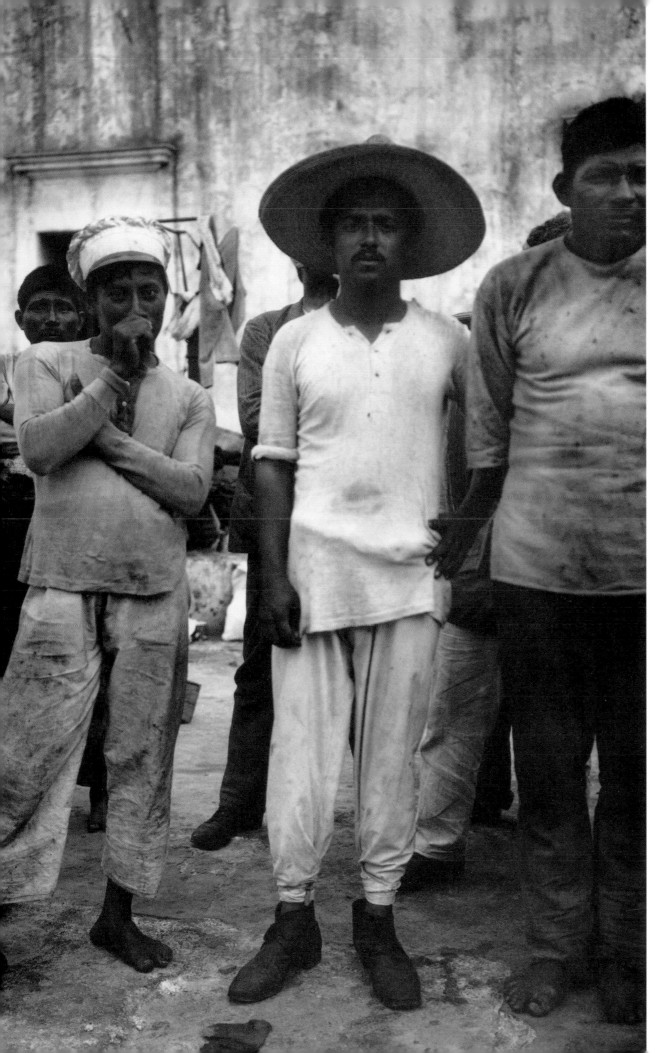

Prisoners,
San Juan de Ulúa,
Veracruz, Mexico,
1914.

249

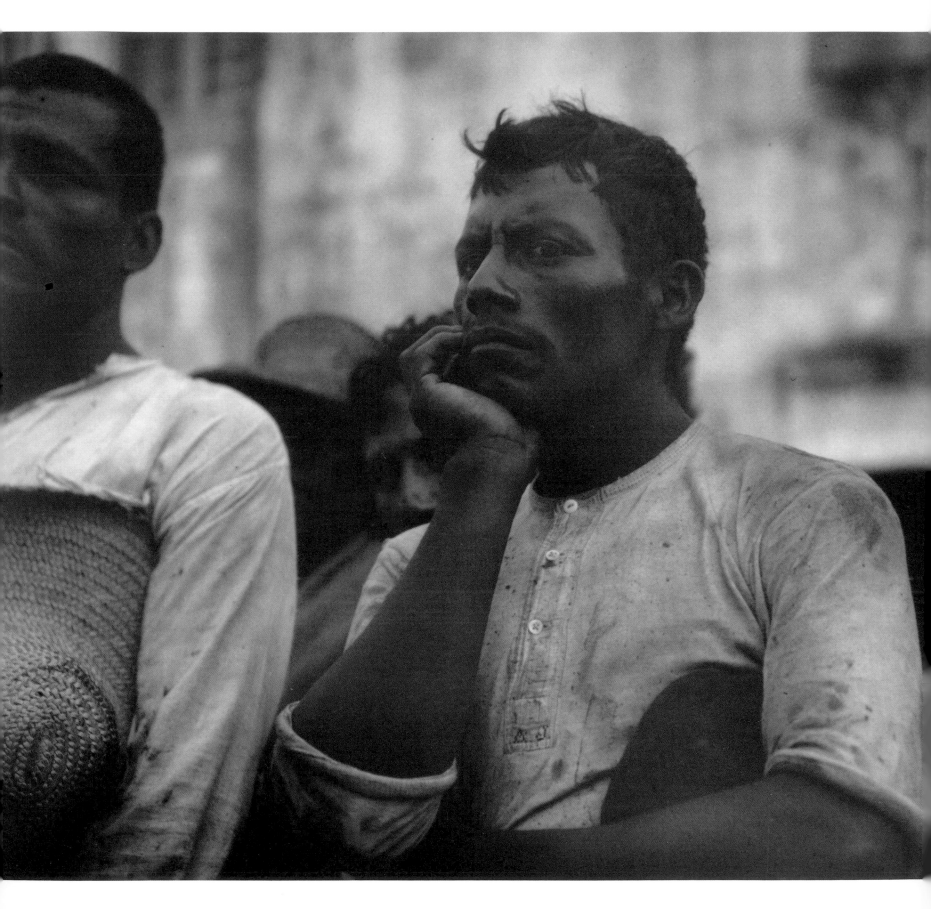

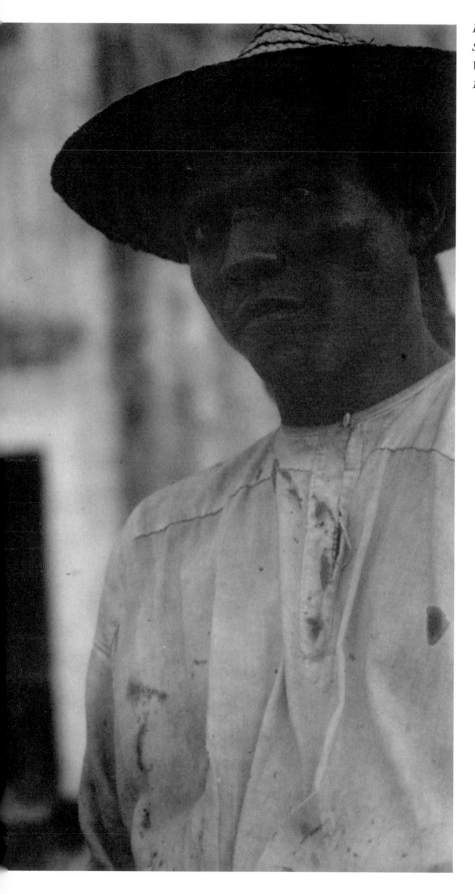

Prisoners,
San Juan de Ulúa,
Veracruz, Mexico,
1914.

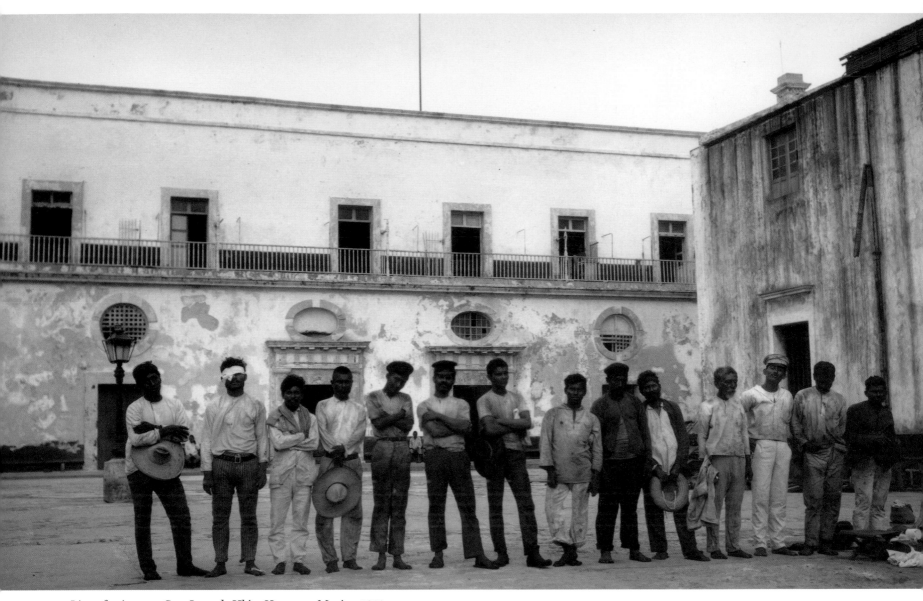

Line of prisoners, San Juan de Ulúa, Veracruz, Mexico, 1914.

Prisoner,
San Juan de Ulúa,
Veracruz, Mexico,
1914.

253

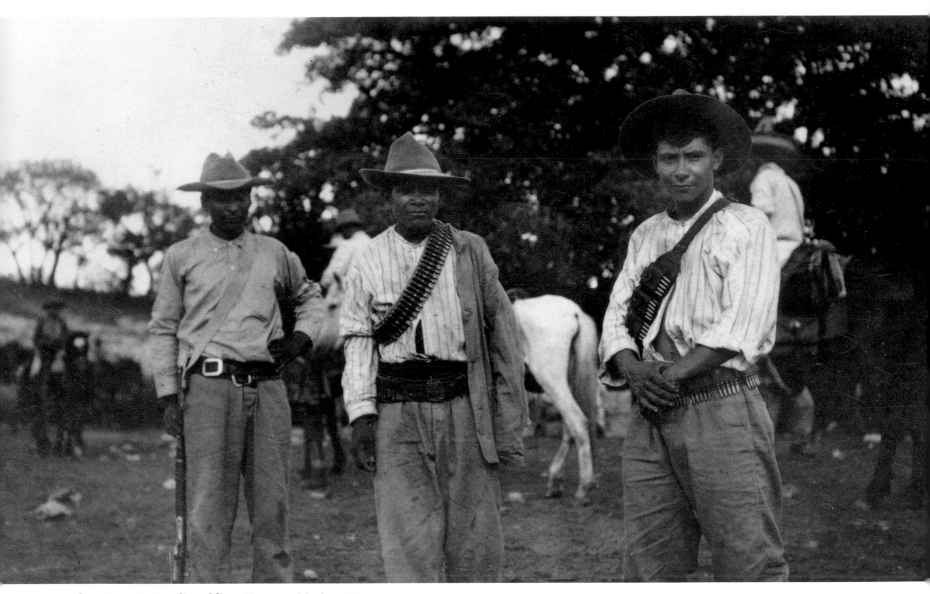

Three Constitutionalist soldiers, Veracruz, Mexico, 1914.

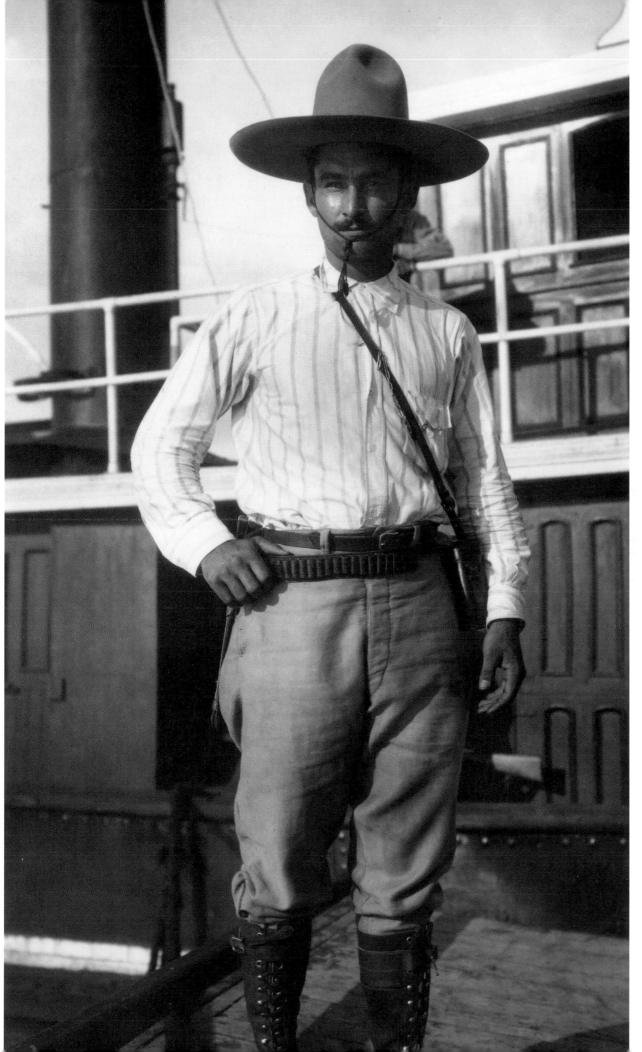

A Constitutionalist,
Tampico, Mexico,
1914.

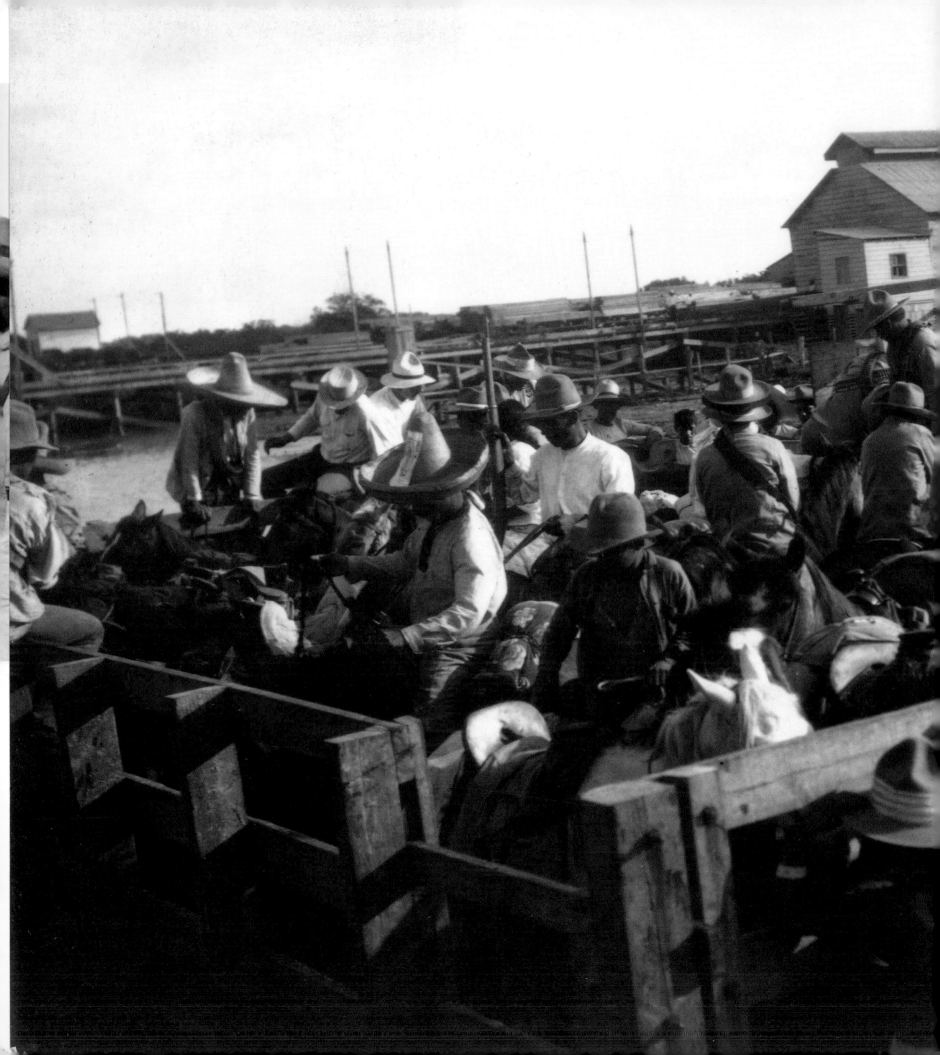

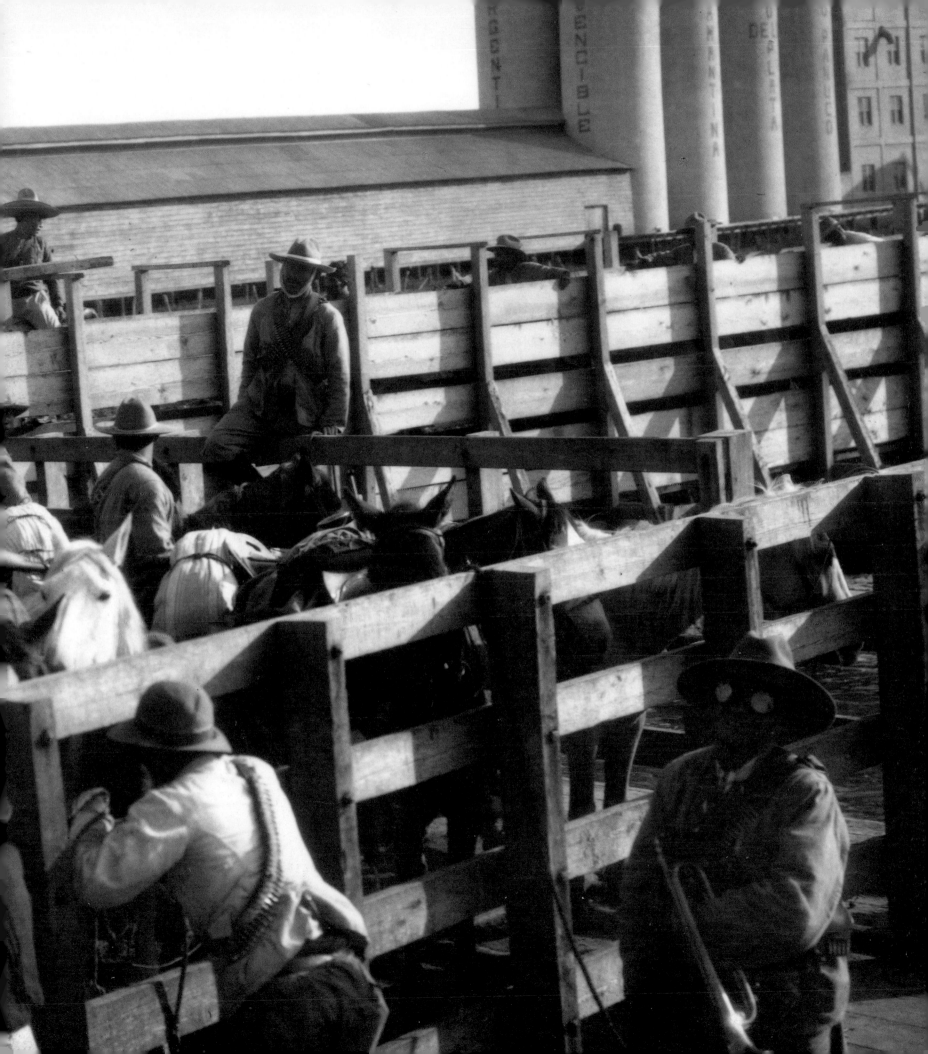

Damaged oil pipeline, Tampico, Mexico, 1914.

"One must go and see in order to know. My advance impression of Tampico, for one, was of a typical Mexican port infested with smallpox, yellow fever, and a few American adventurers of pernicious activities and doubtful antecedents. There were also oil wells, I understood, in and about Tampico, operated by the aforesaid adventurers. And that was about all I knew of the place until I went and saw." ("Our Adventures in Tampico," Collier's, *June 27, 1914)*

TECHNICAL NOTES Philip Adam

In photography, as in life, timing is everything. If Jack London had started his photographic pursuits in 1870 instead of 1900, the glass plates, large tripods, and pack mules required by early photographers might have discouraged a man like him, a man constantly on the move.

But fortunately for London's audiences around the world, by 1900, when he began photographing, flexible roll films, compact folding cameras, and more sensitive film emulsions offered London the perfect combination of materials with which to record his lifetime of adventure.

London's financial success also helped. He could afford to buy a variety of format cameras. His favorites appear to have been some of the folding cameras of the time. They were considered compact, though by today's standards they were cumbersome and heavy. The clarity of his pictures also suggests he always bought top-of-the-line cameras, with the best lenses available.

When London began making photographs, photography had already become an integral part of the American scene. People around the world bought cameras and used them to create lasting, treasured memories. However, photography's easy accessibility did not guarantee total satisfaction. Even the well-intentioned, dedicated practitioner of photography had to do many things right to make technically excellent photographs. Adjusting the lens for the proper exposure did not necessarily ensure predictable results. The accuracy of modern electronic exposure meters was decades away. After exposure of the film, improper development of the negative could (and often did) lead to disaster.

The majority of photographers in London's time were not able to control the black-and-white tonal scale of their negatives. Photographic sensitometry, in the sense that Ansel Adams knew it, for example, was many years away. To attain the level of control necessary, the photographer would have to assess carefully the range of contrasts in the scene, while visualizing how the final print would look. From this

A happy accident, double exposure, Charmian London and friends.

analysis, the photographer would plan how to expose and develop the film to create a negative that, when printed, would produce a photograph matching what had previously been visualized. When the contrast range of the film is less than optimal, as was often the case in much early photography, skillful printing could help make up for negative densities beyond the printable range of the photographic paper. But even then it was extremely difficult to produce details in the positive print when they were essentially absent on the negative because of gross underexposure or overdevelopment of the film.

My challenge has been to preserve as much of the information found in London's negatives as possible. As a printer of historical and vintage negatives, including London's, I often think of

myself as a kind of photo-archaeologist. I do my best to transfer to the print the information contained in the negative, especially that at the extreme ends of the tonal scale.

In London's time, roll film was in an early stage of evolution. Before 1906, photographs were made on film coated with orthochromatic emulsions, which were extra sensitive to the blue part of the visible spectrum. This sometimes produced images that looked odd to the eye. Skin tones often looked strange, and the sky portions of negatives were extremely dense, well beyond the printable range of photographic paper. But in 1906, panchromatic emulsions, which were more evenly sensitive to the entire visible spectrum, became available. They allowed photographers to make black-and-white

images that more closely matched what they saw with their eyes.

The quality of light also had an effect. The northern Pacific sky that illuminated London's San Francisco earthquake pictures was soft and diffused. It was far more forgiving than the harsh tropical light under which he photographed the dark-skinned people of the South Pacific.

Because London photographed in many different environments and lighting conditions, while struggling to adapt to the changing characteristics of available films, it was difficult for him to learn from his technical mistakes. There were always too many variables. Yet during the time London made photographs, from 1900 to 1916, technical success was often the result of educated guessing. Fortunately for us, given the opportunity, London could teach himself how to do almost anything. It is clear that he carefully followed the instruction booklets that came with his cameras.

If we add to these challenges those of war, natural disaster, long voyages at sea, saltwater contamination, high humidity, and extreme temperatures, it is surprising that his films made it back to a safe harbor and produced printable negatives.

Jack London spent a great deal of his vital energy making the photographs in this book. His keen intelligence and sensitivity, combined with the unmistakable clarity of intent evident in his photographs, were the key ingredients leading to his success behind the camera. The resulting photographs made Jack London an important photographer at the dawn of the twentieth century.

NOTES

Introduction.
Jack London's "Human Documents"

1. Jack London, *Letters of Jack London*, 409–10.

2. Jack London, "How Jack London Got In and Out of Jail in Japan," in Jack London, *Jack London Reports*, 32.

3. Jack London, *Before Adam*, 1.

4. Rabb, *Literature and Photography*, xxxix. Twain praised Howells's knack for verbal exactness by telling him in a letter dated January 21, 1879, "everywhere your pen falls it leaves a photograph" (Twain, *Mark Twain's Letters*, 1:346).

5. Alfred Stieglitz, quoted in Haines, *Inner Eye of Alfred Stieglitz*, 23.

6. Jewett, "Human Documents."

7. Ibid., 17–18.

8. Jack London to "the Editor," *Editor*, April [?], 1907, *Letters of Jack London*, 685.

9. Jack London to Cloudesley Johns, October 3, 1899, *Letters of Jack London*, 115.

10. Jack London, *Letters of Jack London*, 685.

11. From time to time, a couple of photographs that supposedly show London in the Klondike are published: one of a young man standing with other miners, and one of London in a fur coat. The young man in the first photograph does not even resemble London, and the fur coat image was made in Truckee, California, when the Londons attended the Truckee Winter Carnival in January of 1915.

12. Jack London, *Letters of Jack London*, 1073.

13. Quoted in Genthe, *As I Remember*, 49.

14. Genthe, *As I Remember*, 49.

15. Ibid., 75.

16. Marien, *Photography*, 37.

17. Parr and Badger, *Photobook*, 38.

18. Marien, *Photography*, 81–83.

19. Boas, *Anthropology and Modern Life*, 92.

20. Jack London, *Letters of Jack London*, 919.

21. Quoted in ibid., 999.

22. Ibid., 919.

23. Ibid.

24. Ibid., 930–31.

Chapter 1. *The People of the Abyss*

1. Jack London, *People of the Abyss*, 121.

2. Jack London to George P. Brett, December 30, 1902, *Letters of Jack London*, 331.

3. Jack London, *People of the Abyss*, 13–14.

4. Jack London to Bailey Millard, February 18, 1906, *Letters of Jack London*, 549.

5. Hamilton, *"Tools of My Trade,"* 27.

6. Parr and Badger, *Photobook*, 39–40.

7. Jack London to George P. Brett, December 30, 1902, *Letters of Jack London*, 331. F. Marion Crawford's *Cecilia, a Story of Modern Rome*, and Jacob Riis's *The Battle with the Slum* were published by Macmillan in 1902.

8. Jack London to George P. Brett, December 8, 1904, *Letters of Jack London*, 456.

9. Warner, introduction to *How the Other Half Lives*, by Jacob Riis, viii.

10. Riis, *How the Other Half Lives*, ix–xi.

11. Riis, *Battle with the Slum*, 1.

12. Ibid., 7.

13. Ansel Adams, preface to Alexander Alland, *Jacob A. Riis*, by Alland, 5–6.

14. Ibid., 7.

15. Brandt, *Night in London*; the quotation is from Parr and Badger, *Photobook*, 138.

16. Brandt, *The English at Home*; the quotation is from Parr and Badger, *Photobook*, 138.

17. Atget, *Atget: Photographe de Paris*; Abbott, *Changing New York*.

18. Evans, "Reappearance of Photography," 126.

19. Caldwell and Bourke-White, *You Have Seen Their Faces*.

20. Evans, *American Photographs*.

21. Agee and Evans, *Let Us Praise*.

22. Hine, *Men at Work*; Lange and Taylor, *American Exodus*.

Chapter 2. The Russo-Japanese War

1. Jack London to Charmian Kittredge, "On board junk, off Korean Coast," February 9, 1904, in Jack London, *Letters of Jack London*, 410.

2. Dunn, "Jack London Knows Not Fear."

3. McKenzie, *From Tokyo to Tiflis*, 64.

4. Jack London, "Advancing Russians Nearing Japan's Army," in Jack London, *Jack London Reports*, 38–39.

5. Jack London, "The Monkey Cage," in ibid., 116.

6. *San Francisco Examiner*, May 1, 1904.

7. Jack London, "Japanese Officers Consider Everything a Military Secret," in *Jack London Reports*, 120.

8. Tsujii, "Jack London Items."

9. Quoted in Van Dillen, "Becky London."

10. Griscom, *Diplomatically Speaking*, 245–46.

Chapter 3. The San Francisco Earthquake

1. Jack London to Merle Maddern, May 1, 1906, *Letters of Jack London*, 572–73.

2. Charmian Kittredge London, diary, 1906, Jack London Collection, Henry E. Huntington Library, San Marino, California (hereafter cited as Jack London Collection).

3. Charmian Kittredge London, *The Book of Jack London*, 2:141, 143.

4. Ibid., 2:142.

5. Ibid.

6. Nolte, "Jack London's Lens."

Chapter 4. *The Cruise of the Snark*

1. Desmond, *Staging Tourism*, 37.

2. Ibid., 40.

3. Jack London, *John Barleycorn*, 46.

4. Jack London, *Cruise of the Snark*, 5.

5. For his work among the lepers, Father Damien was canonized in October 2009 by Pope Benedict XVI.

6. Jack London, *Cruise of the Snark*, 105.

7. Ibid., 95. The Londons' good fortune notwithstanding, it should be emphasized that leprosy, left untreated, is indeed contagious.

8. Ibid., 92.

9. Ibid., 93–95.

10. Ibid., 100–101.

11. Ibid., 165.

12. Ibid., 166–67.

13. Ibid., 161–63.

14. Charmian London quoted in "People: Nature Man," *Letters* 4, no. 4 (April 1937): 3.

15. Jack London, *Cruise of the Snark*, 191–93.

16. Ibid., 197.

17. Ibid., 209–10.

18. Charmian Kittredge London, *Log of the Snark*, 486–87.

19. Jack London to Harold S. Latham, May 31, 1911, *Letters of Jack London*, 1910–11.

20. Jack London to Bailey Millard, February 18, 1906, in ibid., 548.

21. Jack London to Bailey Millard, March 17, 1906, in ibid., 556.

22. Jack London to Bailey Millard, April 3, 1906, in ibid., 542.

23. Jack London to Bailey Millard, July 16, 1906, in ibid., 590.

24. Jack London to Perriton Maxwell, December 1, 1906, in ibid., 553.

25. Jack London to Arthur T. Vance, July 16, 1906, in ibid., 591–92.

26. Jack London to Hayden Carruth, October 25, 1908, in ibid., 756.

27. Jack London to Lucius Pease, August 14, 1909, in ibid., 824–25.

28. Martin Johnson to Jack London, November 5, 1906, Jack London Collection. London wrote to Martin on November 17, 1906, reviewing the plans for the trip: "As regards photographs, I am glad to hear that you are 'way up in the matter. Mr. Stolz (the Stanford man), has been making all the preparations for doing my developing and printing. But you can certainly lend him a hand and I know give him much good advice" (Jack London, *Letters of Jack London*, 633). He told Martin that he could bring his own camera and make photographs ashore, but not of the Londons or the boat without permission, because of London's contracts with magazines.

29. Osa Johnson, *I Married Adventure*, 39.

30. Jack London, *Letters of Jack London*, 1439.

31. Martin Johnson, *Through the South Seas*; Charmian Kittredge London, *Log of the Snark*.

32. Jack London, "A Brief Explanation: [of abandoning the *Snark* voyage]," photocopy of autographed typescript, JL 21258, Jack London Collection.

33. Jack London to the H. C. White Company, October 6, 1910, Jack London Collection.

Chapter 5. The Voyage of the *Dirigo*

1. Charmian Kittredge London, *The Book of Jack London*, 2:249.

2. Ibid., 2:250.

3. Charmian Kittredge London, diary of *Dirigo* voyage, March 13, 18, and 19, 1912; May 17, 1912, 4–6, 9–10, 35, JL 208, Jack London Collection.

Chapter 6. The Mexican Revolution

1. The Mexican Revolution lasted from 1910 to 1920. In 1913, President Francisco Madero was assassinated as part of coup, and Victoriano Huerta assumed the presidency. He was opposed by competing revolutionary groups led by Emiliano Zapata, Pancho Villa, and Venustiano Carranza. U.S. president Woodrow Wilson disliked Huerta, and on the flimsiest of excuses—he felt that Huerta had failed to apologize sufficiently for the brief, accidental arrest of some U.S. sailors—decided to occupy the port of Veracruz, where Huerta received most of his armament shipments (mainly from Germany) and where the customs duties that provided a chief source of income for the government were collected. Starved of cash and arms, Huerta fled the country in July 1914; after the rival revolutionary leaders could not agree on a new president, the country was riven by several years of anarchy and chaos.

2. Charmian Kittredge London, *The Book of Jack London*, 2:299.

3. Jack London, "Our Adventurers in Tampico," in Jack London, *Jack London Reports*, 198.

4. Charmian Kittredge London, *The Book of Jack London* 2:299.

5. Ibid.

6. Jack London, "Mexico's Army and Ours," in Jack London, *Jack London Reports*, 151.

7. Ibid.

BIBLIOGRAPHY

Abbott, Berenice. *Changing New York*. New York: Dutton, 1939.

Agee, James, and Walker Evans. *Let Us Now Praise Famous Men*. Boston: Houghton Mifflin, 1941.

Alland, Alexander. *Jacob A. Riis: Photographer and Citizen*. Preface by Ansel Adams. New York: Aperture, 1974.

Atget, Eugène. *Atget: Photographe de Paris*. New York: Weyhe, 1930.

Boas, Franz. *Anthropology and Modern Life*. New York: Norton, 1928.

Brandt, Bill. *The English at Home*. London: Batsford, 1936.

———. *A Night in London: Story of a London Night in Sixty-four Photographs*. New York: Charles Scribner's Sons, 1938.

Caldwell, Erskine, and Margaret Bourke-White. *You Have Seen Their Faces*. New York: Duell, Sloan and Pearce, 1937.

Desmond, Jane C. *Staging Tourism: Bodies on Display from Waikiki to Sea World*. Chicago: University of Chicago Press, 1999.

Dunn, Robert L. "Jack London Knows Not Fear." *San Francisco Examiner*, June 26, 1904.

Evans, Walker. *American Photographs*. New York: Museum of Modern Art, 1938.

———. "The Reappearance of Photography." *Hound and Horn* 5 (October–December 1931): 125–28.

Genthe, Arnold. *As I Remember*. New York: Reynal and Hitchcock, 1936.

Griscom, Lloyd. *Diplomatically Speaking*. New York: Literary Guild, 1940.

Haines, Robert. *The Inner Eye of Alfred Stieglitz*. Washington, D.C.: University Press of America, 1982.

Hamilton, David Mike. *"The Tools of My Trade": Annotated Books in Jack London's Library*. Seattle: University of Washington Press, 1986.

Hine, Lewis. *Men at Work*. New York: Macmillan, 1932.

Jewett, Sarah Orne. "Human Documents." *McClure's Magazine* 1 (June 1893): 16–18.

Johnson, Martin. *Through the South Seas with Jack London*. New York: Dodd, Mead, 1913.

Johnson, Osa. *I Married Adventure*. New York: Lippincott, 1940.

Lange, Dorothea, and Paul S. Taylor. *An American Exodus: A Record of Human Erosion*. New York: Reynal and Hitchcock, 1939.

London, Charmian Kittredge. *The Book of Jack London*. 2 vols. London: Mills and Boon, 1921.

———. *The Log of the Snark*. New York: Macmillan, 1915.

London, Jack. *Before Adam*. New York: Macmillan, 1907.

———. *The Complete Short Stories of Jack London*. Edited by Earle Labor, Robert C. Leitz, III, and I. Milo Shepard. 3 vols. Stanford, Calif.: Stanford University Press, 1993.

———. *The Cruise of the Snark*. New York: Macmillan, 1911.

———. *Jack London Reports: War Correspondence, Sports Articles, and Miscellaneous Writings*. Edited by King Hendricks and Irving Shepard. Garden City, N.Y.: Doubleday, 1970.

———. "The Japanese-Russian War." In Jack London, *Jack London Reports*, 24–125.

———. *John Barleycorn*. New York: Century, 1913.

———. *The Letters of Jack London*. Edited by Earle Labor, Robert C. Leitz, III, and I. Milo Shepard. 3 vols. Stanford, Calif.: Stanford University Press, 1988.

———. "The Mexican Conflict." In Jack London, *Jack London Reports*, 126–214.

———. *The People of the Abyss*. New York: Macmillan, 1903.

———. "The Story of an Eye-Witness." *Collier's*, May 5, 1906. Reprinted in *The Portable Jack London*, edited by Earle Labor, 486–91. New York: Penguin, 1994.

Marien, Mary Warner. *Photography: A Cultural History*. New York: Abrams, 2002.

McKenzie, F. A. *From Tokyo to Tiflis: Uncensored Letters from the War*. London: Hurst and Blackett, 1905.

Nolte, Carl. "Jack London's Lens on 1906 Quake." *San Francisco Chronicle*, January 6, 2006.

Parr, Martin, and Gerry Badger. *The Photobook: A History*. Vol. 1. London: Phaidon, 2004.

"People: Nature Man." *Letters* 4, no. 4 (April 1937): 3–4.

Rabb, Jane, ed. *Literature and Photography: Interactions, 1840–1990*. Albuquerque: University of New Mexico Press, 1995.

———, ed. *The Short Story and Photography, 1880's–1980's: A Critical Anthology*. Foreword by Eugenia Parry. Albuquerque: University of New Mexico Press, 1998.

Riis, Jacob. *The Battle with the Slum*. New York: Macmillan, 1902. Reprint, Mineola, N.Y.: Dover, 1998.

———. *How the Other Half Lives: Studies among the Tenements of New York*. 1890. Reprint, edited by Sam Bass Warner, Jr. Cambridge, Mass.: Harvard University Press, 1970.

Tsujii, Eiji. "Jack London Items in the Japanese Press of 1904." *Jack London Newsletter* 8, no. 2 (1975): 55–58.

Twain, Mark (Samuel L. Clemens). *Mark Twain's Letters*. Edited by Albert Bigelow Paine. New York: Harper and Brothers, 1917.

Van Dillen, Lailee. "Becky London: The Quiet Survivor Talks about her Father." *Californians* 9, no. 4 (January–February 1992): 38.

147: CSP 350.1
148: CSP 350.9
150: HEH JLP 485 Alb 47 #25820
151: CSP 36.24
152: HEH JLP 485 Alb 47 #05874
153: CSP 241.25.43
154 left: HEH JLP 538 LA 7 #12410
154 right: CSP 50.7
155: HEH JLP 537 LA 6 #12308
159: CSP 37.10
160: CSP 63.0
161 top: CSP 4.7
161 bottom: CSP 4.8
166: CSP 33.1
168–69: HEH JLP 485 Alb 47 #05930
170–71: HEH JLP 554 LA 23 #13794
172: CSP 161.12
173: HEH JLP 489 Alb 51 #06564
174: HEH JLP 542 LA 11 #12921
175: CSP 52.14
176: CSP 52.8
177: HEH JLP 492 Alb 54 #06899
178: HEH JLP 493 Alb 55 #06899 (227)
179: HEH JLP 493 Alb 55 #06899 (228)
180: CSP 154.12
181: CSP 344.1
182–83: CSP 198.2
184: CSP 20.6
185: CSP 24.5
186: HEH JLP 498 Alb 60 #07531
187: CSP 31.2
188: CSP 24.13
189: HEH JLP 495 Alb 57 #07159

190: CSP 68.7
191: HEH JLP 495 Alb 57 #07173
192: CSP 70.18
193: CSP 209.4
194: CSP 292.2
195: CSP 315.5c
196: HEH JLP 498 Alb 60 #07630
197: HEH JLP 500 Alb 62 #07719
198: CSP 45.5
199: CSP 48.10
200: CSP 45.6
201: HEH JLP 500 Alb 62 #07720
202: CSP 29.21
203: HEH JLP 501 Alb 63 #07915
204–5: CSP 19.1
206: CSP 170.1
207: CSP 20.17
208–9: CSP 20.21
210: CSP 24.14
211: CSP 23.6
212–13: CSP 23.7
214: CSP 23.17
215: CSP 24.8
216: CSP 21.20
217: CSP 47.19
218–19: CSP 209.1
221: HEH JLP 538 LA 7 #12363
222 top: Maine Maritime Museum
222 bottom: CSP 335d.2
224: CSP 41.3
225: CSP 343.27
226 left: CSP 343.17
226–27: CSP 343.31

228: CSP 343.35
229: CSP 343.41
230: CSP 343.43
231: HEH JLP 511 Alb 73 #09607
232: CSP 343.19
233 top: HEH JLP 511 Alb 73 #09558
233 bottom: CSP 343.44
234 top: CSP 343.46
234 bottom: CSP 343.54
235: CSP 343.55
236–37: CSP 342.8
238: CSP 15.11
240: HEH JLP 521 Alb 83 #10596
241: HEH JLP 522 Alb 84 # 10774
242: HEH JLP 457 Alb 19 #02247
243: CSP 79.3
244: CSP 174.17
245: HEH JLP 522 Alb 84 #10836
246–47: HEH JLP 521 Alb 83 #10641
248: CSP 158.10
249: HEH JLP 521 Alb 83 #10671
250–51: CSP 158.2
252: CSP 158.7
253: CSP 158.6
254: HEH JLP 522 Alb 84 #10806
255: CSP 174.8
256: CSP 174.11
257: CSP 174.10
258–59: CSP 174.31
260: CSP 174.34
261: CSP 42.2
272: CSP 111.0

INDEX

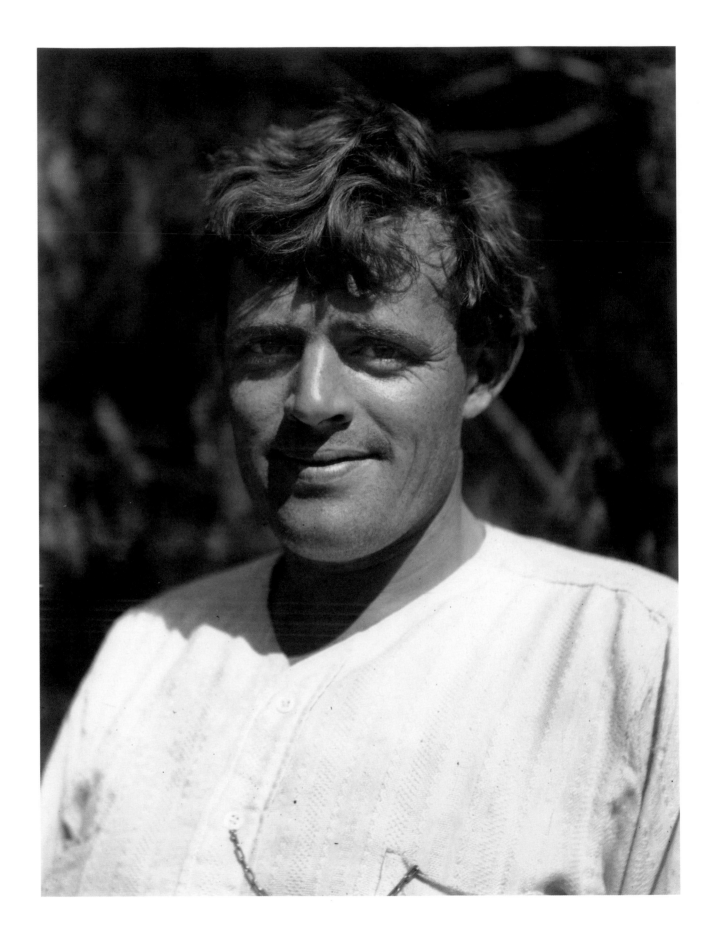